Local Violence,
Global Media

Library of Congress Cataloging-in-Publication Data

Local violence, global media: feminist analyses of gendered representations /
edited by Lisa M. Cuklanz, Sujata Moorti.
p. cm. — (Intersections in communications and culture: global approaches
and transdisciplinary perspectives; v. 23)
Includes bibliographical references and index.
1. Women—Crimes against. 2. Rape in mass media. 3. Sex in mass media.
4. Violence in mass media. 5. Feminist theory. I. Cuklanz, Lisa M. II. Moorti, Sujata.
HV6250.4.W65L63 362.88082—dc22 2008043861
ISBN 978-1-4331-0277-6 (hardcover)
ISBN 978-1-4331-0276-9 (paperback)
ISSN 1528-610X

Bibliographic information published by **Die Deutsche Bibliothek**.
Die Deutsche Bibliothek lists this publication in the "Deutsche
Nationalbibliografie"; detailed bibliographic data is available
on the Internet at http://dnb.ddb.de/.

The paper in this book meets the guidelines for permanence and durability
of the Committee on Production Guidelines for Book Longevity
of the Council of Library Resources.

Printed in the United States of America

This book is dedicated to Kyle Cuklanz.

CONTENTS

ACKNOWLEDGMENTS

Many people contributed their insights and energies to this project over the several years from conception to completion. First, we thank our contributors for the energy and willingness with which they have participated in this project, making our task as editors a pleasure. In addition, we wish here to acknowledge other essential contributions.

First, the editors are indebted to colleagues and staff at two institutions. At Middlebury College, students devoted time and effort to various elements of the production work. Laverne Blackman and Christine Bachman helped with preliminary research for the anthology. Karin Hanta's assistance in various aspects of the project merits special mention. In addition, Stacy Hotte and Naomi Neff provided assistance with many of the administrative details. Staff in the Communication Department at Boston College were consistently supportive and encouraging. The unwavering dedication of Mary Saunders and Leslie Douglas at Boston College are especially appreciated. As usual, Boston College Communication Department faculty, particularly Dale Herbeck, Pam Lannutti, Elfriede Fursich, and Bonnie Jefferson, provided steady mentorship, humor, and support. We are grateful as well for leave time and other material support provided by Middlebury College and Boston College. We thank as well *Critical Asian Studies* for giving us permission to use parts of Linda Isako Angst's essay.

Throughout our collaboration on this project, we have benefited from the helpful feedback and insights of colleagues including Cindy Carter, Marlene Fine, Nina Gregg, Lynn O'Brien Hallstein, Dafna Lemish, Anne Litwin, Marian Meyers, Sarah Projansky, Clemencia Rodriguez, Trish van der Spuy and Usha Zacharias.

Series editor Anghy Valdivia was instrumental in developing and shaping the final outcome through her thoughtful and meticulous attention to the initial proposal and draft. Sophie Appel and Mary Savigar at Peter Lang provided meticulous attention to detail and deadlines that brought this project to fruition in a more timely and seamless way than we ever thought possible.

As with any project unfolding over such a lengthy period of time, our families and friends were of the utmost importance. In particular, the loving support and understanding of Joyce, Harlan, and Kyle Cuklanz were essential to Lisa throughout the duration of this project. Sujata also thanks her family for their support during this project.

CHAPTER 1

Introduction

Tracking Global Media and Local Activism

Sujata Moorti and Lisa Cuklanz

The World Health Organization says gender-based violence accounts for more death and disability among women aged 15–44 years than cancer, malaria, traffic injuries and war combined. As long as there is no real progress on addressing the culture of impunity that surrounds sexual violence, the number of women medically and psychologically scarred for life will increase as the epidemic continues unrestrained.[1]

Issues of gendered violence including the wartime use of rape as a form of torture, global trafficking, and sex slavery have increasingly found their way into international consciousness over the past two decades through a proliferation of images and reports of these developments. The United Nations and other nongovernmental organizations have proffered alarming statistics to make the point that violence against women and gender-based violence (GBV) know "no boundaries of geography, culture or wealth." There is no country in the world where GBV does not exist. Rather, empirical evidence provides a startling reminder that the old feminist adage continues to prevail: from the battlefield to the bedroom, women are at risk of violence. With the rapid emergence of new technologies, the media have become one of the primary means by which this information has been made available and also a critical node for the formulation and contestation of policy initiatives, at the local, national, and global levels.

Elizabeth's brutal rape is one of an unknown number of sexual assaults carried out by peacekeepers and aid workers, the very people who are brought in to post-conflict areas around the world to protect the vulnerable.[2]

Nearly a third of female veterans say they were sexually assaulted or raped while in the military, and 71 percent to 90 percent say they were sexually harassed by the men with whom they served.[3]

It starts with screams but must never end in silence.

　　Statistics show that 12% to 15% of women in Europe face violence in the home every day. The Council of Europe—Europe's leading human rights organisation—has decided it is time it stopped. It has launched a campaign in its member countries to criminalise domestic violence, ensure support for victims and foster new attitudes so that violence against women in the home will no longer be tolerated. Everyone has a role to play.[4]

These are but three instances of the myriad ways in which women have come to experience gendered violence and the ways in which the media have reported them. Significantly, these acts of violence are not isolated to one geographic region or cultural space; rather we find that they occur in the global north as well as the south. Whether it is the rape of young girls by U.N. peacekeepers in the Ivory Coast, the benign neglect of sexual assault and femicide[5] within the U.S. military, or familial violence in the European Union, every day we are bombarded by images and narratives of violation—sexual and otherwise. Representations of gendered violence are staples of media, whether on television, in print, or online. The sites of violence and the subjects of violence are equally heterogeneous, crossing cultures, continents, and national boundaries. As ubiquitous as these images of violence have become, so have been the polemical critiques condemning media practices.

　　The chapters in this anthology move beyond simplistic assessments that are quick to label the media as good or bad. Rather we seek to understand a set of foundational categories that surround media treatment of gendered violence: what is covered under the title gendered violence, who defines it, who is left out of this definition, whether there is a universal definition governing all media practices, whether there are differences in fictional and nonfictional representations of gendered violence, whether there are any variations across the world in media coverage of gendered violence, and so on. In short, we are interested in mapping out the contours of media discourses of gendered violence.[6] We use media representations as a vantage point from which to examine the ways in which gendered violence is now apprehended; media portrayals shed light on the dominant understandings of the concept and also reveal the particular contestations and anxieties that prevail around the topic. Considering the prevalence of gendered violence, our anthology is a continuation and extension of four decades of feminist scholarship that has deftly unpacked the grammar and rhetoric of media representational practices, which has in turn engendered changes in the public sphere and cultural arenas on a

global scale. Simultaneously this anthology opens up new lines of inquiry by offering an assessment of the uneven changes that feminist activism has enabled around the world.[7]

It is axiomatic to declare that violence against women is an international phenomenon, but this anthology is specifically designed to highlight gendered forms of violence. This shift in focus from women to gender is not only significant but is urgently required. The second-wave slogan "the personal is political" brought to the public eye violence against women by challenging the inviolability of the home. Its radical critique of patriarchy and gender-based inequalities served to initiate diverse social changes, particularly in the arenas of law and public policy. While feminists in North America and Europe have long declared that violence against women is a manifestation of unequal power relations, until fairly recently the focus has remained unrelentingly on female subjects as victims. At the level of media coverage, the binarized worldview promoted by the phrase "violence against women" set the stage for the limited grammar within which violence was portrayed. At the most basic level, media representations rehearsed existing "gender scripts" by casting females as always-already victims and males as victimizers. Little of the sophisticated, nuanced, and complex analyses that feminists had formulated about power inequalities found its way to the media. Rather, the media as the exemplary institutions of democratic societies reiterated the gender binaries foundational to the Western project of modernity and our understandings of the liberal subject. Consequently, media coverage either highlighted the feminine characteristics of the victims or the violent masculinity of the perpetrators; sexual violence itself was reduced to a biological drive.

In the global south, where the social is marked by crisscrossing vectors of economic, cultural, and political inequalities, the formulation "violence against women" has been inadequate to capture the variegated forms of sexual violence that are exercised. Further, the gender binary that is constitutive of western modernity fails to capture the realities of everyday life in the global south. Even as third-world feminists struggled to articulate new theories to understand the forms of sexual violence that are enacted, international development organizations have helped recast the terms of the debate as gendered violence, a formulation that seeks to highlight the significant ways in which men and women are sexually subjugated by the powerful. Propelled by the goal to reduce poverty and improve economic opportunities in the global south, international development agencies have put into operation feminist ideas that class, caste, ethnicity, religious identity, sexual identity, and a range of other factors intersect to locate individuals in complex cartographies of oppression that cannot be reduced to the sex binary. The chapters in this an-

thology offer a global perspective to highlight the different ways in which gender and sexual violence are understood; they chart local "geographies of pain" and simultaneously record the forms of activism these traumas have engendered. Recognizing that countries in the global south have charted different paths to modernity, our chapters seek to underscore the alternative archives and narratives the media offer in their coverage of gendered violence. Individual chapters offer a telescopic vision of global media, zooming in and out between individual experiences of violence at their most poignant and intimate level, and broad cultural and political sources and implications of gendered violence. In addition, they offer alternative subject positions—outside those of the modern, liberal subject—from which to understand sexual violence and the resulting media coverage.

Without flattening differences across regions or media genres, this anthology seeks to highlight the cultures of violence and the grammars of terror that shape contemporary representational practices. We wish to underscore the cultural structuring and embodied experience of violence, and the gender, class, and ethnic dimensions of violence as enacted and endured. This anthology thus contributes to the larger scholarship on cultures of violence. Equally significant, this anthology deepens and broadens understandings of gendered violence as no longer limited to media representations of violence against women. The rest of this chapter is broadly divided into two sections; in the first section we clarify some terms central to this analysis and outline the contextual and theoretical frames that animate this project, and in the second section, we highlight the media-specific concerns the chapters address.

In the first section, we offer a definitional overview of GBV. We then provide a brief summary of the legal and policy changes that have been enacted by feminist activism. Because feminist scholarship has very ably charted the many national-level judicial reforms and policy initiatives, we limit our perspective to the international level. Finally, we trace some of the international forms of activism that communities have undertaken.

Gendering of Violence

Sexual violence is a gendered phenomenon: its nature and extent reflect pre-existing social, cultural and economic disparities between men and women. The relationship between victim and perpetrator reflects existing power differentials or struggles between people... In the same way that sexual violence mirrors gender inequalities so it reflects other forms of social inequality. Far from being universal, sexual violence is clearly associated with specific social settings and circumstances...[8]

Feminist activists and scholars have largely been responsible for evoking such a statement from the United Nations Development Program (UNDP). As Julie Hemment notes, "since the 1990s, the campaign against violence against women has had broad resonances across locations. It is thought to address a universal problem, the content of which is assumed and taken for granted."[9] Clearly, gendered violence has gained a higher profile on the international stage, in part through the proliferation and reporting of such violence and of the forms it has taken, including human trafficking and forced prostitution, rape as a war crime, wife battering, hate crimes, gang rape, sexual harassment, and "cultural" practices such as honor killings.[10] In this context, it is time to begin examining representational practices. Our anthology documents the different forms of representations that arise from gendered violence. The individual chapters also interrogate the cultural work conducted by these representations, the cultural contexts in which they are produced, and the larger social climate they engender within which we come to understand and respond to these phenomena.

Hemment and many other scholars have illustrated that the local meanings of rape, domestic violence, and gendered violence are multiple and varied.[11] As feminist scholar Chandra Talpade Mohanty has reminded us repeatedly, cultural contexts of metaphor, social norms, cultural practices, and concepts such as shame and honor come into play and are necessarily different among diverse locations around the world.[12] For these reasons it is important to retain an understanding of the immediate local and cultural contexts for individual cases of GBV. This vigilant attention to the local context even as we locate GBV in a global context requires careful maneuvering. The chapters in this anthology remain attentive to this doubled structuring of the debate.

In recent years, an important development has been the official recognition of rape and gendered violence by government and international groups and agencies. The phrase "gender-based violence" applies to a much wider range of acts of physical violence than many of the precursor terms deployed in earlier decades, such as gendered violence, sexual assault, and domestic violence.

> According to the United Nations High Commissioner for Refugees (UNHCR), the phrase 'gender-based violence' (GBV) is used to distinguish violence that targets individuals or groups of individuals on the basis of their gender from other forms of violence. GBV includes violent acts such as rape, torture, mutilation, sexual slavery, forced impregnation and murder. When involving women, GBV is violence that is directed against a woman or girl because she is female, or that affects women disproportionately.[13]

As implied above, not all GBV involves women or girls as its targets or victims; boys, transgender persons, gays, and lesbians have also been targeted for physical violence because of their gender and/or perceived gender expression. As Lydia Potts and Silke Wenk point out, attempts to place instances or types of gendered violence in hierarchical relationship to each other must necessarily fail.[14] Thus, in this anthology, we do not seek to equate or value-order different forms of GBV. Instead, this mapping of the "geographies of pain" serves to highlight the commonalities and differences of the diverse forms of violence and their representations.

As global attention has moved toward issues of rape and gendered violence, there have been notable implications for the understanding and treatment of these issues. Most significantly, cumulatively they have constituted "an international development issue" and have been prioritized for grant funding by international aid agencies.[15] Many scholarly feminist accounts of the efforts of these organizations point out that, although the issues are still at one level understood as related to gender, at another level the critique of patriarchy as an institutional and structural issue linked to gendered violence has been removed as a part of the mainstreaming process.[16] We contend that any analysis of the representations of GBV must bring us back to a focus on patriarchy and institutional structures that affect the experiences and meanings attached to the various forms of GBV.

Apart from the process of mainstreaming definitions of, and attention to, problems of gendered violence in a global context, it must be recognized that violence—including GBV—can be understood not only to include an ever-broader range of real-world incidents of physical harm, but also to include "physical, socioeconomic, or symbolic violence."[17] Instances of physical harm and elements of symbolic and representational violence are necessarily interrelated, and the relationships among them deserve examination and analysis. With this collection of chapters we hope to move toward a way of examining local issues and individual cases while maintaining an understanding of the global magnitude of the many issues of GBV under discussion. Specifically, these case studies examine representations of GBV in their local contexts and within local definitions and metaphors of understanding. These analyses highlight the ways in which GBV and its meanings are inevitably rooted in, and are expressions of, specific relations of power. At the same time, this anthology moves well beyond an understanding of women and children as victims, through studies that include expressions of protest and resistance on the part of targets of gendered violence and their relevant constituencies. Many of the chapters in this collection point to specific ways in which the effects of GBV

have been resisted, mitigated, and reframed in ways that empower survivors and lead to an improved understanding of their experiences.

International Legal Responses

As we have elaborated in the previous section, the twentieth century was marked by a growing awareness of violence against women, a consciousness that was largely propelled by women's activism. Sexual violence emerged from obscurity and silence, becoming a central arena of international policy formulation and international jurisprudence.[18] Scholars have most often singled out the 1978 formulation of the Convention for the Elimination of All forms of Discrimination Against Women (CEDAW) by the United Nations as a pivotal moment in the international recognition of female subordination. The convention was initially hailed for its capacious definition of discrimination and for highlighting the different cultural factors that produce a climate where violence against women is enacted. National-level policy changes initiated under the aegis of CEDAW were highly innovative in offering a range of solutions to end female subordination. For instance, in post-apartheid South Africa, activists have addressed women's continued economic disenfranchisement by turning to CEDAW. Under CEDAW's directive, activists have compelled the South African government to enact labor law and property law reforms. Significantly, international media covered a number of the discriminations that activists identified, as well as a range of possible solutions ideas that were often elaborated upon in media coverage, particularly in the global south following the formation of organizations such as the Women's Feature Service. These outlets served not only to underscore the prevalence of violence against women but also mobilized CEDAW as a touchstone for national policy formation. CEDAW is also significant for facilitating the enumeration of a refined and elaborate taxonomy of gender-based discrimination. Nevertheless, activists were quick to recognize that CEDAW could not serve as an umbrella formulation from which to address the specific ways cultural forms of discrimination morph into acts of violence directed at women and girls.

Thus, international efforts to formulate comprehensive policies to end violence against women faltered. The scenario was far more sanguine in some national contexts. As scholars have painstakingly documented, the 1970s and 1980s were marked by a number of judicial reforms, legal changes that were designed to address the specificity of (sexualized) violence against women. For instance, North American rape law reform focused on transforming the existing system into one more responsive to victims. Legal scholar Catharine MacKinnon, on the other hand, has decried these efforts, calling for a more radical change. MacKinnon points out that using consent as the primary mode

of understanding rape is meaningless in patriarchal society.[19] Working from this insight, lawyers in the Netherlands and Wales formulated an alternative definition of rape, one that hinges on inequality and the concept of submission. Coercion should be defined as depriving women of the freedom to decide whether they want to have sexual intercourse. This insight, as we illustrate below, has traveled quite felicitously into the international arena and is now used as the basis of one of the most radical redefinitions of GBV.[20]

By the 1990s, even as international development organizations focused on gendered formations, feminist activists recognized that CEDAW, in its complex specificity, failed to encompass violence against women. Women from around the world compelled U.N. officials and the international community to listen to their long-silenced experiences of violation. The testimonies of South Korean "comfort women" and Algerian women whose mobility was sharply limited by religious fundamentalism were juxtaposed with the seemingly banal and now-familiar narratives of incest, familial violence, and acquaintance rape. The evocative quality of these multiple voices and the absence of any overarching international laws for redress propelled the 1993 Vienna Tribunal to coin the slogan, "women's rights are human rights."[21] Even as the United Nations mobilized international attention to the persistent violation of women's human rights, revelations about the systematic use of rape camps in the former Yugoslavia and in Rwanda resulted in monumental shifts in international jurisprudence.[22] Following the Bosnian war, the U.N. High Commission on Human Rights appointed the first Special Rapporteur on violence against women and The Hague Tribunal recognized rape in warfare as a crime against humanity. The establishment of the International Criminal Tribunal for Rwanda (ICTR) and International Criminal Tribunal for the former Yugoslavia (ICTY) were revolutionary on multiple accounts. First, they identified rape as a crime against humanity and broadened the definition of rape to include forced vaginal, oral, and anal sex. Second, the ICTR and ICTY statutes empowered prosecutors to charge individuals. Finally, the tribunals reinforced the recognition of rape as a form of torture. Ultimately, the ICTR emerged as the first tribunal to recognize rape as a form of genocide and to convict a person under this redefinition. The ICTR convicted a Rwandan minister; although he did not individually rape Tutsi women, the ICTR found that this individual encouraged the rapes "by his presence, his attitude and his utterances."[23]

These developments resulted from the Rome Statute, which helped conceptualize the International Criminal Court (ICC) in 1998 and establish it in 2002. The Rome Statute authorizes the first permanent criminal court with jurisdiction over genocide, war crimes, and crimes against humanity. In addi-

tion, the Statute codifies a wide range of sexual and gender-based violent acts—such as rape, sexual slavery, forced pregnancy, enforced prostitution—as crimes against humanity. The Rome Statute's overarching principle against gender discrimination also protects against the ghettoization and trivialization of sexual and gender crimes and encourages their prosecution, where appropriate, similar to crimes such as genocide, torture, enslavement, and inhumane treatment. These juridical reforms have also resulted in a new understanding of consent. Building on the ICTR redefinition of rape, the ICTY in 2001 convicted three Bosnian Serb soldiers of committing crimes against humanity for participation in mass rapes; in effect, consent was redefined.[24] Debra Bergoffen singles out the significance of this ruling, pointing out that the court declined to define rape as an act of sexual penetration accompanied by coercion or force or threat of force.[25] Instead, the court appealed to a "common sense understanding" of the meaning of consent (which can help distinguish submission, the appearance of consent, from genuine consent) to declare "sexual penetration will constitute rape if it is not truly voluntary or consensual on the part of the victim."[26] The court thus stipulated that only apparent consent exists "where the victim is subjected to or threatened with or has reason to fear violence, duress, detention or psychological oppression or reasonably believed that if she did not submit another might be so subjected, threatened or put in fear" and instead demanded proof of genuine consent between a soldier and a noncombatant civilian.[27] This re-definition of consent attends to some of MacKinnon's concerns about the ability of the subaltern, particularly women, to speak meaningfully and to be understood on their own terms within the existing patriarchal order.

The changes in international policy and law have produced a trickle-down effect at the national level. For instance, in 2004 Spain enacted a gender violence law that pivots on the existing inequalities in power relations between men and women. In addition the Spanish law recognizes that violent acts within the domestic sphere are shaped by and reflect inequalities within the public arena. Most recently, Amnesty International has reconceptualized violence against women within the familial sphere as a human rights violation. What is remarkable here is that private and public acts of violence are both being included in international definitions of torture (thus violence against women, regardless of its setting, is beginning to receive recognition).

Thus, at the international level, understandings of sexual violence have become more nuanced and bear the imprint of feminist interventions. Similar shifts cannot be traced in the realm of other sexual subjects, say crimes committed against gays, lesbians, or transpeople.[28] Apart from specific national hate crime laws the international juridical arena has lagged behind the devel-

opment arena; it has failed to integrate concerns that are central to this project in relation to gays, lesbians, and transpeople.

International Activism

There is a wide range of local, community, and grass-roots activism that has been mobilized to counter the prevalence of violence against women. The majority of these projects are designed to secure assistance for survivors or to enact policy change. Few, however, address the specific ways in which media representations foster a climate where such violence is possible or offer solutions to these imaging practices. This becomes particularly important since pitting the global phenomenon against the specificity of locally bound, culturally specific experiences requires different modes of activism.[29] Cautious of the distinctions drawn by Hazel Carby, many activist groups now talk *with* local women about their lived experiences rather than talk *for* them.[30] One of the most effective and long-standing transnational activist coalitions to end GBV is the "16 Days of Activism to End Gender Violence." First established in 1991, this campaign is held between November 25 and December 10—the International Day for the Elimination of Violence Against Women and the World Human Rights Day, respectively. The campaign also encompasses World AIDS Day (December 1) and commemorates the Montreal Massacre (December 6). Every year, the campaign is structured on a particular theme and has addressed a range of concerns that center on GBV. The 16 Days Campaign has become one of the key sites linking local activism with transnational groups. Operating on a different register is the V-Day Campaign, a global campaign that dramatically captures the toll of gendered violence by asking society to imagine a world without violence. An off-shoot of Eve Ensler's very successful play *The Vagina Monologues*, the V-Day campaign has been designed to highlight the forms of violence local to a culture and the solutions that must be formulated.

Like these global campaigns, the chapters in this volume are attentive to the particular ways in which "gender and violence" must be situated within a historical context, specifically the complicated and interconnected histories of western colonialisms and global capitalism. They highlight the need to understand the relation between sexuality and violence as one mediated by cultural difference, and simultaneously how gendered subjectivities are differently constituted in diverse settings. Michelle Fine and Lois Weis have argued that our definitions of survivors have tended to erase poor, working-class women.[31] Our collection of chapters not only seeks to restore these disappeared bodies to visibility, we want to bring into public view those additional people who don't fit into normative categories of the survivor-victim (of institutionalized and

individual violence). While there has been a wide range of materials covered under the rubric of violence against women, there is very little documentation of international-level activism attentive to GBV. Our anthology thus serves to address this gap in scholarship.

In addition, our anthology emulates and extends the critiques and interventions numerous media activists and media advocacy groups have initiated. The range of feminist media activism is staggering: we enumerate here those efforts that have actively worked to reverse the dominance of the global north as well as that of male voices. In the arena of news and print media, the African Women's Media Center has endeavored to bring female voices into the male-dominated arena of the media. More significantly, it ensures that issues pertaining to African women find their way to media outlets around the world.[32] Similarly, the Women's Feature Service, which was established by a U.N. initiative in 1978, offers newspapers and magazines around the world access to a range of articles on development from a gender perspective. It is currently located in New Delhi and is credited with drawing attention to the impact of AIDS on women and sexuality, the rise of the Taliban in Afghanistan, and an Asian men's campaign against domestic violence, "Men Oppose Wife Abuse." The Canadian-based Feminist Media Project specifically draws attention to media depictions of missing and murdered women.

Similar efforts also shape the content of the airwaves. In radio, there is the Canadian-based Women's International News Gathering Service (WINGS). Established in 2000, this all-women independent radio production company produces and distributes news and current affairs programs by and about women around the world. Additionally, a number of web-based activist efforts have evolved over the last decade. Perhaps the most significant for the purposes of this anthology is the U.N.-sponsored Women Watch, an internet platform which ensures the availability of a range of information pertaining to women's empowerment.

While feminist activism has focused attention on ensuring the representation of women's concerns in the mainstream news arena, especially that of GBV, an equally creative and maverick activism marks feminist interventions in the arena of fictional representations. The Canadian-based Adbusters or the U.S.-based About Face are representative of efforts made by community organizations to critique the representations of women and gender in advertisements. In addition, these groups have countered dominant representational practices through postmodern techniques of irony and parody by producing a range of "subvertisements." In the arena of cinematic representations, Women Make Movies has evolved into the iconic nonprofit organization that showcases feminist concerns. In each of these instances, media activists and advo-

cacy groups work within the paradigms of the modern liberal subject and try to shoehorn women into this limited subject position. As some of the chapters in this anthology illustrate, the international context and the presence of gendered violence require alternative forms of engagement and radically different modes of challenging conventional media representational practices.

Representational Paradigms

In most media scholarship the juxtaposition of the terms media and violence raises a number of concerns (and studies) about the effects of these representations. From the hypodermic model to George Gerbner's empirical studies the premise that has dominated this range of scholarship is the idea that media images have a measurable effect on audience behavior.[33] Our anthology draws on a different archive.[34] Situated firmly within the interdisciplinary field of feminist cultural studies, our understanding of media effects shuns causal logic. Instead, we contend that media representations shape existing GBV discourse: the media are the site of the contestation, negotiation, and production of meaning of the complex phrase GBV. Media images are constituted by and constitutive of the social.[35]

Just as the acts and phenomena that can be classified as GBV have expanded and deepened in recent years, so too has our understanding of the targets or victims of GBV been problematized and accordingly expanded. The once-common slogan that "it could happen to anyone," has come under deserved scrutiny in recent works, as some have expressed the belief that low-income women and women of color have not received proper attention. In effect, "it could happen to anyone" has meant "it could happen to those in power."[36] The proliferation of stories of victimization of famous U.S.-based white women such as Susan Estrich and Kelly McGillis was symptomatic of this attitude. Meanwhile, as Beth Richie notes, "victimization of women of color in low-income communities is invisible to the mainstream public" and their victimization "is cast as something other than a case of gendered violence"[37] such as the problem of a troubled community or a symptom of social decay. The "notion that every woman is at risk—one of the hallmarks of our movement's rhetorical paradigm—is in fact a dangerous one in that it has structured a national advocacy based on a false sense of unity around the experience of gender oppression," Richie contends.[38] This insight becomes particularly relevant in the context of GBV as experienced outside the global north, an idea that is elaborated in Elaine Jeffreys' chapter (chapter 2) on media coverage of serial killers in China. In addition, recent studies of news coverage of gendered violence including rape and wife battering have repeatedly shown that cases involving victims of color routinely receive less coverage than

cases involving white victims, with the possible exception of celebrity cases, in which either the victim or the accused is well known before the violent incident in question.[39]

At the same time—as the chapter by Gordene MacKenzie and Mary Marcel (chapter 5) elaborates in this anthology—gay and lesbian advocacy groups have been working to define and deal with gendered violence against members of the gay and lesbian community and to begin to understand violence against transgender persons as a form of gendered violence. Valerie Jenness and Kendal Broad revive Jack Gibbs's definition of "sexual terrorism"—a system of fear and terror that works to control women through a generalized and constant fear of being attacked.[40] Thus, even a general environment that fosters such fear can be understood as a form of gendered violence, particularly as such fear is shared by women and girls and by persons whose gender identity may place them at risk of attack. The collection of hate crimes data and the definition of hate crime do not include gender as a category of victimization under "hate crime." Advocacy groups argue for the expansion of the concept to include "hate incident" in order to include cases that are not actually against the law as currently defined.

Reported cases combined with low report rates suggest that there is "an epidemic of victimization" of gay and lesbian people that can be understood as "hate-motivated violence." These experiences are often understood as "equivalent" to rape, particularly in terms of the post-violation trauma and specific symptoms of it experienced by the victims of hate crime violence. Self-defense and self-protection tactics for hate crimes are similar to those of rape prevention. Often it is hard to differentiate the gendered element of, for example, rape of a lesbian on the basis of gender and/or sexual identity. What is known is that the violence inherent in these incidents does not begin and end with the physical attack. Rather, violence is inherent in the situation of terror in which certain categories of persons fear and are vulnerable to attack, in which other individuals target and commit violence for reasons related to gender and personal identity, and in which physical violence is carried out, experienced, justified, defended, and treated through systems of law and justice. Many elements of this broadly understood system of violence are shared by victims who are female, transgender, feminized, gay, and lesbian. Gay and lesbian antiviolence projects have positioned the problem of antigay and lesbian violence on a par with rape, domestic violence, and other forms of violence against women. That is, recent antigay/lesbian activism has framed the problem of violence against gays and lesbians as a violent crime rather than a sexual one; moreover, it has cast hate-motivated violence directed at gays and lesbians as criminal sexual assault.[41]

The chapters in this volume reveal the complex workings of relations of power, examining not only the power of one individual or group to physically harm another, but also the power to define and express a perspective on the experience of violence, and to create meaning within a particular context. These chapters reveal strategies of resistance to the expression of such powers and, in several examples, document shifts in how meaning is created and maintained in a specific realm or category of gendered violence. It is our hope that this look at representations across various groups, locales, and contexts begins to develop a similarly broad-based picture of GBV and related forms of violence as the expressions of systems of power that can be understood through examination, resisted through concerted effort, and counterbalanced through the assertion of alternate experiences and meanings. By maintaining a local focus in each of these chapters, we resist the temptation to over-generalize, but we hope simultaneously to maintain an understanding of differences as well as the potential linkages between systems of power and their functions.

Local and Global Vectors

This anthology collects chapters that examine representations of particular instances of GBV. In most cases, these instances are real-world incidents of physical violence experienced by the actual victims and their families and communities. This focus on actual cases helps us interrogate the question of what GBV is becoming in this historical time during which it is seemingly both more prevalent and more broadly defined. As the real world becomes a more violent place and as expressions of violence involving conceptualizations of gender become more prevalent and more widely recognized, we hope to return our attention to the structural and patriarchal relations of power that enable and even encourage them. The chapters in this collection reveal the strategies of violence and meaning-making wielded by those who presume power, but they also uncover moments of triumph and trajectories of change within diverse representations.

The anthology offers a feminist assessment of media coverage of GBV along three axes. Taking a global perspective yet simultaneously staying attentive to the local context, we first zero in on media coverage of the archetypal crime of sexual violence: rape. Chapters by Sidra Fatima Minhas (chapter 4), Linda Angst (chapter 7), and Régine Michelle Jean-Charles (chapter 12) explore how the media's role of serving as witness and offering testimony has often resulted in problematic representations of the victims of sexual violence. Second, our anthology includes chapters that broaden mainstream definitions of sexual violence, unpacking the subtle and covert mechanisms through

which seemingly disconnected media sites become the enabling ground for violence. Thus, we have Danica Minic's chapter (chapter 11) that explores how activists in Serbia have protested the objectification of women in mainstream media representations and drawn a connection with everyday acts of sexual violence. M. Cristina Alcalde's chapter (chapter 3) similarly identifies how "reckless" media coverage of indigenous Peruvian women exposes them to further violence from their intimate partners. Third, our chapters then interrogate the subject of such violent acts. Following the lead of feminist scholarship, most media coverage of sexual violence has centered on women as victims. Thus, we have Peter Pugsley and Jia Gao's chapter (chapter 6) which explores how Japanese sex tourism is in effect recast by the Chinese media as a violent act. Similarly, Gordene MacKenzie and Mary Marcel (chapter 5) broaden our understanding by highlighting the particularities of U.S. media coverage of transgender murders. In recent years, scholars have identified how race and class intersect with gender to produce different portrayals of sexual violence. The chapters in this anthology broaden these questions further by including violence committed against transgendered persons and other gendered bodies often marginalized in existing scholarship.

The chapters build on insights developed by a range of scholars who have offered sophisticated analyses of representations of gendered violence, detailing many of the common techniques and strategies deployed therein to contain and minimize public knowledge of the problems of gendered violence, and attempting to understand these problems from the point of view of those targeted by it. In relation to representations of rape and sexual assault, these techniques include the reliance on certain myths of rape, such as the idea that victims provoke or desire sexual victimization and that perpetrators (rather than institutions and social practices) are solely to blame for the phenomenon of rape. Victims are placed on trial and their reputations questioned and destroyed, mothers are blamed for the criminal actions of their sons, and white victims are granted more legitimacy than victims of color. Celebrity cases received the preponderance of media coverage of real-world cases, while specific genres such as pornography, horror, and slasher films continue to make images of sexual victimization of women and girls a widely available subject of mainstream entertainment. Violence that is perpetrated by males in more than 90 percent of cases is referred to as "sexual violence" or "domestic violence," and mainstream media analyses do not directly address (and often do not even bother to mention) the gendered nature of these crimes.

According to Patrizia Romito, the technique of psychologizing has been a frequently employed means of "blaming victims and reducing them to powerlessness" by "interpreting a problem in individualistic and psychological rather

than political, economic, or social terms and consequently responding in these terms."[42] As such, it is also "a simple cognitive method for categorising and interpreting reality and a powerful social mechanism for defusing awareness of oppression and potential rebellion."[43] It is, in short, "a depoliticizing tactic for supporting the status quo and dominant power relationships."[44] Through psychologizing, female victims are presented as "aggressive, provocative or masochistic or all of these things together" while the perpetrator is "frustrated, depressed, with low self-esteem and unhappy."[45] These depictions begin in professional and clinical contexts and are repeated in mediated portrayals of real and fictional cases.

This volume seeks to build on and move beyond the findings of previous work of media scholars such as Marian Meyers, Sarah Projansky, Helen Benedict, Tania Horeck, Patrizia Romito, and its co-editors by assuming rather than re-discovering the by-now commonly discussed tendencies of mainstream (predominantly U.S.) media coverage of cases of gendered violence. In doing this we move to the next level of analysis of representation of GBV through media and popular culture within a wide range of national and local contexts. Thus, we include discussion of cases from China, South Africa, Japan, Pakistan, Serbia, Rwanda, Peru, and the United States. We also include analyses of mainstream representations of cases involving a range of victims including young boys and transgender persons. Although several of the chapters in this volume examine news coverage within the local context, others examine less commonly studied forms of cultural representations including film, television, and U.S. country music.

We have organized the chapters into three broad categories: Representing Violated Bodies; The Politicized Arena of Violence; and Transformative/Alternative Practices. While this arrangement draws attention to some thematic commonalities, as this introduction has illustrated, there are a number of other threads and concerns that allow us to read these chapters productively through and against each other.

The chapters in the first section, Representing Violated Bodies, throw into sharp relief the myth of objectivity that governs news coverage. More significantly the juxtaposition of the chapters illuminates the particular ways in which local cultures (including economic, political, and historical concerns) shape the expression of GBV and its coverage. Cumulatively the chapters also illuminate the complications and complexities of the modernist project of journalism.

The liberalization of the Chinese economy over the last two decades has had two significant effects: first, prostitution, which was officially banned with the formation of the Communist state in 1949, has started to flourish and,

second, the Chinese government has gradually relinquished its stranglehold on the media. Consequently, news coverage has increasingly been governed by the twin imprimaturs of professionalization and commercialization. This is the protean media terrain within which we need to understand Chinese media coverage of the "murdering demon brothers." Elaine Jeffreys' chapter (chapter 2) illustrates that media coverage of the brothers who killed eleven prostitutes contains some elements of sensationalism characteristic of Anglophone coverage of sex crimes. Strikingly, however, the sexualized and sexualizing elements of these murders are largely absent, and media coverage instead reflects the economic anxieties propelled by globalization forces. Thus the focus of news coverage remains on economic disparities between rural and urban China, the haves and the have-nots, and the need to legalize prostitution.

A similar hypervisibility and invisibility marks Peruvian media coverage of familial or intimate partner violence. Juxtaposing analysis of news coverage with her fieldwork in women's shelters, M. Cristina Alcalde's chapter (chapter 3) provides a key insight to how indigenous women's victimization is silenced and naturalized under the sign of patriarchy. Instead indigenous women appear in the news only as economic malingerers, who exploit existing social services.[46] Alcalde details the story of one indigenous woman she assisted in a shelter whose life was endangered by news coverage, allowing her husband to track her down. If Peruvian patriarchy normalizes domestic violence, Sidra Fatima Minhas' chapter (chapter 4) reveals a similar operation of Pakistani patriarchy. Adopting a case study approach, Minhas examines Urdu and English-language newspaper coverage of one particular rape. Her analysis reveals that the good/bad woman dichotomy dominates portrayal of the victim. In addition, particular interpretations of Islam are mobilized to explain away rape.

As we have pointed out, feminist media scholars have exhaustively analyzed news coverage of female sexual assault. Gordene MacKenzie and Mary Marcel (chapter 5) expand this terrain by focusing their chapter on news media coverage of three murders of transwomen of color. Highly localized in its focus, this chapter permits a recognition of the manner in which the specificity of racializing processes in the United States complicate media coverage of transgender crimes. Spanning a decade, the analysis of the three murders reveals the shifting contours of transphobia. While early coverage dehumanized transgender victims, by the end of the decade, the media were practicing a journalism of advocacy and education; transgender murders thus become a site for highlighting other issues pertaining to gender expression. Their chapter in particular highlights how stereotypes of racialized sexuality and trans-

gender deviance come to bear on our understandings of the transwomen of color.

The second set of chapters highlights the manner in which GBV coverage becomes a site of displacement. Issues of nationalism often come to the forefront whereas the victim-survivor disappears from view. Peter Pugsley and Jia Gao (chapter 6) examine Chinese media coverage of a "Japanese orgy" in Zhuhai, an instance when visiting Japanese men hired hundreds of prostitutes for their gala. Rather than uncover the experience of the prostitutes, journalists were motivated by a desire for a scoop and ended up framing the narrative as a recapitulation of the Japanese occupation of China. This chapter highlights as well the changing contours of Chinese media practices and the manner in which individual subjects are subsumed under a nationalist umbrella. As Nira Yuval-Davis has pointed out, the vexed intersections of gender and nationalism, which tend to erase female subjectivity, are foregrounded again in this instance.[47]

If the national memory of the 1930s marks contemporary Chinese media coverage of the Japanese, we see a similar anxiety marking Japanese media portrayals of the rape of schoolgirls, except that, in this instance, the United States is positioned as the occupier. Linda Angst (chapter 7) identifies the key vectors that dominate Japanese media coverage of rapes in Okinawa—the sexual assault of schoolgirls allows the media to rehearse the problematic presence of U.S. military bases. In both chapters, while the identity of the occupied-occupier dyad changes, media practices are marked by a striking similarity: sexual violence is evacuated from the field of visibility, and instead geopolitics is the only framework offered.

Pamela Scully's assessment of the rape trial of South Africa's African National Congress chief Jacob Zuma (chapter 8) foregrounds a range of other displacement strategies characteristic of postcolonial formations. In post-apartheid South Africa, Zuma successfully evaded rape charges by resuscitating ethnic definitions of sex and sexuality. Taking cover under KwaZulu understandings of gender norms, Zuma and his lawyers recast the rape trial as a misunderstanding. Scully's analysis points out that local and international media were skittish about condemning Zuma's manipulative mobilization of ethnic difference. Nevertheless they were less hesitant to condemn his controversial statements about AIDS and HIV during the rape trial.

If the first two sections of the anthology serve to reiterate the belief that GBV, like rape, cannot be accurately represented, the chapters in the final section turn to non-news sites to offer new modes of representing violence. Karen Boyle's chapter (chapter 9) on cinematic representations of child sexual assault underscores the problematic nature of memory work. She contends

that most movies tend to echo social backlash and thus depict experiences of child sexual assault and recovered memory as unreliable. As is the case with news coverage, fictional representations also serve to shore up male patriarchal authority. Examining alternative cinema, Boyle offers one instance where the representation and understanding of child sexual assault are queered. Julie Haynes (chapter 10) offers a fascinating account of country music videos as a vehicle for the discussion of issues of intimate partner violence. Her chapter in particular highlights a significant means of communicating and popularizing feminist understandings of GBV. This chapter points out how the potential disjuncture between the verbal and filmic texts of music videos can be productively developed to produce counter-hegemonic narratives. Framed by Judith Butler's theory of hate speech, Danica Minic (chapter 11) provides a provocative account of the manner in which Serbian feminists have linked the sexual objectification of women in advertisements and everyday media practice with the systematic abuse of women in conflict zones. Her chapter offers another strategy of contesting the hegemonic public sphere. The concluding chapter centers on the Rwandan genocide. Although exhaustively analyzed, the paradigmatic failure of late-twentieth-century geopolitics in Rwanda also offers an instance for new beginnings. Régine Michelle Jean-Charles (chapter 12) undertakes the analysis of Ivorian author Veronique Tadjo's book and the film *Sometimes in April* to offer a feminist critique of the modernist project of realism. Her chapter goes beyond documenting the perils of representing rape to identify the strategies through which an outsider can narrate the pain of traumatized female subjectivity.

Cumulatively, then, these chapters document and offer creative approaches to the conundrum of representing GBV. But even as we celebrate these achievements, media coverage of the Darfur crisis and the Abu Ghraib torture images sadly reveal the work that has yet to be conducted.

Notes

1 http://www.irinnews.org/IndepthMain.aspx?IndepthId=20&ReportId=62814

2 BBC News (27 May 2008): http://news.bbc.co.uk/1/hi/world/7421399.stm

3 Helen Benedict,"For Women Warriors, Deep Wounds, Little Care," The *New York Times*, (May 26, 2008): http://www.nytimes.com/2008/05/26/opinion/26benedict.html?_r= 1&scp=4&sq=rape, %20military&st=cse&oref=slogin

4 "Stop Domestic Violence against Women" http://www.coe.int/t/dc/campaign/stopviolence/default_en.asp

5 Jane Caputi and Diana Russell define femicide as a particular form of sexist terrorism directed at women. While they single out the murder of women by their husbands, lovers, and other family members, they also use the term inclusively for a wide variety of verbal and physical abuse. See "Femicide": http://www.dianarussell.com/femicide.html (1998).

6 We see gender relations mainly as "a primary way of signifying relationships of power." See Joan Scott, "Deconstructing Equality-versus-Difference: Or, the Uses of Poststructuralist Theory for Feminism," *Feminist Studies* 14, No. 1 (1988): 33–50.

7 The editors of the anthology *States of Conflict* offer in their introduction a very succinct account of the different definitions of sexual and violence that have governed feminist discourse on the topic of sexual violence. They offer a textured account of how these different strands of feminisms articulate the causes of such violence and who benefits from it. See Susie Jacobs, Ruth Jacobson, and Jennifer Marchbank, eds., *States of Conflict: Gender, Violence and Resistance* (London: Zed Books, 2000).

8 Peter Gordon and Kate Crehan, "Dying of Sadness: Gender, Sexual Violence and the HIV Epidemic," http://www.undp.org/hiv/publications/gender/violencee.htm

9 Julie Hemment, "Global Civil Society and the Local Costs of Belonging: Defining Violence Against Women in Russia," *Signs* 29, No.3 (2004): 815–840, 818.

10 Adeel Khan and Rafat Hussein, "Violence against Women in Pakistan: Perceptions and Experiences of Domestic Violence," *Asian Studies Review* 32 (2008): 239–253. There exists wide-ranging scholarship on these terms and how they are defined, particularly which forms of violence are marked as "traditional" or "cultural." While we do not delve into this terrain we are clearly aware of the ideological implications of these practices of nomination and the politics of enunciation.

11 Julie Hemment, "Global Civil Society."

12 Chandra Talpade Mohanty, "'Under Western Eyes' Revisited: Feminist Solidarity through Anti-Capitalist Struggles," *Signs* 28, No. 2 (2003): 499–535.

13 http://www.irinnews.org/IndepthMain.aspx?IndepthId=20&ReportId=62814

14 Lydia Potts and Silke Wenk, "Gender Constructions and Violence—Ambivalences of Modernity in the Process of Globalization: Toward an Interdisciplinary and International Research Network," *Signs* 28, No.1 (2008): 459–461, 460.

15 Julie Hemment, "Global Civil Society."

16 Patrizia Romito, *A Deafening Silence: Hidden Violence against Women and Children*, translated by Janet Eastwood (New York: Polity Press, 2008).

17 Lydia Potts and Silke Wenk, "Gender Constructions."

18 Although violence against women has not been condoned historically, there was no shared community of sentiment against it. Thus, although conventions and policies acknowledged the phenomenon of rape (for instance, the 1907 Hague Convention defines rape as a "violation of family honor and rights"), it was often subsumed within other offenses and often the victims were held accountable for their violation. During the Nuremberg and Tokyo trials after the Second World War, rape entered the public arena of discussion but was quickly sub-

sumed within the broad category of human rights concerns. Catharine MacKinnon discusses issues of international law and jurisprudence at great length in her *Are Women Human?* (Cambridge: Harvard University Press, 2006).

19 See Catharine MacKinnon, *Toward a Feminist Theory of the State* (Cambridge: Harvard University Press, 1989).

20 Debra Bergoffen contends that this redefinition of consent and rape introduces a "politics of the vulnerable body which challenges current understandings of evil, war crimes, and crimes against humanity." See "February 22, 2001: Toward a Politics of the Vulnerable Body," *Hypatia* 18, No. 1 (2003): 116–134.

21 Charlotte Bunch and Roxanna Carillo are largely credited with suturing development-centered concerns about the "costs" of sexual violence with feminist concerns about the individual right to self-determination and bodily integrity. For an overview of their arguments that resulted in the formulation of the slogan "women's rights are human rights" and the U.N. Declaration on the Elimination of Violence Against Women, see their *Gender Violence: A Development and Human Rights Issue* (Dublin: Attic Press, 1991).

22 Although scholars tend to focus on U.N.-based legal reform, it is worth noting that the Inter-American Commission on Human Rights had declared rape as a form of torture in adjudicating a Peruvian woman's case in 1996. The European Court on Human Rights followed suit to recognize rape as a form of torture and a severe form of inhumane treatment. But in both these instances, state parties and not the individual are held responsible for these acts of torture.

23 For a more detailed account of the antecedents and precursors to these changes in international jurisprudence, see Christine Strumpen-Darrie, "Rape: A Survey of Current International Jurisprudence," *Human Rights Brief* 7, No. 3 (2000): http://www.wcl.american.edu/hrbrief/v7i3/rape.htm. Régine Michelle Jean-Charles' chapter in this anthology addresses some of the issues around the Rwanda tribunal held in Arusha, Tanzania.

24 The Rome Statute led to the establishment of the ICC in July 1998. On the eve of its tenth anniversary, the ICC indicted Sudanese President Omar Hassan al-Bashir for rapes and crimes against humanity committed in Darfur, this is the first time a head of state has been indicted. Marlise Glasius offers a succinct summary of the ICC's achievements and its shortcomings. See "What Is Global Justice and Who Is It For? The ICC's First Five Years," *Open Democracy* (July 22, 2008): www.opendemocracy.net/globalization/international_justice/the_iccs_first_five_years; and *The International Criminal Court: A Global Civil Society Achievement* (New York: Routledge, 2007). See also, Martha Walsh, "Gendering International Justice: Progress and Pitfall at International Criminal Tribunals," in *Gendered Peace: Women's Struggles for Post-War Justice and Reconciliation* (New York: Routledge, 2008), 31–64. As this book goes to print, news media have announced the arrest of Serbian war criminal Radavan Karadzic, for committing crimes against humanity. After evading arrest for thirteen years Karadzic was handed over to the Hague Tribunal by a newly installed coalition government. Nevertheless, one of the other leading figures of the 1990s war is still at large.

25 For a provocative understanding of how this court decision recalibrated juridical understandings of rape, human dignity, the woman as a sexed body, and the universal subject, see Debra Bergoffen, "February 22, 2001." She contends that the ruling recasts sexual exploitation as a violation of woman's fundamental sexed bodily right to self-determination.

26 http://www.un.org.icty, 440.

27 http://www.un.org.icty, 464.

28 Transnational nongovernmental organizations such as Amnesty International have initiated the process of including homophobic and transphobic hate crimes within the purview of GBV and as human rights violations. Significantly, most of the violence is sexualized and rape is one of the most common practices of punishing those who are perceived to transgress dominant gender norms. See Nicholas Burnham, ed., *Sex Rights: The Oxford Amnesty Lectures 2002* (New York: Oxford University Press, 2005) for key insights to the theoretical and practical stakes.

29 The Newham Asian Women's Project, Southall Black Sisters, AWAZ, and other U.K.-based organizations were formulated in the 1980s to address mainstream organizations' inability to attend to the specificity of black, Asian, and lesbian women's experiences of violence. See Aisha Gill and Gulshun Rehman, "Empowerment through Activism: Responding to Domestic Violence in the South Asian Community in London," *Gender and Development* 12, No. 1 (2004): 75-82.

30 Hazel Carby, *White Women Listen! Black Feminism and the Boundaries of Sisterhood* (London: Hutchison, 1982).

31 Michelle Fine and Lois Weis, "Disappearing Acts: The State and Violence against Women in the Twentieth Century," *Signs* 25, No. 4 (2000): 1139-46.

32 Founded in 1997 in Dakar, Senegal, this is the only continent-wide organization working with and on behalf of African women in the media. It has trained numerous women journalists and offered workshops to ensure the representation of women and women's issues in mainstream media.

33 For an overview of historical concerns see Joseph Klapper, *The Effects of Mass Media* (New York: Columbia University, Bureau of Applied Research, 1949) and George Gerbner, Larry Gross and William Melody, eds., *Communications Technology and Social Policy: Understanding the New "Cultural Revolution"* (New York: Wiley, 1973). For a broad understanding of the trajectories of media-violence debates in contemporary scholarship see Christopher Sharrett, ed., *Mythologies of Violence in Postmodern Media* (Detroit: Wayne State University Press, 1999); Martin Baker and Julian Petley, eds., *Ill Effects: The Media/Violence Debate*, 2d ed. (New York: Routledge, 2001); and Cynthia Carter and Kay Weaver, *Violence and the Media* (Philadelphia: Open University Press, 2003).

34 The global lens of this volume also necessitates that we eschew an "effects" model that has the potential to flatten cultural differences.

35 In her impassioned and evocative critique of the genocidal rapes and rape camps established by the Serbs in the former Yugoslavia, Beverly Allen addresses the ethical and moral issues that one must consider when addressing issues of sexual assault (especially in the mass media). She cautions against narrative strategies and representational grammars that inevitably locate the audience as a voyeur "of the unthinkable." The chapters in this volume are guided by her concerns and are attentive to the ways in which our analyses may inadvertently reinstitute the "power dynamics that obtain in the act of rape itself and in the act of observation." See Beverly Allen, *Rape Warfare: The Hidden Genocide in Bosnia-Herzegovina and Croatia* (Minneapolis: University of Minnesota Press, 1996), 33.

36 Beth E. Richie, "A Black Feminist Reflection on the Antiviolence Movement," *Signs* 25, No.4 (2000): 1133-37.

37 Ibid., 1135.

38 Ibid.

39 See Sujata Moorti, *The Color of Rape: Gender and Race in Television's Public Spheres* (Albany: State University of New York Press, 2002).

40 Valerie Jenness and Kendal Broad, "Antiviolence Activism and the (In)Visibility of Gender in the Gay/Lesbian and Women's Movements," *Gender and Society* 8, No.3 (1994): 402–423.

41 Ibid., 418

42 Patrizia Romito, *A Deafening Silence*.

43 Ibid., 69.

44 Ibid.

45 Ibid., 70.

46 Like Ann Stoler's work, this chapter highlights the colonial histories, which produced raced concepts of sexuality. See Ann Laura Stoler, *Race and the Education of Desire: Foucault's History of Sexuality and the Colonial Order of Things* (Durham: Duke University Press, 1995).

47 Nira Yuval-Davis, *Gender and Nation* (London: Sage, 1997).

REPRESENTING VIOLATED BODIES

CHAPTER 2

Serial Prostitute Homicide in the Chinese Media

Elaine Jeffreys

Women in prostitution are documented victims of serial killers, both histori-cally and in the present day.[1] Jack the Ripper—probably the most infamous serial killer in the Anglophone world—was the alias given to a person who murdered and mutilated at least four and possibly up to eight women, many of whom were allegedly prostitutes, in the Whitechapel area of London in 1888.[2] While not the first serial killer, Jack the Ripper became a household name primarily because the gruesome details of the case were covered by an emerging popular press, keen to expose manifest social injustice in the context of rapid industrialization to an increasingly literate general population.[3] Media coverage capitalized on local concerns by portraying London's East End as a hot-bed of vice, stressing either "the need for social reform to alleviate the poverty causing crime" or berating the metropolitan police for failing to pro-tect lower-class women by catching the perpetrator.[4] The "Ripper" appellative is now routinely attached to serial-murder hunts by the tabloid press.[5]

The Anglophone media recently focused on the issue of serial prostitute homicide because of the 2008 trial of Steve Wright, a man accused of killing five streetwalkers in the Ipswich area of Suffolk, and the 2007 trial in Vancou-ver of Robert Pickton, a man accused of murdering twenty-six women, many of whom were prostitutes.[6] Although police estimates suggest that women in prostitution constitute only 2.7 percent of all female homicide victims in the United States, one-third of prostitute homicides are committed by serial per-petrators, and nearly all such perpetrators are prostitute clients.[7] Anglophone media coverage of serial prostitute homicide suggests that such cases are highly newsworthy, not only because of their violent nature and relation to matters of

sexual pathology, but also because they go unsolved for relatively long periods of time and are related to reports of "missing women."[8]

The Chinese media also recently focused on the issue of serial prostitute homicide because of the solving of a major case. Between June 2003 and August 2004, Shen Changyin and Shen Changping—two brothers from Henan Province—traveled throughout the Chinese provinces of Gansu, Inner Mongolia, Shanxi, Hebei, and Anhui, robbing and murdering eleven female prostitutes. The brothers were detained by police authorities on 8 September 2004 and charged with eleven counts of homicide and the theft of more than 120,000 yuan, four mobile phones, two necklaces, and two rings. The Lanzhou Middle People's Court later heard that the brothers had attempted to eliminate evidence of their crimes by dismembering the victims' bodies and disposing of body parts in random locations, using sulfuric acid to flush soft body tissue down the sewers, and even eating some of their victims' kidneys.[9]

Dubbed "the murdering demon brothers," the case attracted media attention not only because of its gruesome details, but also because the brothers stated that they had murdered for money and would have continued to do so had they not been apprehended. Shocked by this professed financial motivation and apparent lack of remorse, media commentators asked: "What kind of society creates people that value money more than human life?" The brothers also stated that they had decided to rob and murder women in prostitution because they command relatively high levels of income; are highly mobile and therefore alienated from normal kinship and friendship networks; and engage in an illegal and stigmatized activity. Consequently, the disappearance of a small number of such women would be unlikely to attract police or public attention.[10] Equally shocked by the suggestion that legal and social marginality made these women vulnerable to crime, Chinese media commentators asked: "What should be done to protect the rights and lives of women in prostitution?" Media commentators subsequently used the case to interrogate the causes of serial prostitute homicide and the appropriate nature of governmental responses in China.

This chapter examines media coverage of serial prostitute homicide in the People's Republic of China (PRC) for three reasons. First, the very existence of such commentary is a new phenomenon, flowing from the resurgence of prostitution in 1980s China amid the introduction of market-based economic reforms and the subsequent relaxing of former political controls over the media. Second, and in contrast to the PRC's official policy of banning prostitution,

Chinese media accounts of serial prostitute homicides demonstrate a new concern with legalizing prostitution as a potential means to guarantee the safety of women who are socially vulnerable. Finally, Chinese media discussions of serial prostitute homicides display a new and emerging concern with the specificity of the rights and lives of women in prostitution, thereby highlighting the evolving nature of citizenship and legal rights in a country that is undergoing rapid economic and social change.[11]

Prostitution and the Media in the PRC

The upshot of the PRC's post-1978 shift from a centralized to a market-based economy has been what some commentators describe as a "second industrial revolution," resulting in the "biggest mass migration in the history of the world" and the wholesale transformation of the Chinese economy and society.[12] Throughout the 1990s and into the new millennium, an estimated 140 million people migrated from poor, rural areas to take up work in rapidly developing urban centers, primarily working in areas relating to the construction of the country's infrastructure and in the new and burgeoning hospitality and service industry. Economic reform has also led to the heterogenization of the PRC's previously homogeneous cities: As new residents move in to take up new forms of work, other sectors of the population have become self-employed and newly rich, and a more diversified consumer society has emerged. Although lifting millions of people out of poverty and creating a new class of millionaires, one negative side effect of these changes is the growing divide between the "haves" and "have-nots."[13] Another negative effect is the massive upsurge in prostitution and rates and types of crime.[14]

The growth and spread of prostitution in present-day Chinese society stand in marked contrast to its celebrated absence during the Maoist period (1949–1976). In keeping with Marxist theory, the early Chinese Communist Party (CCP) viewed prostitution as an expression of the denigrated position of women under feudal-capitalist patriarchy. Therefore, it was deemed incompatible with the desired goals of building socialism and establishing more equitable socio-sexual relations.[15] Following its assumption of national political power in 1949, the CCP embarked upon a series of campaigns that purportedly eradicated the prostitution industry from mainland China by the late 1950s.[16] The extraordinary nature of this feat, irrespective of its actual validity, meant that the eradication of prostitution was (and still is) vaunted as one of the major accomplishments of the new regime. Indeed, a Chinese Government white paper describes it as effecting an "earth-shaking historic change in

the social status and condition of women."[17] However, along with China's adoption of a market-based economy, governmental authorities have acknowledged that prostitution has reappeared on the mainland and that it constitutes a growing problem. In terms of statistics, women in prostitution figures range from official estimates of three million women nationwide, to U.S. State Department reports of ten million, to twenty million sex workers according to economist Yang Fan, who contends that they account "for fully six percent of the country's gross domestic product."[18]

China's growing incidence of crime also stands in marked contrast to the low crime rates that characterized the Maoist era. During the Maoist period, crime rates remained extremely low due to the curtailment of population mobility and the monetary economy to meet the requirements of centralized planning. By 1957, an estimated ninety percent of China's urban population belonged to a work-unit, an institution that was meant to overcome the alienation of labor by merging life and work and which provided all manner of welfare and services—housing, schools, hospitals, policing, shops and entertainment.[19] This system of allocation, in conjunction with a system of household registration, created a geographically "fixed" population that was permanently open to surveillance. Urban residents became tied to their place of work, and rural agricultural producers became tied to their place of birth because work and major resources were allocated by the state and the state needed to know the identity and location of its workers. This system ultimately created an entrenched rural-urban divide, as urban residents benefited from better access to state welfare and services, and rural residents became "second-class citizens" because of more limited access to education and other opportunities for self-advancement. Following the opening up of China's labor and commodity markets, and the subsequent flow of people and goods into developing urban centers, it was neither possible nor desirable to maintain this static system of social control. Yet one of the most significant effects of the introduction of market-based reforms, and the concomitant loosening of controls over population mobility, was a dramatic upsurge in rates and types of crime.[20]

Crime and prostitution constitute highly newsworthy items for the Chinese mass media, which itself underwent a radical transformation during the reform period. From the establishment of the PRC in 1949 until the early 1990s, China's print and communications media were wholly funded by central or local government and functioned as the "voice" of the CCP, publicizing

and eliciting support for its directives. With the expansion of market-based reforms in the 1990s, controls over less-official media and the dissemination of nonpolitical information became more relaxed.[21] Then, in 2003, the Chinese government stipulated that state-subsidized newspapers and magazines must earn at least half of their revenue from voluntary subscriptions. It also introduced a series of regulations designed to make China's television stations more competitive and independent. In this context, sensationalist news items and tabloid-style formats have proliferated as a means to attract audiences and advertisers.[22] The expansion of private Internet content providers, licensed and unlicensed cable networks, and "cross-investment by the Chinese media into other commercial enterprises, including joint ventures with international media giants," has furthered this trend.[23]

Chinese media coverage of prostitution-related issues has altered in ways that reflect both the growth and spread of prostitution in Chinese society and the changing role of the media. In 1990s China, discussions in the print media of the resurgent phenomenon of prostitution were limited in number and focused on issues of law and order. Such accounts predominantly itemized the expansion of legal controls over prostitution following the PRC's promulgation of its first criminal code on 1 January 1980, and were marked by clear support for the CCP's historical and current opposition to the prostitution industry.[24] They highlighted police efforts to control the spread of prostitution throughout the developing hospitality and service industry and to combat the new crime of trafficking in women for the purposes of forced prostitution.[25] They also tended to focus on the plight of young, rural women who had migrated to developing urban centers seeking work, only to be deceived or tricked into prostitution, often with horrendous consequences.[26] The primary purpose of such cautionary tales was to elicit public support for the PRC's ban on prostitution, although this did not stop some commentators from capitalizing on the sordid details of particular cases or noting some academics' support for a governmental policy of toleration.

Discussions of prostitution in the Chinese media today are more diverse as processes of social change and the expansion of tabloid-style formats have encouraged different types of news content. Prostitution-related reportage still focuses on police efforts to crack down on forced prostitution and on the development of a commercial sex trade as a means to underscore the illegality of the industry. However, discussions of prostitution-related issues in the Chinese media now also take the form of "human interest" stories that are designed to "shock" the general public by demonstrating the spread and "ugly"

side of prostitution. These stories include: "prostitute diaries"; sensationalist accounts of teenage involvement in prostitution; exposés of male–male prostitution; and stories that "name and shame" prominent public figures by detailing their association with prostitution practices.[27]

Chinese media also have focused on the dramatic resurgence of sexually transmissible infections (STIs) and government efforts to curb the perceived threat of prostitution-related disease transmission. Sexual health comprises a new object of governmental concern in the PRC due to the early Communist Party's successful eradication of active venereal disease from "New China" by the mid-1960s. Following its assumption of political power in 1949, the CCP declared that syphilis and gonorrhea were preventable social diseases stemming from the exploitation of man by man: their root causes being "poverty, prostitution, ignorance, and the subordinate status of women."[28] Through a combination of campaigns involving mass education, the virtual eradication of prostitution, and the large-scale provision of costly penicillin, the CCP announced to the World Health Organization (WHO) in 1964 that active venereal disease no longer existed in China.[29] However, since the mid-1980s, the Chinese Government has acknowledged the rapid resurgence of prostitution and STIs now rank among the most prevalent reportable infectious diseases. In terms of STIs, 5,838 cases were registered in 1985, 461,510 cases in 1997, and 703,001 cases in 2005.[30]

While China's first AIDS case was reported in Beijing in 1985, figures published by the Chinese government, along with WHO and UNAIDS, in January 2006 suggest that 650,000 people are now living with HIV, the majority of whom are young people.[31] Many new cases are linked to sexual transmission, whereas earlier cases were either "imported" from overseas or else linked to contaminated blood transfusions and needle-sharing practices. Acknowledging the potential for an HIV epidemic, China's State Council issued a circular in 1998 stating that the unchecked spread of STIs-HIV poses a serious public health problem which could threaten national socio-economic development.[32] A 2001 UNAIDS report more dramatically described it as a "titanic peril," claiming that the country is poised "on the verge of a catastrophe that could result in unimaginable human suffering, economic loss and social devastation."[33] The nationwide promotion of sex education and condom use is thus seen as essential for averting an epidemic.[34]

Media coverage has focused on the fact that campaigns to promote sexual health and HIV/AIDS awareness in China now target sellers and buyers of

commercial sex, even though Chinese law prohibits the sex industry. Based on the perceived success of Thailand's 100 Percent Condom Use Program, the Chinese Ministry of Health, in conjunction with various international organizations, began to implement pilot programs in 1999 and nationwide programs in 2006–2007. These programs aim to prevent the spread of STIs-HIV/AIDS by encouraging a commitment to 100 percent condom use in all commercial sexual encounters. They offer participatory workshops to women in prostitution on STIs-HIV/AIDS transmission and how to use condoms properly and encourage the managers of public entertainment venues to provide visible supplies of condoms and to display 100 percent condom use posters in their establishments. The 2006–2007 roll-out of the 100 Percent Program in China attracted considerable media interest because the provision of participatory workshops was viewed as signaling a potentially radical shift away from the CCP's historical opposition to the prostitution industry and toward governmental tolerance.[35]

Last, but not least, the Chinese media have begun to cover cases of horrific violence against women who sell sex in a voluntary as opposed to forced capacity. These cases include: the murder of various women following disagreements over the fee for commercial sex[36]; the murder of a female prostitute for allegedly infecting a male client with an STI[37]; the kidnapping and repeated rape of two female sex sellers whose foreheads and breasts were tattooed by their captors with the words "prostitute number one" and "prostitute number two"[38]; and the hire and subsequent murder of a prostitute whose body was sold to act as a "ghost bride," i.e., to be buried with a deceased bachelor in order to keep him company in the after-life.[39] The Chinese media have also covered at least five cases of serial prostitute homicides in recent years.[40]

While often capitalizing on the ugly combination of "sex and crime," Chinese media coverage of violence against women in prostitution is remarkable because of its new focus on the vulnerability to violence of women who sell sex in a voluntary capacity. Even more remarkable is that the emphasis on victim vulnerability has led to suggestions that China should abandon its historical opposition to the prostitution industry to combat the spread of STIs and HIV/AIDS and also to provide enhanced legal protection to women vulnerable by virtue of their social marginalization as "prostitutes" and often as migrant, second-class citizens. In the process, Chinese media reports of serial prostitute homicide reiterate the organizing concerns of Anglophone media accounts by simultaneously sensationalizing crime and emphasizing victim

vulnerability, while displaying a different range of concerns vis-à-vis perpetrator profiling.

Reporting Serial Prostitute Homicide

Women in prostitution, especially streetwalkers, are described as the "most at-risk people" for serial murder in the United States and Canada today for three reasons.[41] First, their mobility and "availability," combined with the anonymity and "invisibility" of prostitute clients, makes them vulnerable to opportunistic crime. Second, they may prove unwilling to report violent clients and missing colleagues to the police or may encounter problems that hinder police action, such as lack of credibility, due to their stigmatized and often illicit trade. Prostitution is prohibited in many countries, including those where sex work is viewed as a legitimate profession; for example, in Australia, streetwalking is illegal. Finally, streetwalkers are stigmatized as whores, lack social prestige, and typically suffer ongoing social and economic hardship, which may impact the decision of serial killers to target them as both vulnerable and somehow "less than human."[42] Legalization or governmental policies based on tolerance are thus frequently promoted as a means to counter negative societal attitudes toward prostitution as an "immoral" and "dirty" trade and to provide enhanced legal protection to women who, as a result of these negative attitudes, "are often seen as deserving of what they get" and not afforded the "same protections or even value as other human beings."[43]

Anglophone media coverage of the Steve Wright and Robert Pickton trials underscores these issues by noting that legal marginalization makes women in prostitution vulnerable to violence and inciting the general public to accept the need for legal reform. To use the words of Cari Mitchell from the English Collective of Prostitutes: "When the [Wright] murders took place, there was a public outpouring of compassion and demand that things should change. People really did grasp that it was because women were criminalised that they were so vulnerable."[44]

Chinese media reports of serial prostitute homicide respond to a similar set of concerns as those of the Anglophone media regarding the need to minimize victim vulnerability by providing women in prostitution with improved legal protections. These reports routinely suggest that women who sell sexual services in China are young women from poor, rural backgrounds who have come to developing urban centers to look for work but have limited means of generating an income. Effectively pushed into prostitution by eco-

nomic hardship, they are then further marginalized by being condemned as "fallen women" by mainstream society and by the fact that prostitution is a proscribed activity in China.[45] On the one hand, media commentators note that there is a "commonsense" perception that prostitution is a "disease-ridden and dangerous" occupation that inevitably attracts violence and crime. On the other hand, while studies confirm that female prostitutes are at very high risk of physical abuse, rape, robbery, and homicide, the stigmatized and illicit nature of prostitution makes many women in prostitution unwilling to report problems to legal authorities and makes them secretive about their activities, even using false names, which hinder police investigations and prosecution of cases on file.[46] At the same time, many women in prostitution are wary of police officials because of documented cases of harassment and corruption, including police collusion in protecting the owners and patrons of places of prostitution.[47]

Concerned media commentators conclude that legal education and protections need to be established for members of these socially vulnerable groups and that the general public should learn to understand rather than blame China's growing number of "have-nots" for the existence of controversial social phenomena such as prostitution.[48] Although the precise nature of these protections is left unclear, media commentators justify the implicit endorsement of a governmental policy of tolerance by arguing that offering women in prostitution legal protection is not equivalent to condoning prostitution. It simply means that a marginalized subpopulation will no longer be denied their civil rights because of their work.[49]

Unlike in the Anglophone media, Chinese reports of serial prostitute homicide offer a perpetrator profile based on issues of cultural traditionalism and socio-economic hardship rather than sexual pathology. Chinese media accounts of serial prostitute homicide often share a common narrative in terms of perpetrator profiling. Poorly educated men from socially disadvantaged backgrounds resent the young women whom they meet for illicit commercial sex in recreational and leisure venues for making "quick and easy money." Knowing that such women usually come from impoverished rural backgrounds and are living temporarily in large cities without the everyday support of family and friends, they decide that these women constitute easy targets for robbery and murder. The plan is simple. Rob the "whores" of their immediate material assets (cash, mobile phones, MP3 players, and jewelry) and coerce them into providing ATM passwords so that their bank accounts can be

emptied. In worst-case scenarios, the women are then murdered and their bodies disposed of in ways designed to stymie police investigations.

The organizing concerns of social disadvantage and economic greed are made explicit in Chinese media accounts of "the murdering demon brothers." Shen Changyin and Shen Changping—two brothers from a poor, rural family background and with only a junior middle-school education—were tried in 2005 for robbing and murdering eleven prostitutes. The brothers told the Court that they had hit on a plan to rob and murder women in prostitution following a failed business enterprise. Changyin and Changping had borrowed 45,000 yuan from a Henan cooperative in 2002 to set up a motor vehicle repair shop in Lanzhou, the capital city of Gansu Province. This business had failed due to inept management and the brothers' inability to manage money responsibly, which had resulted in loan repayment difficulties.[50] The brothers reportedly were fond of spending their earnings in karaoke-dance venues and bathhouses, i.e., venues associated with the provision of commercial sexual services and patronized by "men of means."[51] Media commentators therefore concluded that the brothers had decided to rob and murder female prostitutes because they desired the "fast money" and "dissolute" lifestyle that is associated with China's new male rich.[52]

Chinese media reports highlight the brothers' greed and disregard for female prostitutes as "lesser human beings" by detailing how they orchestrated a series of robberies and murders that involved the assistance of four women in prostitution through coercion. In May 2003, Shen Changping met Du Surong, a 22-year-old woman who had left junior middle-school without graduating, and had worked as a waitress before becoming a "hostess" in a Lanzhou bathhouse in 2002.[53] Du subsequently arranged to meet the brothers at a private venue for the purposes of commercial sex, believing that they ran a successful car business. The brothers then coerced Du into helping them murder their first victim, Yao Fang, threatening to kill Du or her family members if she refused or tried to escape. Yao Fang also worked as a bathhouse hostess and lived near the two brothers in the kind of cheap rental accommodations that tend to be used by rural migrants working in developing urban centers. On 8 June 2003, the two brothers, with Du's help, persuaded Yao to go with them to another rental property, which they had hired for this purpose. They bound and trussed Yao, took 800 yuan from her purse and forced Yao to disclose her banking details, enabling them to empty her account of 30,000 yuan. On 10 June 2003, the two brothers strangled and dismembered Yao, spread-

ing her body parts across three different locations in the surrounding countryside, and using sulfuric acid to destroy any evidence of murder at the property concerned.[54]

The two brothers left Lanzhou with Du Surong in November 2003 for the Inner Mongolian city of Baotou, where they proceeded to rob and murder five more women in prostitution for a sum amounting to 20,000 yuan. In Baotou, the brothers befriended a 21-year-old karaoke hostess named Li Chunling, also a rural migrant with a junior middle-school education. The two brothers later physically beat and robbed Li Chunling but offered to spare her life if she would introduce them to other hostesses working in recreational venues.[55] On 12 April 2004, Li Chunling introduced the brothers to a 25-year-old migrant karaoke hostess named Zhao Meiying. With Li's help, the brothers persuaded Zhao to come with them to a rental property where they drugged her, assuming that she had personal savings of around 90,000 yuan. When the brothers discovered that Zhao only had nine yuan in her bank account, they forced her to persuade another karaoke hostess, Yang Zhiling, to come to the property. They then robbed Yang and forced Zhao to kill her, disposing of the body in a similar manner to that of their previous victims.

Chinese media coverage suggests that the case first came to police attention on 14 April 2004, when Zhao Meiying escaped from the brothers and surrendered herself to the Taiyuan police as a murderer.[56] Zhao reportedly was so distraught that local police initially believed that she was suffering from some kind of nervous breakdown. However, with the urging of an accompanying friend, they eventually accepted Zhao's story and decided to investigate any sales of unusual quantities of sulfuric acid in related locations. This investigation culminated in the arrest of Li Chunling and the issuing of a warrant for the arrest of the two brothers, who fled with Du Surong and proceeded to rob and murder four more women before being detained by the police on 8 September 2004.[57] The first three of these murders took place in Anhui Province and were accomplished with the help of a 15-year-old karaoke hostess, Guan Yongxin. The final murder took place in Hebei Province with the help of Du Surong.

In keeping with Chinese government directives, the media praised both the prompt actions of the police and the speedy resolution of the case. On 19 May 2005, the two brothers and four women—Du Surong, Guan Yongxin, Li Chunling, and Zhao Meiying—were arraigned on charges of willful homicide.[58] The brothers were sentenced to death on eleven counts of murder and multiple counts of theft of property amounting to more than 120,000 yuan. Li was

sentenced to death on one count of murder, four counts of acting as an accomplice to murder, and six counts of theft of property amounting to one ring, one necklace, three mobile phones and a sum of 24,000 yuan. She was meted the death sentence on the grounds that, although she was initially forced into homicide, she had become a willing participant in later murders. Zhao was sentenced to three years imprisonment and a fine of 1,000 yuan on one count of murder and theft of property amounting to 1,000 yuan. Zhao received a lenient sentence because she had been coerced into murder, and her voluntary surrender to the police had led to the brothers' apprehension.[59] Du and Guan were sentenced to twenty years fixed-term imprisonment and fined 5,000 yuan. Du was charged as an accomplice in the murder of two women and for theft of property amounting to 12,400 yuan.[60] Guan was charged as an accomplice in the murder of three women and for theft of property amounting to one mobile phone, one necklace, one ring, and 62,000 yuan. Guan was not meted the death penalty on the grounds that she was an accessory to murder and was a minor under 16 years of age when the crimes took place.[61]

Following sentencing, the brothers' defense lawyer declared to reporters that the case might be closed from a legal perspective, but the social aspects required further consideration.[62] Both brothers reportedly had apologized to their parents, and Shen Changyin had further apologized for leading his younger brother astray. The lawyer therefore concluded that the brothers were not "inhuman" sociopaths, but rather their actions, as those of all six defendants, were prompted by a combination of poverty, poor education, and the growing gap between China's "haves and have-nots." He also attributed the brothers' actions to the fact that they ascribed to traditional Chinese understandings of women in prostitution as both "toys" and "tools" and as people who deserved neither the income they derived nor human regard because they had forfeited the conventional female role of being "a virtuous wife and a good mother."[63] Media commentators concurred that growing social and gendered inequalities had contributed to the brothers' crimes, adding that the missing aspect in discussions of the case was the "voices" of the victims and the victim's families.[64] This conclusion is remarkable in the Chinese context because it displays a new and emerging concern with the specificity of the rights and lives of women in prostitution.

Conclusion

Although the trial of "the murdering demon brothers" focused media and public attention on the specificity of violence against women in prostitution in China, it is not an isolated case. In 2008, three men were arrested in Yunnan Province for forcing two prostitutes to stab two colleagues to death in order to bring the women under their control and force them to hand over their earnings.[65] In January 2005, Chinese police authorities arrested a group of six men for the robbery and murder of five women in prostitution, following a report that a 29-year-old karaoke hostess and mother of two children was missing. In June 2003, the Beijing police arrested a 41-year-old taxi-driver on charges of robbing and murdering five karaoke hostesses, dismembering and disposing of their bodies, and eating their eyes and kidneys.[66]

In each of these cases, media reports characterize perpetrators of serial prostitute homicide as men from poor rural backgrounds with low levels of education, who enjoy spending their limited funds in recreational venues associated with commercial sexual activities, and who ascribe to traditional understandings of women in prostitution as "less than human." Perpetrators are also characterized as viewing women in prostitution as "ideal" targets of robbery and murder on the grounds that they make "easy money" through disreputable means and are vulnerable by virtue of social and legal condemnation. Hence, unlike the concern with sexual pathology that characterizes Anglophone media reports of serial prostitute homicide, Chinese media reports attribute the actions of perpetrators to a combination of poverty, poor education, and the growing gap between China's "haves and have-nots."

In other cases of serial prostitute homicide, such as the "murdering demon brothers," Chinese media reports further conclude that the social responsibility for such cases rests with both the greed and ruthlessness of the male perpetrators *and* the illicit nature of prostitution. Media accounts note that the presiding judges in many trials contend that women in prostitution are vulnerable as rural migrants who are isolated from kinship networks, who display obvious signs of relative wealth; they are willing to go with "strangers" to secluded places for commercial sex, and generally refuse to report instances of violence and extortion to police officials because they fear being implicated in an illicit activity.[67] Hence, while concurring that cases of serial prostitute homicide are related to growing socio-economic inequalities, concerned media commentators conclude that women in prostitution require improved legal protection, and that public awareness of the necessity of improved legal protection should be raised by including the "voice" of the prostitute in media

discussions.[68] This conclusion constitutes a veiled criticism of the PRC's ban on the prostitution industry and highlights a new concern with the specificity of the rights and lives of women in prostitution.

In short, increased reports of violence against women in prostitution, and the new imperatives of HIV/AIDS prevention, are changing debates on the most appropriate governmental response to prostitution in China. Whereas Chinese media accounts of prostitution-related issues were once marked by uniform support for the official policy of banning prostitution, they now variously suggest that the PRC should relax its historical opposition to the prostitution industry in order to give women in prostitution legal protections, halt police and cadre corruption, and help the work of HIV/AIDS prevention. In fact, in 2006, two members of the CCP received widespread coverage in the Chinese media for proposing that China's highest legislative body should make prostitution legal and open to a system of government management.[69] Their proposals were heralded as "extraordinary" due to their standing as active CCP members and their corollary claim that such actions would assist the PRC's current policy goal of developing a civilized and harmonious society. In this context, Chinese media discussions of alternative responses to prostitution are likely to increase in number as part of broader discussions about ways to reduce social inequality, promote citizen rights, and ensure political stability in a country that is undergoing rapid economic development and dramatic social change.

Notes

1 A "serial killer" is defined as a person who murders "three or more people, in three or more separate events over a period of time." Their characteristic profile includes a lack of empathy for their victims and a lack of remorse for their crimes. See "List of Serial Killers by Number of Victims," http://en.wikipedia.org/wiki/List_of_serial_killers_by_number_of_victims; "Why Serial Killers Target Prostitutes," CBC News (December 19, 2006).

2 "Casebook: Jack the Ripper," Casebook, 1996–2006: www.casebook.org/intro.html.

3 Ibid.

4 Heather Creaton, "Recent Scholarship on Jack the Ripper and the Victorian Media," Centre for Metropolitan History, Institute of Historical Research (2003): http://www.history.ac.uk/reviews/articles/creatonH.html.

5 Heather Creaton, "Recent Scholarship on Jack the Ripper"; "'Ipswich Ripper' Trial Gets Underway," Sydney Morning Herald (January 14, 2008).

6 "'Ipswich Ripper' Trial"; "Robert William Pickton: Trial Timeline," CBC News (December 12, 2007).

7 Devon Brewer, Jonathan Dudek, John Potterat, Stephen Muth, John Roberts, and Donald Woodhouse, "Extent, Trends, and Perpetrators of Prostitution-related Homicide in the United States," Journal of Forensic Science 51, No. 5 (2006): 1101–1108, 1107.

8 Devon Brewer, et al., "Extent, Trends, and Perpetrators," 1107; Micol Levi-Minzi and Maria Shields, "Serial Sexual Murderers and Prostitutes as Their Victims: Difficulty Profiling Perpetrators and Victim Vulnerability as Illustrated by the Green River Case," Brief Treatment and Crisis Intervention 7, No. 1 (2007): 77–89.

9 Dong Jing, "Shepan 'xiongdi sharen mo' zhi yi: Lanzhou tingshen meiyou xuannian," [No. 1 of the Trial of the 'Murdering Demon Brothers': Arraignment of the 'Murdering Demon Brothers' in Lanzhou Holds No Surprises], Yanzhao Dushi Bao (May 30, 2005); Dong Jing, "Shepan 'xiongdi sharen mo' zhi er: huanyuan 'xiongdi ermo' de zhen mianmu" [No. 2 of the Trial of the 'Murdering Demon Brothers': The True Background of the 'Murdering Demon Brothers'], (May 30, 2005); http://www.yzdsb.com.cn/20050530/ca492402.htm; Qing Wen, "Xiongdi sharen mo haowu fuzui gan—jizhe kanshousuo nei yu yifan mian dui mian" [Murdering Demon Brothers Show No Remorse: Reporter Meets Them Face-to-Face in a Detention Centre], Yanzhao Dushi Bao (September 8, 2004); "Xiongdi sharen mo zhijie 11 ren xu: zai kanshousuo nei haowu fuzuigan" [Murdering Demon Brothers Kill 11 People in Succession: They Show No Remorse for their Crimes while in Detention], Yanzhao Dushi Bao (September 8, 2004); Nüyan Zhang and Dang Yun, "Xiongdi shiren mo shasi 10 ming zuotainü chaoshi qiguan beipan sixing" [The Murdering Demon Brothers Who Killed 10 'Working Girls' and Ate Their Stir-Fried Organs Are Sentenced to Death], Lanzhou Wanbao (September 1, 2005).

10 Dong Jing, "Shenpan 'xiongdi sharen mo' zhi er"; Qing Wen, "Xiongdi sharen mo haowu."

11 In this anthology Peter Pugsley and Jia Gao offer another perspective on how media coverage of prostitutes is shaped by concerns specific to a modernizing Chinese state.

12 "The Second Industrial Revolution," BBC News (May 11, 2004).

13 David Goodman, The New Rich in China: Future Rulers, Present Lives (Abingdon, Oxon: Routledge, 2008).

14 Elaine Jeffreys, China, Sex and Prostitution (London: RoutledgeCurzon, 2004), 96–122 and 150–176; see also Matthew Forney, "Blood in the Streets," Time (January 27, 2003); and Matthew Forney, "Making a Killing in China," Time (November 17, 2003).

15 Friedrich Engels, The Origins of the Family, Private Property and the State (New York: International Publishers, 1972).

16 Elaine Jeffreys, *China, Sex and Prostitution*, 96–97.

17 Information Office of the State Council of the People's Republic of China, "Chapter 1: Historic Liberation of Chinese Women," *The Situation of Chinese Women* (1994): http://www.china.org.cn/e-white/chinesewoman/indes.htm.

18 Harold French, "Shenzhen's Public Humiliation of Sex Workers Provokes a Backlash," *International Herald Tribune* (December 8, 2006).

19 David Bray, *Social Space and Governance in Urban China: The Danwei System* (Stanford: Stanford University Press, 2005).

20 Elaine Jeffreys, *China, Sex and Prostitution*, 153.

21 Anne-Marie Brady, *Marketing Dictatorship: Propaganda and Thought Work in Contemporary China* (Buffalo: Rowman and Littlefield, 2007); Stephanie Donald, Michael Keane, and Yin Hong, *Media in China: Consumption, Content & Crisis* (London: RoutledgeCurzon, 2002).

22 Mara Hvistendahl, "China's Pulse Races," *Los Angeles Times* (June 24, 2005); Yuezhi Zhao, "The Rich, the Laid-off, and the Criminal in Tabloid Tales: Read All About It," in *Popular China: Unofficial Culture in a Globalizing Society*, edited by Perry Link, Richard Masden, and Paul Pickowicz (Lanham, MD: Rowman and Littlefield, 2002), 111–136.

23 Roya Akhavan-Majid, "Mass Media Reform in China," *Gazette: The International Journal of Communication Studies* 66, No. 6 (2004): 553–565.

24 During the Maoist period (1949–1976), the formal legal system fell into disrepute as a tool of class-based oppression and was replaced by the Chinese system of administrative and party disciplinary sanctions. This latter system, under the auspices of the Chinese public security forces, was used to police the activities of those who were deemed to have committed social offences or political "errors," but whose criminal liability was not deemed sufficient to bring them before the courts. Following the PRC's introduction of a criminal code in January 1980, the administrative system operated in a controversial fashion alongside the formal legal system. The administrative system has now been revised and codified as law in the PRC's *Security Administration Punishment Law* of March 1, 2006 (Quanguo Renda Changweihui, 2005).

25 Elaine Jeffreys, "Over My Dead Body! Media Constructions of Forced Prostitution in the People's Republic of China," *PORTAL Journal of Multidisciplinary International Studies* 3, No. 2 (2006).

26 Ibid.

27 "Baitan shangke wanshang jieke, nüdaxuesheng de zibai" [I Attend Class in the Daytime and Solicit Clients in the Evening: Confessions of a Female University Student], *Lianhe Wanbao* (June 11, 2002); "Zhongxue liang nüsheng xiang zheng qingsong qian: wangshang maiyin meici shoufei 300 yuan" [Two Schoolgirls Sought to Make Easy Money: Sold Commercial Sex on the Internet for a Fee of 300 Yuan], *Sichuan Xinwen Wang* (July 27, 2004): http://news.tom.com; Elaine Jeffreys, "Governing Buyers of Sex in the People's Republic of China," *Economy and Society* 35, No. 4 (2006): 571–593; Elaine Jeffreys, "Querying Queer Theory: Debating Male-Male Prostitution in the Chinese Media," *Critical Asian Studies* 39, No. 1 (2007): 151–175.

28 Herbert K. Abrams, "The Resurgence of Sexually Transmitted Disease in China," *Journal of Public Health Policy* 22, No. 4 (2001): 429–440.

29 Ibid.

30 Kong-Lai Zhang, Mao Shao-Jun, and Xia Dong-Yan, "Epidemiology of HIV and Sexually Transmitted Infections in China," *Sexual Health* 16 (2004): 39–46; Z-Q. Chen, G-C. Zhang, X-D Gong, C. Lin, X. Gao, G-J. Liang, X-L. Yue, X-S. Chen, and M.S. Cohen, "Syphilis in China: Results of a National Surveillance Program," *Lancet* 369 (2007): 132–138.

31 "HIV and AIDS in China," (2007): http://www.avert.org/aidschina.htm; "China AIDS Survey," (2007): http://www.casy.org/policy.htm.

32 State Council AIDS Working Committee Office and UN Theme Group on HIV/AIDS in China, "A Joint Assessment of HIV/AIDS Prevention, Treatment and Care in China" (2004): http://www.chinaaids.cn/worknet/download/2004/report2004en.pdf.

33 UNAIDS, "HIV/AIDS: China's Titanic Peril–2001 Update of the AIDS Situation and Needs Assessment Report" (2002): http://www.casy.org/engdocs/China's%20Peril.pdf.

34 Joan Kaufman, "China: The Intersections between Poverty, Health Inequity, Reproductive Health and HIV/AIDS" (2005): http://www.ids.ac.uk/ghen/resources/papers/Kaufman-ChinaHealthSystem.pdf.

35 "Haerbinshi 'xiaojie' peixunban yinfa de zhenglun" ['Working Girl' Training Class in Haerbin City Triggers Debate], Haerbin Ribao (October 15, 2006).

36 Yueying Wang and Wang Wenbo, "Piaozi zhengzhi jing nu jiang xiaojie shahai: yipi bufa fenzi jin bei chujue" [Fight over the Cost of Prostitution Transaction Results in the Death of a 'Working Girl': Group of Lawbreakers Are Executed Today], Zhongxin Wang (July 19, 2006).

37 Qiang Lei, "Chuzuche siji piaochang: huaiyi bei ran xingbing cansha maiyinnü fenshi" [Taxi Driver Who Visits Prostitutes Suspects He Has Contracted an STI: Murders and Burns the Body of a Female Sex Seller], Wanjia Huodong (April 7, 2006).

38 "Shaonü etou rufang bei cizi xu: jin 20 jia yiyuan yuan tigong zhiliao" [Young Girls Tattooed on the Forehead and Breast: 20 State-run Hospitals Say They Want to Provide Treatment], Nanfang Dushi Bao (August 26, 2005).

39 Antoaneta Bezlova, "China's Grave Offense: Ghost Wives," Asia Times (June 29, 2007).

40 Shiming Huo, "Wei zai wuting zhuang dakuan qiangjie shahai peiwunü" [Man Kills Female Dance Companions: Pretends to Be One of the New Rich at the Dance Venues], Fazhi Ribao (November 13, 2006); Shenliang Liu, "Banian hai qi ming, lianhuan shashou shi dige" [Killed Seven People within Eight Years, the Serial Murderer Is a Taxi Driver], Beijing Qingnian Bao (December 23, 2003); "Shenyang xiagang changzhang qiangjie shahai 7 ming wunü shimo" [The Complete Story of a Laid-off Factory Manager Who Robbed and Murdered Seven Female Dance Companions], Shenzhen News Agency (November 13, 2006); Fengwei Xiao, Jie Mei, and Mei Xue, "Etu wu yue jiesha wu ming zoutai xiajie bing zhijie qishi zhufan bei qiangjue" [Main Culprit Is Executed for the Crime of Robbing and Murdering Five Working Girls and Dismembering and Disposing of Their Bodies, All Within the Space of Five Months], Henan Shangbao (November 27, 2006); Qian Zhao and Li Yu, "Sichuan dadiao yi qiangjie shahai 'xiaojie' shenfu 7 tiao ming'an de tuanhuo" [Sichuan Police Smash and Charge a Criminal Gang Who Robbed and Murdered 'Working Girls' on Seven Counts of Homicide], Lanzhou Wanbao (September 1, 2005); Gui Zou, "Liang jiefei jie 'xiaojie' sharen suishi: fating shang huzhi duifang dongshou" [The Case of Two Bandits Who Robbed and Murdered 'Working Girls' and Dismembered Their Bodies; They Accuse Each Other in Court], Jinghua Shibao (November 30, 2004).

41 Devon Brewer, et al., "Extent, Trends, and Perpetrators," 1101; "Why Serial Killers Target Prostitutes," CBC News (December 19, 2006).

42 "Why Serial Killers," CBC News.

43 Micol Levi-Minzi and Maria Shields, "Sexual Serial Murderers."

44 "Ipswich Ripper."

45 See "Liu ming 'xiaojie' bei jiti jiansha: 'xiaojie' cheng gao fengxian requn?" [Six 'Working Girls' Raped and Murdered: Are 'Working Girls' Now a High-Risk Social Category?], Xinhua News Agency (April 30, 2004); Hanjun Xu, "Bei jian zao qiang diuming: xiaojie cheng zuigao fengxian renqun? [Rape, Robbed, and Murdered: Are 'Working Girls' Most at Risk?], Qian-

long Wang (April 29, 2004); Hanjun Xu, "Zao qiangjian qiangjie shenzhi diu ming: 'xiaojie' cheng gao fengxian renqun" [Rape, Robbery, and Murder: 'Working Girls' Fall into a High-Risk Category], *Qianlong Wang* (April 29, 2004).

The act of organizing, facilitating or forcing another person to engage in prostitution is a criminal offence, punishable by five to ten years imprisonment with the possible addition of a fine, according to the PRC's first criminal code, promulgated on January 1, 1980, and the revised 1997 *Criminal Law of the PRC*. First-party participation in the prostitution transaction is not criminalized, but rather is banned as constituting a social harm, punishable by a maximum of 5 days administrative detention or a fine of 500 yuan; and, in more serious cases, by 10 to 15 days administrative detention with the possible addition of a fine up to 5,000 yuan, based on the PRC's new *Security Administration Punishment Law* of March 1, 2006. See Quanguo Renda Changweihui [Standing Committee of the National People's Congress], *Zhonghua renmin gongheguo zhi'an guanli chufa fa* [Security Administration Punishment Law of the People's Republic of China], (2005): http://www.chinacourt.org/flwk/show1.php?file_id= 104073. The latter law gives the Chinese police the authority to fine and detain first-party participants in the prostitution transaction, while significantly reducing former penalties for less serious offences—previously 6 months to 2 years detention and a fine of up to 5,000 yuan. See Elaine Jeffreys, *China, Sex and Prostitution*, 139–140. Reduced penalties for first-party engagement in the prostitution transaction were introduced partly in response to the growth of prostitution in Chinese society, but primarily to eradicate arbitrary sentencing and police profiteering from the fining of participants in the prostitution transaction. This means that the vast majority of prostitution-related offences, i.e., the processes of investigating and penalizing the activities of sellers and buyers of sex, are handled by the Chinese police, with only serious cases, such as those relating to the organization of prostitution, forced prostitution, and trafficking in women and children, being handled through the courts and criminal justice system.

46 Hanjun Xu, "Bei jian zao."

47 Heqing Zhang, "Female Sex Seller and Public Policy in the People's Republic of China," in *Sex and Sexuality in China*, edited by Elaine Jeffreys (Abingdon, Oxon: Routledge, 2006), 139–158.

48 "Xiaojie zhisi zhaoshile shenme?" [What Does the Death of 'Working Girls' Illustrate?], *Guangdongsheng Renmin Zhengfu Wang* (December 23, 2003); Hanjun Xu, "Bei jian zao."; Hanjun Xu, "Zao qiangjian."

49 Hanjun Xu, "Bei jian zao."; Hanjun Xu, "Zao qiangjian."

50 Dong Jing, "Shenpan 'xiongdi sharen mo' zhi er"; Qing Wen, "Xiongdi sharen mo haowu fuzui gan— jizhe kanshousuo nei yu yifan mian dui mian" [Murdering Demon Brothers Show No Remorse: Reporter Meets with Them Face-to-Face in a Detention Centre], *Yanzhao Dushi Bao* (September 8, 2004).

51 Dong Jing, "Shenpan 'xiongdi sahren mo' zhi yi"; Qing Wen, "Xiongdi sharen mo."

52 Elaine Jeffreys, "Advanced Producers or Moral Polluters? China's Bureaucrat-Entrepreneurs and Sexual Corruption," in *The New Rich in China*.

53 The term "hostess" is used in this chapter as an imprecise translation for the Chinese term *sanpei xiaojie*. In Chinese-language writings, the term *sanpei xiaojie* refers to a woman who acts as a paid companion for a man in three main ways, and whose defining activities primarily occur in public entertainment and leisure venues. Discussed in relation to the kinds of activities that occur within karaoke-dance venues, the term refers to the notion that some women will talk, sing, and dance with a man in return for material gifts or financial compensation. In other contexts, it refers to women who offer massage services in health, hairdressing, bath-

houses, and beauty centers. By other definitions, *sanpei* activities invariably involve commercial sexual services of some form. Hence the term *xiaojie* (Miss) is now a common euphemism for "prostitute" or "working girl" in colloquial Chinese. See Elaine Jeffreys, *China, Sex and Prostitution*, 183.

54 Qing Wen, "Xiongdi sharen mo haowu."; Nüyan Zhang and Dang Yun, "Xiongdi shiren mo shasi."

55 Qing Wen, "Xiongdi sharen mo."

56 Ibid.

57 Dong Jing, "Shenpan 'xiongdi sharen mo' zhi yi."; Nüyan Zhang and Dang Yun, "Xiongdi shiren mo."

58 Dong Jing, "Shenpan 'xiongdi sharen mo' zhi yi."; Qing Wen, "Xiongdi sharen mo."

59 Nüyan Zhang and Dang Yun, "Xiongdi shiren mo."

60 Dong Jing, "Shenpan 'xiongdi sharen mo' zhi yi."

61 Nüyan Zhang and Dang Yun, "Xiongdi shiren mo."

62 Donghai Hao and Xia Chen, "Xiongdi liangren chahai zuotai nü xu: emo cong jianyu li xuehui chiren," [Two Murdering Demon Brothers Kill 'Working Girls' in a Serial Fashion: The Two Devils Learnt about Eating People in Prison], *Lanzhou chenbao* (20 May, 2005).

63 Dong Jing, "Shenpan 'xiongdi sharen mo' zhi er."

64 Nüyan Zhang and Dang Yun, "Xiongdi shiren mo."

65 Yihui Cheng, "Qiasi wuxiaojie luozhe shiti liu" [Body of Strangled 'Dance Girl' Found in the Gutter], *Yunnan Xinxi Bao* (March 28, 2008): A07; Nian Wu, "San ming nanzi xiepo zuotai xiaojie tongsi tonghang" [Three Men Force 'Working Girl' to Stab Another 'Working Girl' to Death], *Shenghuo Xinbao* (April 12, 2008).

66 "Xiaojie zhisi."

67 Fengwei Xiao, Jie Mei, and Mei Xue, "Etu wu yue."

68 Nüyan Zhang and Dang Yun, "Xiongdi shiren mo."

69 "Dalu dixia xingchanye 'hefahua' fengbo" [Debating the 'Legalization' of China's Underground Sex Industry], *Fenghuang Zhoukan* No. 9 (2006).

CHAPTER 3

Ripped from the Headlines

Newspaper Depictions of Battered Women in Peru

M. Cristina Alcalde

Women experience domestic violence at alarmingly high rates despite legislation and interventions to eradicate this phenomenon around the globe. In Latin America, intimate partner violence rates vary by country but range between 10 percent and 70 percent.[1] Almost all countries in the region established national women's offices to focus on the prevention, treatment, and eradication of violence against women in the 1990s. By 1993 Peru was among the first Latin American countries to pass laws specifically on domestic violence. Nevertheless, today, more than half of the women in the Peruvian coastal city of Lima and approximately two-thirds of the women in the Andean city of Cusco have been physically or sexually abused by their partners.[2] Nationally, over 120 homicides are classified annually as crimes of passion. The majority of the victims are women, and the majority of the murderers are women's partners or ex-partners.[3]

Peruvian newspapers routinely cover stories of domestic violence that end in femicide.[4] The work of feminist scholars has underscored bias and distortion in news coverage of violence against women in various parts of the world.[5] In Peru sensationalistic headlines attract readers to stories of domestic violence and femicide that fail to explain the dynamics of abusive relationships. Newspapers both reflect and influence public opinion on violence against women.[6] Yet, in reflecting public opinion, newspapers privilege some interpretations of men's violence against women over others, rendering some accounts more legitimate than others.[7]

In this chapter I critically examine the connections and disconnections between mainstream media representations of women and men in abusive relationships, and the realities lived by women in abusive relationships in

Peru. I focus on newspaper coverage of domestic violence in 2001 and draw on more recent articles from 2007 and 2008 to a lesser extent, examining how stories on domestic violence filter women's experiences of abuse through the lenses of domestic violence myths, class bias, sexism, and racism embedded in contemporary Peruvian society. In 2001, I collected approximately forty newspaper pieces related to domestic violence, and from 2007–2008, I collected approximately twenty additional pieces. Women who are marginal ized by inequalities of class and race are the most common subjects of public scrutiny in these domestic violence stories.

My examination of domestic violence coverage suggests that news stories systematically blame women and frame men's violence against women in terms of one popular interpretation of domestic violence (although this approach is never mentioned by name in stories): expressive tension. According to the expressive tension perspective, men's violence against women is the result of inner forces over which men have little or no control.[8] In Peruvian newspapers, men's violence is commonly attributed to jealous rage or blind passion Consistently omitted as contributing factors are references to men's long history of violence against their partners and to patriarchal structures within Peruvian society that maintain violence against women. Violent episodes are presented as extraordinary, surprising, and isolated. Newspaper accounts justify men's violence by emphasizing uncontrollable rage or passion and women's supposed transgressions as triggers for men's actions.

I draw on my 2001 fieldwork with indigenous and mestiza (mixed European-indigenous ancestry) battered women in Lima, as well as on more recent research trips to Lima, to discuss moments in battered women's lives that do not reach the headlines. In 2001–2002 I employed life history methodology to interview thirty-eight battered women whom I initially contacted through shelters, reproductive health clinics, and personal contacts.[9] Interviews with women were one-on-one and were based on an unstructured interview guide that allowed for repeated sessions to elicit their life stories. All interviews were conducted in Spanish and each interview session lasted between one and four hours. Through analysis of their life stories, I explored the intersections of the women's identities as poor, nonwhite, rural migrants with few or no years of formal education with their experiences of intimate, institutional, and structural violence in Lima. I was dealing with sensitive topics with women at various stages of the leaving process; it was important to build trust and understanding, so I did not interrupt these women when they discussed topics unrelated to what I had originally anticipated as part of my research topics.[10] Although I referred to a thematic guide which was initially written and subsequently memorized during interviews, the themes varied by person. One

person might not wish to discuss her childhood, but a question or comment regarding her employment might trigger a flood of information about other aspects of her life that were highly significant in the life of that individual.

In the end, it was precisely the flexibility of the interview process and of listening to women's life stories that allowed me to better understand their experiences and the contexts in which these experiences took place. I also observed and participated in the everyday routine of one shelter through volunteer work during the course of one year (2001–2002), and regularly visited and observed two other shelters, women's neighborhoods, specialized women's police stations, health clinics, and women's nonprofit organizations. Analysis of court records of domestic violence cases, shelter records, and articles and editorials complemented observations and interviews. This chapter draws primarily on my analysis of media representations and their disconnections to women's experiences as discussed in interviews.

I explore and contrast the complicated dynamics that inform women's everyday lives to the media portrayals of battered women and the causes for violence. Following an intersectional approach,[11] I begin by discussing how some women are more vulnerable to having their behaviors publicly scrutinized and sensationalized by newspapers because of how their gender, race, culture, and class are interpreted in the national imaginary.

The Peruvian Setting

In Peru, laws against family violence are interpreted and applied in an environment where racism and sexism are constant yet invisible parts of everyday life. The country is home to approximately 28 million people, nearly one-third of whom live in the capital Lima. Approximately 45 percent of Peruvians are officially classified as indigenous, another 35 percent as mestizo, and 15 percent as European white descent; the remaining population is mostly of African and Asian ancestry. As in other parts of Latin America, in Peru the power associated with whiteness can be traced to the colonial experience. Historically in the Andes "citizenship has been constituted through Spanish heritage, language, and literacy and administered via European-style legal and educational systems" that left the indigenous majority practically disenfranchised.[12] Soon after Peru's independence from Spain in 1821, it became evident that the elite associated poor indigenous Peruvians with resistance to modernization and viewed them as impediments to progress.[13]

In contemporary Peru, race has more to do with social status than with skin color; those "who 'look Indian' are rarely called Indian if they are middle or upper class."[14] Thus, a wealthy socially white person may have darker skin than a poor mestizo. In identifying the battered women I interviewed as

indigenous or mestiza, I am referring to the ways others commonly identify them based on each woman's social status rather than on how each woman self-identifies or on her precise skin color. On the one hand, the identities these women claim for themselves are generally deracialized and accentuate the positive aspects of their lives, reminding us that "a single subject can no longer be equated with a single individual."[15] On the other hand, the negative connotations of the racialized identities attributed to women by others significantly influence the resources to which they have access and how they are treated.

Although discrimination based on race, gender, and class is illegal today, it continues to shape everyday life. On the one hand, in 2001 Peruvians elected the first president of indigenous background, Alejandro Toledo, and the first indigenous congresswoman, Paulina Arpasi. Since that time, other indigenous women have been elected to Congress. Today, Hilaria Supa insists on speaking her native Quechua in Congress, an official indigenous language in Peru and one long viewed as inferior to Spanish by Lima society. On the other hand, discotheques, beaches, and social clubs in Lima routinely deny citizens entry on the basis of race. Soon after beginning her term in Congress in 2001, Arpasi complained that the press refused to treat her with the same respect given to non-indigenous citizens, noting how she was asked indiscreet questions other congresswomen would not be asked.[16] In 2001, newspapers and television programs paid more attention to her indigenous dress and customs than to her political ideas. Similarly, Supa's use of Quechua in Congress has been criticized by fellow congresspeople, and opposition to Toledo's presidency has often been accompanied by discussions of his poor and indigenous background and by racial epithets. Stereotypes regarding poor indigenous and mestizo individuals permeate everyday life and are echoed in various societal spaces including popular media, where most of the domestic violence stories focus on poor mestizo or indigenous people.

Over half of the women I interviewed in Lima in 2001 trace their descent to the highlands. In the popular imagination, the racist and sexist popular saying "más me pegas, más te quiero" (the more you beat me, the more I love you) is used to refer to as amor serrano (highland love). The underlying idea is that physical, psychological, and sexual violence against women from the highlands by their intimate partner need not be addressed by state policies because these practices are based on indigenous customs and traditions. According to this logic, women expect and even enjoy men's violence and are therefore complicit in their own suffering as members of a backward culture.

Peru's Family Violence Law lists physical, psychological, and sexual violence as forms of domestic violence, regardless of an individual's class, race, or

gender, and regardless of whether or not the individual is married to the abuser. In 1988 Peru's first women's police station opened in Lima, specifically to respond to women's complaints of violence in the home. By 2002 Lima had six women's police stations and there were seven more in other parts of the country. These specialized police stations play a crucial role in providing services to battered women and in raising awareness of domestic violence and domestic violence laws. Several women I interviewed had positive experiences at these stations. However, there is evidence that women visiting these stations are discriminated against by officers who blame them for the violence and discourage them from filing complaints against their abusers.[17]

Thirty-eight-year-old Amada described how, during a recent visit to the police station in her neighborhood, the officers blamed her for the violence, misinformed her about family violence laws, dismissed her requests to file a complaint against her abusive husband, and told her that the best method for avoiding future violence was to be more obedient. Amada turned to one of the women police officers in the station and said "because I am a poor woman, or because I am not dressed up, or because the policemen haven't fallen in love with me, you don't pay any attention to me." Like other women I interviewed, Amada was fully aware of the ways in which her poverty and the assumptions made about her cultural background influenced how she was treated by many Peruvians, including those responsible for upholding national family violence laws.

Newspapers play an important role in raising awareness of domestic violence and the existence of women's police stations. They also perpetuate myths and disinformation regarding domestic violence. In January 2002, *El Comercio* ran a small public service announcement with the question, "Tired of the abuse?" in the center. Underneath the question, it offered the phone number of the main women's police station. On 25 November 2007—International Day for the Elimination of Violence against Women—the same newspaper featured a small announcement on psychological violence with the title, "The abuse that is not seen, but still hurts." During the same period, news stories on femicides provided little to no discussion of the complexities of the Family Violence Law, of the possibility of psychological abuse, or of the effects of abuse over time. Stories focused on specific episodes of physical violence and presented male jealousy as isolated from a pattern of male abuse.

Lima has approximately twenty-five standard, specialized, and tabloid newspapers.[18] The three Peruvian newspapers on which this analysis draws most heavily are *El Comercio*, *La República*, and *Ajá*. *El Comercio* is the major, most influential, and oldest daily newspaper in Peru. The paper appeals mostly to middle- and upper-class Peruvians in Lima and has a nationwide daily

readership of 599,300[19] of its print and online versions. *La República*, also a leading newspaper with print and online versions, is somewhat more liberal than *El Comercio* and boasts a nationwide daily readership of 305,100.[20] Both of these newspapers provide coverage of political, economic, and social events. Domestic violence pieces appear in both of these newspapers but *La República* contained more stories during the 2001–2002 period. My examination of online versions from 2007 and 2008 indicates that this trend continues. One possible reason for this is that *La República*, unlike *El Comercio*, includes a police section.

The third newspaper, *Ajá*, belongs to the category of "chicha" newspapers. Since the 1980s and 1990s, tabloid-style sensationalist newspapers popularly known as "chicha" newspapers have increased in popularity throughout Peru. These newspapers cost less than half of the price of standard newspapers, making them more affordable to many Peruvians. The routine use of slang in headlines and stories also appeals to a broader group of readers. Similar to what Zeynep Alat documented in Turkish newspapers, chicha newspapers exploit women's bodies to increase circulation.[21] Regardless of the headlines of the day, partly naked women appear prominently in the front and back pages with pictures that focus on women's buttocks and breasts. *Ajá* is the most widely read chicha newspaper, with a nationwide daily readership of 340, 900.[22]

Domestic violence stories in all three papers are characterized by victim blaming and the depiction of men as subject to uncontrollable jealousy and passion. The victim, who is usually dead by the time the news story is published, is silenced and often indirectly blamed as the trigger for the abuser's actions. Significantly, *El Comercio* and *La República* also provide space for occasional critical feminist pieces on violence against women in Peru. These critical pieces appear in the same newspapers as the sensationalized stories, but there is little evidence that they have any influence on the coverage of domestic violence. Bias and distortion continue to characterize domestic violence stories. *Ajá* contains more coverage of domestic violence cases than *El Comercio* and *La República* but little if any critical analysis of the complexities surrounding domestic violence in Peru. The news stories in these three newspapers are not a representative sample of all stories on violent relationships in Peruvian newspapers, yet an analysis of these three widely read newspapers' portrayals of domestic violence provides a preliminary understanding of current popular discourses.

Portrayals of Abusive Men: Jealous Rage as Justification

This section explores prevalent patterns in news coverage of domestic violence cases, noting how news stories reflect and contribute to racism, sexism, class bias, and domestic violence myths in the Peruvian setting. I first discuss stories in which the protagonists are poor indigenous and mestiza women and men, and then discuss a recent high-profile case involving celebrities. Although the men and women are not directly identified as indigenous, mestiza, or poor in the noncelebrity stories, accompanying photographs, references to place of residence and to occupations allow us to identify them in these ways.

In her analysis of Turkish news coverage of lethal domestic violence cases, Alat examines how news stories justify men's actions by portraying them as respectable individuals who snap because of uncontrollable love and passion for a woman. She proposes that, in describing men's homicidal actions, the "common phrase 'something snapped' ignores the fact that for most of the cases the crime was premeditated."[23] Similarly, in Peruvian newspapers, stories of jealous men suddenly losing control and killing their wives, partners, or ex-partners abound. In these stories, men's histories of abuse against their partners are notoriously absent, thereby promoting the belief that these otherwise respectable men simply snapped. Men's actions are often couched in terms of acts of passion triggered by a woman's imagined (or, in rare cases, proven) infidelity.

One characteristic example of the sort of victim-blaming and justification provided for men's actions is the case of a man who killed his wife in front of the couple's three-year-old son. The article describes the man, who was never interviewed, as "a man poisoned by jealousy." The man left a note by his wife's body and fled the scene. In the note, he justified his actions by writing that "her family knew she was unfaithful to me."[24] The newspaper provides no information on whether or not this claim was true or on the woman's life leading up to her murder. Similarly, in another story a man who murdered his wife is quoted as telling reporters that "I could no longer stand it and I killed her. What man could accept this? While one kills oneself working hard all day, the damn woman sleeps with another [man]."[25] Again, there was no evidence to support the man's claim of his partner's infidelity.

In a third story a police officer is reported to have shot his wife to death "in a jealous rage after discovering she was being unfaithful."[26] A fourth story reports a Peruvian man living in Chile who killed his wife by stabbing her after an argument. No reason is provided for the murder but the story closes with the reporter's suggestion that the woman was killed "presumably, because of the man's jealousy."[27] A fifth story introduces a man who "blinded by jealousy and feeling victimized by a supposed infidelity first attacked her [his estranged

wife] with a pair of scissors and then strangled her with his own hands."[28] Although the man traveled several hours from Lima to the city where his wife was living, pointing to the possibility of premeditation, the article characterizes this murder as a crime of passion. Also, the possibility that the wife moved away from her husband to escape his violence was never mentioned in the story. News reporting to the contrary, in reality, the majority of intimate partner homicides is preceded by ongoing abuse of the woman by the man.[29]

In a second group of stories, women's attempts to leave their abusers are questioned and given as the man's justification for femicide. One story told of a man who stabbed his estranged wife to death in the middle of the street, and that "according to the police, this was a crime of passion, since the victim had abandoned her home."[30] By focusing on the woman's abandonment of her home without providing any information on the reasons why (did he abuse her? was she attempting to separate from him?), the story invites readers to question the woman's moral status as a good wife. This story, like others in which the victim is living apart from her husband, neglects to mention that, in cases of abuse, a woman may attempt to leave and that the most dangerous time for a woman is after leaving her abusive partner.

According to a special investigative report on domestic violence among police officers, there are on average three cases of domestic violence involving police officers reported each day in Lima.[31] These stories also claim jealousy and imagined infidelity as the trigger to violent actions. Drawing on and pointing to uncontrollable jealousy as the cause of violence, one article reports that a policeman shot his wife to death "in a jealous rage" not long after he was honored as "Policeman of the Year."[32] Although the policeman's wife had filed several domestic violence complaints against her husband, these had not affected the decision to honor him as Policeman of the Year. This article is not only disturbing because of its emphasis on the man's jealousy as the cause of his lethal violence, but because it indicates this violence is accepted, or taken for granted, in men with the responsibility to enforce laws and protect civilians.

In 2007, another police officer shot his wife to death supposedly as a result of jealousy. The couple had separated and he suspected that she had begun to date another man. Describing his actions as the result of violent emotions brought about by jealousy, the man explains that when his wife told him that he should not meddle in her life because they were no longer together, he felt humiliated and took his gun out. He later stated that he had done "what any other man would have done."[33] Thus, jealous rages that end in a woman's death are simultaneously uncontrollable and expected, as well as fair punishment for threatening a man's masculinity and ownership of his wife

or partner. The same article reports that the man had recently sent his wife threatening text messages, one of which read, "Bitch, your days are numbered, you're going to die and I'm going to keep your children."[34] Having gone through with his threat he later relied on the discourse of uncontrollable jealous rage to justify the murder. It is these sorts of details and insights into the dynamics of abusive relationships that news stories typically ignore.

In Peru, jealousy is among the most common reasons men use to justify their violence.[35] Abusive men may feel that their virility is measured by how well they are able to control their partner. In this scenario, a woman's real or imagined infidelity threatens her partner's ability to perform masculinity through control of his woman. Violence may also function as a "preventative act that dissuades [the woman] from any attempt, more imaginary than real, of infidelity."[36] How many femicides are "preventative acts" is not known.

Among the thirty-eight battered women I interviewed in Lima in 2001, none had engaged in extramarital affairs, yet most had been accused of being unfaithful by their partners and had been beaten as punishment for imagined infidelities or to prevent the possibility of future infidelities. Teresa's husband was jealous of his own brother and routinely accused Teresa of "being capable of doing anything," including sleeping with his brother. Although Teresa denied the allegations, her husband accused her of having an affair with his brother because she would seek help from her brother-in-law when her husband beat her. Similarly, Rocío's husband accused her of being interested in other men and threatened to kill her if he ever discovered she was with another man. In Rocío's words, "whenever I would think of leaving [he would say], 'I'm going to kill you, if you won't be mine you won't be anyone else's'." In Aurora's case, even after she separated from her husband, he "believed he had the right to control me" and continued to spy on her to make sure she did not speak to other men. Whenever he believed she had spoken to another man, he beat her.

Articles that discuss women's violence against men also emphasize jealousy as the motivation for women's actions. However, news stories of women who kill their husbands deviate from the typical jealousy script in that they rarely present the men's behavior as justification for women's actions. In one case a woman is accused of fatally stabbing her husband. The newspaper describes that woman as a "jealous and temperamental woman" and states that, "it is said" that "she had always been jealous." Although the reporter did not speak to the woman, the story states that the woman killed her husband because he refused to stop visiting his three children from a previous marriage.[37] In this sense, the man is portrayed as a moral and good father and the woman is portrayed as a jealous and bad woman. Another piece attracts readers' atten-

tion with the title, "Jealous Woman Beats Husband" and describes the woman as someone "blinded by jealousy" and reports that a policeman found her husband hiding underneath a table. The police charged the woman with domestic violence.[38]

Although women do sometimes beat men, in the vast majority of cases it is men who beat women. Reading news stories that fail to provide information on the larger picture of domestic violence, however, leads to the false belief that women beat men just as much as men beat women. News stories also fail to discuss whether the woman's so-called violence was committed in self-defense or whether it resulted in injuries to the man. Recent research underscores that in most cases, women's use of violence against their partners constitutes a form of self-defense to men's abuse over time.[39]

Of the women I interviewed in Lima who responded to their husbands' violence by hitting back with their bodies or an object, all acted in self-defense. In these cases, women used physical force in reaction to their husbands' violence not from premeditation but because at that moment they believed they had no other option to protect themselves and their children. For example, after years of beatings, during one particularly violent episode Maria defended herself when she "grabbed the knife and I stabbed him" because "it was already too much." When I asked Maria if she had reacted by hitting or stabbing her husband on other occasions, she responded, "no, that was the first time. Other times when he beat me, before, I have scratched him." In spite of the differences between a scratch in self-defense and a series of punches by the batterer, news stories may fail to distinguish between an isolated incident of self-defense and a history of battering when discussing women's violence against men.

Media Depictions of High-Profile Cases

Moments in which high-profile individuals divulge information about their own experiences of domestic violence to the public have the potential to significantly raise public consciousness.[40] As a result of new laws, public education campaigns, and sensationalist news stories, domestic violence is becoming more visible because of the willingness of celebrities and other public figures to speak up about their experiences of abuse and the willingness of media outlets to cover these stories.

In 2007 the popular actress Marisol Aguirre filed for divorce from her husband, actor and singer Christian Meier, after 12 years of marriage. Meier, a white Peruvian from an affluent family, is among the most well-known, respected, and adored (especially by young women) contemporary celebrities. Aguirre filed a domestic violence complaint on the grounds of physical and

psychological abuse not long before she filed for divorce. After repeated questions about their divorce, Aguirre appeared on the popular celebrity gossip show *Magaly* to declare that, for the sake of their children, she wanted to clarify that her husband had never punched her or hit her.[41] She explained that "physical violence doesn't necessarily mean being hit, but also breaking a door or [violently] grabbing something from someone; there are a thousand forms of physical violence." The day after Aguirre's appearance on the show, Magaly told her viewers that there were always two guilty people in domestic conflicts, not just one. Aguirre's explanation of the subtleties of physical violence was widely interpreted as a declaration that there had been no physical abuse and that her husband, the beloved celebrity, should not be blamed.

Within a few days of Aguirre's appearance on *Magaly*, another popular celebrity, Jaime Bayly, used his TV show to discuss the Aguirre–Meier case and to ridicule Aguirre's statements about the abuse she experienced. Bayly told his viewers that only "real" physical violence deserved to be reported; breaking a door was not real violence. He also claimed that verbal violence did not meet the criteria of real violence and that Aguirre should have considered the impact of her complaints on her husband before filing her complaint. In the following days, more television commentators followed Bayly's example by questioning Aguirre's claims and publicly supporting Meier.

Because it involved celebrities, the Aguirre–Meier case garnered significant public attention. As in previous cases discussed in this chapter, victim-blaming characterized the Aguirre–Meier stories. In one interpretation, Aguirre's explanation of the violence she experienced is reinterpreted and wipes away her husband's blame. In a second interpretation, blame is directly shifted on to Aguirre for speaking out and reporting her husband. Notable among the coverage of the Aguirre–Meier case was an open letter sent by one dozen women's organizations to Bayly. Citing national laws and international treaties that theoretically govern Peru's treatment of domestic violence, the letter reminds Bayly that contrary to his statements, domestic violence includes psychological violence. The organizations recognize Bayly as one of the most influential people in Peru and suggest that, given his status, he correct his public statements on such an important topic. To my knowledge, Bayly never corrected his statements.

The Woman Behind the Story

The complicated realities behind the brief and superficial stories presented on television rarely make it to the printed page of newspapers. When news coverage of battered women fails to consider how intersecting forms of

oppression including sexism and racism affect women's lives, the public is provided with an incomplete view of women's experiences. In some cases, however, the women whose lives are publicly and selectively scrutinized are also directly and immediately affected in dangerous ways by news-coverage-as-usual, reporting that uncritically portrays indigenous and mestiza women's lives. This section examines the disconnects between the newspaper portrayal of one woman and parts of the same woman's substantially more complicated life story as it intersects with structures of racism in Lima.

In 2001 a story on poor women seeking assistance from a state agency appeared in *Ajá*.[42] The story featured a photograph of a poor indigenous woman with a child strapped to her back and waiting in line at the agency. To the reporter, this woman simply represented the stereotypical poor indigenous woman readers would expect to see seeking assistance from the state agency. The reporter did not speak to or in any way find out about the woman's life, and he did not ask for the woman's consent to publish her picture.

The woman photographed was Daisy. At the time of the coverage, Daisy was a battered woman with four young sons fleeing from her abusive husband. After months of living in shelters, Daisy and her sons moved into a very poor neighborhood far away from where her husband lived to avoid being tracked down. The newspaper photograph appeared just a few weeks after Daisy moved out of the shelter and into her new home. She found out about the photograph from a neighbor. Within a week of the story's publication, Daisy received a newspaper clipping with "I found you" scribbled across her picture. The agency pictured in the photograph was in Daisy's neighborhood and provided assistance to many women, including battered women fleeing their partners. The reporter identified the agency by location and name, and Daisy's abuser used this information to narrow down his search for her to the neighborhood identified in the newspaper. With the photograph in hand, he asked individuals living in the area if they had seen his wife. Once he discovered where she lived, he paid a teenager in the community to deliver his message. After receiving the newspaper clipping with her ex-partner's message, Daisy and her sons experienced several tense and difficult weeks as Daisy devised increasingly complicated plans to keep her children safe.

I met 29-year-old Daisy and her four sons at the shelter at which I regularly volunteered and conducted research and began interviewing her three months before her photograph appeared in *Ajá*. Daisy had migrated to Lima from the highlands with her first husband several years earlier. Her first husband abandoned her and their three young sons shortly after moving to Lima, and during the following months Daisy found it very difficult to find jobs to

support herself and her sons. She went through a series of temporary jobs as a domestic servant, cleaning a library, and selling candy on the streets.

Four years after arriving in Lima, and still struggling to make ends meet, Daisy met her second husband. He refused to allow her to use birth control and she became pregnant within a few months of meeting him. Soon after learning of her pregnancy, Daisy discovered her second husband was a drug addict. He began to abuse her a few months after she gave birth and also refused to work and contribute money or labor to the household. He drank, did drugs, came home late, and stayed in bed during the day while Daisy worked.

When Daisy discovered that he beat her children while she worked, she decided to leave him. She and the father of her youngest son had been together for one and one-half years. Daisy confronted him and told him she was leaving him. When he responded that she could not leave because she had no place to go Daisy told him that she would leave anyway and that she would take her children, including their son. Her partner became very angry and grabbed a kitchen knife. He attempted to kill her oldest child, a 12-year-old boy. It was only because her sister-in-law entered the room and managed to take the knife away from him that Daisy's son was not stabbed. While her sister-in-law called the police, her husband grabbed the knife again and threw it at Daisy. The knife barely missed her and their son, whom she had strapped to her back. When police officers arrived they took the husband into custody.

During the twenty-four hours her husband spent in jail, Daisy had to leave the house and the belongings she worked so hard to acquire and find a new place to live for herself and her sons. The police referred Daisy to a shelter. After a brief stay, she and her children transferred to the shelter at which we met. During the two months at this second shelter, she attempted to find a job and save money to establish a new home for her family. She avoided all contact with her husband's family and with her former neighbors so that her ex-partner could not track them down.

Daisy's efforts to rebuild her life after leaving her husband were thwarted in part by the pervasive racism in Lima. Her experiences in attempting to rebuild her life after leaving her husband exemplify how in contemporary Peru, even when race is not directly identified, "race lies just below the surface."[43] During her search for work throughout her stay at the shelter, Daisy and I would together read the help wanted ads in *El Comercio*. These ads commonly listed "*buena presencia*" as a requirement or preference for applicants to jobs as varied as waitresses, cooks, domestic servants, nannies, and entry-level salespeople. *Buena presencia* may be translated as "good appearance" yet it is commonly understood as a euphemism for someone who is light-

skinned, urban, well-groomed, well-dressed, and with at least some years of formal education. Because Daisy did not fit these descriptors, she had little chance of being hired for any of the jobs. Four months after leaving her home, Daisy secured a part-time cleaning job through personal contacts and supplemented her income selling candy on the streets. She began to save money for a new home.

In the United States, a woman is most at risk of being seriously hurt or killed by her abusive partner just after she leaves him.[44] The same appears to be true in Peru. In understanding women's attempts to leave abusive partners and rebuild their lives we must also consider that structures of racism exacerbate the difficulties some women encounter. My brief discussion of the routine forms of racism in contemporary Peru in the first part of this chapter provides depth to our understanding of Daisy and her sons' heightened vulnerability to violence leading up to and following the newspaper photograph and to the discrimination Daisy experienced on the job market.

Daisy was not alone in worrying about running into or being tracked down by her batterer. Kristina, a 45-year-old woman with two teenage daughters, panicked each time she spotted a yellow cab near the shelter because her partner drove a yellow cab. Every time she left the shelter and, later, at her new home, she feared she or one of her daughters would see her husband and she knew he would hurt them if they did. Many other women shared these fears. Several women also shared Daisy's experiences of racist discrimination on the job market.

Representing Violence Against Women and Battered Women

An analysis of news stories on domestic violence underscores that newspapers are especially prone to publicly scrutinize women from marginalized groups, such as poor and indigenous battered women. In Daisy's case, her everyday experiences in Lima underscore that some battered women in Peru confront racism as well as sexism in their attempts to acquire access to existing resources and to leave abusive partners. According to Marian Meyers, to change media representations of domestic violence we must "recognize the patriarchal myths and stereotypes within the news" and journalists must "refuse to buy into and perpetuate [patriarchal] mythology."[45] In Peru, journalists must also refuse to buy into the cultural–racial status quo that heightens poor indigenous and mestiza women's vulnerability to violence and discrimination.

This chapter has discussed the myths and stereotypes present in domestic violence stories and noted that, while newspapers have in recent years provided space to raise awareness of violence against women, the message in these progressive pieces has not reached those journalists who routinely cover

domestic violence stories in standard or chicha newspapers or on television. An analysis of the information presented, excluded, and emphasized in news stories reveals a script that privileges individual and psychological causes in explanations of men's violence against women. Stories present and emphasize men as victims of uncontrollable impulses in ways that reflect the expressive tension approach to domestic violence. Women's suspected behaviors are presented as triggers to men's violence and the resulting femicide as an isolated incident. In these stories, the construction of domestic violence as the result of men's uncontrollable forces is highly problematic because the reports miss the broader structures that maintain patriarchal domination and violence. As well, they do not report the intersections of race, class, and gender that inform how some women's lives are publicly scrutinized and presented in the media.

The prevalent focus on uncontrollable impulses and on violence against women as isolated incidents is detrimental to readers' understanding of domestic violence—it ignores women's lived experiences and a vast amount of domestic violence research in recent years. For example, the inclusion of feminist and ecological approaches to domestic violence would enhance readers' understanding of battered women's experiences. Feminist analyses of violence against women recognize structural oppression that women experience in patriarchal societies. According to the feminist instrumental power approach, men use violence because it is an effective way of getting what they want because men can generally abuse women without being punished.[46] From this perspective, "if we live in a patriarchal society that encourages male violence against women, we must deal with that society" as a whole, not simply with individual men, to end violence against women.[47]

In approaching the various dimensions of Peruvian society that contribute to violence against women, an ecological approach may be particularly useful.[48] The ecological model allows us to identify multiple factors that increase women's vulnerability to male violence. This model presents four overlapping dimensions that may contribute to women's experiences of violence: personal history, microsystem, ecosystem, and macrosystem. Personal history refers to features that shape an individual's responses to environmental factors, such as witnessing violence as a child and poverty. Microsystem refers to the "immediate context in which the abuse takes place," such as familial relations and relationships with peers.[49] Ecosystem includes formal and informal structures within the community that affect a person's ability to respond to violence, such as police stations and the prejudices and discrimination within these, and isolation from support networks. The macrosystem is the broadest level and represents societal and cultural norms and policies, including family violence

laws, patriarchal gender norms, and racism. An ecological approach is useful in examining cultural beliefs because it cautions us against simplistic one-cause models and facilitates consideration of various factors that contribute to violence against women at the structural and individual level. From this perspective, men's jealousy may be understood as a contributing factor, but men "snapping" due to uncontrollable impulses cannot fully explain men's violence against women.

The insights offered by feminist perspectives and the ecological model underscore the importance of sensitizing media outlets to alternative explanation for domestic violence. The widespread exoneration of men and blaming of women for beatings and femicide within the Peruvian media are consequences of models that identify individual men's uncontrollable impulses as the primary or sole culprit of, and women's behaviors as the trigger to, men's violence. Infusing coverage of domestic violence with feminist and ecological perspectives cautions us against identifying uncontrollable impulses as the primary or only cause of men's violence, because these alternative perspectives encourage journalists to consider how multiple intersecting factors that include racism and sexism may increase women's vulnerability to discrimination and violence. This discrimination results in increased public scrutiny of some women's lives and in the revictimization of battered women by media outlets.

Notes

1 Myra Buvinic, Andrew Morrison, and Michael Shifter, "Violence in Latin America and the Caribbean: A Framework for Action," in *Too Close to Home: Domestic Violence in the Americas*, edited by Andrew Morrison and María Loreto Biehl (Washington, D.C.: Inter-American Development Bank, 1999): 3–34.

2 Ana Güezmes, Nancy Palomino, and Miguel Ramos, *Violencia sexual y física contra las mujeres en el Perú* (Lima: Flora Tristán, 2002); Claudia Moreno Garcia and Lori Heise, *WHO Multi-Country Study on Women's Health and Domestic Violence Against Women: Initial Results on Prevalence, Health Outcomes and Women's Responses* (Washington, D.C.: World Health Organization, 2008).

3 "Cado año se reportan más de 120 crímenes pasionales en el Perú, advierte IGL," *La República* (March 4, 2008).

4 Jane Caputi and Diana Russell define femicide as a particular form of sexist terrorism directed at women. They single out the murder of women by their husbands, lovers, and other family members. See "Femicide": http://www.dianarussell.com/femicide.html (1998).

5 See Zeynep Alat, "News Coverage of Violence Against Women: The Turkish Case," *Feminist Media Studies* 6, No. 3 (2006): 295–314; Elizabeth Carll, "News Portrayal of Violence and Women: Implications for Public Policy," *American Behavioral Scientist* 46, No. 12 (2003): 1601–1610; Lisa Cuklanz, *Rape on Prime Time* (Philadelphia: University of Pennsylvania Press, 1999); Carolyn Michelle and C. Kay Weaver, "Discursive Manoeuvres and Hegemonic Recuperations in New Zealand Documentary Representations of Domestic Violence," *Feminist Media Studies* 3, No. 3 (2003): 283–299; and Maria João Silveirinha, "Displacing the 'Political': The 'Personal' in the Media Public Sphere," *Feminist Media Studies* 7, No. 1 (2007): 65–79.

6 Moira Peelo, "Framing Homicide Narratives in Newspapers: Mediated Witness and the Construction of Virtual Victimhood," *Crime, Media, Culture* 2, No. 2 (2006): 159–175.

7 Charlotte Ryan, Mike Anastario, and Alfredo DaCunha, "Changing Coverage of Domestic Violence Murders: A Longitudinal Experiment in Participatory Communication," *Journal of Interpersonal Violence* 21, No. 2 (2006): 304–326.

8 Miriam Gottlieb, *The Angry Self: A Comprehensive Approach to Anger Management* (New York: Zig, Tucker & Thiesen, 1999).

9 By life history methodology I am referring to the process of eliciting life narratives from an individual woman. In these narratives a woman describes her life up to the point of the interview. Most of the women I interviewed focused on the prevalence of violence throughout their lives.

10 Building trust and understanding was a long and necessary process made possible through time (I was in Lima conducting fieldwork for over a year) as well as by efforts to demonstrate my accountability and genuine interest in the women's lives. For example, throughout my fieldwork I volunteered at a shelter, demonstrating that I was interested in women's well-being in aspects that were not limited to research interviews. Women also went to great measures to explain and make their lives understandable to me by meeting with me on numerous occasions and by answering many questions during our meetings.

11 Kimberlé Crenshaw, "Intersectionality and Identity Politics: Learning from Violence against Women of Color," in *The Public Nature of Private Violence*, edited by Martha Fineman and Rixanne Mykitiuk (New York: Routledge, 1994), 178–193.

12 Susan Paulson, "Familias que no 'conyugan' e identidades que no conyugan: La vida en Mizque desafía nuestras categories," in *Ser Mujer Indígena, Chola, o Birlocha en la Bolivia*

Postcolonial de los años 90, edited by Silvia Cusicanqui and Denise Arnold (La Paz: Subsecretaría de Asuntos de Género, 1996): 85–161.

13 Cecilia Méndez, "Incas sí, indios no: Notes on Peruvian Creole Nationalism and Its Contemporary Crisis," *Journal of Latin American Studies* 28, No. 1 (1996): 197–225.

14 Blenda Femenias, *Gender and the Boundaries of Dress in Contemporary Peru* (Austin: University of Texas Press, 2004), 87.

15 Henrietta Moore, *A Passion for Difference: Essays in Anthropology and Gender* (Bloomington: Indiana University Press, 1994), 55.

16 "Conversación con la congresista Paulina Arpasi: 'Yo no soy un fenómeno'," *La Liberacion* (June 24, 2001).

17 "Peru Law of Protection from Family Violence," *Human Rights Watch* (2001): http://www.hrw.org/backgrounder/wrd/peru-women.htm

18 Monica S. Cappellini, "La prensa chicha en el Peru," *Chasqui* 88 (Lima: Chasqui, 2004).

19 Carlos Cosme, Martín Jaime, Alejandro Merino, and José Luis Rosales, *La imagen in/decente: Diversidad sexual, prejuicio y discriminación en la prensa escrita peruana* (Lima: Institut de Estudos Peruanos, 2007).

20 Ibid.

21 Zeynep Alat, "News Coverage of Violence."

22 Carlos Cosme, et al., *La imagen in/decente*, 125.

23 Zeynep Alat, "News Coverage of Violence," 306.

24 "Celoso mata a conviviente en hostal," *La República* (March 7, 2001).

25 "Pegalón mata esposa a palazos," *Ajá* (February 8, 2001).

26 "Teniente de la policia asesina a balazos a su esposa y se suicida," *El Comercio* (January 3, 2008).

27 "Peruana mata esposa," *La República* (February 3, 2008).

28 "Confeccionista celoso mata a esposa," *La República* (February 17, 2007).

29 Jacquelyn C. Campbell, Daniel Webster, Jane Koziol-McLain, Carolyn Block, Doris Campbell, Mary Ann Curry, Faye Gary, Nancy Glass, Judith McFarlane, Carolyn Sachs, Phyllis Sharps, Yvonne Ulrich, Susan A. Wilt, Jennifer Manganello, Xiao Xu, Janet Schollenberger, Victoria Frye, and Kathryn Laughon, "Risk Factors for Femicide in Abusive Relationships: Results from a Multisite Case Control Study," *American Journal of Public Health* 93, No. 7 (2003): 1089–1097, 1089.

30 "Asesina a su mujer en plena calle," *El Comercio* (May 30, 2007).

31 "El asesino vive en casa," *La República* (February 25, 2007).

32 "Policia del año mata a tiros a su esposa," *El Comercio* (January 21, 2001).

33 "El asesino vive en casa," *La República* (February 25, 2007).

34 Ibid.

35 Miguel Ramos, *Masculinidades y violencia conyugal: Experiencias de vida de hombres de sectores populares de Lima y Cusco* (Lima: Universidad Peruana Cayetano Heridia, 2007), 22.

36 Miguel Ramos, *Masculinidades*, 24.

37 "Mujer mató de una cuchillada a conviviente por infidelidad," *La Razón* (August 22, 2001).

38 "Mujer celosa golpea a esposo," *El Comercio* (October 25, 2007).

39 Susan Miller and Michelle Meloy, "Women's Use of Force: Voices of Women Arrested for Domestic Violence," *Violence Against Women* 12, No. 1 (2006): 89–115, 91.

40 Maria João Silveirinha, "Displacing the Political," 65.

41 Julie Haynes' chapter in this volume illustrates a different format through which women successfully reclaim and redefine their experience of intimate partner violence.

42 The article I am referring to appeared in March 2001. On the day it was published I was unaware of this story and the accompanying photograph. Soon, however, I was shown a copy of the article and the accompanying photograph by the woman whose picture appeared in the newspaper. Due to the absence of an online search engine for this newspaper and the absence of past editions at local newspaper kiosks in Lima, I have not been able to locate a copy of the article for my own records in recent years. However, I have personally witnessed the effects of the publication of the photograph on the woman who was photographed.

43 Linda Seligmann, *Peruvian Street Lives: Culture, Power, and Economy among Market Women of Cuzco* (Champaign: University of Illinois Press, 2004), 148.

44 Lori Heise and Megan Gottemoeller, "Ending Violence Against Women," *Population Reports* Series L, No. 11 (Baltimore: Johns Hopkins Bloomberg School of Public Health, 1999).

45 Marian Meyers, *News Coverage of Violence Against Women: Engendering Blame* (Thousand Oaks: Sage, 1997), 124.

46 Russell Dobash and Rebecca Dobash, *Violence Against Wives* (New York: Free Press, 1979).

47 Martin Schwartz and Walter Dekeseredy, "Interpersonal Violence against Women: The Role of Men," *Journal of Contemporary Criminal Justice* 24, No. 2 (2008): 178–185, 182.

48 Lori Heise, "Violence against Women: An Integrated, Ecological Framework," *Violence Against Women* 4, No. 3 (1998): 262–290.

49 Lori Heise, "Violence against Women," 264.

CHAPTER 4

The Politics of Rape and Honor in Pakistan

Sidra Fatima Minhas

2005 dawned with hopes and dreams for many, but as a nightmare for Doctor Shazia Khalid. Dr. Shazia, while working in Pakistan Petroleum Limited (PPL), was raped by an unidentified assailant and later when she tried to report it, was stopped by PPL officials to prevent tarnishing their image. Shazia was initially sent to a psychiatric hospital in Karachi as part of a cover up and meanwhile her husband was informed of the incident. Later on, the couple was kept under tight security and they could only be met with in the presence of persons belonging to security agencies. Another reason for this precaution was that one of the chief suspects was an army captain and association with the rape could have a negative impact on the Pakistan military government in rule at the time. As news of the rape became known, Baloch[1] tribal leaders took up the fight for Dr. Shazia's case in Sui the tension mounted and it soon became a complete fiasco. In March, Dr. Shazia and her husband left Pakistan, claiming that they had otherwise been threatened with murder. To date the couple remains overseas.

Human Rights Commission of Pakistan

Violence against women in Pakistan is rampant. The Constitution of Pakistan protects women but it is hard to see its practical application.[2] A survey of national daily newspapers between January and July 1997 indicated 365 rape cases were covered in the newspapers during that period. In one area of the Punjab province, fifty cases were reported in ten days. It is estimated, however, that the actual incidence of rape could be three times higher because a significant number of instances go unreported.[3] With no sign of decrease in the incidence of rape,[4] there is concern about what sustains such violence in a society despite efforts of groups such as War Against Rape (WAR). I contend that violence against women is embedded in the patriarchal practices articulated in Pakistani society, and I present a case study to examine the role of the media in sustaining these patriarchal structures. Analyzing a segment of the print media coverage of Dr. Shazia's rape and the political crisis that subsequently developed, I illustrate how the media specifically present only certain

voices from particular viewpoints and influences, and sustain the popular social discourse on violence against women.

This chapter first introduces the adopted methodology, followed by an overview of the context in which the media operate, highlighting how patriarchy operates and dominates women in the Islamic society of Pakistan. The analysis appraises the techniques adopted by news media in covering violence against women; as well, I offer a comprehensive reading of the Dr. Shazia rape case, foregrounding the various groups who have been given voice by reporters. In the conclusion, I illustrate how the major players in the newspaper industry foster and maintain popular sociocultural understandings of rape via value-laden messages. Such narrative strategies allow violence against women to be ignored and, paradoxically, make the media a factor in fostering abuse in all forms.

Research Methodology

I examined English and Urdu newspapers to obtain a cross-sectional view of contemporary Pakistani media. The Urdu newspapers included *Jang, Nawa-i-Waqt,* and *Khabrain. The News, Dawn, Nation,* and *Daily Times* were the English dailies I examined. Each of these newspapers is reputed to be a market leader and has a significant national circulation.[5] For the majority of Pakistanis who can read only Urdu, the dailies I have selected are an important source of information. However, I have neglected popular Urdu evening newspapers due to the lack of a reliable archive.[6] The newspapers I examined define the boundaries of popular discourse.

I analyzed newspaper coverage between January 2005 and September 2005, the period during which reporters initiated coverage of Dr. Shazia's rape and until the time she left the country. I examined 143 reports but did not include editorial content. The reports were grouped according to the sources they cited: the state, the opposition political party, nongovernmental organizations, activist groups, the victim, and her family. In each instance, I assessed the quality of reporting, the trends, and the underlying message, if any. A caveat is in order here: Although the newspapers I analyzed are major Pakistani dailies, their quality of reporting varies. Additionally I have not included electronic media in this analysis.[7]

The Pakistani Context

Before I delve into my analysis, it is necessary to define "patriarchy," especially its manifestation and specificity in Pakistan. I am primarily guided by Sylvia Walby's definition of patriarchy "as a system of social structures and practices in which men dominate, oppress and exploit women."[8] Pakistan is a highly

patriarchal Muslim society with numerous rules, regulations and norms defining women's roles and space in society. These ideas are encapsulated in practices relating to religion, family, law, politics, and cultural practices. Farida Shaheed claims that the core of the patriarchal structures in a Muslim society are the same as in any other society with its roots in religion, and women's subordination is compounded by appearing in various forms—in the structures of family, in state policies, and in discourses at all levels.[9]

The Pakistani state is engaged in gendered politics and has gendered political forces. The patriarchal character of the state is reflected in laws and the sexist attitudes of the judiciary especially when faced with crimes such as rape.[10] In these situations even "neutral" laws become instruments of power.[11] In addition, religion has been one of the primary vehicles through which Pakistani patriarchy is expressed and mobilized. For the most part, social beliefs are influenced by the interpretations of Quranic laws that circulate in popular discourses.[12] Although Islamic fundamentalists have never been able to form a government, they have successfully penetrated the state apparatus at multiple levels so as to legitimize their positions. Consequently, women's rights are mostly debated within the confines of the Shari'a.[13] Religion has been manipulated through state legislation to uphold gender-based cultural attitudes such as through the passage of Hudood Law.[14] In Pakistan, laws are made for men and by men, facilitating their domination of women.[15] Farida Shaheed asserts that

> ... the continuation of patriarchy is the ultimate aim of Islamic legislation and ... the interweaving of traditional customs, mores, and beliefs with religion obscures the sources of both the law and ethnically defined or geographically specific frameworks outlining the parameters of a Muslim woman's identity.[16]

Ziba Mir-Hosseini supports the idea that Islam, as a religion, does not address the issue of sexuality.[17] However, religion is frequently used as an excuse for male dominance. In the Pakistani context, Afiya Shehrbano Zia contends that, "female sexuality, has been understood by male theologians, encapsulated in terms of the concept of *fitna* (chaos, disorder)."[18] Women are considered to be very sexual creatures and therefore need to be controlled to maintain social order. Consequently, society identifies chastity as the highest virtue for women. Simultaneously, the majority of male Muslim scholars believe that women possess "*qaid* power" (the ability to deceive men, overpowering them with shrewdness and intrigue)."[19]

Noted scholar Fatima Mernissi posits that the idea of the control and regulation of female sexuality is the basis of all patriarchal societies and violence may be advocated to achieve it.[20] Some South Asian feminists such as

Yudishtar Kahol, Shahla Haeri, Mahnaz Afkhami, Farida Shaheed, Sunila Abeyesekera, and Ferida Sher concur that violence is a major cause of women's oppression and an expression of masculine power.[21] Neelam Hussain argues that, although it is very disturbing when power is expressed by the use of physical violence, "it is most intense and durable when it runs silently through the repetition of institutionalized practices."[22] Violence or even the threat of it becomes even more influential when an "individual internalizes ... the processes of socialization." The unwritten social "laws" are bigger hindrances than formal legislation. Women are treated in a manner that is not considered a violation but thought of as socially appropriate to their nature, which is essentially in favor of male sexual interests.[23] Simultaneously, rape, battery, sexual harassment, sexual abuse of children, prostitution and pornography not only express and actualize the distinctive power of men over society, their existence and persistence confirm and extend it.[24] Rukhsana Iqbal asserts that men from all classes commit violence that could be categorized as a continuum, with rape and mutilation at one end, and son preference and child marriage at the other. Rape is a form of social control of women's sexuality by men and represents an "act of violence and humiliation in which the victim experiences not only overwhelming fear for her very existence, but an equally overwhelming sense of powerlessness and helplessness."[25]

(Re)producing Violence: The Role of the Media

Samia Jasam claims that there are "channels" or "ideas" through which culture and discourses are "reproduced, reinforced, spread and internalized."[26] Farida Shaheed also states that "gendered culture" and identities are reaffirmed through socialization, families, and education.[27] The media play a very important role in this context. According to Neelum Hussain and Nasrene Shah, the media are a "tool for the production and dissemination of ideology that, of necessity, serves the interests of the group/class that exercises economic and political control over it, it occupies a strategic place in the game of power relations within a given social formation."[28] They contend that in terms of gender images, contemporary media are biased in favor of men.

On the other hand, media portrayals of women are sharply dichotomized as "good" or "bad." In the South Asian context, good women are portrayed as "self-sacrificing," "self-abnegating," "virtuous," "domesticated," courageous when it comes to protecting their family, "honest in poverty," "religious," "traditional," "dependent," "conservative," "emotional," and "irrational."[29] Good mothers, daughters, wives, and sisters find their sole reason for existence with reference to their male kin. The bad woman is portrayed as a woman who indulges her ego, seeks recognition for her work, and neglects her

"family responsibilities." When women defy the norms and values of society, they are characterized as bad women who must be made to suffer.

In Muslim societies, women are expected to be responsible for religious and marital duties. Because they have the potential to be a *fitna* and stray off the true path, authoritative male scholars use the media to control them. Consequently, those theologians who contribute to newspapers emphasize the duties of a good wife and advise those who are not married to do so quickly.[30]

Over the last fifty years of Pakistan's history, the media have been under the control of the government and have been used as an instrument of the state. During the era of *Islamization*, the media propagated the concept of *"chadar* and *char divari"* (the veil and the four walls of the home).[31] The media thus sustained the social belief that women's sexuality and mobility should be controlled. Media representations supported the dominant ideology that women are the carriers of male honor and the private sphere was the appropriate place for them.[32] Simultaneously, in the interests of promoting consumer culture, the same media outlets presented women as sex objects.[33] Scholars contend that the media have reinforced women's subordinated status in Pakistani society and have tended to trivialize women's concerns.[34]

The NGO Coordinating Committee for Beijing +5 claims that a small percentage of media, especially in the English press, has improved the portrayal and coverage of women's issues but these changes have not affected the Urdu press.[35] Thus, the majority of media coverage of women, especially regarding issues of violence, is presented in a "tabloid style."

Through my close reading of rape coverage I argue that the media are key actors in sustaining hegemonic understandings of violence against women. Pakistani media are beginning to provide rape victims a voice, a space to share their experiences. However, the media's tendency to reproduce the dominant social order also ends up sustaining the limited definitions of the good woman.

The Sui Rape Case

Sensationalism is a signature feature of Pakistani media's coverage of rape cases.[36] Headlines such as "Theft and Assault at Jiabga Road, Two Girls Raped"[37] are a common feature of the daily news. Even as these reports identify violence against women as a public concern, a close analysis reveals the particular mechanisms through which the media sustain prevailing gender norms in Pakistani society.

Media coverage of the Dr. Shazia rape case was no different. The initial coverage was dramatic with headlines such as "Lady Doctor Gang-Raped in Quetta"[38] and "The victim of a beastly act, Lady Doctor Shazia fighting for her

life."[39] Some news reports emphasized events following the rape, adding to the victim's torment: "Fear and terror after loss of honor of Lady Doctor in Sui."[40] These reports highlighted women's vulnerability, while other reports described rape as a "horrifying game of lust."

As media coverage intensified, the police came under more pressure to apprehend the accused. Every new development in the case was detailed: "*Ziadti*[41] against lady doctor proven in medical report ... the victim was tortured on trying to resist"[42]; and "Lady Doctor Case: Three officers of PPL held on charges of destroying evidence,"[43] "Tribunal has started investigating Dr. Shazia case, Case lodged against three officers of gas company for concealing the attack against Dr. Shazia."[44] News coverage also highlighted the victim's assistance in identifying the culprit: "Lady Doctor Case: PPL and DSG Staff to be included in lineup."[45] Other reports highlighted the administrative malfeasance: "... the provincial administration was trying to cover up the incident" and that "several security personnel posted at the hospital were also reportedly involved in the rape."[46]

News coverage of this rape case was framed by the norms of "investigative journalism." And newspapers recast the crime as a conspiracy and a mystery. For instance *Nawa-i-Waqt* reported:

> *Ziadti* with lady doctor. Case lodged against PPL manager and two doctors, PPL management made an effort to disguise the incident as a robbery.[47]

Another report claimed, "The management of the Pakistan Petroleum Limited (PPL) did not allow the police to record the statement of the victim."[48] These reports helped produce the effect of a soap opera, an effective strategy to sell newspapers and a technique that distracted readers from the reality of the crime. In what follows I have isolated the media portrayal of some of the key players who helped frame the understandings of rape.

The Chief Suspect, the Government, and the Opposition

As the Shazia case gained prominence, several people tried to associate themselves with the incident, and newspaper coverage increasingly portrayed it as a dramatic fight between good and evil. In the early news reports, many of the sources sought justice for the victim. As Keith Soothill and Sylvia Walby observe, male journalists tend to evoke sympathy for the victim and anger toward the perpetrator when reporting sex crimes,[49] and the Pakistani newspapers followed this practice. They put pressure on the military government to respond. And each of these actions was recorded: "The Balochistan government ordered action against all those involved in the alleged rape"[50]; "Lady

Doctor's statement recorded, progress has been made in the case: Press note. Orders for investigation of the incident given: Chief Minister Jam Yousaf."[51]

News coverage often tends to portray the rapist as a "sex fiend," a practice that helps to "mask the general reality of sex crime" and locate it outside the continuum of violence against women.[52] News coverage of the Shazia case followed a different path. One of the chief suspects was a captain in the armed forces. Although the army declared "If any army personnel is found involved in the incident, he will not be spared," media coverage also gave prominence to their assertions that the captain was a respectable man, "... the captain, who is being accused in this case, was married just two weeks ago and was living with his family."[53]

While the military government expressed concern, the opposition used the case as a political opportunity. The media reported quite extensively on the ensuing political power struggle that became intricately linked to the rape. A well-known politician, Nawab Bugti, was quoted in a popular Urdu daily as saying he "will not talk with the Government until the perpetrators of Lady Doctor Shazia's sexual assault are punished."[54] As the investigation progressed with little concrete result, Dr. Shazia left the country; her husband claimed that she was forced to leave. The federal social welfare minister, Zubaida Jalal, a woman, contested this assertion.[55]

Professional Organizations

Leaders of several professional organizations appeared in news coverage demanding justice for Dr. Shazia. In one report, "Dr. Syed, the Pakistan Medical Association's (PMA) central secretary general, criticized the government's indifference ..." and "... he appealed to all doctors in Pakistan to wear black armbands to protest the incident and the government's attitude."[56] In addition, the PMA demanded:

> 2 Crores should be given to Dr. Shazia and hanging to accused, will celebrate black day tomorrow: PMA. Judicial inquiry should be completed in 45 days, those destroying the evidence and tabooing Shazia as zina should be severely punished."[57]

Significantly, the victim's trauma was assessed in monetary terms, implying that it is something that could be bought and sold.

Mukhtar Mai, a victim of gang rape and now well known for her humanitarian and advocacy work, also asserted that Dr. Shazia did not get justice.[58] These voices from civil society in support of Dr. Shazia are smaller in proportion to the other sources (i.e., the government, law enforcement agencies, and the accused).

The Victim and Her Family

One of the small percentage of women brave enough to press charges against their rapists,[59] Dr. Shazia found herself facing the "public courtroom" of media audiences. Dr. Shazia was never an anonymous victim. Her name was a regular feature in the newspapers, tabloids, and magazines and she was made to relive the trauma with reports such as these: "Dr. Shazia Khalid, who had been raped at the Sui Gas Plant,"[60] Further press coverage identified the precise location of her residence:

> It is learnt that the lady doctor is being kept under strict security and now she has shifted from her residence in Tauheed Commercial Area in Defence Housing Authority Phase V to the house of her close relation at Boat Basin, Clifton....[61]

Nevertheless news coverage also provided a sympathetic portrayal of her victimization:

> ... Dr. Shazia's condition is deteriorating by the day. She can't sleep at night. ... she is afraid of the dark, she screams. What she has gone through, it is very painful, the horror will always stay with her deep in her heart. She can't face anyone, she is unable to meet anyone. A talented and responsible girl, a professional doctor, a saviour of human beings, is today fighting for her own life. She just wants to live with the same respect she had ...[62]

The victim and the rape were transformed into a spectacle. Women usually keep silent about rape in order to avoid humiliation and abandonment by their families.[63] In tribal societies women *were* and *are* treated as mere "commodities"; they are owned and controlled by the male members of their families.[64] If a woman's act brings dishonor, she may be punished by death.[65] Farida Shaheed states that rape victims may be murdered by family members, as the victim "is considered defiled and her innocence is of no consequence."[66] Dr. Shazia had to face this form of persecution as well when her own "tribal *jirga* in Sindh ... decided to kill" her in order to "... restore the lost honor" of her tribe."[67] According to *The Nation*, "... the family's patriarch, Mr. Khalid's grandfather, sent word that because Dr. Shazia had been raped, she was *kari*—a stain on the family's honor—and must be killed or at least divorced."[68] As Farida Shaheed says, although the family is the main source of support for Pakistani women, it is also "the seat of patriarchal control."[69] Women are thought to have little or no honor themselves but are carriers of honor for the male members of their families. Feudal tradition also mobilizes symbolic honor or *ghairat* to control female sexuality in Pakistan.

News accounts also offered graphic details about the rape:

I resisted but he overpowered me. I then begged him to leave me for the sake of Allah. I asked him as to what my fault was and why was he doing this to me. He ordered me to keep quiet otherwise a man was standing outside with kerosene and he had a matchbox. He said if I raised an alarm, he would set me on fire. I could not see him as it was dark and he had blindfolded me with my dupatta (scarf). He beat me brutally, then assaulted me and wrapped me in a blanket.[70]

Constructing the Victim: The Politics of Media, Rape, and Honor

In Pakistani newspapers, reports of rape tend to be either fillers or devices to sell newspapers.[71] The sustained coverage of the Dr. Shazia case is exceptional. At first glance, newspaper coverage strives toward impartiality; however, a deeper analysis does not support this impression. The media present themselves as a channel of change, letting women voice their experiences, yet the language used and the content in the articles seem contradictory.

In media coverage, the everyday reality of violence in women's lives is diminished and the rape appears as a chance occurrence. The media address the "demand for justice" but do not mention the hurdles that the rape victim must face. Media coverage offers an object lesson to other women who may have experienced violation: Dr. Shazia is quoted in a headline, "No law, no protection in Pakistan."[72] Most often though, rape is presented as a woman's loss of honor and not a violent crime against her person.[73] News reports often cited officials who "began to hint that Dr. Shazia was a loose (in character) woman, perhaps even a prostitute—presumably as a way to pressure her and her husband to keep quiet."[74] Simultaneously, the press seemed eager to expose police inefficiency and corruption in law enforcement agencies. Even as the government's legitimacy was being questioned, news accounts demanded greater state accountability "Gangrape of doctor: Army implicated for politics: ISPR"[75]; and "Judicial probe demanded into gang-rape of lady doctor."[76] As soon as Dr. Shazia left the country these demands disappeared also. This is in line with Afiya Zia's observation that the media provide extensive coverage to those sex crime cases that political leaders select for use for political gains.[77] It also highlights that the dominant discourse in present day Pakistani society does not view violence against women as an issue and, therefore, it is sidelined by other more "important" issues such as politics.

Fatima Mernissi claims that in Muslim societies men cling to their traditional images of women to secure their concept of self-identity in a rapidly changing world.[78] My analysis concurs with existing scholarship that Pakistani patriarchal society has increasingly felt compromised by professional women's autonomy and independence.[79] Women are now present in the workplace, the state, and public cultural institutions, albeit subordinated within them. We can see the resistance of patriarchy to the challenge of the changing role of

women through the increase in violent crimes against them. In the Dr. Shazia case, the newspapers repeatedly focused on the term "Lady Doctor." In one instance "woman doctor" was used, emphasizing the fact that the victim is an educated professional woman. The public activities of women disturb the traditional structures of public and private in Pakistan.[80] Whether women can enter certain territories normally inhabited by men, without being regarded as available to any man, is still questionable and brought forward by the newspaper headlines. Reaffirming the negative attitudes of patriarchal societies towards education and agency of women, Sudhir Kakker asserts "… that one way of making women unagentic is to humiliate them sexually, or worse yet, to subject them to the violence of rape, which sends a double message: stay out of sight and behave or else pay the consequences."[81] Afiya Zia elaborates that in Pakistan "rape is an extreme form of this fetishism of women where the onus of transgression falls on the woman and not the man, since he is in fact seen as the victim of her sexuality."[82]

Oftentimes political scores are settled and a political rival is dishonored through the rape of "his women." The rape itself as well as the target of humiliation and shame is not necessarily a specific woman but rather a political rival or an old enemy.[83] Dr. Shazia's rape became a national political issue. In this instance, the media played a major role in the politicization process by highlighting the "crusade" that the tribal Balochis undertook on behalf of Dr. Shazia and their daily demands for "justice." The viciousness of the act itself was sidelined and the rape was resignified as a matter of honor, highlighting women as the carriers of their family's *Izzat*, a dynamic socio-cultural construct shifting and adapting with the surrounding environment. News coverage emphasized that women were carriers of honor and thus had to be protected by men. For instance, Baloch political leaders such as Akbar Bugti were cited as asserting that the "rape incident with the lady doctor in Sui was an assault on the honor and dignity of Balochistan nation which pushed the nation into a war position."[84] Rubina Saigol explains that "the desire for women gets transferred onto the nation and women's bodies come to signify the nation: communal, regional, national and international conflicts come to be played out on women's bodies. Their bodies thus become arenas of violent struggle.[85] These values are transferred to public discourse via the media, and so far it has been effectively used to develop the concept of women as carriers of honor who need protection. The idea of women as the weaker sex is also highlighted in the coverage of Dr. Shazia's departure: "Doctor Shazia leaves with husband for London in a flood of tears."[86] Once in the United Kingdom, Dr. Shazia gave a few interviews to the international media in which she was more candid. She claimed that the government had violated her rights. The

local media reproduced these interviews but attention slowly moved away from the rape case. The case remains unsolved and there is no reference to it in the media.

Conclusion

By stepping forward and confronting issues like rape, educated Pakistani women, like Dr. Shazia, have challenged traditional and male-centered cultural perceptions of women's individuality and sense of honor while trying to generate "honor parity."[87] They have attempted to draw attention to the violence perpetrated against women and to highlight the hollowness in the word "honor" in Pakistani society.

The case presented herein is an example of the trends in the media's treatment of rape and violence against women in Pakistan. It points toward the collusion of the state, mainstream political parties, and the media, which increasingly marginalize women. The media help perpetuate violence against women by not placing these acts in a continuum but by reporting them as individual acts of aggression. The Pakistani media may be sympathetic toward individual victims, but they fail to offer linkages with broader social issues, such as the existing power structures of society and the fact that women are a marginalized sector of society, treated as the "other." In the case of rape, no matter what the scenario, women are portrayed as passive victims no matter what they do; they cannot fight the system.

The media play an important role in bringing about change in society. The messages that are played and replayed through media go a long way in shaping the mindsets of the reader, audience, and viewer. The media must use their authority to raise public debate on social issues such as these. In addition, the reporting and coverage of incidents that perpetuate the prevailing gender norm need to be conducted with more caution so as to develop a new discourse that challenges the hegemony.

When it comes to the coverage of issues specifically related to violence against women, there is no media policy in Pakistan. It is imperative to develop a policy in this regard and develop some accountability. Some organizations have attempted to formulate a sensitized code of ethics for the print media.[88] The policy, among other things, should demand gender-sensitive reporting and forbid the disclosure of victims' identities. Above all, women need to play an active and deeply invested role in the development of the space provided by the media. Instead of amplifying inequalities and perpetuating the dominant discourse, with the active intervention of women, the media could engender truly transformative social relations.

Notes

1 The people belonging to the Pakistani province of Balochistan are known as Balochs. Throughout this chapter, following Pakistani press convention, I refer to the victim as Dr. Shazia and not as Dr. Khalid.

2 Savitri Goonesekere, "Overview: Reflections on Violence Against Women and the Legal Systems of Some South Asian Countries," in *Violence, Law and Women's Rights in South Asia*, edited by Savitri Goonesekere (New Delhi: Sage, 2004), 13–76.

3 Hina Jilani and Eman Ahmed, "Violence Against Women: The Legal System and Institutional Responses in Pakistan," in *Violence, Law and Women's Rights in South Asia*, 148–206.

4 Human Rights Commission, "Women in State of Human Rights in Pakistan" (2006): http://www.hrcp-web.org/images/publication/annual_report/pdf_2005/5-1.pdf.

5 *Jang* claims its circulation to be 800,000 papers daily. See http://www.Jang.com.pk.

6 World Press Encyclopedia, "Pakistan" (2006): http://www.pressreference.com/No-Sa/Pakistan.html.

7 Before the advent of cable television in 1992 and the subsequent liberalization of the media, there existed very little coverage of violence against women. See NGO Coordinating Committee for Beijing +5, "Women and the Media" in *Pakistan NGO Review, Women 2000: Gender Equality, Development and Peace for the 21st Century* (2000): http://sedc.org.pk/portal/reports/beijing_report.pdf.

8 Sylvia Walby, *Theorizing Patriachy* (Oxford: Basil Blackwell, 1990), 20.

9 Farida Shaheed, "The Cultural Articulation of Patriarchy," in *Finding our Way: Readings on Women in Pakistan*, edited by Fareeha Zafar (Lahore: ASR, 1991), 135–158.

10 Rashida Patel, "Murder for Male Honor," in *Woman versus Man: Socio-legal Gender Inequality in Pakistan*, edited by Rashida Patel (Karachi: Oxford University Press, 2003), 148–240; Afiya Shehrbano Zia, *Sex Crime in the Islamic Context: Rape, Class and Gender in Pakistan* (Lahore: ASR, 2003).

11 WEDO, "South Asia in Asia and the Pacific in WEDO, Beijing Betrayed New York" (2005): http://www.wedo.org/files/gmr_pdfs/gmr2005_asiapac.pdf; Saima Jasam, *Honor, Shame and Resistance* (Lahore: ASR, 2001); Afiya Shehrbano Zia, *Sex Crime*.

12 The sacred text of the Muslims.

13 Saima Jasam, *Honor, Shame*; Deniz Kandiyoti, "Reflections on the Politics of Gender in Muslim Societies: From Nairobi to Beijing," in *Faith and Freedom. Women's Human Rights in the Muslim World*, edited by Mahnaz Afkhami (London: I.B. Tauris, 1995), 19–32.

14 Human Rights Commission of Pakistan, *Women in State*; Hina Jilani and Eman Ahmed, "Violence Against Women"; Shahnaz Khan, "Zina and the Moral Regulation of Pakistani Women," *Feminist Review* 75, No. 1 (2003): 75–100; Shaheen Sardar Ali, *Gender and Human Rights in Islam and International Law: Equal Before Allah, Unequal Before Man* (Hague: Kluwer Law International, 2000); Farida Shaheed, "Networking for Change: The Role of Women's Groups in Initiating Dialogue on Women's Issues," in *Faith and Freedom*, 78-103.

15 Saima Jasam, *Honor, Shame*.

16 Farida Shaheed, "Networking for Change," 86.

17 Ziba Mir-Hosseini, "Sexuality, Rights and Islam: Competing Gender Discourses in Postrevolutionary Iran," in *Women in Iran from 1800 to the Islamic Republic*, edited by Lois Beck and Guity Nashat (Urbana: University of Illinois Press, 2004), 204–214, 210.

18 Afiya Shehrbano Zia, *Sex Crime*, 2

19 Ibid., 13.

20 Fatima Mernissi, *The Fundamentalist Obsession with Women* (Lahore: SIMORGH Women's Resource and Publication Center, 1987); Sylvia Walby, *Theorizing Patriarchy*, 114-116.

21 See Yudishtar Kahol, "The Rape," in *Violence Against Women* (New Delhi: Reference Press, 2003), 146-161; Shahla Haeri, "The Politics of Dishonor: Rape and Power in Pakistan," in *Faith and Freedom*, 161-174; Shahla Haeri, *No Shame for the Sun: Lives of Professional Pakistani Women* (Syracuse: Syracuse University Press, 2002); Farida Shaheed, "Networking for Change"; Farida Shaheed, "The Cultural Articulation of Patriarchy"; Sunila Abeyesekera, "On the Violence of Patriarchy," in *In the Court of Women: The Lahore Tribunal on Violence Against Women, 1993-94*, edited by the SIMORGH Collective (Lahore: SIMORGH Women's Resource and Publication Center, 1995), 13-16; Ferida Sher, "Introduction and Conceptual Parameters of Violence Against Women," in *In the Court of Women*, 11-13.

22 Neelam Hussain, "The Narrative Appropriation of Saima: Coercion and Consent in Muslim Pakistan," in *Engendering the Nation-State* edited by Neelam Hussain, Samiya Mumtaz and Rubina Saigol (Lahore: SIMORGH Women's Resource Center, 1997), 119-242, 208.

23 Saima Jasam, *Honor, Shame*.

24 Rukhsana Iqbal, *Violence Against Women: SWAT, North-West Frontier Province, Pakistan* (Lahore: UNICEF, 1999); Ferida Sher, "Introduction and Conceptual Parameters."

25 Yudishtar Kahol, "The Rape," 145.

26 Saima Jasam, *Honor, Shame*, 35.

27 Farida Shaheed, "The Articulation of Patriarchy."

28 Neelum Hussain and Nasrene Shah, "Women, Media and the Production of Meaning," in *Finding Our Way*, 159-176, 159.

29 Ibid.

30 Afiya Shehrbano Zia, *Sex Crime*.

31 Neelum Hussain and Nasrene Shah, "Women, Media."

32 Saima Jasam, *Honor, Shame*.

33 NGO Coordinating Committee for Beijing +5, *Pakistan NGO Review*.

34 Neelum Hussain and Nasrene Shah, "Women, Media."

35 NGO Coordinating Committee for Beijing +5, *Pakistan NGO Review*.

36 Keith Soothill and Sylvia Walby have pointed out that the media use rape and sex crimes to maximize profits. See their *Sex Crime in the News* (London: Routledge, 1991). See also Rashida Patel, "Murder for Male Honor", NGO Coordinating Committee for Beijing +5, *Pakistan NGO Review*; Afiya Shehrbano Zia, *Sex Crime*.

37 *Nawa-i-Waqt* (November 11, 2005).

38 *Daily Times* (2005).

39 *Khabarain* (January 9, 2005); all translations from Urdu are by author.

40 *Jang* (January 8, 2005).

41 *Ziadti* literally means injustice, but is usually used to imply rape in such a situation.

42 *Jang* (January 5, 2005).

43 *Jang* (January 29, 2005).

44 *Jang* (January 18, 2005).

45 *Nawa-i-Waqt* (January 27, 2005).

46 *Daily Times* (January 7, 2005).

47 *Nawa-i-Waqt* (2005).

48 *The News* (January 2005).

49 Keith Soothill and Sylvia Walby, *Sex Crimes in the News*.

50 *Daily Times* (January 7, 2005).

51 *Jang* (January 10, 2005).

52 Quoted in Afiya Shehrbano Zia, *Sex Crime*, 48.

53 Ibid.

54 *Nawa-i-Waqt* (January 27, 2005).

55 *Daily Times* (February 10, 2005).

56 *Daily Times* (January 7, 2005).

57 *Khabarain* (2005)

58 *Khabarain* (August 4, 2005).

59 Savitri Goonesekere, "Overview."

60 *Daily Times* (January 30, 2005).

61 *Daily Times* (January 17, 2005).

62 Sameera Shah quoted in Beena Sarwar, "The Ultimate Violation," (2005): http://www.chowk.com/articles/8768

63 Shahla Haeri, *No Shame for the Sun*.

64 Rashida Patel, "Murder for Male Honor"; Anjana Raza, "Mask of Honour: Causes Behind Honour Killings in Pakistan," unpublished paper, 2003; Saima Jasam, *Honor, Shame*; Rukhsana Iqbal, *Violence against Women*.

65 Rukhsana Iqbal, *Violence against Women*; Afiya Shehrbano Zia, *Sex Crimes*.

66 Farida Shaheed, "The Cultural Articulation of Patriarchy," 147.

67 *Daily Times* (January 27, 2005).

68 *The Nation* (3 August 2005).

69 Farida Shaheed, "Networking for Change," 89.

70 *Dawn* (February 2, 2005).

71 Afiya Shehrbano Zia, *Sex Crimes*.

72 *Daily Times* (22 February 2005).

73 Afiya Shehrbano Zia, *Sex Crimes*.

74 *The Nation* (3 August 2005).

75 *Daily Times* (15 January 2005), emphasis in original.

76 Ibid.

77 Afiya Shehrbano Zia, *Sex Crimes*.

78 Fatima Mernissi, *The Fundamentalist Obsession*.

79 Shahla Haeri, *No Shame for the Sun*.

80 Ibid.

81 Quoted in Shahla Haeri, *No Shame for the Sun*, 163.

82 Afiya Shehrbano Zia, *Sex Crimes*, 15.

83 Shahla Haeri, "The Politics of Dishonor."

84 *The Nation* (1 February 2005).

85 Rubina Saigol, "Militarisation, Nation and Gender: Women's Bodies as Arenas of Violent Conflict" (2005): http://www.sacw.net/Wmov/RubinaSaigol.html

86 *Nawa-i-Waqt* (19 March 2005).

87 Shahla Haeri, *No Shame for the Sun*.

88 In 2004, a Pakistani research, resource and publication center on women and media organized a regional conference on the theme of a gender sensitive code of ethics for the print media in Islamabad. The findings at this conference indicated that other countries in the South Asian region face a situation similar to the one in Pakistan. In spite of these efforts, there is major room for improvement since the practical application of such strategies leaves much to be desired.

CHAPTER 5

Media Coverage of the Murder of U.S. Transwomen of Color

Gordene MacKenzie and Mary Marcel

The rape and murder in 1992 of Brandon Teena, a young white transgender man, was the first case of homicidal violence against a transgender person to receive national attention. John Sloop observes that much of "the discourse about the Brandon Teena case works to reify traditional binarized notions of sex and gender," framing the story as a "deception narrative," which privileges Teena's female anatomy as the "true" source of his gender identity, rather than his own consistent practice of living as a man and seeing himself as male.[1] Headlines suggested Teena was a woman "posing" or "masquerading" as a man, a cross-dresser, or a woman whose "true identity" was "bared." None suggested Teena was exercising his right to live as a man with female anatomy without violent repercussions.

More than 200 transgender people have been murdered in the last fifteen years, a rate extremely disproportionate relative to their population numbers.[2] But only a handful have received news coverage and then usually only for a day or two in their local news markets.[3] Most of these killings, tracked by Gwen Smith and other transgender activists on her online "Remembering Our Dead Project," are described as "overkill," distinguished by multiple stab wounds, strangulation, mutilation and beatings that destroy faces and bodies beyond recognition. Smith states, "It gets to a point where it's not just about killing a person. It is about obliterating them, erasing them."[4] Smith began the Remembering Our Dead Project after the 1998 murder of Rita Hester and two other transwomen in Massachusetts. "The media's reluctance to cover our deaths lies near the heart of this project. It can be all but impossible to find honest, reliable media on the death of a transgendered person: It either does not exist ... or it uses names that the deceased did not own, and pronouns that did not fit their reality."[5] The Transgender Day of Remembrance was formed a year later as an outgrowth of Smith's project. Now an annual observance, it memorializes transgender persons killed because of gender violence and hate during the previous year, and calls attention to the overarching issue of anti-transgender violence.

This chapter examines the groundbreaking newspaper coverage of three transgender women of color murdered between 1995 and 2002—Chanelle Pickett, Rita Hester, and Gwen Araujo—and documents changes in tone and substance. By transgender[6] women, we mean persons who at birth, based on the shape of their genitals, were assigned as male but who identify as and live full- or part-time as women, another gender or as gender queer ("someone who identifies as a gender other than 'man' or 'woman,' or ... as neither, both, or some combination thereof").[7] We focus on race because estimates suggest that for those whose racial identity could be determined, transgender women of color are victimized four times as often as any other category of transgender person.[8]

In addition to some of the central news frames identified by feminist scholars that journalists apply to cases of rape and violence against women, we identified three frames which are repeatedly employed in transgender cases: "deception" and the transgender panic defense; undermining transgender identity; and depicting transgender women of color as socially isolated, hyper-sexual monsters. By examining the extent to which these three frames were either manifested or interrupted in each case, we establish an arc of change in the coverage for the period we are analyzing.

We also examine the ways activists, allies, and families have worked to balance and re-frame transphobic, racist, and misogynist narratives with stories that educate the public, and instantiate transgender women as beloved and valued members of their families and communities. We conclude by weighing the effects of this body of coverage on journalistic practices and pending legislation and on public attitudes regarding gendered violence.

The first case we examine took place in 1995, when two transwomen were murdered in the Boston area. Deborah Forte, a 57-year-old white transwoman, was beaten until unrecognizable and stabbed in the chest in Haverhill, Massachusetts, by Michael Thompson, a 24-year-old white male who received fifteen years to life for her murder. Five months later, Chanelle Pickett, a 23-year-old African American transwoman, was beaten and strangled to death in Watertown, Massachusetts, by William Palmer, a 34-year-old white man who received a two-year sentence for assault and battery. We examine the Pickett case in detail, to show the contrast in coverage around race. The second case we examine is that of Rita Hester, a 34-year-old African American transwoman, who in November of 1998 was stabbed multiple times in her home in Allston, Massachusetts, and whose killer or killers have never been identified.

The third and final case is that of Gwen Araujo, a 17-year-old Latina transwoman who in 2002 was tortured, severely beaten, strangled to death, and buried in a shallow grave near her home in Newark, California, by Jaron

Nabors, 19, and Jose Merel, Michael William Magidson, and Jason Cazares, all 22. Two of her assailants are white. Her murder trial resulted in a mistrial, a retrial, and a second mistrial for Cazares, who then plea-bargained and was sentenced to six years. Merel and Magidson were each sentenced to fifteen years to life. Nabors, who plea-bargained, was sentenced to eleven years.

We selected these cases because, of the hundreds of murders identified on the Remembering Our Dead website, they are among the handful that received newspaper coverage for more than a week.[9] We believe that race, age, and perceived attractiveness of the victims, as well as journalistic notions about the "unusualness" of the cases in contrast to mainstream ideas about gender, may account for this coverage.[10] Stories of white men murdering transwomen of color enable even greater "othering" of the already marginalized victims. The Pickett and Hester cases also resulted in widespread public outcry and activism. This activism, we believe, had a decisive impact on coverage in the later Araujo case.[11]

Gendered Violence Against Women

Representations of the murder and rape of women in newspapers, television news and prime time entertainment have been extensively analyzed by feminist scholars.[12] A set of victim-blaming myths and frames repeatedly surface in such media treatments. First, most crimes against women are committed by strangers. This myth ignores the frequency of violence committed by male intimates. Second, white men, especially prosperous, educated, and/or "handsome" ones, simply do not commit such crimes. Third, violence against white women by men of color represents an atrocity, whereas violence against women of color, especially by white men, is no crime. We found evidence of all these elements.

The "good girl–bad girl" dichotomy is another stereotype commonly used in crime reporting. The "good girl" is presented as one who adheres to rigidly defined gendered behaviors and whose sexual behavior is considered "respectable," making her an "innocent victim." "Bad girl" stories include references to the victim's substance abuse, the way she dresses, and her sexual behavior—elements which attempt to justify the violence perpetrated on her by blaming her own "bad behavior." The stories we analyze explicitly and implicitly state that "she asked for it." Rarely is the *assailant's* dress, substance abuse, prior record of crime or violence, or sex life developed as a rationale for his criminal acts. Such victim-targeted coverage usually serves to strengthen the defendant's legal case[13]; this certainly operates in the cases we studied.

Principles of newsworthiness shape which crime stories journalists cover. These guidelines include the uniqueness of the event, clearly a factor in the

coverage of transwomen of color cases. Marian Meyers found that journalists believe if the female victim is young, old and frail, or rich, white and privileged, the story is more likely to hold the public's interest and therefore will be covered; such persons are seen as less likely to be crime victims.[14] Age certainly played a factor in both the Chanelle Pickett (age 23) and Gwen Araujo (age 17) cases. We found, however, paradoxically, that covering cases of economically marginalized transwomen of color allows journalists to more easily reinscribe the dominance of the white, privileged, putatively heterosexual men who murder them. Feminist scholars also have observed that most cases of gendered violence are underreported or not covered at all.[15] This is also the norm in cases of transgender women who are murdered, as we have noted. But when they are covered in the news, the press generally sensationalizes details relating to gender and genitals and employs victim-blaming clichés. This is especially true when the victim is of color and the assailant is white. Gordene MacKenzie has observed how transgender persons and stories are used to boost television ratings during sweeps week.[16]

Gendered Violence Against Transwomen

In addition to these patterns in media coverage, we find three problematic frames that shape newspaper reporting on transgender murders: deception and transgender panic; undermining the woman's transgender identity; and, for women of color, depicting them as socially isolated but also exotic and sexually insatiable. These additional frames reinforce and legitimize such violence, we contend.

First, the frame of "deception" is among the most harmful in crime stories about transgender victims. It works to justify the "trans panic defense," where assailants allege that they were unaware that the transgender woman had a penis (or the transgender man did not). When they made the discovery, before, during, or after sex with a transgender woman, their rage at having been "deceived" led them to kill and often mutilate her. It uses shame and disgust for the transgender woman to justify the murder in the court of public opinion, often successfully drawing on the "heat of passion argument."[17] In the trial of the four men accused of killing Gwen Araujo, "lawyers suggest defendants committed a crime because they were thrown into a panic by a sexual advance from a person of the same gender."[18] Thus, in both the courtroom and news coverage, the trans panic defense shifts the blame away from the murderer(s) and onto the transgender woman. It collaborates in homophobia as well as transphobia, by making the transwoman guilty of being herself, rather than blaming her killers for having transphobic reactions and committing violence against her. This frame was also operative in the Brandon Teena coverage, as we have seen. Such "logic" creates a fatal double bind. Transgender women who don't "pass" as their desired gender are marked as mon-

strous, as "men in dresses," for example, who become easy targets for "disciplinary violence."[19] Those who do "pass," however, are blamed for triggering their assailants' rage on the grounds that they "deceived"[20] the men involved, and thus become *legitimate targets of men's rage*—Brandon Teena's killers alleged this as their reasons, as did the killers of Gwen Araujo. In both cases, the power to determine and control the transgender person's gender identity is located outside herself or himself—by the medical establishment; by civil society; by killers; by passive onlookers; and by the journalists who repeat without question the killers' reasons in news stories.

This is similar to the argument in crime news of violence against women that the woman provoked her killer.[21] This frame uses individual pathology to excuse the murderer. It implies that the victim did something that caused her assailant to "snap" and go crazy, thereby making her guilty of her own murder. Feminist writers on gender violence warn that myths that make women guilty of the violence perpetrated against them work to keep patriarchy in place. They corroborate the logic of men's violence against women, by construing their victims as inferior—and even disposable—because of their gender, race and class. As news coverage, they influence the formation of misogynistic public opinion.[22]

The second frame works to undermine the transwoman's transgender identity, rather than representing her as a person with a legitimate gender and body. Even the gay press, such as the *Advocate*, wrote that Brandon Teena was having a good run until people found out he was "really a woman." Every case we examined repeated this formulation. Such constructions are neither accurate nor are they the only way to describe gender identity. Brandon Teena lived his life as a man, and he clearly experienced himself as a man. His genitals were not determinative of his gender.

In news stories, this undermining of the murdered transgender woman's identity follows several patterns. First, reporters refer to the victim by the person's birth name, which usually references a different gender than the name she has chosen to reflect her true gender identity. The transwoman's chosen name is placed in quotation marks, as if it were an alias, rather than her legitimate identity. Second, reporters use incorrect pronouns—he for she—when referring to the transwoman. Finally, the reporter undresses the victim—describing every item of clothing which the reporter considers to be part of the transwoman's "deception." Once past the clothing, the transwoman's body and genitals are often verbally exposed, and a description of how beautiful she was, or, in other words, how effectively she "passed," is also included.

We found, as our third frame, that news accounts often portray murdered transwomen of color as isolated outsiders with no link to family or community. Transwomen of color are presented as exotic and sexually insatiable. They are never reported as having steady boyfriends, girlfriends, or long-term partners. Instead, they are portrayed as the eroticized repositories for (often

white) men's sexual and violent fantasies. Activists, allies, and family members must work hard to establish that the slain transwoman was a valued member of her community. We also found repeatedly that the words of transgender persons, and especially other transwomen of color, are completely discounted, and afforded no credibility when they bear witness to the victim's life and character, including in court. This was especially true, as we shall see, in the case of Chanelle Pickett.

All too often reporters capitalize on the socially isolated condition of transwomen, sexualizing and re-packaging them for male sexual consumption. From the undressing and the descriptions of clothing and hair to detailed descriptions of the transwoman's body, reporters serve up caricatured and almost pornographic descriptions of the murder victims. Fortunately, news coverage of their dreams and aspirations becomes more three-dimensional over time.

Adding to their social isolation is legalized discrimination. With an unemployment rate at seventy percent and a high under-employment rate for all transgender persons,[23] transgender women of color in reality have unreliable and inadequate access to employment, housing, health care, and education. Some transgender women who feel they have no other options engage in commercial sex work. While these life-threatening conditions are well documented in the public health and legal arenas,[24] they are almost never mentioned in news coverage. Instead, particularly in the early coverage, transgender women of color are stereotyped as hypersexual prostitutes in need of "control," who *choose* their dangerous "lifestyle," and therefore its risks. The stereotype glosses over the widespread and intense public hostility to their very presence in society, reinforcing their status as disposable people.

In sum, newspaper narratives about a murdered transgender woman of color typically call attention to her body, and undress and objectify her as a tool of male sexual gratification, as if that were her choice. While race is usually not mentioned in the news coverage of their murder, the three transwomen of color we study are subjected to covert and some overt racism by the press and the legal system. Typically, they are depicted as more exotic, wild, desirable, and out of control than their white counterparts. Until recently, their killers received lighter sentences than the assailants of white transwomen. The contrast in coverage and legal response in the same news market between Deborah Forte, who was white, and Chanelle Pickett, who was African American, demonstrates this starkly. Like all women of color, most transwomen of color who are murdered receive little if any news coverage, and their cases are rarely solved.

But we also find, in response to activist protests and education of journalists, some progress in the coverage. Gaye Tuchman's "phenomenon of sym-

bolic annihilation"[25] dominates mainstream media coverage of transgender women of color. Symbolic annihilation refers to "… the historical non-representation or under-representation of specific groups by the media and/or to the trivialization of those groups when and if they infrequently appear … and how whey will be represented."[26] We argue, following Cedric Clark's four stages of television representation of minorities,[27] that there is a distinct shift in the coverage, from **non-representation**, where the group does not appear in the media; to **ridicule**, where the group is negatively stereotyped and disrespected; to the stage where the group is **represented but regulated**; to the final stage, where the group is presented in a **range of positive and negative roles** that members occupy in real life. In the final stage, stereotypical characterizations still appear but in a context of other representations.

To elucidate these frames, we begin by examining the role of race and class in the contrasting newspaper coverage of two 1995 murders of transwomen in the Boston area: Deborah Forte, a white transwoman, and Chanelle Pickett, an African American transwoman. We proceed with an examination of coverage of a second murder of an African American transwoman, Rita Hester, in Boston in 1998, and the resulting interventions by activists to educate the media and make coverage of transpeople reflective of their self-determined identities. The final case we analyze is the murder of a Latina transwoman, Gwen Araujo, in California in 2002, which to date has garnered more news coverage that any other transgender murder in U.S. history, including that of Brandon Teena. We used the ProQuest, Factiva, and Lexis-Nexis databases as well as personal archives to identify newspaper and news wire articles.[28] We included articles containing the victim's chosen or birth name in the article text.[29]

Sensationalizing Murder: Coverage of Chanelle Pickett

In May 1995, five months before the murder of Chanelle Pickett, Deborah Forte was murdered in the Boston area. Forte and her killer were both white. We first briefly examine the coverage of her case to establish the significant differences in reporting. We attribute these differences to the race and class of both victims and assailants.

The Deborah Forte case manifests the first two frames we identify regarding the coverage of murdered transgender women: reinforcement of "deception" and the transgender panic defense; and denying and undermining the victim's transgender identity.

Lover questioned in death of transsexual man

Police yesterday [questioned] the "husband" of a pre-op transsexual man found lying nude on his back in the couple's Park Street apartment with a steak knife stuck in his

chest. John J. Forte, 56, who was known to friends and neighbors as "Debbie," was dead when police arrived at 21 Park St. around 9:20 p.m. Monday. He had been badly beaten around the head and shoulders in addition to suffering the knife wound. ... John Cuneen, 47, who used to dress up with "Debbie," said, "We've been friends since I was 18. She was very nice. Full of fun. She got along with everybody." Cuneen's roommate, who declined to give her name, said, "She was a very nice looking girl. She had a heart of gold. We all loved her."[30]

This headline and story (which continues for another 260 words) demonstrate the latter frame. The victim is identified as a pre-operative transsexual man, which is inaccurate. Deborah Forte is a transgender woman. *The Boston Globe*'s David Weber, by contrast, refers to her as a man named John Forte in its May 17 story.[31] The *Boston Herald*'s June 3 story betrays its fuller sexualizing intentions with a standard "deception" headline: "DA says new lover killed man he thought was a she."[32] Here, it is the *prosecutor* who sets up the trans panic defense! The ensuing story further eroticizes the victim: "When 'Debbie' Forte's new lover discovered she was a he, he flew into a murderous rage and plunged a knife between the voluptuous cross-dresser's hormone-induced breasts." The story uses the specific language of deception when it states that "Thompson originally believed Forte was a woman. Forte invited Thompson back to his apartment and they were 'messing around' when Thompson discovered Forte was a man."

Regarding our third frame of social isolation and deviance, the reporting is mixed. On the one hand, Forte and her partner are ridiculed in their relationship of 27 years when Weber refers to Philip Feole not as her partner or her husband, but as her lover and "husband." On the other hand, Weber also quotes close friends and neighbors, including one who states that Feole "was very protective of Debbie. He loved her very much." Significantly, Forte and her partner Philip Feole are white. In ridiculing any long-time partner of a transwoman, the media discipline not only transgender women, but anyone in loving, committed relationships with them.

In September 1996, Michael Thompson was convicted of second-degree manslaughter and sentenced to life in prison, with the possibility of parole in fifteen years.[33] Five months after Deborah Forte was murdered, Chanelle Pickett, a 23-year-old African American transgender woman, was killed by a white male, William Palmer, in November 1995 in Watertown, a suburb of Boston. The reporting of her case, however, heightens the "othering" effect of the three frames we identified much further than in the Forte case.

Man Accused of Killing Transvestite

A man who took someone he thought was a woman home from a bar allegedly strangled his date after learning she was really a he.

> William Palmer, a 34-year-old computer programmer, pleaded innocent Monday to murder and was ordered held without bail.
>
> Police on Monday discovered the body of 23-year-old Roman Pickett in a bedroom at Palmer's home. Pickett, who went by the name Chanel, was wearing jeans and a woman's top, and police also found a curly, long-haired wig.
>
> Palmer had met Pickett near Boston's Combat Zone—the city's adult entertainment district—and apparently learned the victim's secret in his bedroom, authorities said. Prosecutors would not say whether the two had sex.[34]

The frame of undermining Chanelle's transgender identity is dominant from the beginning of coverage. The quoted material above from the first day of coverage reflects the confusion in names, pronouns and terminology used to refer to her. In the first seven days of coverage, headlines and stories refer to Ms. Pickett both by her chosen and preferred first name, Chanelle, and by her birth name, Roman, with Chanelle or Chanel (sic) generally given in quotation marks, as if an alias. Headlines variously refer to her as a transvestite; a transsexual; a "woman," in quotes; a "date[] in drag"; as having a "sex secret"; as a cross-dresser whose "deception" cost "his" life; and as a "man who posed as [a] woman."[35] She is called a "man" or referred to as a "brother" five times in the first two days of coverage.

Journalists represent society's confusion about transgender identities even though the transgender victims and their familiars are often clear about and comfortable with them. There is a similar confusion regarding appropriate pronouns. Both "she" and "he" are used to refer to Chanelle, at times within the same article. In some cases the journalist uses "he" but quotes friends and others who refer to Chanelle as "she." In other cases, the journalist uses "she" and quotes others referring to Chanelle as a man. The same is true for Chanelle's twin sister, Gabrielle, also a transsexual:[36]

> But Gabriel Pickett, who uses the name Gabrielle and has appeared with his brother on television shows such as Jenny Jones and Geraldo, said Palmer had been seen several times in the Playland Cafe, which patrons described as a bar frequented by gay men and transvestites. "He didn't kill her because he didn't know," Pickett said yesterday, referring to his brother as a woman. "He's saying that to cover up. He's been in Playland several times. He knew exactly what she was."[37]

The articles frequently report on gender markers—names, pronouns, clothing, and interests. A description of Chanelle's clothing at the time her body was found is included in eleven stories.[38] Further dividing Chanelle's gender identity, her pre-operative body and her clothing, the Herald's Sean Flynn and Jason Johnson wrote, "Prosecutors Tuesday said Palmer killed Pickett in a rage after discovering a man beneath a feminine costume of tight jeans and lacy top, replete with a wig and hormone-enhanced breasts."[39] Her feminine gender, however, was clearly not a costume in Chanelle's mind. According to her

twin Gabrielle, the two were both pre-operative male-to-female transsexuals, and both were trying to save money for their hoped-for surgeries.[40] The media's binarized view and repetitive emphasis on genital shape as the *definitive* indicator of sex and gender undermines Pickett's feminine identity and works to justify the *defendant's* trans panic. The frame of deception and trans panic is also immediate and widespread: "A man who took someone he thought was a woman home from a bar allegedly strangled his date after learning she was really a he." This formulation, at times verbatim and at times with only slight variations, appeared as the first line in fourteen of the first twenty-three stories that appeared about the murder. Such coverage reinforces the violent social dictate that gender identity is equivalent to and determined by genital shape, and that anything else is "deception."

One headline, from the *St. Petersburg Times*, calls Chanelle's murder "The Choking Game," borrowing from the movie *The Crying Game* (1992). In the movie plot, the "secret" is that the female protagonist, Dil, is a transwoman with a penis. Upon learning this, the male protagonist Fergus hits her and then throws up.[41] The "choking game" becomes a callous rephrasing for murder, and a code for the shock and subsequent sickness supposedly experienced by male partners of transwomen. Using such a headline also insinuates that Pickett's death is the result of a game. However, in the 1992 film, Fergus stands by Dil in the end. This contrasts with Palmer, who strangles Chanelle to death. The headline thus malignantly reshapes the allusion.

The transgender panic defense is cannily applied in this case by Palmer's very expensive legal team, which included members of the O. J. Simpson defense. Maintaining throughout that he was no habitué of transgender bars was necessary to sustain the plausibility of Palmer's denial that he had known that Chanelle Pickett was a transgender woman, and that he was, in essence, a *stranger* to her as well. In keeping with his carefully depicted upper-class self-control, Palmer alleged that it was Chanelle who "went crazy" and attacked *him* when he "discovered" she had a penis. In one story, "The housemates ... told investigators they heard Palmer arguing with a man ... But Palmer shouted through his bedroom door, "I've got a crazy bitch in here.""[42] In his trial, Palmer's defense lawyer claimed that the two were high on cocaine, and Chanelle attacked Palmer in a drug-induced rage.[43] The lawyer further depicts Chanelle as descending into a "psychotic" state:

> Pickett used crack cocaine in the bedroom and "suffered a psychotic attack" during which he shouted, "God will never die! The devil won't allow it! The devil is king!"
> Prince urged jurors to ignore the sexual aspects of the case and said the prosecution cannot prove beyond a reasonable doubt that Palmer strangled Pickett.

By claiming he was only attempting to "restrain her," Palmer managed to establish enough doubt about what happened to cause uncertainty in the jury about how Chanelle sustained extensive bruising on her face and evidence of strangulation on her neck. Thus Palmer claimed he was deceived, but hid her strangulation and beating behind *her* violent reaction to his "discovery." By not admitting that he was a regular at transgender bars or that he personally was thrown into a crisis at "discovering" the "truth," Palmer was convicted only of assault and battery, and sentenced to a two-year term. The trans panic defense worked in his favor. News stories had reinforced it through their consistent undermining of the possibility that an upstanding, self-controlled white "gentleman" would ever knowingly date or subsequently attack an African American transgender woman, one whom journalists reconstructed as a "psychotic" "bitch." The stereotype of the angry and aggressive black woman served to present Palmer as a self-controlled and self-regulated white male.

The frame of social isolation includes transgender women's partners and dates distancing themselves from the women they kill. Palmer's defense works hard to establish him as "normal" *and therefore credible* from the earliest days of coverage. Reporters echo Helen Benedict's analysis of "preppy killer" Robert Chambers' media-developed image in the headline of the November 23, 1995, *Boston Herald* story, "Preppy wanted dates in drag, cops say."[44] Calling the defendant a "preppy" neutralizes the otherwise explosive idea that he was *seeking* "dates in drag." Preppy, as in the Chambers case, carries connotations of wealth, education, and implicitly (white) color. It also serves to undermine the notion that anyone like Palmer would ever *knowingly* or willingly consort with a transgender woman:

> Palmer's attorney, Walter Prince, branded as "absurd" the allegations that Palmer had dated transsexuals and knew Pickett was a man.
> "We have it on pretty solid ground that any accusations of that nature are certainly false and out of character for a gentleman who has lived the normal upstanding life that he has," he said.[45]

(By trial time, Palmer's apparently non-transgender female fiancée appears in court with him.) The same story cites Palmer's lawyer representing him as "a man with deep roots in the community."

There is, however, no discussion or counterpoint regarding Chanelle's and Gabrielle's roots in the community, despite the fact that both are residents of Chelsea, a working-class suburb of Boston with a largely Hispanic and immigrant population. Their familiars from Playland and the other transgender people interviewed (including Gabrielle herself) are not represented as similarly credible, despite their statements in five stories describing Palmer's frequent visits to Boston's two transgender bars, and in some cases, his dates with them.[46] Implicitly (and strategically), the words of Palmer's African

American male attorney are taken at first glance as more credible than any transgender woman, especially one of color.

The formula that a transgender woman who wants sex reassignment surgery engages in commercial sex work is presented without qualification. This de-legitimates the victim rather than the society that denies her employment and access to affordable medical treatment. In 1995, there was no legal protection in Massachusetts or most other states or localities against harassment based on gender identity and expression in employment, housing, education, medical care, or even hate crimes. Chanelle Pickett was legally fired, due to someone else's discomfort with her gender identity.[47] Thus, while Palmer is presented as a successful computer programmer,[48] Chanelle is presented as a prostitute with a police record. Her lack of access to legal employment and sought-after medical treatment are not thematized in any of the coverage.

While Rita Hester's and Gwen Araujo's mothers will be sympathetically covered at the time of the murders and shown publicly mourning their daughters' killings, Chanelle Pickett's only visible family, her sister Gabrielle, is immediately discredited by the press as a "pre-operative transsexual." This means that the sympathetic frame of "from a 'normal' (non-transgender) family who loves her" is not available. The only mention of Pickett's mother comes years later at the trial, on April 27, 1997, in *The Boston Globe*. The columnist Patricia Smith describes her as having arrived from Buffalo, and sitting "stoically" with no other family members present.[49] This contrasts with an "ever-widening" circle of friends and supporters, including a fiancée with Bible in hand, who are present for Palmer. The apparent silence or absence of Chanelle Pickett's parents from the mediated scene of her death deprives her of a socially acceptable familial connection. Her sister Gabrielle, as a transgender woman, seemingly does not count as "family," despite being present and interviewed throughout the course of the coverage. As a transperson, Gabrielle's identity and legitimate humanity are deconstructed and undermined in the same way as her sister Chanelle's: "Pickett's twin transsexual tearfully fled the courtroom after Judge Robert A. Barton decided to lower the bail. 'Leave me alone,' sobbed a leather mini-skirted Gabriel Pickett, also known as 'Gabrielle'."[50]

Transgender activists wrote letters to the editors protesting the news coverage and the light sentence, and held a vigil attended by 125 persons. They demonstrated outside the courthouse several times during the Pickett trial. Flyers for a demonstration urged: "We can't change the jury's verdict and we can't influence the sentence. What we can do is assure the court knows people are watching and they cannot treat people outside of the mainstream as if they don't matter." Their actions helped put a human face on Chanelle Pickett.

Only three years later, transgender activists in the Boston area were once again forced to decry the harm that transphobic and disrespectful news coverage caused, this time in the case of Rita Hester. This case moved from non-representation of transgender women of color to Clark's second stage of media representation of minorities, where members of the stigmatized group are disrespected, negatively stereotyped, and publicly ridiculed.

Activists and Public Mourning: The Death of Rita Hester

Friends of murdered transvestite recall pal, mourn loss

From Brighton to Bay Village, friends of the transvestite known as Rita were in shock last night after learning that a killer fatally stabbed him Saturday during a violent struggle inside his apartment.

"I know everybody is devastated around here," said George Anthony, owner of the Model Cafe in Brighton, a neighborhood bar where William "Rita" Hester was always welcome. "She wanted it to be known that her name was Rita when she came in. She let everybody know what she was about. We're kind of stunned."

... Hester's killer stabbed him multiple times inside the first-floor apartment where the 34-year-old man lived among neighbors who described him as friendly but sometimes noisy.[51]

This first story on the murder of Rita Hester captures elements that recur in all five of the news stories about her that ran in 1998 and demonstrates the frame of undermining Rita Hester's transgender identity. The journalist privileges Hester's birth name, "William," and male sex, by using masculine pronouns to refer to her. She also labels Hester a "transvestite,"[52] a derogatory term in this context. At the same time, the first interviewee establishes Rita Hester as she saw herself, by using her chosen name, Rita, and feminine pronouns when speaking about her.

Nevertheless, journalists continued to refer to Rita Hester as "William." Using the pronoun "him" further mocked and denied her identity and life. A few early stories made an effort to use her chosen name, Rita, but placed it in quotation marks, which functioned on one level to question the very existence of transgender women, and also "to cast aspersion on her chosen name."[53] Interviews with friends and family members were included in four of the five stories, and established Hester's good character, feminine gender, popularity, and friendliness. This coverage interrupts the frame of the African American transgender woman as socially isolated and monstrous. At the same time, as Benedict observed, in absence of any suspects or an assailant, coverage of what friends had to say about Hester solidly framed her as a deviant "bad girl," including that she engaged in commercial sex work to support herself. The lead paragraphs of Donlan's December 1, 1998, *Herald* story[54] establish this frame:

> Rita, a slain pre-op transsexual, was a popular "call girl" who was fatally stabbed more than 20 times after he apparently let the killer into his Brighton home Saturday afternoon.
>
> "I know that she was a call girl," said Norell Gardner, who made show gowns for Rita, a 34-year-old entertainer at gay clubs who was born William Hester.
>
> "She worked an ad, but at the same time, she was honest and she was a good person," Gardner said. "Nobody deserves this. She was very loving and open to people and she trusted people. Violence and harm and stuff like that was not in Rita's mind."

While the *Herald* coverage more equivocally establishes "who Rita was," Daniel Vasquez' November 30 story in *The Boston Globe*[55] sets the frame of deception. In a self-contradicting story, Vasquez wrote:

> Before he was stabbed to death in his Allston apartment, William Hester was a night-club singer and a party-thrower, a man who sported long braids and preferred women's clothes, according to neighbors.
>
> Hester was a mystery to those around him—so much so that, until his body was found on Saturday, many in the building on Parkvale Avenue believed Hester was a woman.

In addition to ignoring her correct name and gender identity, and using the wrong pronouns to describe her, this journalist asserts both that she was a man, and that she successfully "deceived" her neighbors by wearing inappropriate clothing and an inappropriate hairstyle for her gender. The article also degrades Hester as a "bad-girl," prostitute and "transvestite," and suggests that the journalist has "revealed" a mystery where previously there was none: many people in her building did indeed "believe" Hester was a woman. In this instance, the reporter himself undresses Rita for her neighbors and the public. What is perhaps most shocking about the journalist's need to emphasize "deception" is that there is no suspect in the crime, and no motive alleged by the police. Yet the journalist cannot resist supplying the frame of Rita's "deception," as if the only possible motive someone would have to kill her has to be her own gender "fault."

Coverage from the first day connected Hester's killing to the Chanelle Pickett case:

> Hester's slaying dredged up memories of another slain transvestite, 23-year-old Roman "Chanelle" Pickett, whose killer was acquitted of murder and convicted instead of assault and battery.
>
> "We know that every time we go out that there's always the chance that someone who hates us for who we are will hurt us," [Stephanie] Diamond said. "But we live the life because of who we are."[56]

This coverage served to interrupt the frame of the individual as a singular disturbed killer. The article asserted a pattern of crime against transgender women.

Interrupting the frames of social isolation and destruction of transgender identity became the goals of activists and family members who were determined not to allow the travesty of the Chanelle Pickett coverage to be repeated. Within twenty-four hours of the first public notice of her murder, the director of the Boston-based Transgender Education Network, with the help of transgender activist Nancy Nangeroni, called an open meeting in "response to overwhelming demand from community members for a response to the murder of Rita Hester, and the subsequent disrespectful press coverage." On December 1, local activists joined transgender activists, family, and friends of Rita in the well-attended meeting. A vigil was planned and the media were admonished for "re-assassinating Rita Hester in their stories."[57] The meeting inspired activists to contact editors and journalists at the *Boston Herald*, *The Boston Globe* and *Bay Windows*[58] about the disrespectful coverage.

Subsequently, there were slight shifts in stories about Rita Hester. Articles at the *Herald* began to refer to Rita as a "transsexual" instead of a "transvestite," a description closer to how Rita self-identified.[59] Subsequent news stories included interviews with Rita Hester's mother, brother, sister, and friends. These news stories changed the representation of Rita Hester from an isolated, marginal, and expendable person whose death was justified because she crossed gender boundaries, to a beloved and valued member of both her community and her family. The last story of 1998 even attempted to balance the prostitution angle:

> Whether prostitution was a factor in Hester's murder, reliance on sex for income shows the need to steer transvestites and transsexuals away from the sex industry to help them lead safer lives, said Ashe and others.
> "Most trans people that engage in professional sex work do so because they are unable to find legal employment, and it is not necessarily because they are untrained," Ashe said.[60]

This quote from transgender activist Penne Ashe was the only mention in all the coverage we found on Deborah Forte, Chanelle Pickett, and Rita Hester that gave an alternative and more accurate image of transgender women's employment options—one that undercut the misogynist notion that women ever *choose* sex work when better options are open to them.

Transgender activists and allies also wrote letters to the editors of all the daily and weekly Boston papers. Significantly, three letters from three different people criticizing the defamatory coverage were printed: two in the *Boston Herald* and one in *The Boston Globe*. These letters opened a dialogue between the community and the press. After a public demonstration outside the offices of *The Globe* and *Herald*, transgender activists worked to educate reporters and the public about the severe discrimination and hate to which transgender per-

sons are subjected in their daily lives. This initiative laid the foundation for change.

Because Hester's killer has yet to be identified, there was no trial, in contrast to the Chanelle Pickett and Gwen Araujo cases. However, the vigil on December 4, 1998, attended by over 300 persons, was covered by the press. It underscored the terrible loss suffered by Rita Hester's family, friends, and the wider community. Rita's mother, Kathleen Hester proclaimed, "I want the world to know how much my son means to me, cross gender or not ... I loved him unconditionally. I would have died for my son ... I wish I was there to take the stabs for him ... I would of yelled 'Run Rita, run'." Brandon Teena's mother and family were active in fighting the identity assassination that took place in his case. This, however, was the first time a mother—an African American woman—was publicly reported as mourning the loss of a transgender daughter. And it profoundly shifted the ground beneath the media-perpetuated frame of transgender women of color as socially isolated sexual freaks.

News of Rita's death inspired the founding of the now internationally observed annual "Transgender Day of Remembrance" and the "Remembering Our Dead Project" by transgender activist Gwen Smith.[61] The Transgender Day of Remembrance has been observed every November since 1999, on or near the anniversary of Rita Hester's death. Activists, students, allies, and community members across the world gather to speak out and remember those killed because of hate and gender intolerance. In 2007, the sixth annual event was observed in over 400 locations world-wide.

Coverage of Rita established her as a beloved daughter, sister, friend, and member of the community and inspired the largest national effort to combat negative stereotypes of transgender persons in the press. But despite activist efforts, local journalists would persist in writing disrespectful stories that ignored the way Rita Hester identified and lived. A 2005 article in the *Boston Herald* on unsolved murders misrepresented Rita Hester and negated her gender identity: "Seven years after he was stabbed to death on Nov. 18, 1998 a photograph of William 'Rita' Hester in drag still hangs on a wall in Brighton's Model Café, even though gossip about who may have killed the 32-year-old transsexual has long run dry."[62]

"Please don't, I have a family"

Protest set for burial

... I loved my child beyond words. I gave my child life and I simply cannot understand how anyone else thought they had the right to take the life which I gave him. I want justice for Eddie [Gwen's birth name] because this should never have happened and I never want it to happen to any other child or any other family.[63]

Gwen Araujo's murder (2002), and her killers' trial (2004) and retrial (2005) are by far the most covered news story to date of any transgender person killed because of hate—over 400,000 words through April 2008 were published, excluding stories concerning the movies based on her story. The fact that Araujo was an attractive 17-year-old Latina transwoman no doubt made the story more newsworthy and therefore more subject to sensationalism. As in the other two cases, journalists initially denied her identity as a transwoman. She was portrayed as deceiving her assailants about her "true sex." Early stories specifically implied that she "asked for it." However, the Araujo case also marks a turning point in the news coverage of transgender women of color. The strong presence of family and community supporters worked to effectively interrupt the frame of social isolation and exoticism. And coverage of the callous statements of her killers and details of how she was tortured and murdered ultimately undercut to some extent the trans panic defense used in the trials. Overall, journalistic coverage in this watershed case shifts from sensationalism to education, advocacy, and legislative change.

The initial news coverage in 2002 of Gwen Araujo is similar to coverage of Chanelle Pickett and Rita Hester. She is misnamed, and masculine pronouns are frequently used to describe her, erasing her female identity. In news stories she is characterized by her assailants as "deviant" and "disgusting," and by journalists as a stereotypical "bad girl" who abused substances and was sexually promiscuous. A number of stories blame Araujo for her own death, supporting the trans panic defense:

> But some residents question whether Araujo may have put himself in harm's way. Police are investigating whether the teen, who wore makeup and dressed in women's clothing, may have had sexual encounters with one or more of the suspects, who knew her as "Lida."[64]

Stories that describe Araujo as "beautiful," a gender-laden term,[65] use it to blame her for her own death. Associated Press (AP) writer Margie Mason's formulaic story from October 19, 2002,[66] was repeated widely in the press:

> Eddie "Gwen" Araujo was a good-looking girl—so good, it cost him his life.
> The 17-year-old with high cheekbones and soft, pretty eyes never came home from a house party earlier this month. Instead, Araujo was allegedly beaten and strangled by three enraged men who discovered she was a he.

We have argued that transwomen are subjected to the same degrading and sexist stereotypes in the press as are women victims of crime. As in the previous cases we analyzed, news coverage of Araujo also publicly undresses her, characterizing her wearing women's clothing as a deception, while simultane-

ously publicly revealing and reviling her genitals. Mason reports on October 19, 2002, that

> Araujo left for the Oct. 3 party in his hometown of Newark, a San Francisco Bay area suburb, dressed in flip flops and a denim skirt, but took a change of pants so it would be easier to conceal his true sex when he got drunk, according to court documents.

An October 22, 2002, AP story calls Gwen a "teen boy who dressed as girl." Heredia describes Gwen as "Eddie Araujo[,] who called himself Gwen, wore girls' clothing and makeup and liked to date boys."[67] Both statements question both activities and over-write them as unacceptable. Conversely, we do not see equivalent reports about her assailants' gender or sexual preference. Such reporting again works to sensationalize, objectify, and blame the transgender woman of color as wild, exotic, and asking for trouble. They support the trans panic defense that argues that the "deceiving" victim provoked her own death. While what a woman is wearing at the time of her murder has been widely challenged by feminists as not a just cause for the crime, articles repeatedly imply that the clothes Gwen was wearing were not only inappropriate for her gender and served to conceal her "true sex" but may have provoked the crime.

Sensationalized accounts of Gwen, including statements that "she played with [the assailants'] emotions," "they discovered she was really a boy in girl's clothing," and "it's a man,"[68] echo the AP formulaic coverage of both the Chanelle Pickett and Rita Hester cases.[69] Eight stories in the first week alone recount how Nabors, Merel, and Magidson were "enraged" upon their "discovery" that she had male genitals, a sentiment repeated throughout trial coverage. Four first-week stories describe Araujo as a "flirty girl" and report the defendants saying, "it's a man."[70] This type of coverage parallels stereotypical rape stories, where women are blamed for having invited or incited the attack. Reducing her to an "it," a flirt, and a man further render Araujo a disposable person.

A few early stories treat the assailants more sympathetically than the victim, who is blamed for tricking the men:

> Friends of three men accused of killing a transgender Newark teen when they found out he was anatomically a man...say the men are incapable of such a crime. Jose Merel, 22, and Jaron Nabors, 19, are hardworking fathers who support their girlfriends and babies. Michael Magidson once raised an abandoned pit bull puppy...some supporters say the men had a right to be mad for being tricked by Eddie "Gwen" Araujo... Many described the men as obedient, sweet, hardworking, and helpful.[71]

However, interrupting this myth of the innocent and likable defendants are the gruesome details of the killing that are repeated in over four years of trial coverage.[72] Here readers learn how Araujo was punched, kneed in the face, kicked so hard that her head made a dent in a wall, beaten with a skillet and a soup can, repeatedly choked, hit with a shovel, and then strangled to death with rope. One of the killers stopped before the 150-mile drive to bury Araujo, in order to change out of his "good" shirt. According to the evidence presented, one defendant said at the burial site that he wished Gwen was still alive so he could kick her again. After burying her all four went to McDonald's for breakfast.

Press coverage of the defendants being charged with committing a hate crime[73] worked to educate the public about hate crimes, although none of the defendants was ultimately convicted on that count. It also made the trans panic defense used in the trial very prominent.

> Merel began crying and said in disbelief, "I can't be f— gay," Nabors testified. Merel struck Araujo with a can and skillet, Nabors said.
> Nabors said he and Cazares then went to Cazares' home to get some shovels and "kill that b—."[74]

These comments serve to discredit the defendants, who clearly had other possible responses to their "discovery" about Gwen.

In attempting to set up a plea bargain, one of Araujo's attackers stated that her final words were, "Please don't, I have a family."[75] In the news coverage of her murder, we are made aware that Araujo's family extended well beyond her very large family of origin and included transgender activists and allies across the nation. Araujo's body was discovered after family members informed the police about rumors of her death. From the first crime reporting through all of the trials, the news coverage focused on Gwen's mother, Sylvia Guerrero, and the Araujo's family's profound grief, establishing that she was "a struggling but beloved teenager."[76]

In 2002, in response to the negative press coverage, the Gay and Lesbian Alliance Against Defamation (GLAAD) and the Bay Area LGBT community protested and engaged in outreach. Subsequently, the AP San Francisco Bureau and the *San Francisco Chronicle* independently announced that they would update their reporting guidelines for transgender persons.[77] Instead of recommending that pronouns be changed only if the person had sex reassignment surgery, the AP announced that pronouns should be consistent with the way the person publicly lives.[78]

An AP story from December 22, 2002, covers this change, unfortunately leading with the sensational headline, "Was Eddie "Gwen" Araujo a 'he,' or 'she'?"

> News media, including The Associated Press, initially used the masculine pronoun. AP has taken its lead from Araujo's family members, who called their child a "he." Transgender activists saw the masculine pronoun as disrespectful saying it was clear that Araujo...would have wanted to be referred to as a girl. Others argued that allowing people to essentially self declare their gender without undergoing a physical change is too subjective an approach to grammar. After gathering more information from Araujo's family the AP decided to switch to the feminine pronoun when referring to the slain teenager from Newark, Calif.[79]

Important changes are evident in the coverage of Araujo, even in the midst of harmful and erroneous stereotypes. From the very first, some journalists use her chosen name or refer to her in a more neutral way as "Araujo," or simply a "transgender teen" instead of using her male name. Most journalists also refer to Gwen as transgender. This is in stark contrast to how Chanelle and Rita were mislabeled by the press as transvestites, cross-dressers and "a man in disguise," even though they lived full time as transwomen. By the retrial in 2005, most AP journalists with few exceptions[80] consistently use correct feminine pronouns and Gwen Arajuo's now legal name, posthumously changed by her mother in 2004.

An unprecedented and key change in reporting also took place as some stories began to educate the public about the violence faced by transgender persons. Transgender activists were interviewed and respected as authorities. Riki Wilchins, the executive director of Gender Political Action Committee, informed the *San Francisco Chronicle* within the first week of coverage that

> Kids are dying out there because they don't meet narrow gender norms—the boy who throws 'like a girl' or the girl who is perceived as being too masculine... I'm confident change is coming as crimes like these raise people's awareness. Unfortunately, it's not happening quick enough.[81]

Like most early coverage, the story combines education with disrespect and inaccurate pronouns, and sympathy with sensationalism. The same story, intentionally or not, blames the victim:

> The slaying of a 17-year-old Newark boy who police say was killed because he identified as a female has drawn national attention to the struggle of transgender people to overcome discrimination. The story of Eddie Araujo—who called himself Gwen wore girl's clothing and makeup and liked to date boys—is being discussed in classrooms and receiving coverage on CNN, in USA Today an in the New York Times.

Significantly, within the first two weeks, a number of stories, including the very first in the *San Francisco Chronicle*, address the frequency of violence against transgender people, and the need for policy change and for sensitivity training for the schools and police (all Mason, Heredia, and U.S. Newswire stories). Such stories provide website information and attempt to define

"transgender." The reporters make references to other transgender victims like 16-year-old F.C. Martinez, a Navajo two-spirit, whose murderer in 2001 bragged to friends that he had "bug-smashed a fag."[82] The National Latina/o Gay and Lesbian Organization in a press release expresses grief over how many persons are targeted based on their race and ethnicity.[83]

During the 2005 retrial, Gwen Smith and other activists reminded the press to "not forget that it is the defendants that are on trial, not Gwen Araujo." In 2006, José Merel and Michael Magidson were found guilty of second-degree murder and sentenced to fifteen years to life in prison. After two mistrials, Jason Cazares pleaded guilty to manslaughter and was sentenced to six years in prison, though his sentence did not begin until after the birth of his third child. Jaron Nabors, who pleaded guilty and testified against the other three defendants, was sentenced to eleven years in prison.

In 2006, inspired by the Gwen Araujo Justice for Victims Act (AB 1160), California became the first state in the nation to limit the use of the gay and trans panic defense, banning defendants from playing upon the bias of the jury and disallowing the use of bias as a defense.[84]

Stories about Gwen, who in death has achieved iconic status, continue to be written. Recent stories talk about using films about Gwen to promote diversity in classrooms.[85] Many focus on the Lifetime movie channel airing of the sympathetic film "A Girl Like Me: The Gwen Araujo Story" and more recently the 2007 independent film "Trained in the Ways of Men," by transgender filmmaker Shelly Prevost. The film focuses on Gwen's death and trial from an insider perspective and includes interviews with Sylvia Guerrero. Such media coverage functions to educate increasingly larger audiences. However, Gwen's story is in marked contrast to the untold stories of most transgender women of color who have been murdered and for whom there is no coverage and no justice.

Historic Changes

Marian Meyers observes, "news stories that seek to educate the public rather than blame the victim ... can have a positive impact on the community."[86] We find that during the ten-year period from 1995 to 2005, news stories of murdered transwomen of color shift from sensationalizing and dehumanizing victims toward education and advocacy. Several key developments contributed to this shift. First, transgender activists and allies brought national and international attention to the harmful stereotyping of victims targeted by transgender violence. They succeeded in educating individual journalists and news services, which led to more stories that were respectful of transpersons. Second, increasing support from family members and the community changed the

stereotype of transgender women of color from monstrous, isolated, crazy, deceptive, and responsible for their own deaths, to valuable and beloved members of the community. Finally, some stories supported significant legal rulings that challenged the use of the trans panic defense, supported transgender inclusion in Hate Crimes Legislation, and made the connection between violence against transgender people and the struggle for transgender Civil and Human Rights.

Notes

1 John Sloop, "Disciplining the Transgendered: Brandon Teena, Public Representation, and Normativity," *Western Journal of Communication* 62, No. 2 (2005): 58.

2 Sandra P. Thomas, "From the Editor: Rising Violence Against Transgendered Individuals," *Issues in Mental Health Nursing* 25, No. 6 (Sept. 2004): 557–58.

3 See, for example, the 2005 murder of Joel Robles, whose stabbing death was covered in three stories by the local paper, the *Fresno Bee,* one in the *Merced Star* and one AP report, including the court process. After stabbing Robles twenty times, Estanislao Martinez was given a four-year sentence, successfully pleading the "gay panic" defense. Robles was dressed as a woman when stabbed.

4 Michelle Locke, "Brutality a Hallmark of Crimes Against Those Defying Sexual Norms," AP Newswire (March 16, 2003).

5 Gwendolyn Ann Smith, (February 8, 1999): http://209.85.215.104/search?q=cache: DA5xXqAPYFQJ:glog.movingforwords.com/2006/11/international-transgender-day-of.html+Gwen+Smith+media%27s+reluctance+dead&hl=en&gl=us&strip=1

6 Transgender is a term derived from the term "transgenderist," coined by Virginia Prince to refer to a person cross-living full time with no plan to have sex reassignment surgery (SRS). In the 1990s it was used as an umbrella term for political purposes, covering transsexuals, transgender persons, gender queers, cross-dressers, and anyone who transgresses gender. It is a self-generated term, unlike transsexual, which is a medically derived term. Some activists resisting medical categorization spell transexual with just one "s" instead of two.

7 Gender Queer is a phrase used primarily by white upper and middle class persons. Interview with Steven Hocker, Gender Talk Radio (August 14, 2007): http://www.gendertalk.com/radio/programs/251/gt271.shtml

8 Ethan St. Pierre, personal communication, July 24, 2006. St. Pierre compiles statistics for the Remembering Our Dead website. These estimates have been confirmed as well by other activists who track transgender murders.

9 We were unable to find any newspaper stories at all for most of the names listed on the website.

10 In some contexts, racial and ethnic difference can render other acts of violence invisible. See Cristina Alcalde's chapter in this volume for an example from Peru.

11 The only other notably reported case in this time period is that of F. C. Martinez, a 16-year-old Navajo Two Spirit who was brutally murdered in Colorado in 2001, and whose killer received a 40 year sentence. Two Spirit is a Native American generated term to describe one who walks in both gender worlds, or who has two spirits, transcending rigid gender binaries. It is beyond the scope of this chapter to analyze her case in depth, but we discuss it in the context of its appearance in the coverage of Gwen Araujo. Two Spirit replaces an earlier anthropologically generated and widely used term "berdache," which meant "kept boy" and marks an indigenous society with a more complex understanding of gender that allows some members to choose their own gender, without penalty. Instead of being stigmatized, those that walk the Two Spirit path are revered and occupy a special place in the culture. Not all Native American societies in the United States recognize that role. Two Spirits were revered as shamans and healers before colonization, and in some Native American tribes, particularly in the southwest, they still occupy an important and sacred role.

12 See Helen Benedict, *Virgin or Vamp: How the Press Covers Sex Crimes* (New York: Oxford University Press, 1992); Marian Meyers, *News Coverage of Violence Against Women: Engendering Blame* (Thousand Oaks, CA: Sage Publications, 1996); Lisa Cuklanz, *Rape on Trial: How the Mass Media Construct Legal Reform and Social Change* (Philadelphia: University of Pennsylvania

Press, 1996); Lisa Cuklanz, *Rape on Prime Time: Television, Masculinity and Sexual Violence* (Philadelphia: University of Pennsylvania Press, 1999); Sujata Moorti, *Color of Rape: Gender and Race in Television's Public Spheres* (Albany: SUNY Press, 2002).

13 Meyers 1996; Benedict 1992.

14 Marian Meyers, *News Coverage of Violence.*

15 Marian Meyers, *News Coverage of Violence*; Bronwyn Naylor, "Reporting Violence in the British Print Media: Gendered Stories," *Howard Journal of Criminal Justice* 40, No. 2 (2001): 180–94.

16 Gordene MacKenzie, *Transgender Nation* (Bowling Green, OH: Bowling Green State University Popular Press, 1994); MacKenzie, "Fifty Billion Galaxies of Gender: Transgendering the Millennium," in *Reclaiming Genders: Transsexual Grammars at the Fin de Siècle*, edited by Kate More and Stephen Whittle (New York and London: Cassell, 1999).

17 Victoria Steinberg, "Book Review: A Heat of Passion Offense: Emotions and Bias in 'Trans Panic' Mitigation Claims: Hiding from Humanity. By Martha Nussbaum," *Boston College Third World Law Journal* 25, No. 499 (Spring 2005).

18 Robert Airoldi, "Lawyers Plan Tactics for Araujo Case," *The Oakland (CA) Tribune* (November 1, 2002).

19 John M. Sloop, *Disciplining Gender: Rhetorics of Sex and Identity in Contemporary U.S. Culture* (Amherst: University of Massachusetts Press, 2004).

20 Because not all transgender women desire surgery, we can only infer that in a transphobic culture, they are at great risk for violence. However, transsexual women who have had surgery have also been targets of violence.

21 Marian Meyers, *News Coverage of Violence.*

22 See note 12 and also Jane Caputi, *The Age of Sex Crime* (Bowling Green, OH: Bowling Green State University Popular Press, 1987).

23 Patrick LeTellier, "Beyond He and She: A Transgender News Profile," *The Good Times* (January 9, 2003).

24 See, for example, Kristen Clements-Nolle et al., "HIV Prevalence, Risk Behaviors, Health Care Use, and Mental Health Status of Transgender Persons: Implications for Public Health Intervention," *American Journal of Public Health*, 91 (2001): 915–22.

25 Kylo-Patrick Hart, "Representing Gay Men on American Television," in *Gender, Race and Class in Media*, second ed., edited by Gail Dines and Jean Humez (Thousand Oaks, CA: Sage, 2003), 597–607.

26 Ibid., 598.

27 Cedric Clark, "Television and Social Control: Some Observations on the Portrayal of Ethnic Minorities," *Television Quarterly* 9, No. 2 (1969): 18–22.

28 Nancy Nangeroni, transgender activist and founder of GenderTalk Radio based in Cambridge, Massachusetts, made her archives available to us. She co-organized the first demonstration for murdered transgender persons (Brandon Teena). She organized several demonstrations outside the murder trial of Chanelle Pickett and led the first vigil for Rita Hester in 1998.

29 To establish changes in coverage over time, we compared the number of words published about each person over the first seven days on which coverage appeared. Story word counts were published by the databases. If the story was not covered every day for a week, more than seven calendar days would elapse before the first seven days of coverage had been reached. For Deborah Forte, more than three years would elapse before her name was mentioned on seven separate days of coverage. For Chanelle Pickett, nineteen calendar days elapsed during the first seven days of coverage, from November 22 to December 11, 1995. For Rita Hester,

twelve days elapsed, from November 30 to December 11, 1998. For Gwen Araujo, however, only eight days elapsed—meaning that there was coverage every single day but one in the week in which her body was discovered—from October 19 to October 26, 2002. In comparison, 299 days elapsed during the first seven days of coverage in the Brandon Teena case—from January 1, 1994, to October 26, 1994.

The number of words published also reflects noticeable changes. For Deborah Forte, in 1995, the year of her murder, there were three days of coverage amounting to 1,137 words, all confined to the Boston area. In the first seven days of coverage of Chanelle Pickett's murder, 5,400 words, including wire service and newspaper reports, were published. For Rita Hester, all coverage in the first seven days was local to the greater Boston area, and amounted to 3,939 words. For Gwen Araujo, however, in the first seven days of coverage, 16,685 words were published, with extensive coverage in local and national newspapers as well as wire services. Subsequent stories in the Araujo case through April 2008 amounted to over 392,000 words, making her case by far the most covered news story on violence against transgender persons. In comparison, the Brandon Teena murder in 1994 received 14,961 words of coverage in the first seven days of coverage. Coverage of the Teena case from January 1992 through the end of 1995, apart from three articles discussing plans for a movie, amounted to 39,708 words, which included the trial proceedings of Teena's two killers.

In terms of the geographic scope, the Forte case was covered only by Boston area newspapers. The Pickett story was picked up within the first two days of coverage by wire services. Reports subsequently ran in the Indiana, Houston, New Orleans, Washington, D.C., Providence, and St. Petersburg news markets, as well as in USA Today. The Hester story, however, received no wire service coverage at all until a year later, when the Transgender Day of Remembrance was started. For Araujo, by contrast, within the first week of coverage, stories appeared not only in national and local newspapers, but in other media as well. Brandon Teena's story had extensive AP coverage from the first day, and was picked up in the first week of coverage by Canadian and Australian newspapers as well as a wide range of U.S. newspapers.

30 David Weber, "Lover Questioned in Death of Transsexual Man," *Boston Herald*, second edition (May 17, 1995).

31 "Haverhill Death Ruled a Homicide," *The Boston Globe* (May 17, 1995).

32 Bill Hutchinson, "DA Says New Lover Killed Man He Thought Was a She," *Boston Herald* (June 3, 1995).

33 "Suspect Admits Killing Transvestite," *The (Quincy, MA) Patriot Ledger*, September 17, 1996.

34 "Man Accused of Killing Transvestite," AP (November 22, 1995).

35 See, respectively in the November 22–23, 1995 time frame: for transvestite, AP, "Man Accused of Killing Transvestite" (November 22, 1995); "Suitor Allegedly Kills Transvestite," *The Washington Post*, Final edition (November 23, 1995); "Man Accused of Killing Transvestite Date, *Bloomington (IN) Pantagraph*, Final edition (November 23, 1995). For transsexual, see Ric Kahn and Matt Bai, "Victim's Twin Says Gender Was No Secret; He Disputes Alleged Motive for Slaying of Transsexual," *The Boston Globe*, city edition (November 23, 1995). For "date in drag," see Sean Flynn and Jason B. Johnson, "Preppy Wanted Dates in Drag, Cops Say," *Boston Herald* (November 23, 1995). For "sex secret," see Ellen O'Brien and Matt Bai, "Man Slain; Police Cite Sex Secret as Motive; Watertown Resident Met 'Woman' in Bar," *The Boston Globe*, city edition (November 22, 1995). For "deception," see "Deception Cost Cross-Dresser His Life," *New Orleans Times-Picayune*, third edition (November 23, 1995); and for "man who posed as a woman," see "Man Who Posed as a Woman Is Slain," *Quincy (MA) Patriot Ledger* (November 23, 1995).

36 See, for example, Ric Kahn and Matt Bai, "Victim's Twin Says Gender Was No Secret"; Sean Flynn and Jason B. Johnson, "Preppy Wanted Dates in Drag"; and Maggie Mulvihill, "DA Says Suspect Knew Date Was Man; Bail Reduced for Computer Whiz Accused of Slaying Transsexual," *Boston Herald*, Nov. 25, 1995.

37 Ric Kahn and Matt Bai, "Victim's Twin Says Gender Was No Secret."

38 This information was reported as follows: November 22, 1995 by AP, "Man Accused" and O'Brien and Bai; November 23, 1995 by Kahn and Bai; Flynn and Johnson; "Man Accused," *Bloomington Pantagraph*; "Man Charged in Murder of Transvestite," *Houston Chronicle*; "Deception Cost," *New Orleans Times Picayune*; "Man Who Posed," *Quincy Patriot Ledger*; "Suitor Allegedly," *The Washington Post*; Wire Reports, "Cross-Dresser Found Strangled in Bedroom," *South Bend (IN) Tribune*; and November 24, 1995 by AP, "No Bail for Man in Transvestite Murder," *Providence (RI) Journal-Bulletin*.

39 Sean Flynn and Jason B. Johnson, "Preppy Wanted Dates in Drag."

40 Paul Sullivan, "Slain Transsexual Mourned at Arlington Street Church," *Boston Herald* (December 11, 1995).

41 Gordene MacKenzie, *Transgender Nation*.

42 Sean Flynn and Jason B. Johnson, "Preppy Wanted Dates in Drag."

43 "Opening Arguments Held in Trial of Man Charged with Killing Transvestite," AP Newswires, April 16, 1997.

44 Sean Flynn and Jason B. Johnson, "Preppy Wanted Dates in Drag."

45 Ric Kahn and Matt Bai, "Victim's Twin Says Gender Was No Secret."

46 See Ric Kahn and Matt Bai; Sean Flynn and Jason Johnson; *Quincy Patriot Ledger*, "Man Who Posed"; *USA Today*, "Waltham- Prosecutors Say William Palmer, 34, Strangled Transvestite Roman Pickett, 23, Whom He Picked up at a Downtown Bar, After Discovering the Victim's True Gender" (November 24, 1995); and Robin Vaughan, "WBCN Rave Benefits Marquee Name Causes," *Boston Herald* (December 8,1995).

47 For the Netherlands, for example, see Y. L. S. Smith et al., "Sex Reassignment: Outcomes and Predictors of Treatment for Adolescent and Adult Transsexuals," *Psychological Medicine* 35 no.1 (2005): 89-99; for Denmark see T. Sørensen, "A Follow-Up Study of Operated Transsexual Males," *Acta Psychiatrica Scandinavica* 63 No. 5 (1981): 486-503. For Singapore, see W. F. Tsoi, "Follow-Up Study of Transsexuals After Sex Reassignment Surgery," *Singapore Medical Journal* 34 No. 6 (1993): 515-17. For the United States, see Clements Nolle et al. "HIV Prevalence, Risk Behaviors."

48 See, for example, Ric Kahn and Matt Bai, "Victim's Twin Says Gender Was No Secret"; Sean Flynn and Jason B. Johnson, "Preppy Wanted Dates in Drag."

49 Patricia Smith, "Facts, Decision Hard to Explain," *The Boston Globe* (May 19, 1997).

50 Maggie Mulvihill, "DA Says Suspect Knew Date Was Man."

51 Ann E. Donlan, "Friends of Murdered Transvestite Recall Pal, Mourn Loss," *Boston Herald* (November 30, 1998).

52 Many activists prefer the term cross-dresser instead of the medically generated and stigmatizing term "transvestite."

53 Nancy Nangeroni, "Rita Hester's Murder and the Language of Respect," *Sojourner: The Women's Journal* 24, No. 6 (February 1999): 16-17.

54 Ann E. Donlan, "Transgender Slay Victim Apparently Knew Killer," *Boston Herald*, (December 1, 1998).

55 Daniel Vasquez, "Stabbing Victim a Mystery to Many; Police Seeking Clues in Allston Slaying," *The Boston Globe* (November 30, 1998).

56 Ann E. Donlan, "Friends of Murdered Transvestite Recall Pal, Mourn Loss."

57 See note 40.

58 Massachusetts' largest gay and lesbian newspaper.

59 Nancy Nangeroni, "Rita Hester's Murder."

60 Ann E. Donlan, "'It's So Much like a Premonition'; Transgender Victim May Have Known Fate, Pal Says," *Boston Herald* (December 6, 1998).

61 www.rememberingourdead.org

62 Laurel J. Sweet, "Can-Do Cop Aims to Heat up Cold Cases," *Boston Herald* (April 17, 2005).

63 AP, "Protest Set For Burial," *The Grand Rapids Press* (October 25, 2002).

64 Janine DeFao, "School Play Hits Close to Home/ Newark Students Feel Real Sting of a Hate Crime," *The San Francisco Chronicle* (October 24, 2002).

65 See, for example, Knight Ridder Newspapers and *LA Times*, "Police Last to Know in Murder of Transsexual," *The Seattle Times*, Fourth edition (October 24, 2002); Michelle Locke, "Family, Community Bid Farewell to Killed Boy Who Lived as a Girl," AP (October 25, 2002); "Family, Community Bid Farewell to Killed Transgender Teen," AP (October 25, 2002); "Hundreds Attend Transgender Burial," AP (October 25, 2002), "One Defendant in Slaying of Transgender Teen Pleads Not Guilty," *The San Diego Union-Tribune* (October 25, 2002); "Family, Community Bid Farewell to Slain Teen Who Dressed as a Woman," AP (October 26, 2002); AP, "A Genderless 'Angel': Boy Who Dressed Like Girl Mourned After Being Killed at a Party," *Houston Chronicle* (October 26, 2002).

66 Margie Mason, "Violence Targets Transgender Community, Newark Teen Latest Victim," AP (October 19, 2002).

67 AP, "News in Brief from the San Francisco Bay Area" (October 22, 2002); Christopher Heredia, "Transgender Teen's Slaying Shakes Nation/ Newark Boy's Death Prompts Discussion in Schools, Among Advocates—and at Home," *The San Francisco Chronicle* (October 23, 2002).

68 Janine DeFao, "School Play Hits Close to Home."

69 Margie Mason, "Violence Targets Transgender Community, Newark Teen Latest Victim," AP (October 19, 2002), "California Teen Became Latest Victim of Violence Against Transgender Community," AP (October 24, 2002); AP, "Slain Teen Suffered Familiar Fate, Anti-Transgender Violence Is Common," *San Diego Tribune* (October 20, 2002); AP, "News in Brief From the San Francisco Bay Area," (October 22, 2002); *US Newswire*, "Murder of CA Youth Spotlights Need for Better Implementation of School Safety Law; GLSEN Calls on CA Dept. of Education to Respond" (October 23, 2002); Knight Ridder and *LA Times* (October 23, 2002); "Boy Who Acted as Girl Killed," *The Cincinnati Post* (October 24, 2002); Michelle Locke, "Family, Community Bid Farewell" (October 26, 2002); AP, "A Genderless 'Angel'," *Houston Chronicle* (October 26, 2002).

70 Margie Mason, "Violence Targets Transgender Community"; AP, "California Teen Became Latest Victim; AP, "Slain Teen Suffered Familiar," *San Diego Tribune*; and AP, "Boy Who Acted," *Cincinnati Post*.

71 AP, "News in Brief from the San Francisco Bay Area" (October 22, 2002).

72 See, for example, Michelle Locke, "Defendant Coolly Lays Out Ugly Details of Teen's Death," AP (February 25, 2003).

73 None of the defendants were convicted of a hate crime.

74 Henry K. Lee, "Guilty Plea in Transgender Killing/ Defendant Makes Deal, Testifies Against Friends," *The San Francisco Chronicle* (February 25, 2003).

75 Phillip Matier and Andrew Ross, "All in the Family," *The San Francisco Chronicle* (June 28, 2004).

76 Michelle Locke, "Family, Community Bid Farewell to Killed Boy Who Lived as a Girl," AP (October 25, 2002). This is in sharp contrast to how Chanelle and Rita were depicted in the

news as apart from family and community. It wasn't until the vigil that Rita's family appeared in the coverage.

77 Gay and Lesbian Association Against Defamation, "GLAAD Was There": www.glaad.org/documents/about/2002accomplishments.pdf.

78 The updated wording reads "Use the pronoun preferred by the individuals who have acquired the physical characteristics (by hormone therapy, body modification, or surgery) of the opposite sex and present themselves in a way that does not correspond with their sex at birth. If that preference is not expressed, use the pronoun consistent with the way the individuals live publicly." Dana Hull, "He Said, She Said," *Columbia Journalism Review*, 41, No. 10 (2003): 10.

79 "Was Eddie 'Gwen' Araujo a 'He' or a 'She'?," AP (December 22, 2002).

80 Locke now uses Gwen's legal name. Gwen Smith notes Locke and other journalists whom transgender activists worked with have also become advocates for transgender rights.

81 Christopher Heredia, "Transgender Teen's Slaying Shakes Nation/ Newark Boy's Death Prompts Discussion in Schools, Among Advocates—and at Home," *The San Francisco Chronicle* (October 23, 2002).

82 Deborah Frazier, "Killer of Teen Gets 40 Years; Man Apologizes for Slaying, but Mom Still Claims He's Innocent," *Rocky Mountain News* (June 4, 2002). Some reporters reduce the idea of two-spirit to "he felt like a girl in a boy's body," which does not convey the complexity of how gender is viewed in some Native American cultures (Mason, "California Teen Becomes").

83 "LLEGO Mourns Death of Latina Transgender Youth; Organization Joins Efforts to Create Healthy Communities for Transgendered Individuals," *US Newswire* (October 24, 2002).

84 Yomi Wronge, "Bill Aims to Block 'Panic' Defense: Proposal Named for Transgender Teen," *San Jose Mercury News* (January 16, 2006).

85 Carolyn Jones, "San Leandro Tensions Ease over Gay Posters: Conflict Resolved by Faculty Meetings, Principal Says," *San Francisco Chronicle* (January 26, 2006).

86 Marian Meyers, *News Coverage of Violence*.

THE POLITICIZED ARENA OF VIOLENCE

CHAPTER 6

Invisible Women

Chinese Media Responses to the Japanese "Orgy"

Peter C. Pugsley and Jia Gao

This chapter explores the portrayal of the 2003 "Zhuhai Incident" in China where several hundred Japanese businessmen were involved in procuring the services of hundreds of young female Chinese prostitutes for a "three-day orgy" (as widely described in the media) at a luxury hotel in southern China. The ensuing media outcry—locally and internationally in both the conventional and digital media—focused on a range of side issues mostly concerned with Sino-Japanese history. The women involved, as victims of gendered violence, were virtually ignored in subsequent debates. Instead, the story was to be ultimately framed in relation to the day commemorating the 1931 Japanese invasion in China's northeast, as shown by the comment in the online English-language edition of the *China Daily*: "They [the Japanese businessmen] came on purpose for September 18."[1] This is a significant date in China's history, known as "9/18" (*jiu yiba*) and etched into China's memory in a similar fashion to the United States' 9/11. Yet most reports note that the "orgy" began on the 16th, two days before the anniversary and had all but petered out by the 18th. Why then, the insistent link to the anniversary date? This chapter is interested in not only the Zhuhai incident itself and the reporting of it, but also the broader positioning of gender in such an event, and, as well, the practices of the Chinese media in dealing with reportage of events involving prostitution and sexual assault. While the Chinese media played an important role in revealing this serious incident of mass prostitution, forcing the government to take swift action, the media also portrayed the event as shameful and humiliating to the nation. As a result, there is little discussion of the sex workers/prostitutes as "victims," nor as the recipients of sexual violence.

The issue of prostitution has long been problematic in China. The state-based All China Women's Federation, for example, has held firm on the line that "the commercialisation of sex is 'exploitation', 'harmful' to women's rights and completely inappropriate in a socialist state."[2] But the central problem of prostitution in China seems to be one of recognition, with one academic even posing the (rhetorical) question of whether China actually has *any* sex workers.[3] This lack of recognition supports Lisa Rofel's contention that China's "postsocialist feminists decry the invisibility of women's bodies,"[4] an invisibility that renders it "impossible for women to speak about new forms of devaluation they experience."[5] There is also a divide in Western feminist discourses on the issue of prostitution with one camp placing prostitution "on a continuum with the forms of sexual abuse and inequality that women frequently experience," and another camp proposing that "consensual sexual acts, whether cross-generational, sadomasochistic, or commercial, are not vices to be prohibited and thereby kept marginal and distorted."[6] But the Chinese mainstream media remain silent on this debate.

This chapter is concerned with the discursive uses of the contemporary Chinese media as a socio-political institution, and its role in spreading gender-biased stereotypes through the particular framing of news stories. We will first look at how the story of the Japanese "orgy" (this problematic term suggests the involvement of willing participants in the sexual acts, rather than as a commercial transaction) in Zhuhai was made public in the People's Republic of China, a country where freedom of the press is often believed to be non-existent. We will track how a highly localized event in a hotel in a medium-sized coastal town not only reached the local media but spread quickly and widely as an international event. The discussion will continue with an analysis of how the conventional press and broadcast media combined with digital media sources to (eventually) generate political pressure on state government officials at all levels, thus initiating a media-orchestrated campaign against those involved in the criminal activities in Zhuhai. But most importantly, we will examine how the Chinese media have treated this episode of gendered violence, and, in the process, denied agency and voice to several hundred Chinese sex workers. By reframing this story as a national humiliation, China's media chose to turn a blind eye to the alarming fact that 500 sex workers could be corralled together at short notice to provide sexual services for a touring party. Instead, the print and digital media chose to fan the flames of nationalism throughout China and its diasporic reaches.

Putting the Japanese Orgy in the News

The incident occurred in the Zhuhai International Convention Centre Hotel (*Zhuhai Guoji Huiyizhongxin Dajiudian*), a luxury hotel in Zhuhai, a coastal tourist resort city in the southwest of Guangdong Province near Hong Kong and Macau. Although the media and Internet activists firmly link the incident with September 18th, it actually began on the night of September 16th and lasted until late September 17th with many of the Japanese leaving the hotel on September 18th. This was an organized tour, sponsored by an Osaka-based construction company as part of its fifteenth anniversary celebrations. The company arranged a three-day "party tour" for its male staff members and clients, aged between 16 and 37, beginning on September 16th, with the promise of "fun times" with Chinese girls.[7] The unashamed grouping of male-only staff reflects Pierre Bourdieu's contention that "manliness must be validated by other men," and, with the involvement of young men, or boys, as young as 16, suggests that certain "rites of institution" were being enacted.[8]

The tour was carefully orchestrated by the company, which sent three staff members to Zhuhai in August to not only book hotel rooms, but also to make arrangements with local night club operators to procure the services of hundreds of Chinese girls. A contract was signed between the company and the hotel, with the latter part of the contract dealing exclusively with the procurement of young women for the party.[9] The entire incident began with a welcome dinner held soon after the arrival of the approximately 100 Japanese male visitors on September 16, 2003.[10]

What the organizers and Japanese company neglected to consider was that this event was held in the midst of a rising anti-Japanese sentiment in China.[11] While Zhuhai is a highly commercialized coastal town, far from the traditional heartland of Chinese culture and politics, it is also notorious for its international sex tour industry, with most of its trade coming from the neighboring nations including Japan and Korea. The party organizers also overlooked the fact that the Zhuhai International Convention Centre Hotel is a large hotel (as shown in Figure 1) and often houses a number of large events concurrently. At the conclusion of the official welcome dinner on the evening of September 16, 2003, the first group of hundreds of Chinese girls was introduced to their foreign clients. However, their behavior drew the ire of many Chinese staying in the hotel, and reports later emerged describing the event as involving "scenes of promiscuity and carnality."[12]

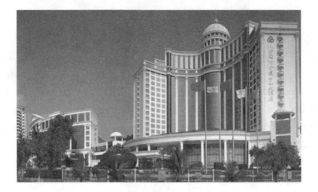

Figure 1. The Zhuhai International Convention Centre Hotel

One of many guests attending a national summit on hospital management and investment was Zhao Guangquan, a successful medical entrepreneur from Henan Province in eastern central China. Zhao was profoundly disturbed by the large number of Chinese girls offering their services to the huge delegation of Japanese men. As a native of the traditional, culturally conservative north, Zhao describes himself as a person who is not intolerant to, nor unaware of, certain types of new social phenomena including prostitution in coastal cities and in luxury hotels.[13] What he observed in the foyer of the hotel, the floor where he stayed, and even in the hotel's lifts, was too much for him: offensive at a personal level and humiliating for the people of China as a whole. In the early morning of September 17th, as Zhao told *Zhengzhou Evening News* in his hometown, "all eight lifts in the hotel were sending hundreds of Chinese girls and Japanese men up and down for more than an hour."[14] Through his observation, he collected five pieces of evidence. First, the number of Japanese male tourists and Chinese girls was unbelievably large, and he was shocked to see that a number of Japanese guests shamelessly began their sexual acts while hundreds of Chinese girls were still jammed in the foyer and lifts. Second, there was a large display board in the foyer, clearly indicating that this was part of "The 15th Anniversary Celebration of Heisei Ltd. of Japan."[15] Third, Zhao was told by receptionists that two big tourist coaches would deliver more girls from other nightclubs to these Japanese visitors, which proved to be true as loud noises and open sexual activities throughout the hotel disturbed him and his colleagues for the entire night. Fourth, and perhaps even more offensive, when some of the young Japanese men were asked by Zhao why they were in China, a number explicitly replied that they had "come to f... Chinese girls."[16] And finally, this massive prostitution event was repeated for the whole of the next day, making more than one hundred attendants of the hospital manage-

ment summit extremely angry. These ugly scenes became their main topic of discussion for more than two days. When the hospital delegates gathered for a cruise on September 18th, the collective anger was so obvious that Zhao felt he had to do something.

After failing to convince either the hotel management or the local officials to take immediate action to punish the Japanese tourists and the orgy organizers, Zhao decided to apply his entrepreneurial spirit to this serious issue by contacting the media. Zhao contacted *Nanfang Daily* and *Chinese Youth Daily*, two highly regarded newspapers that have been actively engaged in reporting on contentious social and political issues in recent times. Two young journalists, Xiang Xianjun from *Nanfang Daily*, the official newspaper of the Guangdong provincial committee of the Chinese Communist Party (CCP), and Lin Wei, a Guangzhou correspondent of *Chinese Youth Daily*, the institutional newspaper of the Chinese Communist Youth League (CCLY) sensed that this was a "newsworthy" topic. Zhao's story had the ability to either help the two journalists produce an investigative masterpiece that would enhance their reputation (and the possibility of promotion), or, if they ignored it, destroy their careers. As a result of the ongoing professionalization (*zhuanyehua*) drive of media personnel (as part of the nation's broader modernization push since the 1980s), each journalist's professional and enquiring manner is now seen as the key to career advancement.[17]

As in many Western societies, crime is an inherently "newsworthy" topic for the Chinese media.[18] Since the 1980s China's news media have enjoyed varying degrees of independence as a result of the commercialization of the news industry, most notably the newspaper industry. Having operated for more than a decade in an increasingly commercialized and competitive market place, newspapers are hungry for newsworthy items, which can be utilized to increase sales. In addition to the basic news "values" of truth in reporting, there are also two different types of "political awareness" in China that influence what must be reported. First, because of a deeply-rooted history of popular anti-Japanese sentiment,[19] the Chinese media have long considered it their duty to keep the humiliation of Japan's invasion of China in the 1930s and 1940s in the national collective memory. This is supported by the old Chinese saying, *Qianshi buwang, houshi zhishi* (past experience, if not forgotten, is a guide for the future),[20] which has been repeatedly used by generations of Chinese leaders when meeting Japanese guests. In fact, any anti-Japanese or Japanese invasion-related story always receives widespread coverage, let alone a story as shocking as the events in Zhuhai. For the same reason, it would be a critical oversight if a Chinese newspaper failed to report on a story as shocking as the mass prostitution event, which resonated with the anger and shame felt

following the Japanese invasions in the 1930s and 1940s in which the "[b]rothels and the battlefield were both sites for the production of gender" and increasingly weary Japanese soldiers were committing "acts of brutality" against women in China.[21]

Apart from information that they collected from Zhao Guangquan in the week following the incident, the two journalists also went to the hotel on September 25th to interview hotel staff. Through their own investigations, not only was the entire event proven to be true, but they also confirmed that this was a well-organized event involving hundreds of Japanese male tourists and Chinese girls. The price of each girl's service ranged from ¥1,200 to ¥1,800 Chinese yuan per night (equivalent to US$145 to US$218 at the time).[22] What was more "newsworthy" to these two journalists was that the Japanese had wanted to hang their national flag in the foyer when they first arrived but had their request refused by the hotel management. Also, they discovered that most of the Japanese businessmen had left the hotel on September 18th. When the confirmed incident was linked with September 18th (or "jiu yiba," literally "9/18"), the two young journalists found both the evidence and the theme not only to write a masterpiece but also to convince their bosses to get the incident published.[23]

The news appeared in four newspapers on the next day, September 26th: The New Express (Xin Kuaibao), a Guangzhou-based local newspaper; Nanfang Dushibao (Southern Metro News); Nanfang Daily; and Chinese Youth Daily, a Beijing-based newspaper.[24] Within a day, almost all major Chinese Websites (such as sina.com, sohu.com, chinadaily.com) and the People's Daily, the largest official newspaper run by the CCP, had put the report on their front pages framed as an issue of Sino-Japanese sensitivity.

The Media-Orchestrated Campaign Against the Orgy

The report of the Japanese orgy and its involvement of approximately 400 Japanese male tourists and 500 Chinese girls sparked outrage in China and its diaspora. While the print media played a crucial role in the initial coverage of the incident, its slow pace for the further spreading of emotive responses was not as effective as the digital media's ability to produce and disseminate immediate reactions. Messages left by net-surfers surpassed 10,000 within only a few hours after the news was carried by the Sohu Websites, and increased at more than 1,000 items every hour according to the China Daily.[25] Another popular website recorded about 15,000 messages posted on the subject within hours, according the BBC's correspondent in Beijing.[26] The print media's role in influencing its readers and spreading information about the incident was again overshadowed by China's massive digital media and its immediate

mobilization of thousands of Internet users. A nationwide public campaign against the Japanese orgy was then well underway.

One important factor in later assessments of the incident as a media event was that some foreign media viewed the Chinese media's response as a typical case of oppressive state control, with Reporters Without Borders posting an article stating that:

> At the end of September, Guangdong propaganda department ordered local media to change their articles on an orgy organised by nearly 200 Japanese tourists in Zhuhai hotel. The media were accused of fuelling anti-Japanese sentiment and local journalists who had broken the story were reminded that Japanese investments were important to the province. On 20 November, a few weeks after the revelation of the orgy by New Express, the daily devoted its front page to the story of a retired Japanese man who over 13 years donated more than two million euros to the region's schools and hospitals.[27]

While this report may seem to provide a logical explanation of state intervention given China's past history of heavy-handed media control, there is no supporting evidence to show that there were authoritarian directives from either the party leadership or the state to prevent coverage of the incident.[28] There is a tenuous link between the first part of the story with the propaganda department "ordering" the media to alter their work and the second part with the front-page story of the Japanese philanthropist. Instead, the November 20th report may be more effectively explained by considering a market- or audience-based approach in which the newspaper's editors were directly responding to local demands, taking into account that the province wished to attract more foreign investment, including Japanese capital, and to open up its tourist industry. Contrary to the "oppressive control" theory, the party-state systems were forced to follow public opinion and take swift action against people involved in the crime, regardless of financial cost. The Zhuhai International Convention Centre Hotel was closed on 27 September 2003, one day after the New Express and other newspapers broke the story, and both the Public Security Bureau of Guangdong and the Zhuhai Municipal Government began immediate investigations. Originally, the investigations were said to be to find out whether the media report of the orgy was true, but the suspension of the hotel's trade appeared to provide firm evidence of its accuracy.

Shortly before this episode, investigative reporting in China's media had uncovered numerous serious issues such as the AIDS problem in Henan province, the safety issues of Chinese mines, and the SARS cover-up involving Guangdong.[29] Each of these issues highlighted the inappropriate responses of the party-state system to the initial media coverage of the events, resulting in the termination of the political career of many officials at the national, pro-

vincial and local levels. What made this Japanese orgy different from the three prior episodes was that this time it was not merely a "local" issue but an internationally significant event that involved some 400 Japanese men, an incident that would, in the words of the BBC's Beijing correspondent, become "a lightning rod for anti-Japanese sentiment."[30]

The outpouring of anger quickly rolled across almost all major websites in China, generating not only political pressure on the party-state system at different levels but also unleashing an opportunity for both the print media and digital media to pursue the issue further. Apart from angry and provocative remarks, calling for the Japanese to be executed and the hotel "blown up," the general consensus among China's internet community was that the incident was "the shame of the nation."[31] The public outcry was escalating, with nearly 96,000 messages posted on the popular NetEase, (known as "163 Net" in China), in the following twenty-four hours, criticizing both the Japanese tourists and the government, especially officials in Zhuhai and Guangdong.[32] The swift involvement of both the CCYL's *Chinese Youth Daily* and the *People's Daily*, the institutional newspaper of the CCP Central Committee, reinforced the groundswell of anger and sent a strong message that was considered to be more threatening to higher-ranking officials than other sources. The *People's Daily* in particular not only covered the incident but also allowed for a large number of openly hostile messages to be posted on its website, many demanding that the Japanese be brought back to China to stand trial and that Zhuhai officials resign. Yet there was still no information on the fate of the sex workers involved in the event, apart from one article that noted that the hotel guards checked the purses of the prostitutes to ensure that "they did not take anything away from the Japanese." While this was a further humiliation for the women involved and an overt show of the guards' distrust of their fellow citizens, this detail was not mentioned in any other reports.[33] There was no mention whether they had been harmed or subjected to violent behavior during the event. The debate raged on, with the women all but forgotten.

A key person responsible for dealing with the incident and the public outcry was the CCP's Guangdong provincial secretary, Zhang Dejiang, who was transferred to the province as its party chief in November 2002. It is not known whether Zhang learned his lesson from the SARS cover-up that took place almost at the same time as he assumed this provincial post, or because of his long-time experience within the CCP and his education at Kim Il-sung University in North Korea, but Zhang swiftly ordered the Public Security Bureau to handle the case in the strictest manner. His order was also reflected in the comments made by a number of Zhuhai local officials, claiming that they had taken the case very seriously and would track down any people breaking

laws. Under such circumstances, although the hotel's spokesperson insisted that the reports were exaggerated, and police believed it would be difficult to retrospectively investigate the incident, the message from higher-ranking officials was loud and clear: arrest and punish those involved in organizing the event. Up to this point, the media further politicized the issue by quoting a Peking University professor who reportedly said that the Chinese government's attitude was the key, and if the government did not take it seriously, it would be hard to predict the public's behavior.

The growing wave of anger and its subsequent political implications also put pressure on the national leadership, who were no longer able to ignore the ongoing public debate. Shortly after the initial media reports of the incident, on September 29th China's Foreign Ministry summoned a Japanese Embassy official to Beijing to make a formal protest. It was said that officials described the incident as an "abominable" act that had "hurt the feelings of the Chinese people" and "severely damaged" the image of Japan in the world.[34] Before this official protest, the spokesman for China's Foreign Ministry described the case as being of an extremely odious nature and recommended that the Japanese Government needed to better "educate its citizens"—not a very diplomatic response even by Chinese standards![35] At the same time, a Japanese Foreign Ministry spokeswoman admitted that within a few days of the story entering the public arena, the government had received an official request for "cooperation" from Chinese authorities in investigating the incident. Despite diplomatic words, the president of the Osaka based firm would only admit that his company had organized more than 280 staff to visit Zhuhai at the time of the alleged orgy but, in a statement carried by the Japanese media, bluntly denied allegations that the trip had involved the "systematic engagement" of prostitutes."[36]

While the digital media were spreading strong emotional responses, the print media took advantage of their existing correspondent network, focusing on follow-up coverage and in-depth analysis. To show just how nasty the incident was, a later newspaper report revealed that a Chinese interpreter attending the welcome dinner on September 16th had become furious when a Japanese imperial military song was played and more than 330 Chinese girls filed into the dining hall. Chinese people are familiar with such music and the scene of the Chinese girls "marching" to the Japanese tunes replicated the sights and sounds of many anti-Japanese films, TV series, and stage plays. The interpreter angrily protested but was told that his employment position did not entitle him to voice his anger.[37] Under increasing pressure from the media and higher-ranking leaders, including Zhang Dejiang, the head of the Provincial Public Security Bureau went to Zhuhai with a team of officers to take

charge of the investigation. In fact, police had initially arrived at the hotel several hours after the incident was first reported, but unlike the Zhuhai municipal government officials first contacted by Zhao Guangquan, the police did not pause to question the validity of the report. Instead, they seized videotapes from surveillance cameras in the hotel and detained several people. A Chinese woman suspected of being one of the key organizers of the event fled to Hunan after media reports of the incident but was arrested just days later. Within two or three days, police had arrested other suspects, mostly in Zhuhai, including about fifty prostitutes involved with the orgy, however there is no public record of their versions of the initial incident.[38]

A unique approach in this media-orchestrated and very public crusade was the push for the punishment of those government officials responsible for the massive and illegal sex tourist industry in the city and for the slow response to the initial reports of the incident. It became obvious at the start of the investigation that police from the provincial public security bureau had focused their enquiry on the Chinese suspects involved in organizing the mass prostitution, but both the print and digital media wanted police to expand their investigations to probe local officials at the same time. Of course, the digital and print media were playing different roles in this regard. While the former was carrying a large number of comments and criticisms put forward by Internet activists, the latter was seen to engage in interview and investigative styles appropriated from popular on-line forums or chat-rooms. In this particular course of action, the media outside the local party-state system of Guangdong had been more active than the local provincial media in pursuing officials responsible for not only the incident but also for failing to conduct subsequent measures.[39]

What this action also suggests is that Chinese readers and audiences have finally shown their powers of influence by taking an active, grass-roots role alongside organizers and media producers as one of the so-called "three contractual partners"[40] in opening up communications in China. They have generated a dynamic "bottom-up" process that is believed to have been absent from Chinese society for decades. This contrasts with the more commonly favored "top-down approach" in attempts to portray an accountable state by encouraging the media to highlight activities such as official corruption through the reporting of misbehavior by officials, resulting in the Chinese media becoming visibly more active in engaging in investigative reporting.[41] In fact, China's coverage of the Japanese orgy has shown that the rapid transformation of its media has moved beyond the traditional dichotomy between "profit and ideology," brought about by the schism between the decidedly "free-market" of the nation's oft-cited "socialist market economy" and the

formerly authoritarian approach of Communist rule.[42] There has been a convergence, of sorts, in which the "bottom-up" approach is no longer seen as anathema to the state, providing the topic does not pose a direct threat to the workings of the party-state system.[43]

Because of this media-orchestrated campaign, more than fifteen officials from the Zhuhai municipal party-government system, including directors and their deputies of both the Zhuhai public security bureau and the municipal bureau of tourism, were disciplined at the internal party and executive levels for negligence of duty. Although the subsequent punitive actions were not harsh, and no local government officials were found to be involved in organizing the orgy, the number of officials disciplined was large enough to calm the internet activists and the hostile public opinion. At the same time, after almost two and a half months, the local public prosecutor in the Zhuhai Intermediate People's Procuratorate took the case to court, filing proceedings against those suspected of being involved with the event. Once the court action was well underway, drawing the attention of the media, the hotel quietly reopened on 6 December 2003, with approval from the local bureaus of public security and tourism.

A local Zhuhai court opened its trial on the case on 12 December 2003, less than three months after the incident. Although the public and nonessential court employees were barred from the courthouse due to privacy concerns, the entire procedure had been under extensive scrutiny of both local and international media. The court spent a week on the case, and then sentenced two Chinese defendants, one of which was the assistant to the general manager of the hotel, to life in prison on 17 December 2003 for organizing the mass prostitution. The hotel's deputy sales manager was sentenced to fifteen years. Eleven other defendants were sentenced to prison terms ranging from two to twelve years, including hotel staff, night club bosses, pimps, prostitutes and the employees of a local Japanese-funded company; police requested the assistance of Interpol to locate three Japanese men suspected of soliciting prostitutes for the orgy.[44]

China's Hidden Prostitution

Bringing prostitution into the public eye has long been a difficult proposition for China's ruling elites. When the CCP took power in 1949, they were quick to embark on a number of campaigns to eradicate prostitution in line with Mao Zedong's idealistic and seemingly non-discriminatory slogan that "Women hold up half the sky." While the eradication of prostitution was held up as "one of the major accomplishments of the Maoist regime," the later appearance of anecdotal evidence to the contrary convinced a number of outside

observers that this claim occurred "irrespective of its actual validity." [45] But with China's efforts at presenting a modern, transparent state since the 1980s, the government has had to acknowledge that "the phenomenon of prostitution has not only reappeared on the mainland, it also constitutes a widespread and growing problem."[46] The main concern with this confession, of course, is that to admit that prostitution exists in China is "an acknowledgement that the long-term education of the Party has accomplished nothing."[47] As one attempt to broach the subject in an acceptable manner, an 8 October 2003 *China Daily* report, some two weeks after the Zhuhai event, firmly stated that "Chinese police have already detained suspects and closed the Zhuhai International Conference Centre Hotel where more than 400 Japanese male tourists allegedly had sex with some 500 Chinese prostitutes from September 16–18."[48] In this way the media neatly framed the story through emphasizing the efficacy of its police force, the "guilt" of the Japanese tourists, the significance of the date, *and* through a de-emphasizing of the issue as one that involves gender, health and rights issues.[49]

While the public forum offered by the media in the Zhuhai incident may have seemed to provide a suitable space for opening a broader discourse around the role of women and repression (state or otherwise) in contemporary China, this opportunity was denied by the reframing of the event. But again, this is hardly a new phenomenon. Lisa Rofel writes of Chinese feminist Li Xiaojiang's ill-fated "women's museum" (a public space designed to commemorate the role of women in China's history) and Li's struggle with finding a visible site for constructing a lasting monument to female identity within the confines of "the representational and practical powers" imposed by the state."[50] The problem of recognition is seemingly so entrenched for women in contemporary China that:

> The masculinist politics that transnational capitalist and cultural productions brought to China operated counter to her [Li's] desire to theorize women into existence. Western feminism was equally useless to her project. For Li Xiaojiang, Western feminism is a struggle for rights and equality. Since the socialist revolution, she pointed out, Chinese women have long had these rights. They have not led to liberation.[51]

Similarly, Harriet Evans argues that 1980s reforms led to major interventions in women's lives ranging from the "fertility limitation program" (the "one-child policy") to the state's withdrawal from providing employment for all citizens, which resulted in "new spaces for the construction of women as commodities for sale—and often violent abuse—on the open market."[52]

This brings us to one further discourse that suggests that women working in prostitution are willing participants in a capitalist system, rather than innocent, oppressed girls to be pitied. This view further victimizes the role of female sex workers in China. Indeed, this proposition is supported by reports that "as presumed high income earners, an increasing number of women who sell sex have been physically assaulted, and even murdered, in the course of attempts to steal their money and property."[53] Others portend that the nation's sex workers are "more like autonomous bread-winners than miserable victims of a social system,"[54] but to dismiss China's sex workers as simply "autonomous bread-winners" is to adopt a blinkered approach. Evidence of the trafficking of young women from China's poorest rural areas is abundant, and the fact that the organizers of the Zhuhai incident were able to source hundreds of girls for the event (some who were later tracked back to their hometowns in rural areas)[55] suggests that prostitution is rampant and the exploitation of vulnerable women still takes place on a grand scale. For example, even while the Zhuhai incident was unfolding, Guangdong police were involved in a massive antiprostitution campaign which uncovered a prostitution ring involving prostitutes from Hunan, Jiangxi, Sichuan and Guangxi Zhuang regions.[56]

Such prostitution rings offer many women in the poorer nations of the world a rapid entry into a global economy where "the most vilified and illicit forms of trade are quietly condoned and encouraged."[57] Is this why the Chinese and other media fail to criticize the large-scale use of prostitutes in the Zhuhai case? While much research on sex trafficking focuses on the forcible movement of women and girls across national borders, the description of organizers as a "contemporary version of slave-traders" is no less relevant in China's case where the ring-leaders of prostitution rackets are involved in a process where they are said to "abduct their victims and transport them to other places against their will, usually for profit."[58] With the support of a willing tourism sector the Zhuhai incident can be seen to mirror the (admittedly larger problem) of the sex industry in countries like Thailand where the "tacit acceptance" of the industry "has become so lucrative and so powerful that this industry's need for a constant supply of labour has shaped planning policies for the nation."[59] For example, a Zhuhai hotel spokesperson was reported as saying that although they played no direct role in the "sex rites," it was the hotel's duty to "serve every client well" and that prostitution was "a common phenomenon in star hotels across the country."[60] As noted, China's regulatory discrepancies between different locales, resulting in "looser standards in more developed regions,"[61] certainly contribute to the rise of more visible forms of prostitution. And while China's coastal cities lure a steady "stream of dis-

placed young female workers" in search of employment, for many, sex work is often the only option available to them.[62]

That this event occurred in this particular locale is perhaps not surprising: Zhuhai and other cities in the Pearl River delta adjoining Hong Kong have become centers for prostitution, drawing women/girls to work from more impoverished parts of the country and enticing male customers from Hong Kong, Taiwan, and Japan.[63] Located on the curiously named Middle Lover's Avenue, the Zhuhai hotel that hosted the event is the largest convention center in a city that sees itself as a gateway into the province of Guangdong. Indeed, Pan Suiming suggests that at least three different versions of the standard "red light district" exist in China.[64] The first and most apt example is the "Lately Developed and Extroversive" district, which has experienced rapid economic growth and is physically close to bordering provinces and other nations. Pan draws from an example in the Pearl River delta which "principally services the people of Hong Kong and Taiwan."[65] In other words, Pan is describing the city of Zhuhai. Importantly, he notes the government's dilemma whereby it is "confronted with a widespread essential tolerance towards prostitution" simply because "[o]fficial dogma does not dare to associate prostitution with foreign investment because the latter is the engine for the open policy, the gateway to new found prosperity."[66] Any threat to the sex industry in this region is, therefore, likely to have widespread economic implications. This created a dilemma for the Chinese media: shifting the debate from an issue of gender to an issue of nationalism risked long-term damage to regional tourism through any resultant fallout with Japan.

The rise of prostitution in China's coastal areas has also led to a return to the (previously noted) sexual abuse and inequality that was quickly and quietly hushed up by authorities and that negate any hope of a public discourse based on the identity politics of China's female sex workers. Furthermore, Western understandings of prostitution and the oppression of women as an issue of "individual rights/identity politics" are mostly limited to cultures where individualism and other forms of democracy are favored and cannot sufficiently explain "Chinese prostitution discourses."[67] Although some believe that the individual rights issue is restricted, or smothered, in China, there has never been an absence of idealistic talk about such rights.[68] But talk is one thing: any positive action to address rights violations has been overshadowed by the new systems created by reformist policies in which the media (and the state) struggle to find the best way to manage or present the issue of individual rights. Of course it would be remiss of us to cite this as merely China's problem. Many Western commentators view prostitution as "a form of violence against women" and decry the fact that it continues as an "invisible issue" that re-

mains "low on just about everybody's agenda: moralists; law reformers; police; feminists."[69] What this does illustrate is that the media portrayal of the Zhuhai incident is indicative of broader and more complex political and societal discourses in which women are slighted. It highlights a missed opportunity for the Chinese media to engage the public in long-overdue debates on gender hierarchy and the rights of women.

This lack of visibility is perhaps not surprising in societies where patriarchal structures still deeply influence various facets of the public sphere. In a society with strong patriarchal traditions like China, where the state-run media system plays an important role in reflecting and promoting particular ideologies, men are able to play out their fantasies of maintaining "their social power through the subordination of women."[70] Thus, the nation's ruling elites attempt to "legitimise unity" by constructing narratives that draw on "traditional Chinese 'values' of devotion, piety and face-saving,"[71] and the women central to the Zhuhai incident are framed in a way that eradicates them as individuals and recasts them as collective representations of a vulnerable nation. After all, China's leaders are ever vigilant to avoid any comparisons to the late nineteenth-century narrative of China as the "sick man of East Asia:" overly effeminate and vulnerable to defeat.[72] In an odd twist, prostitutes are also "doubly linked to the nation" with the rapidly developing economy seen as an opportunity for them to work their way out of prostitution, while "any breach of prostitutes' bodily integrity" by foreign men is seen as indicative of a defenseless economy.[73]

This return to the circle-the-wagons approach found in the national collective is supported by the adherence to nationalistic narratives, even though the CCP's Propaganda Department had tried to guide the media to avoid "stirring nationalism" after initial reports of the Zhuhai incident appeared in Chinese Youth Daily and Xinkuaibao.[74] Indeed, this recognizable narrative gave the government the "opportunity for a distraction from everyday problems" including "poverty, rapidly escalating unemployment and overcrowding of urban areas, and corruption at various levels of the provincial and state hierarchies," and, of course, we can add prostitution to this list.[75] As noted, the CCP's "continued reliance on the equally outmoded campaign formula of the 1950s" to eradicate prostitution had failed spectacularly due to it being "predicated on an outdated 'ideological' construction" of prostitution that saw the trade of sexual services as counter to the aims of the socialist movement.[76] However, the ideological and hierarchical construction of gender still remains, and the media continue to promote the nation along these lines utilizing a "gendered strategy" of "erasing" women in the name of "worlding China."[77]

While the failure to eradicate prostitution in China can be easily blamed on earlier campaigns, the campaigns themselves cannot be held singularly responsible. Ever-present corruption at all levels of officialdom has also contributed significantly to the problem of prostitution, with a blurring of the line between those officials who push for the effective delivery of policy (the carrying out of campaigns), and those who engage in corrupt behavior in order to gain financial (and physical) benefits. This has been noted by other commentators, to the extent that:

> By the start of the new millennium, a whole host of disparate concerns had converged to ensure that China's burgeoning hospitality and service industry was posited as a necessary target of 'macro political' intervention. I say 'necessary' in the sense that, if the late 1999 'strike hard' campaign to enforce the Entertainment Regulations was designed to control illicit business operations and the activities of 'hostess-cum-sexual service providers', the follow up campaign of 2000 further aimed to address public and governmental concerns over the continued link between the provision of commercial sexual services and governmental corruption.[78]

This increasingly complex intertwining of public and private "profit-seeking practices" in China is exacerbated by the vast disparities between "provinces, counties and cities in their interpretations and sometimes outright violations of central policies."[79] These violations are such that Yan Sun has constructed a typology of the ten most "Common Categories of Cadre Corruption" which includes the category of "moral decadence" (*daode duoluo*).[80] While a broad canvas of corrupt activities is presented, Sun makes special note of those cadres that patronize prostitutes, arguing that these "personal lapses" really only become "corrupt behavior when paid for by public funds or at bribe giver's expense."[81] And while police departments impose heavy fines on prostitutes and their clients, the "real purpose may often be the money supply rather than law enforcement. In fact, more prostitution means more revenues and rooting out prostitution would actually end that supply."[82]

That the Chinese media chose to ignore the issue of the sex workers as exploited individuals suggests that male dominant ideologies still prevail, and that the swift return to the nationalist argument is little more than a diversion from the real issue. We know little of what went on in the hotel rooms on the 16th, 17th and 18th of September 2003: what violent acts may have been committed; the level of exploitation that generally accompanies the "gruesome intersection between the sex trade and forced labour" and marks out the territory of organized prostitution rings.[83] By reframing the entire event as one of national shame because the "perpetrators" were Japanese, the Chinese media were able to collect kudos for conducting "investigative journalism," but at the expense of turning a blind eye to an ongoing social problem.

Conclusion: The Role of the Media

Chinese media responses to the Zhuhai incident highlight a range of issues facing contemporary China, including media transparency, state control issues, and the increasing presence of an online, media-savvy public. But most significantly they reiterate a head-in-the-sand approach toward the treatment of women in China's flourishing sex trade. The traditional Chinese media are content to report on incidents after the fact, when events have reached the point where the public demands some kind of investigation. The rise of the "citizen journalist" through the use of new media technologies poses a significant threat to those journalists or media outlets that fail to react in a timely manner. In attempts to defend their position as the leading news source, the traditional media become complicit in enacting the theme of nationalism as either their first response, or as a counter to more complex social problems.

Can the construction of a more investigative journalistic standard prevent the rise of both the sex industry and the accompanying corruption and violence in China that mark it as a harmful by-product of China's open market policies? It is doubtful; however, there is certainly more that can be done in the interests of transparency and greater regional diplomacy. By removing the individual voice of China's sex workers, the media deny the opportunity for recognition of a broader problem. Increasing divides between rural and urban, rich and poor in China can only further social unrest and despondency among those unable to freely share in the rewards of China's ventures in the global economy. For the 500 or so women/girls involved in the events at Zhuhai, interaction with the global marketplace was short-lived and may have offered some temporary financial relief; however there is little to suggest that China's sex workers are any closer to escaping the oppressive and ultimately harmful industry to which they are all but enslaved. It is also not credible that the Chinese government has a more open mind to representations of prostitution (or admitting that it exists): early in 2008 the Chinese government banned the movie *Lost in Beijing* set in a Beijing brothel, citing that the movie breaches state regulations on sexual content in the media.[84]

The events in Zhuhai in September 2003 reiterated the ambivalence of the Chinese state to the issue of prostitution. The pastoral care of women is low on the agenda, and the media would rather focus on framing the incident as one of national shame than as one in which young women could be subjected to servile, and perhaps violent, behavior. By failing to give voice to even a single one of the sex workers involved, the media have managed to create an image of a faceless mass of prostitutes with which the general public cannot empathize. Through their marginalization in the media, these "invisible

women" recreate earlier visions of a subordinate China, one where women fail to "hold up half the sky," and where violent, exploitative behavior is condoned. This is an image that the contemporary media in China would no doubt have been eager to avoid.

Notes

1 For example, the official Chinese newspaper *China Daily* quoted a comment from the www.sina.com.cn website, that "they came on purpose for September 18." Another typical example appears in the online comments stating: "this issue can't be taken as prostitution simply. Those Japanese wanna challenge our nation" and "it's a trivial matter for Chinese prostitutes to sell sex, but the key is to look at the intentions of the Japanese devils." See "Zhuhai hotel closed after Japanese Orgy," *China Daily* (September 28, 2003): http://www.chinadaily.com.cn/en/doc/2003-09/28/content_268324.htm; and "Riben rentuan Zhuhai maichun shehui zhennu, Guangdong lingdao yaoqiu yancha" (The whole society is furious at mass prostitution by Japanese tour group, Guangdong leaders order to investigate it seriously), Sina.com (September 28, 2003): http://news.sina.com.cn/c/2003-09-28/0713833262s.shtml

2 Anne E. McLaren, "Introduction," in *Chinese Women: Living and Working*, edited by Anne McLaren (London: RoutledgeCurzon, 2004), 1–16, 7.

3 Elaine Jeffreys, "Feminist Prostitution Debates: Are There Any Sex Workers In China?" In *Chinese Women*, 83–105.

4 Lisa Rofel, *Desiring China: Experiments in Neoliberalism, Sexuality and Public Culture* (Durham: Duke University Press, 2007), 76.

5 Lisa Rofel, *Desiring China*, 77.

6 For a detailed discussion of both sides of the argument, see Elaine Jeffreys, "Feminist Prostitution Debates," 85–88. These quotes from pp. 85 and 86, respectively.

7 Sun Juan. "Guochiri Zhuhai laile Riben 'Maichuntuan,' mujizhe nujie chouju" (Japanese 'sex-tour group' came to Zhuhai on the National Humiliation Day: a witness angrily reveals ugly scenes), (2003): http://www.people.com.cn/GB/shehui/1062/2112848.html

8 Pierre Bourdieu suggests that this "validation" takes place "in its reality as actual or potential violence" and must be "certified by recognition of membership of the group of 'real men'." See his *Masculine Domination*, translated by Richard Nice (Cambridge: Polity Press, 2001), 52.

9 Taking a more defensive approach, Japanese news sources headlined one article with "Prostitute buying not systematic, company says," suggesting that rather than an orchestrated event, the use of prostitutes was an ad hoc affair. "Prostitute buying not systematic, company says," *The Japan Times* (October 10, 2003): http://search.japantimes.co.jp/print/nn20031010b6.html

10 There are discrepancies between reports on the number of Japanese men involved. For example, one report says "more than 200," another says "a 300-member group," and a number of others say "more than 400 Japanese male tourists."

11 Yinan He, "History, Chinese Nationalism and the Emerging Sino-Japanese Conflict," *Journal of Contemporary China* 16, No. 50 (2007): 1–24. This incident followed a series of incidents between the two nations, including the escalating territorial dispute over the Spratly Islands (known by the Chinese as the Diaoyutai Islands, and the Japanese as the Senkaku Islands), and the Japanese Prime Minister's controversial visit to the Yasakuni shrine to honor soldiers who had died in previous wars.

12 "Firm involved denies 'en masse prostitution' scheme," *China Daily* (October 10, 2003): http://www.chinadaily.com.cn/en/doc/2003-10/10/content_270651.htm

13 Joseph Kahn, "China Angered by Reported Orgy Involving Japanese Tourists," *The New York Times* (September 30, 2003).

14 Sun Juan, "Guochiri Zhuhai."

15 Once again discrepancies arise, this time in the name of the Japanese company. A *China Daily* report from October 8 said that the name had been "witheld by the media," but by

October 10 had named the company as "Kouki Limited." By October 23 the name of "Heisei" was used, while *sina.com* reports referred to the company as "Yuki." See "Riben guomin," sina.com

16 Many newspaper reports have translated this quotation into "fun times with Chinese girls" in order to make it publishable. Such an "innocent" translation does not help readers understand why young Chinese Internet users became so enraged about the incident. The original words can be seen in Sun Juan, "Guochiri Zhuhai."

17 Peter C. Pugsley and Jia Gao, "Emerging Powers of Influence: The Role of the Anchor in Chinese Television," *International Communication Gazette* 69, No. 5 (2007): 451–466.

18 Yvonne Jewkes, *Media and Crime* (London: Sage Publications, 2004), vii.

19 Yinan He believes that "the increasingly liberalized but often biased Chinese media," alongside the role of nationalist sub-elites and the government's accommodation, have contributed to anti-Japan popular nationalism that has deeply rooted in the national collective memory. See his "History, Chinese Nationalism."

20 Caroline Ross, *Interpreting History in Sino-Japanese Relations: A Case Study in Political Decision-making* (London: Routledge, 1998).

21 Morris Low, "The Emperor's Sons Go to War: Competing Masculinities in Modern Japan," In *Asian Masculinities: The Meaning and Practice of Manhood in China and Japan*, edited by Kam Louie and Morris Low (London: RoutledgeCurzon, 2003), 81–99; 91–93.

22 "Japanese orgy in Zhuhai hotel sparks Chinese fury," *China Daily* (September 27, 2003): http://www.chinadaily.com.cn/en/doc/2003-09/27/content_267962.htm

23 Pamela Scully's chapter in this anthology documents in a different register how local concerns helped resignify sexual violence in South Africa.

24 Wenzhong Xu mentioned that the three Guangzhou-based newspapers published the story on the same day. See "*Nanfang Dushi Bao* beizhengsu goucheng jiemi" (Inside information about how *Southern Metro News* is purged) (April 21, 2004): http://www.chinaelections.org/NewsInfo.asp?NewsID=15562

25 "Japanese orgy," *China Daily*.

26 "China hotel 'orgy' sparks fury," BBC News (2003): http://news.bbc.co.uk/2/hi/asia-pacific/3146514.stm

27 Vincent Brossel, ed., "China: 2004 Annual Report, 2004 Asia Annual Report," *Reporters Without Borders* (2004): http://www.rsf.org/article.php3?id_article=10166

28 Even if some officials had wanted to use their power, there is little to suggest that they would have been effective.

29 Stephanie Buus and Eva-Karin Olsson, "The SARS Crisis: Was Anybody Responsible?" *Journal of Contingencies and Crisis Management* 14, No. 2 (2006): 71–81.

30 "China media fury over 'orgy'," BBC News (2003): http://news.bbc.co.uk/2/hi/asia-pacific/3151856.stm

31 "Japanese orgy," *China Daily*.

32 MacNN Forums, http://forums.macnn.com/95/political-war-lounge/179494/japanese-orgy-china-anniversary-japans-1931-a/

33 "Japanese orgy hurts Chinese feelings," *China Daily* (September, 30 2003): http://www.chinadaily.com.cn/en/doc/2003-09/30/content_268745.htm

34 Ibid.

35 Ibid.

36 The Japanese company "acknowledged paying for female 'companions' to attend a reception" but "denied organizing the late-night romp that occurred afterward." See "Firm

involved denies 'en masse prostitution' scheme," *China Daily* (October 10, 2003): http://www.chinadaily. com.cn/en/doc/2003-10/10/content_270651.htm

37 "Riben rentuan," sina.com

38 "Beijing expresses 'strong indignation' over orgy," *Sydney Morning Herald* (September 30, 2003): http://www.smh.com.au/articles/2003/09/30/1064819935022.html. One further omission in reports at the time was the failure to report in detail (until October 8) Japan's "apology" where the Japanese Foreign Minister despaired (somewhat ambiguously) that it was "extremely regrettable" that some "people would go all the way to a foreign country to injure women's dignity." See Chua Chin Hon, "Zhuhai 'hotel sex orgy' pimp arrested," *The Straits Times* (October 1, 2003): http://www.irischang.net/human_rights_article.cfm?n=3. The report that appeared in the Chinese press altered the quote to read that the Foreign Minister "said she regretted 'the kind of act that would damage women's dignity' and urged Japanese tourists to obey the laws of China." See "Tokyo to launch probe into Zhuhai hotel orgy," *China Daily* (October 8, 2003): http://www.chinadaily.com.cn/en/doc/2003-10/08/content_269770.htm

39 Shen Binyu and Zhao Jing, "Zhuicha Ribenren Zhuhai piaochang zhenxiang: Dui zhengfubumen renyuande zhiyi" (Further invesigating the Japanese mass prostitution in Zhuhai. More questions about the government department officials): http://www.jxgdw.com.cn/ jxgd/news/gnxw/userobject1ai583056.html

40 Wanning Sun, *Leaving China: Media, Migration, and Transnational Imagination* (New York: Rowman & Littlefield, 2002), 167.

41 See Peter Pugsley and Jia Gao, "Emerging Powers of Influence."

42 Liu Hong, "Profit or Ideology? The Chinese Press between Party and Market," *Media, Culture & Society* 20, No. 1 (1998): 31–41.

43 It is also unknown to what extent Zhang Dejiang's role in dealing with this case helped him later be promoted to Vice-Premier at the Eleventh National Congress in 2008. However, it is very clear that the popularity of the case established his reputation as a leader capable of acting swiftly to quell controversy and to quickly grasp control of tarnished bureaucratic systems such as the one operating in Guangdong at the time of the incident.

44 "China jails orgy organisers," BBC News (December 17, 2003): http://news.bbc.co.uk/2/hi/asia-pacific/3326541.stm. Interestingly, this report names two of the prosecuted Chinese as Ming Zhu and Zhang Junying as two prostitutes who were central to the gathering together of the larger group of prostitutes. While named in one *China Daily* report, there is no mention of their role in events, nor that they were allegedly prostitutes. See "Masterminds of Japanese orgy in Zhuhai get life," *China Daily* (December 18, 2003): http://www.chinadaily.com.cn/en/doc/2003-12/18/content_291373.htm

45 Elaine Jeffreys, "Feminist Prostitution Debates," 96. A common perception is that any hint of sexual promiscuity during the years of the Cultural Revolution was attributable to prostitution. However, there is a plethora of documentation to show that the state was effective in stamping out prostitution during these years. See Harriet Evans, *Women and Sexuality in China: Dominanat Discourses of Female Sexuality and Gender Since 1949* (Cambridge: Polity Press, 1997), 174–177.

46 Ibid.

47 Suiming Pan, "Three 'Red Light Districts' in China," in *Sexual Cultures in East Asia: The Social Construction of Sexuality and Sexual Risk in a Time of AIDS*, edited by Evelyne Micollier (London: RoutledgeCurzon, 2004), 23–53, 51.

48 "Tokyo to launch probe into Zhuhai hotel orgy," *China Daily* (October 8, 2003): http://www.chinadaily.com.cn/en/doc/2003-10/08/content_269770.htm

49 For more on the framing of issues, see John M. Bublic, "American as Baseball and Apple Pie," in *It's Show Time! Media, Politics, and Popular Culture*, edited by David A. Schultz (New York: Peter Lang, 2000), 1–11.

50 Lisa Rofel, *Desiring China*, 82.

51 Ibid.

52 Harriet Evans, *Women and Sexuality in China*, 167.

53 Elaine Jeffreys, *China, Sex and Prostitution* (London: Routledge, 2004), 99.

54 Evelyne Micollier, "Social Significance of Commercial Sex Work: Implicity Shaping a Sexual Culture?" in *Sexual Cultures in East Asia*, 3–22, 7–8.

55 "Ribenren Zhuhai piaochang'an you tupo, dangshi "Jitou" Hunan luowang" (A breakthrough in the Japanese orgy case: alleged 'pimp' was caught in Hunan), Tom.com (September 30, 2003): http://news.tom.com/1006/2003930-427257.html

56 "Japanese orgy in Zhuhai hotel," *China Daily*.

57 Gargi Bhattacharyya, *Traffick: The Illicit Movement of People and Things* (London: Pluto, 2005), 155.

58 Ibid., 154.

59 Ibid., 176.

60 "Japanese orgy in Zhuhai hotel," *China Daily*.

61 Yan Sun, *Corruption and Market in Contemporary China* (Ithaca: Cornell University Press, 2004), 35.

62 Costs of living in the city, or of transport to return home, and the losing of face by having "failed" in the city are often cited as reasons for entry into prostitution. Gargi Bhattacharyya, *Traffick*, 176.

63 "Chinese hotel closed after Japanese sex orgy," Newindpress: http://www.newindpress.com/ Newsitems.asp?ID=IEW20030929132153&Title=World&rLink=0

64 Suiming Pan, "Three 'Red Light Districts' in China," 23.

65 Ibid.

66 Ibid., 51.

67 Elaine Jeffreys, *China, Sex and Prostitution*, 122.

68 Indeed, Gail Hershatter discusses the 1992 Law Protecting Women's Rights and Interests in which "prostitution appeared primarily as a violation of the rights of the woman-as person." See her *Dangerous Pleasures: Prostitution and Modernity in Twentieth-Century Shanghai* (Berkeley: University of California Press, 1997), 360–361.

69 For example, see Dorothy McBride Stetson, "The Invisible Issue: Prostitution and the Trafficking of Women and Girls in the United States," in *The Politics of Prostitution: Women's Movements, Democratic States and the Globalisation of Sex Commerce*, edited by Joyce Outshoorn (Cambridge: Cambridge University Press, 2004), 245–264, 245. Tracking debates on prostitution in the United States, Stetson notes how abolitionists have portrayed prostitution as little more than "sexual slavery," 249.

70 Dawn Heinecken, *The Warrior Women of Television: A Feminist Cultural Analysis of the New Female Body in Popular Media* (New York: Peter Lang, 2003), 2.

71 Peter C. Pugsley, "Constructing the Hero: Nationalistic News Narratives in Contemporary China," *Westminster Papers in Communication and Culture* 3, No. 1 (2006): 77–92, 91. Similarly, Zhongshi Guo, drawing from Gellner's notion of "manifest nationalism," maintains that such "dramatic and melodramatic events are capable of 'awakening' nationalism from a cognitive slumber into a state of fist-raising agony or flag-waving ecstasy." Zhongshi Guo, Weng Hin Cheong, and Huailin Chen, "Nationalism as Public Imagination:

The Media's Routine Contribution to Latent and Manifest Nationalism in China," *International Communication Gazette* 69, No. 5 (2007): 467–480, 469.

72 Kam Louie, "Chinese, Japanese and Global Masculine Identities," in *Asian Masculinities: The Meaning and Practice of Manhood in China and Japan*, edited by Kam Louie and Morris Low, (London: RoutledgeCurzon, 2003), 1–15.

73 Gail Hershatter, *Dangerous Pleasures*, 377.

74 See the last comment at TECN, "Wang Keqin: Wei gongping he zhengyi erzhan" (Wang Keqin: The fight for equality and justice) (November 20, 2003): http://www.tecn.cn/data/detail.php?id=2397

75 Peter Pugsley, "Constructing the Hero," 87.

76 Elaine Jeffreys, *China, Sex and Prostitution*, 161.

77 Lisa Rofel, *Desiring China*, 29.

78 Elaine Jeffreys, *China, Sex and Prostitution*, 177.

79 Lisa Rofel, *Desiring China*, 10.

80 Yan Sun, *Corruption and Market*, 33.

81 In fact, in a brief endnote, Rofel cites a highly visible Beijing "massage parlor (with sexual services included)" that is "run by the Retired Government Cadres Bureau." See Lisa Rofel, *Desiring China*, 201.

82 Yan Sun, *Corruption and Market*, 173.

83 Gargi Bhattacharyya, *Traffick*, 174.

84 "China bans movie showing Beijing's seedy side," ABC News: http://arts.abc.net.au/news/artsnews_2132145.htm

CHAPTER 7

The Sacrifice of a Schoolgirl

The 1995 Rape Case, Discourses of Power, and Women's Lives in Okinawa

Linda Isako Angst

13 Years Later: The 1995 Okinawa Rape Revisited

As I consider re-prefacing the following article about the rape of the 12-year-old girl in Okinawa in 1995, I am suddenly overtaken by the uncomfortable realization that my own daughter is now the same age as that young girl was in 1995. In fact, my daughter was born just months after the rape.[1] Today, the 1995 rape resonates all too clearly with my own feelings of protectiveness toward my daughter—how horrific the possibility that this could happen to my own child, radically altering her relationship to the world forever.

That is precisely the reason for presenting this material in a "new" frame; unfortunately, however, things themselves have not changed enough for me to be able to say that things are now different. Although the frame for this chapter may be new, the condition of threat to foreign local women living in communities occupied by U.S. military personnel is all too familiar and anything but new.

It has been nearly thirteen years since the tragedy that occurred in Okinawa, Japan in 1995, now referred to as the rape of the schoolgirl. As I discuss below, the rape provoked outrage in Okinawa as well as throughout Japan, not only because it was another example of an ongoing list of assaults on women since the occupation of the island prefecture in 1945 and continuing well into the post-occupation era (from 1972), but precisely because the assault in this case was against a child and committed as a gang rape. This particularly heinous act was unfortunately not the only instance of the rape of a child—one of the earliest recorded assaults was the rape and murder of a 6-year-old girl in 1955 by a U.S. serviceman.

The tragic fact that assaults continue—in Okinawa, Japan, and throughout the world where U.S. troops are stationed or deployed—invites a re-reading of the case of the 1995 rape of the Okinawan schoolgirl. Except for knowing her age, the press in Japan (and internationally) was prevented from learning the personal details about the girl, including her hometown in Okinawa. I learned this recently after giving a talk in Honolulu, Hawaii, that mentioned this information.[2] As I contemplated several highly publicized recent assaults by U.S. servicemen abroad, the breaking news of yet another rape in Okinawa reached my attention. In February 2008, a U.S. Marine raped a 14-year-old girl in Okinawa when he gave her a ride home[3]; more recently, a U.S. airman at Misawa Air Base in Aomori, Japan, was arrested for having fondled a 19-year-old woman. In related crimes by U.S. servicemen previous to this, a Nigerian American in the U.S. Navy was arrested for stabbing a taxi driver to death in mainland Japan.[4] The list of crimes against Okinawans also goes on.

Perhaps as noteworthy is the response of Japanese and U.S. military officials to these ongoing crimes. As in the past, the U.S. military puts its troops on heightened security and restricts movement between base and local areas for some time after such an incident. In the case of the 1995 rape in Okinawa, the commanding officer of the Pacific Fleet made such an offensive and insensitive remark that he was removed from his position. In the February 9, 2001, accident that involved the collision of the *Ehime Maru* fishing vessel and educational training ship by a resurfacing U.S. Navy submarine, the *U.S.S. Greenville*, off the coast of Hawaii, four Japanese school boys and five other passengers on an educational excursion were killed while the submarine was piloted by visitors—part of a Navy public relations campaign.[5] Again, as in earlier cases, the commanding officer, Scott D. Waddle, made remarks that indicate a lack of sensitivity to the loss of innocent civilian lives and to the context in which the U.S. military bases and personnel operate: as guests of foreign countries. In the case of the *Ehime Maru*, the commander made reference to the actions of the Japanese during the Pacific War as though somehow to excuse and/or justify the outcome of his actions.[6] Still, U.S. military commanders are generally more aware of the need to conciliate local tensions, and in Okinawa today, troops continue to be on curfew schedules in the aftermath of several incidents, starting with the February 2008 rape. Nevertheless, even as military authorities are making gestures toward improving relations with local communities after such assaults, this does not mean that there will be a reduction in numbers of U.S. troops stationed in Japan.[7] Perhaps quite the opposite is the case.

Japanese lawmakers, too, have consistently shown a lack of real sensitivity to the plight of Okinawans. Despite his current sympathetic and indignant stance toward this most recent rape, Yasuo Fukuda, the current prime minis-

ter, is indeed noteworthy for having made a callous comment about rape and assaults against women while he served as the country's chief cabinet secretary. In 2001, the then foreign secretary, Makiko Tanaka, made a similarly callous statement after the rape of a young Japanese woman in Okinawa by a U.S. Marine.[8]

True sensitivity toward local populations that have to house U.S. military personnel would require the removal of troops, but this is unlikely to happen any time soon as the U.S. government continues to raise the specter of military threats in Asia, particularly from a growing China and an "unpredictable" North Korea. Perhaps closer to home is the trial of U.S. soldiers for the rape and murder of a teenager in Iraq, which also resulted in the murder of the girl's entire family.[9] This and other crimes committed by U.S. troops in Iraq, including the Abu Ghraib Prison violations, are indications that such atrocities will continue wherever U.S. troops are stationed. In 2000, a member of the U.S. peacekeeping forces in Kosovo, a U.S. Army sergeant, lured into a basement, raped, and then murdered an 11-year-old girl. He was later tried, convicted, and sentenced to prison for this crime. Peacekeeping does not mean local populations can trust these soldiers any more than they can other occupation troops.

In Okinawa, the reported cases since 1995 can be counted, but this brings up the question of how many others go unreported because of the stigma attached to such victimization, as well as the comparatively little real compensation for having reported the crime. The charge by the February 2008 rape victim was ultimately withdrawn, most to avoid the likely protracted trial and the attention it would continue to bring to the girl, perhaps doing more damage than good. This is the usual scenario based on women's reports of the insensitive ways in which most rapes are handled by police in Japan. These include the implication that perhaps the woman invited such "attention" and/or the handling by the police of the rape case without sensitivity to the mental and physiological damage done to the victim. This raises the question of what is to be done. And, as always, there are no clear answers except the one that seems least likely to be put into action: removal of U.S. troops from foreign soil. Okinawans continue to protest the presence of U.S. troops. In the aftermath of the 1995 rape, many things were promised to the Okinawans, including the closing of the U.S. Marine Corps Air Station, located in the heart of Ginowan City, one of the three largest cities in Okinawa. The Air Station is located in the heart of a dense urban environment of commercial and residential buildings. In 1997, the U.S. proposed, and is now building, an offshore base in northern Okinawa near the town of Henoko, and the initial protest against the rape of the 12-year old girl has morphed into ongoing opposition by local Okinawans and mainland Japanese.[10]

Okinawans are cynical toward any responses made by either U.S. military leaders or Japanese politicians. They've heard it all too often before. As *The Los Angeles Times* reported:

> And the mood was darkened further on Thursday with reports of another U.S. serviceman under investigation on suspicion of raping a Filipino woman in an Okinawan hotel. But many here, though they share in the condemnation of sexual assault, argue that Japanese politicians are speaking out forcefully only because of the acute sensitivities of Okinawa's status as host to about 42,500 Americans, the bulk of the U.S. military presence in Japan. Japanese officials privately acknowledge that their recent criticisms are motivated, in part, by the need to assuage Okinawa public opinion,[11]

especially as the Americans and Japanese are still attempting to sell to Okinawans the idea of a heliport off the coast of Henoko. The above article later quotes lawmaker Kantoku Teruya stating, "It's all a performance," staged to appease Okinawans, yet again.

The context for all of the incidents I raise that have occurred since 1995 remains more or less the same: that is, U.S. troops continue to exist cheek by jowl alongside local community residents—in Okinawa, in Aomori, in South Korea, in Iraq, and in all other places where U.S. troops are deployed, warzones and otherwise. There is no real protection for locals, particularly for women and children, who are the more common prey of military men who are away from their homes and families or who are simply trained in aggression and full of pent-up fears, anxieties, and/or anger from being in conditions of war or war training. Of course, this is not to say that all servicemen are aggressors. But the potential exists, and it is all too often acted on by at least a small minority of this group. As I suggested earlier, it is difficult to separate the personal story of the rape victim from the larger political issues of American military expansion and what Dwight D. Eisenhower warned about a growing military industrial complex. Today, scholars such as Chalmers Johnson remind us that since 1960, the U.S. economy has continued to rely on the machinery of an industry that still requires close collusion between the military and industrial/post-industrial economy, and Okinawa is a place where this is clearly in evidence.[12] *Okinawa Times* senior correspondent Tomohiro Yara believes that there is no compelling reason to have brought U.S. troops to Okinawa nor to have kept them there for as long as the United States has, except that it is a decision that suits the powers that be. It was a prior decision that is easier simply to uphold, particularly due to the investment of infrastructure over sixty-plus years, than reverse.[13]

In the meantime, we do not know the fate of the young rape victims in Okinawa. The one piece of information I am able to verify directly about the

1995 Okinawan rape victim is that she spoke in 2004 to an audience at the Ritsumeikan Peace Museum in Kyoto about her tragic ordeal, and I was told that she had plans to speak to a small number of other anti-base and anti-war venues in Japan.[14] We can only imagine how tragically these survivors' lives have been affected and forever changed by the brutality they experienced, particularly as girls just entering young womanhood. How we, as scholars and concerned citizens, negotiate the intellectual, emotional, and political terrain between understanding the personal experience of terror felt by the victims of rape and the larger political contexts of U.S. military bases abroad that make such atrocities possible remains the acute point of tension and the focus of this work.

The 1995 Rape of a Schoolgirl

On the night of September 4, 1995, as she walked home after purchasing a notebook for her lessons from a neighborhood store, a 12-year-old Okinawan schoolgirl was abducted at knife-point by three U.S. servicemen in a rented car in the town of Kin and gang-raped. This was the Labor Day holiday for U.S. forces in Okinawa, and the three men—two Marines and one sailor—had been partying all day in the capital city of Naha, an hour south of Kin. According to a fourth Marine who was with them earlier in the day, the three plotted to "get a girl" after failed attempts to meet women in Naha. Unwilling to join them should they follow through with their plan, he left the others but did not report the plan to authorities or do anything to stop the impending crime.

The three then drove back to Kin, the location of their home base, Camp Hansen. The old bar and brothel area outside the main gates of Camp Hansen thrived during the Vietnam War era. ... The remote town is a far cry from the lively, sophisticated entertainment district of Kokusai-dori (International Boulevard), the hub of tourist commerce in downtown Naha where the men had been. But on weekends and on that particular American holiday in 1995, the Kin area was full of the usual crowd of bar hostesses, prostitutes, service workers, and lonely young Marines too broke or too uninterested to spend time and money in hip Naha.

Lacking the means to venture far beyond the gates of the base, the Marines at Camp Hansen gain a perspective on the world "outside the base" (Okinawa itself) through the circumscribed lens of base authorities. Tours of the island by (military) bus are called "off-base" excursions, clearly indicating the perspective soldiers adopt as their legitimate source of knowledge regarding Okinawa. Both the land around them and its occupants are peripheral to their primary (American) presence, despite (or perhaps because) they themselves are (unwelcome) "guests" on the island. The tour guides are military personnel or affiliates working for the United Service Organizations (USO).[15]

Most Camp Hansen Marines are new recruits, sent from the United States right after basic training. From the 1950s through the 1990s, troops who trained at Camp Hansen and other bases in Okinawa were deployed to conflicts in the immediate Pacific region and around the world, serving in the Korean, Vietnam, and Gulf wars. Camp Hansen comprises the bulk of Kin, leaving most of local residents along the narrow strip of town land that hugs Okinawa's northeast coast. Its primary purpose is to train recruits for artillery and other kinds of combat. For most, the tour of duty on Okinawa is their first time abroad and, indeed, the first time many of them have ever been away from their American hometowns. As part of the military services' recruiting strategies, such tours of duty are billed as cross-cultural experiences, opportunities to "see the world." In fact, recruits often find that, for a variety of reasons, including deficiency in language skills, high costs of the local economy, and sometimes local resentment of their presence, their lives are confined to the narrow world (and world view) of the base.

The Marines in Kin are physically isolated from the general population, living and working within the barbed-wire fences of the camp and far removed from the urban centers of life on the island. Because the salaries of recruits are notoriously low (and the value of the dollar in 1995 was also low compared to the yen), regular excursions off base are difficult if not impossible, except to the areas right outside the base that were established to cater to their needs.

Marines at Camp Hansen are also separated from others through the nature of their work as combat soldiers, that is, labor that is physically focused, much as was their basic training. Through the nature of their work as well as their segregation on the base, their attentions are unavoidably, intensely, and intentionally fixated on the manifestations of their own physicality. As well as being geographically, socially, and economically outside the bounds of ordinary Okinawan life, they most profoundly experience their difference from local people in terms of their physical (including racial) differences. All of these factors suggest that an occupation army of young foreign men is a clear and present danger to the local community, as Okinawans have long argued.

On the night in question, the three U.S. soldiers returned from Naha to the familiar terrain of Kin. Early September is still summer in Okinawa, and nightfall offers some respite from the day's subtropical heat and humidity. They cruised the neon-bright area outside the gates of Camp Hansen before finally heading for the darker local neighborhood streets of Kin. At 8 P.M., the world of a 12-year-old schoolgirl was forever changed by her brutal encounter with the three servicemen. After pulling the girl from the street into the car, the soldiers silenced and immobilized her by taping her mouth and binding her arms and legs. They then took her to the remote beach military officials label the Kin Blue Amphibious Training Area, a place that by day is haunt-

ingly beautiful: a peninsula of jagged rocks jutting into the deep waters of a
wild-looking, dark-blue sea. At night the area is pitch black, and locals steer
clear. Discarded beer bottles reveal that Marines frequent the spot late at
night, sneaking past the military's "off-limits" sign once the lights from local
houses and streets are out. At this lonely site, the three men repeatedly raped
the girl, who was still bound, then discarded their bloodied undershorts in a
trash bin before abandoning her limp form on the beach.

The girl managed to drag herself up to one of the string of houses beyond
the stretch of mangrove trees on the cliffs overlooking the beach. She gave a
description of the car and the men (she even remembered the rental number
of the vehicle, according to one source), and the three rapists were appre-
hended within hours of the crime. Although initially taken into U.S. military
custody, as a result of public outrage over the rape, the men were eventually
handed over to the local authorities, then tried and convicted in Japanese
courts of law in Okinawa and sentenced to time in a Japanese prison—both
unprecedented actions.

Sovereignty, Gender, and Postwar Identity Politics

The abduction and gang-rape of the schoolgirl prompted powerful responses.
Locally these included the demand by women's groups in Okinawa to publi-
cize the crime immediately and increase protection for women, particularly
around U.S. bases; renewed protests by landowners forced for decades to lease
lands to the U.S. military; and promises by then-governor Ota Masahide to
heighten his ongoing efforts to pressure Tokyo to rid the island of U.S. bases.
Internationally, its most profound effect was the sparking of a debate over the
nature and role of the U.S.–Japan Security Treaty, particularly as it affected
the Status of Forces Agreement (SOFA) regarding the treatment of U.S. mili-
tary personnel accused of crimes abroad.[16] Protest of the rape also caused the
postponement of President Clinton's November 1995 Tokyo visit and trig-
gered a premature end to Prime Minister Murayama's tenure as the first non-
LDP (Liberal Democratic Party) postwar Japanese leader in decades.

Soon after the rape, media coverage began to concentrate on the "larger"
political issues of land leased for U.S. bases, base returns, and troop reduction,
pointing out the long-standing victimization of Okinawa by both the United
States and Japan. Initial coverage of the rape carried by CNN, *The New York
Times*, and the *Asahi Shimbun* showed images of women demonstrating in
downtown Naha, notably Naha City councilwoman Takazato Suzuyo,[17] and of
80,000 people protesting the rape at Okinawa's Ginowan City Convention
Center.[18] These reports were soon replaced by editorials debating the base is-
sue,[19] photos of Chibana Shoichi[20] sitting in protest on his ancestral property
in Yomitan Village,[21] and of vast, virtually empty tracts of land comprising the

Marine Corps Air Station (MCAS) at Futenma, cheek by jowl with the crowded urban sprawl of Ginowan City.[22] The rape itself gradually disappeared from the media.

Later media coverage of Okinawa spoke metaphorically of the rape in terms of rapacious behavior of imperialist powers acting on a historically marginalized population. Commentators in the media and in the anti-base movement shifted public intellectual and ethical focus. While feminist groups protested the rape as the figuration and potential rape of all women in and around U.S. military installations in Asia, the Okinawan political establishment and international media moved from a particular sexual crime of violence against an individual, a young girl, to a crisis of sovereignty. Prefectural officials and political activist leaders interpreted the rape more broadly, focusing on the perpetrators' identity and agency. Doing so emphasized the political/nationalist dimension of Okinawan autonomy over the more immediate personal dimension of the act. Like the land, which is the main object of political leaders' concerns, women and the violated body of the schoolgirl became significant mainly because they pointed out the crisis of sovereignty. Most stories situated the rape not only among the many heinous crimes perpetrated by U.S. soldiers against local Okinawans in the fifty years since the war but also within a broader historical context that included colonial and neocolonial oppression by Japan and the United States. In a representative example, ratified by *The New York Times*, the *Okinawa Times* editorialized that it took the "sacrifice of a schoolgirl" to make progress in the movement to scale back the American military bases that occupy twenty percent of the land on this Japanese island.[23]

The female victim, a Kin schoolgirl, the original focus of concern, and the rape (*her* rape) were hidden from view as they were appropriated by all sides, including the prefectural government, various women's groups, landlords, and other activist groups throughout Japan. Her pain was transformed into a symbol of national subjugation with its own narrative: the concerns of Okinawans are routinely ignored, and Okinawa, as the feminized body politic, remains a site of contestation between contending political powers, local and international.

Interpretations of the rape by political leaders and feminists, while very different, both make explicit unequal power relations. Although both groups have appropriated the image of the rape for their own agendas, for feminists and women's rights activists the rape itself continues to inform a larger feminist politics as a violent physical act against a female victim. But within the protest for Okinawan rights as part of Japan, the rape is nearly invisible, operating almost purely as a political metaphor. The abstracted idea of the ravaged female body, victim of a misplaced and grotesquely twisted sexual desire, has

been juxtaposed with Okinawan soil as the object of nationalist desire; the point has become the rape of the body politic. In this reading, desiring an under-aged girl and inflicting violence on her both show the perversion of desire for the bases in Okinawa. Both woman (or her representation) and soil are critical symbolic elements within (emergent) nationalist discourses.

When various groups appropriate the incident and the victim for larger political purposes, they are participating in the complex field of identity politics in Okinawa. By engaging feminist and other critical approaches, I wish to re-frame and re-position questions of agency, determination, and victimization.

I first consider the reasons why this particular incident, one in the long history of abuses committed by U.S. servicemen against Okinawan people and property, resonates so strongly throughout Okinawa and mainland Japan. I suggest that the answer has to do with more than the literal (political), on-the-ground conditions of the violation of a local child by soldiers of an occupying force at a particular moment in Okinawan history—although this cannot be minimized—and must include a figurative (poetic) reading of the rape as the defilement and victimization of an idea of pure and innocent Okinawa. Clearly, the rape of the schoolgirl is enmeshed in these larger and complex discursive realities.

Second, I argue that through a feminist politics, we can counteract the objectification of the 12-year-old girl (and the rape event) and reclaim her subjectivity, indeed her very humanity. We must return to the rape to understand it both concretely and symbolically as an act of violence between perpetrators and victim. One aim here is to examine the power of rhetorical strategies and agendas in politicizing and thus transforming the rape into metaphors for contemporary Okinawa's condition of subjugation.

Third, I problematize the idea of a unified voice of Okinawan identity politics as presented in the media explosion surrounding the rape and promoted especially in the rhetoric of the prefecture's elected leaders at the time, who quickly assumed the position of main spokespersons after the rape. While a unified voice helps build momentum for social change, I question to what degree this unified voice acts hegemonically in Okinawa to subsume and defer other voices and agendas? By examining the anti-base protest movement, I hope to show some of the internal Okinawan tensions—ideological, regional, classist, and gender-based—that are welded together into local anti-base demands. Here, too, I work from a feminist critique. As Judith Butler and Joan Scott have argued, women's voices are often lost in a generalized voice of identity politics,[24] and as Cynthia Enloe has pointed out, feminist agendas are often subsumed under the rubric of the larger political good and deferred, ostensibly for the short term.[25] The presumably more pressing needs of the "good of the political whole"—repatriation of land and political sovereignty, in

the Okinawa case—replace the "private" importance of the rape and the suffering of the young female victim.

The focus on sovereignty appears to have sidelined, on the grounds that it is part of a less-central "feminist" agenda, the wider universal issue of women's (and general human) rights, as well as the initial efforts of local women's groups to improve safety and work/living conditions for all Okinawan women.[26] I also suggest, however, that feminist agendas must meet the same standards of critical inquiry, and feminists must recognize their own classist and regional political biases and engagements in hegemonic practices.

The rape victim and the rape have been absorbed into existing political ideologies and discourses, local and international, in various ways, and redeployed in a variety of representative capacities. The rhetoric used by activist groups explains the rape as something else; as a catalyst in local political leaders' long-standing negotiations with the Japanese government over rights to land and Okinawan sovereignty[27]; as the unwitting and unwanted object of post-cold war military alignments in the transnational policies of Japan and the United States, the world's wealthiest and therefore most powerful "first world" countries; and as the subject of feminist campaigns to further women's human rights.

In each instance, groups draw upon and interpret particular aspects of a colonial, pre-colonial, and postwar/occupation-era past to buttress their representations of the rape. Such conscious remembering of Okinawan pasts generates sometimes competing images of contemporary Okinawan identity, attesting to the heterogeneous and mutable character of a politics of identity and ethnic identity formation. Situated as they are within various, contending spheres of power, these competing discourses are, by turns, dominant and dominated.

Finally, not only has the rape been redeployed in a representational capacity, it has simultaneously been absorbed into and redefines existing symbolic expressions of Okinawan victimhood. It is as symbol that the rape/rape victim functions most powerfully and critically for Okinawan identity politics. Moreover, particularly in the discourse of nationalism, as Carol Delaney tells us, "Women do not represent, they are what is represented ... This observation opens theoretical space to think about the differences between symbolization and representation, often held to be the same." In many countries, women symbolize the nation, but men represent it, and often the nation is referred to as female and represented as a female statue. Most fundamentally, "because of their symbolic association with land, women are, in a sense, the ground over which national identity is played out."[28]

As symbol, the 1995 rape and the rape victim can serve in many capacities to many Okinawans, and as such, the event and the girl made it possible, be-

yond the immediate exigencies of political protest, for a variety of groups with different goals and competing agendas to come together as a unified Okinawan voice of dissent. Identity politics is implicitly one of resistance—in this case, against the Japanese state and the powerful myth of Japanese cultural homogeneity, and against U.S. military power. ...

The Trope of the Sacrificed/Prostituted Daughter

The fervor with which Okinawans protested the rape—and by implication the ongoing policies under the U.S.-Japan Security Treaty—cannot be explained solely by a literal reading of the rape as an act of violence by members of a foreign occupation force against a local girl. Beyond the outpouring of outrage at the attack and compassion for the girl by Okinawans, it was also because of its powerful figurative capacity that this particular act of violence elicited such a strong reaction. That is, a fuller understanding of Okinawan politics requires us to consider how the image of a victimized schoolgirl resonates over time as a symbol of both wartime and postwar Okinawa, and thus of Okinawa as a victim of both Japanese and United States hegemony. The unity of the anti-base movement in Okinawa today seems to rest on a shared symbolic understanding of Okinawa and Okinawan history as violated and sacrificed schoolgirl/daughter. Behind that unity lies the "split" to which Ernesto Laclau and Chantal Mouffe refer[29]; that is, the pluralistic and often competing nature of interest groups, with their "specific literal demands," within the totalized idea of Okinawan identity politics and the shared goals of greater autonomy and rights to confiscated land.

One possible way to return attention to the actual experience of Okinawan women would be to focus on the direct experience of the raped girl herself. Yet direct attention to the personal experience of the victim of the 1995 rape is not possible. Her very youth, as well as the crime itself, which traditionally stigmatizes its victims, demands that she be protected through anonymity. It is precisely because she goes unnamed—and is thus anonymous—that the rape victim serves so well in a general symbolic capacity. Her youth contributes to this symbolic power. As a child, she is innocent and pure; she does not yet know the world of work or women. Her position shifts from that of general female victim symbolizing (all) women to a more abstract, and therefore more generalizable, category of victimization: the symbol of an innocent, pure, and feminized Okinawa subjugated by the dominant powers of the United States and Japan.

The potency of this image of violated innocence and purity has great power in Okinawa because it is already part of an existing iconography of modern Okinawan victimhood.[30] The Himeyuri, or Maiden Lily, Student

Nurse Corps, is an earlier, highly salient (because widely accepted and recognized) symbol of Okinawan sacrifice. In 1945, 219 female students of the top two girls' higher schools in pre-surrender Okinawa were forced to accompany Japanese soldiers into the battlefield as student nurses. Most were killed in the last days of the battle, trapped between Japanese soldiers and U.S. troops. In the minds of most Japanese, the Himeyuri have come to embody an idea of Okinawa as sacrificial victim. To both Okinawans and mainland Japanese, Himeyuri has become the canonical narrative of Okinawan identity in the postwar era. In this scenario, the socially peripheral becomes the symbolically central.

Since the rape, however, I would argue that mainland Japanese focus, although not the Okinawan one, has shifted: the raped schoolgirl now acts as the preeminent symbol of postwar Okinawan victimhood. In a crucial difference, unlike the case of the Himeyuri, who were victimized by Japanese soldiers, this time the active agent of violence is the U.S. military.

In each case, however, both countries are implicated: the Himeyuri were quite literally caught between the Japanese and American forces on the battlefield, although the schoolgirls were compelled to follow Japanese soldiers into battle areas on the orders of Japanese commanders. Today once again, Okinawa is caught between the political agendas of these two world powers (this time in alignment), and the schoolgirl's pain was a grotesque manifestation of Okinawa's powerless position. Thus, for Okinawans, the resonance with the story of the Himeyuri Student Nurse Corps is enormous.

Drawing direct parallels between the rape of women citizens and the invasion of land by foreigners is not unusual for nationalist discourse. Carol Delaney makes this argument eloquently in the case of Turkey when she argues that Turks conceived of the nation-state as their mother who was being raped and violated. This motivated them to protect their threatened soil.[31] Takazato Suzuyo, who led the Okinawan delegation to the 1995 Women's Conference in Beijing, explicitly links the 1995 rape of a young girl to an allegorized image of Okinawa as a daughter sold by Japan into prostitution: "Okinawa is the prostituted daughter of Japan. Japan used her daughter as a breakwater to keep the battlefields from spreading over the mainland until the end of World War II. After the war, she enjoyed economic prosperity by selling the daughter to the United States."[32]

... Referring to the 1995 rape victim as a sacrificed daughter figures her within an existing nationalist patriarchal discourse. This language is used not only by male leaders of Okinawa's political movement, but more disturbingly by women in the feminist movement, as in the quote by Takazato, above. This language re-inscribes Okinawa as a dependent of the patriarchal family state,

even as Okinawans (and especially feminists) adamantly reject that role as one imposed on them by coercive U.S. and Japanese policies.

The Himeyuri and the rape discourses both thrive on the relationship between the tropes of virginity and purity betrayed, on the one hand, and nationalism, on the other. Purity seems to be a critical component of nationalist symbols that are gendered female. In the Okinawa case, however, it is not the purity of selfless motherly love mobilized in Turkey. Rather, the virginity of the Himeyuri maidens as well as of the schoolgirl rape victim is celebrated here, as is patriarchal authority, as the foundation of the modern nation-state. The rape victim has been framed rhetorically by activists as a daughter violated because her father failed to protect her. Moreover, if the violation is understood to be a sacrifice, then the Japanese parent/nation is even more gravely implicated: mainland Japanese lived a safer life under the U.S.–Japan Security Treaty because their leaders agreed to sacrifice the Okinawan daughter.[33]

Okinawan politicians and activists link the rape of the schoolgirl and the continued presence of U.S. military forces on Okinawan soil—that is, the rape of Okinawa. In their rhetoric, the violation of the girl's virginal body is equated with the violation of the Okinawan body politic and thus Japan's discrimination toward Okinawa.

Okinawans also build their identity politics today on a narrative of reconstructed Okinawan history. They look to a pre-colonial past marked by peace and prosperity. In so doing, Okinawans identify with a mythic, hence prepolitical, and thus pristine (pure) past.[34] In this narrative, there are discursive parallels between how the rape ended the schoolgirl's innocence and defiled her purity and how the colonization by Satsuma fundamentally changed (that is, politicized) Okinawa. Both violations brought about a transformation toward a new, critical self-consciousness: the end of innocence and the birth of a political consciousness.

The appropriation and colonization of Ryūkū by Satsuma in 1609 represents a fundamental shift in political status (the loss of real autonomy), while the rape of the schoolgirl shatters and reformulates her personal identity (through the loss of childhood innocence) and re-politicizes Okinawa through an ongoing identity politics. Okinawans consciously reclaim and privilege as their official history a version of their past character as that of an inherently peace-loving people, despite the reality of pre-colonial internal struggles for territorial power. This creates a seamless whole, short-circuiting Okinawan history. Yet this is precisely the point: identity politics seeks out a compelling narrative of, quite literally, mythic proportions about the collective self around which people can rally. And to be compelling, the story has to be sufficiently accessible—that is, simple. The 1995 rape, too, lends itself well to this purpose

and provides a positive reading of the idea of a unified Okinawan identity politics.

This idealized history is linked with certain functional political and economic ends. For example, Governor Ota originally proposed the development of Okinawa as a free trade zone, which would bring in trade from the Asian region to make the local economy more independent of Japanese government subsidies. This has been defended ideologically as a "natural" strategy for a historically peaceful, maritime Okinawa. Similarly, peaceful Okinawa is a critical ideological component of a still-struggling economy of tourism. This idealized past offers Okinawans the moral high ground, positing Okinawans against Japanese as a traditionally non-arms-bearing people, and therefore, inherently non-aggressive. It claims a virtually sacred genealogy rooted in a pristine, pre-political past, used today to approve and shape a morally superior identity to those of the mundane and profane politics of "first world" imperialist control.

Analysis of this strategy also raises the question of whether gender is re-inscribed in the international political relation between the powerful imperialist nation-states of Japan and the United States, on the one hand, and occupied Okinawa, on the other. This is an explicit area of difference among Okinawans. In one view, Okinawa is gendered as woman by virtue of a negation—the emasculation of Okinawan cultural and political autonomy. Other Okinawans, who purposely seek to present an image of themselves as inherently different from traditionally warlike, aggressive Japanese, however, read their own cultural persona as "peace-loving" rather than "emasculated."

Understanding the Rape in Feminist Terms

Although the 1995 rape may be read as an allegory of long-standing Okinawan suffering, it also exists fundamentally on its own terms, prior to its appropriation as a symbol of Okinawan victimhood. The power relations between the victim and the perpetrators of the rape are made clear by a focus on different political realities in Okinawa such as the presence of Camp Hansen that gave rise to the possibility of the rape.

Considered on its own terms—as an event with its own ontology, occurring at a specific place and point in time—the rape evokes outrage as a particular act of violence. Yet its facticity is eclipsed and eventually overlooked by the power of its metaphorical, representational significance. Sharon Marcus, in "Fighting Bodies, Fighting Words," argues "against an identity politics which defines women by our violability," that is, against the political efficacy of interpreting rape as the fixed reality of women's lives. She argues for a shift in focus, from the scene of the rape and its aftermath to "rape situations themselves and to rape *prevention*."[35] Women need to empower themselves by understanding rape as a process to be analyzed and undermined as it occurs, rather than as a fact

that is accepted, opposed, tried, or avenged.[36] This challenges the view of rape as endowed with a "terrifying facticity."

To be sure, the rape is already a metaphoric relation even when described in the most basic possible terms: *as* the violation of a girl('s body) by three men. Even so, attention to the event of the rape helps to unpack a variety of its possible meanings. First, it exists a priori as an action, specifically an act of violence, and as such, it is clearly a political action on several levels. The act of the rape consists of a fundamental power differential defined in terms of a(n inherent), gender(ed) asymmetry: a girl overtaken by three men. The shift in media representation of the rape from violation of one girl's body to that of the Okinawan body politic signals an interpretive reorientation of the rape from the private/personal realm to the public/political realm. Strictly speaking, however, the political cannot be separated from the private in any instance of rape. As Marcus has argued, "A rapist chooses his target because he recognizes her to be a woman, but a rapist also strives to imprint the gender identity of 'feminine victim' on his target. A rape act thus imposes as well as presupposes misogynist inequalities; rape is not only scripted—it also scripts."[37]

Moreover, the affiliation of these men with the U.S. military—the very reason for their being on Okinawa—is also a critically defining aspect of this basic political relation. In this case, the girl's gender may be primarily what drew the men to her, but it is impossible to separate out issues of gender, race, ethnicity, class, age, and national identity from the identity of the victim or the act of the rape. Indeed, the rape is simultaneously the rape of an *Okinawan* girl by *foreign*—in this case, U.S. military—men who are part of an occupying military force, as discussed earlier. Furthermore, the men themselves are also implicated within these asymmetrical power structures. They imprint "the gender identity of 'feminine victim' on [their] target"[38] and, in this case, they also imprint the victim as "Okinawan." Furthermore, the victim is a child, abused and attacked by adults. The sheer physical power of three men over one girl must not be overlooked, for this signifies once more the position of power that the United States exercises over Okinawa.

As feminist activists argue, the rape represents the potential endangerment of all women in Okinawa from the presence of thousands of mostly young, unaccompanied men who train on a regular basis to fight and kill enemy forces.[39] This threat is real. Since 1945, there have been thousands of examples of U.S. servicemen assaulting local women. In this sense, the rape of a female Okinawan forces us to appreciate the daily reality of all women in Okinawa.

Okinawan Identity Politics: Official Voices

Although many interest groups, often with competing agendas, make up Okinawan identity politics, the official representative voice of Okinawan protests

after the rape was elected prefectural officials, especially Governor Ota. According to Laclau and Mouffe, the nature of political struggle or "revolution" in a bourgeois state, is (appropriately) representative—that is, carried out by an elected official.[40] The power of the protest movement in the last decade has, to a large degree, been the result of Ota, whose tenure as governor (1990–1998) was predicated on a platform prioritizing base removals. Many groups in Okinawa, including feminists seeking improved safety conditions, have rallied behind this cause, deferring their own agendas for now.

... Identity politics is at one level a unified voice, but simultaneously internally pluralistic, if not sometimes divisive. In Okinawa it is a combination of the struggle for political and economic equity with Japan's other forty-six prefectures and recognition of Okinawa's distinct cultural heritage from that of Yamato (mainland) culture. This "same but different" argument is one of the tensions at the heart of Okinawa's internal politics. Most Okinawans want to resolve this tension by enhancing Okinawa's position within Japan, but a handful of Okinawans, mostly intellectuals, make the case for an independent Okinawa.

The main tension, however, is the internal pull between groups promoting their own goals within the anti-base movement and presenting the overarching goal of a unified voice of protest. The news of the rape initially bridged that tension. Okinawans felt both a deep compassion for the raped girl and rage toward the perpetrators, and they were profoundly affected by the brutality she suffered. The crime, acting as a catalyst to mobilize Okinawans (including tens of thousands of women for the first time) across all lines, was an important and positive rallying point, galvanizing long-standing frustrations about U.S. bases and the abuses inflicted by U.S. personnel against local people.

The rape itself has also been situated within a roster of other crimes or unethical acts committed by U.S. soldiers over the past 55 years. These include robberies, beatings, and violence ending in manslaughter. That context has the effect of minimizing the impact of, and thereby desensitizing us to, the horror of this particular crime and to the crime as a rape, a violent sexual attack. In effect, we are encouraged to read that history according to certain specifications; that is, we are to read it as a history in which U.S. servicemen have committed repeated offenses against Okinawans—not just Okinawan women—in the years since 1945. In this sense the gender dimension of the crime at hand is minimized or forfeited to the larger ethical issues of human rights violations, violations of international law by soldiers of a foreign occupation force, and felonious crimes against the local civic order. Ironically, the metaphorization of rape as the violation of the Okinawan body politic similarly takes the focus off the specific experience of Okinawan women. This focus does not highlight crimes committed against women alone, or crimes commit-

ted by Okinawans or Japanese against women or Okinawans in general. The focus is placed explicitly on the imperialist relationship of U.S. military dominance over Okinawa, not on the unequal relationship between Japan and Okinawa or on women, per se. These absences reveal how the rape—and its unwilling subject, woman—have been appropriated (and in effect erased) by all sides.

In the period after World War II, most Okinawans expressed opposition to the U.S. occupation and favored reversion to Japanese sovereignty. Okinawan leaders argued that unity on this strategy was crucial to secure rights from both the United States and Japan. The early years of protest were motivated by a desire to improve desperate economic conditions. Although its economy has improved recently, Okinawa remains the poorest of Japan's 47 prefectures with per capita income at seventy percent of the national average, and Okinawans continue to live in the shadow of U.S. military bases.

The demands made by Okinawan interest groups within the anti-base movement vary. They include demands for the return of or compensation for base lands, often contaminated by toxins; policies and programs to protect women; stronger environmental regulations against noise and other pollution generated by the U.S. military; and greater regular access to ancestral tombs located on bases. Yet at the prefectural level, elected officials argue for removal of all bases, which does not address or may be at odds with many of the above issues. Base removals do not guarantee compensation for U.S.-used lands nor do they address how families will get along whose livelihoods, until now, depended on leased lands. Women's groups will still require policies and infrastructure to deal with the influx of foreign male tourists, and women in the military service industries, who may not be in the anti-base movement, are torn: on the one hand, concerns for personal and family safety may lead to shared sentiments against the presence of bases; on the other hand, their livelihoods have depended on the work generated by bases.

Many Okinawans feel that development projects that enhance Okinawa's main industry, services for the military and tourists, have forced them to reconcile or compromise moral/political concerns and revealed schisms within the protest movement. The proposed construction of a heliport off the coast of Nago (for U.S. equipment transferred from MCAS Futenma in Ginowan City) is not only politically controversial, but also raises environmental concerns, including the endangerment of the dugong manatee, the flightless native bird yanbaru kweena, and the habu snake, and the destruction of local coral reefs by increased construction.

Furthermore, the local postwar politics of protest has been guided historically by a series of narratives about Okinawa's relationship to the rest of Japan, often drawing on images similar to that of the betrayed but (for some) still lov-

ing daughter. ... Political rhetoric is employed strategically to emphasize Okinawa's role as loyal prefecture, oppressed colony, occupied territory, or a combination of these. The ambiguity of Okinawa's status within Japan remains useful to a politics of resistance, and the redeployment of history (and memory) is critical strategy. Citing their history as a weapons-free culture, as well as the list of military crimes since 1945, Okinawans have pleaded with other Japanese for the removal of U.S. bases. Their requests have become part of a larger struggle over how to remember Japan's wartime past. Many insist that the national conscience cannot rest until the internal problems of the Japanese house and its history are set in order, including the placement of Okinawan wartime and postwar suffering.

Gender in Identity Politics

Referring to Homi Bhabha's interpretation of nations and nationalist discourse, Lydia Liu comments that by foregrounding marginal spaces and peoples of the "nation-space," the taken-for-granted boundaries of imagined national communities are clearly revealed. Distinctions among "us" and "others" are made and provide the grounds on which resistance can take place. Okinawans raise the question of the "otherness of the people-as-one" by highlighting their distinctiveness from Yamato culture: Okinawan identity resists the model of a racially and culturally homogeneous Japan.[41] The potency of that politics today derives largely from the transformations inside and outside Japan since the end of the cold war and the Shōwa emperor's death. In particular, Japanese are contending with ways to compensate or make reparations to victims of imperialist aggression, most prominently Asian "comfort women" who suffered as sex slaves to Japanese soldiers.[42]

This presents the problem of gender in postwar Japanese politics, which persists on a range of fronts, including contemporary Okinawan politics surrounding the rape. The relationship between military aggression (including occupation) and sexual abuse of local women is not accidental; rather, they are intimately linked, as Cynthia Enloe and Carol Delaney both argue. Enloe examines the profane dimension of the relationship between women, nationalism, and war—including how base economies embed and exploit women's work[43]—while Delaney focuses on the ways in which the relationship between woman and nation is elevated to the status of sacred symbol in nationalist discourses.[44] In either case, they argue, woman is made an object in body or sentiment, compromising her (political) human rights.

This raises a critical problem with Okinawan identity discourse, which is precisely the problem suggested by Liu about Bhabha's analysis: it fails to acknowledge the individuality of the groups comprising that identity politics. That is, Bhabha, in Liu's estimation, makes the mistake of conflating distinct

modes of oppression and lumping marginal groups into one category, thereby
"level[ing it] down to homogeneous totality."[45] Okinawan political leaders, who
insist on a unified Okinawan voice, effectively silence the voices of other
groups including Okinawan women activists on measures promoting women's
rights. ...

The gender problem begs the identity of the hegemon: for feminist activ-
ists, it is not just the Japanese state or the U.S. military, or even both. While
Okinawan feminists participate in the broader politics of Okinawan rights,
which situates itself against the hegemon of Japanese politics and culture, they
are engaged simultaneously in a universal protest movement for women's
rights, in which the hegemon is male dominance and patriarchal institutions,
including within Okinawa.[46]

Yet some feminists are frustrated by the expectation that they defer their
own agendas "for now,"[47] in the interest of showing Okinawan solidarity. In
linking local social ills and the presence of U.S. bases, the prefectural govern-
ment's position invariably results in advocating the development of valuable
base-leased lands into profitable (generally tourist) businesses for Okinawans.
In effect, the rape becomes an opportunity for business and political leaders to
emphasize (and conflate) the volatile issue of U.S. occupation in ongoing dis-
cussions about the economy. ...

Economically, Okinawans today no longer rely as heavily on the business
from U.S. bases as they did before 1972, when the bulk of the labor force was
employed directly or indirectly in a military service economy.[48] (There is no
reliable figure for the thousands of women who worked for U.S. service per-
sonnel in eateries, shops, nightclubs, and brothels in and around bases.[49])

During his tenure Ota focused on improving Okinawan living conditions
by linking the removal of bases with the development of a more autonomous
economy. Ota's economic goals were reasonable. To feminists, however, their
involvement in the peace movement is a means of securing better lives for
women, and the prefecture's economic development agenda—more closely tied
to Tokyo's agendas for the island since Ota's departure—does not directly ad-
dress safety and economic concerns of women, especially women dependent
upon base economies. Feminists argue that because these women work in the
sex/entertainment sector, the prefecture's tourist-based development agenda
means that their livelihoods will continue to be precarious.

One feminist activist expressed concern that the Ota government took ad-
vantage of the groundswell of anti-base sentiment and Ota's immense popular-
ity after the rape to promote an economic development agenda that ignored
women's concerns. Ota is not necessarily anti-feminist, but after 1995 he
seemed less attentive to women's demands. Feminist activists worked hard to
get a prefectural government contribution of 500,000 yen per year, or slightly

less than $5,000 in (1995-1996), toward the funding of a long-awaited rape crisis center (RAICO-Rape Intervention Crisis Center in Okinawa), which became a reality in October 1995 at the initiative and with the support of women's groups. However, the Ota government refused to house the center in the prefectural government building (the Kento), as Takazato and other feminists had hoped. Since then, prefectural funds have been cut for this and for other social services.

Women active in the prefectural government were also upset that, although they were part of a delegation from Okinawa to Washington in 1998 to argue for base closures, they were merely visual props and were not given the opportunity to raise their concerns about women's safety. The Ota government did support and house the prefectural Women's Affairs section in the new Kento building, located in the heart of Naha. The new governor, Inamine, however, supports plans to replace the women running this section with a male bureaucrat and perhaps to remove the Women's Affairs section from its offices in the government building, suggesting that his administration does not see the Women's Affairs operations as a central concern of the prefectural government. Moreover, the fact that the new government is responsible for encouraging the development of a new base in Nago without attention to women's safety indicates not only that the rape has receded from view, but that the broader issue of women's safety has also been set aside. Feminists, however, keep the rape in mind, as well as the safety of Nago women, as they continue to protest the construction of the heliport.

The Rape within Meta-discourses of Identity Politics

The appropriation of the rape its extrapolation to represent larger issues of sovereignty in Okinawa—signals its politicization, no matter how closely implicated the rape event may be from the outset within the larger political realities in Okinawa. In this sense, we might argue that the rape victim undergoes a second metaphorical assault, no matter how unwitting or unintended. As I argue above, a sense of compassion was the original impetus for Okinawans to rally around the rape event, but they quickly allowed it to stand for other things.

The focus has shifted from the rape as a particular, physical act of violence to the metadiscourses of Okinawan rights within the arena of international power politics or of Asian women's human rights, moving from the thing itself to the representation of the thing as defined by two distinct lines of political movement. One line emanates from a combination of political activists, labor union leaders, and prefectural officials in Okinawa who often operate in coalition, while the other line is articulated by Japanese and Okinawan feminist activists.

Concerned with issues of sovereignty and economy when they invoke the rape to protest U.S. military presence on their lands, some Okinawan men have moved far from the rape itself. Women and the concept of gender appear to have been erased from this portion of the political discourse. Feminists and other women in Okinawa continue to keep the rape in the foreground within the larger discourse of women's human rights, distinguishing themselves from the other groups comprising an ostensibly all-encompassing Okinawan voice. On a positive note, the rape has served as a catalyst in bringing together women from all classes in Okinawa, as well as Japanese and other Asian feminists, particularly from the Philippines and South Korea, where there is also a long history of U.S. base presence.

The shifting of focus, from the rape to its political representation, and again from feminist protest to identity politics, reveals the nature and direction of power politics in Okinawa. The discourse has been transformed from protests voiced largely by women concerning human rights and headed by an outspoken local feminist human rights activist, Takazato Suzuyo, to protests by (male) landowners about rights to land, and hence to issues of national sovereignty and political identity, led by former governor Ota. Women address the issue of individual rights as they adhere in female bodies, while male politicians generalize in order to address the identity and rights of the body politic.

In her critique of Homi Bhabha, Lydia Liu warns that distinct and specific modes of oppression must not be conflated. Each and every discursive system of discrimination, such as the ones based on gender and sexuality, deserves an explanation specific to its own historical practice.[50] As "part of a patriarchal ideology of nationalism," Okinawan nationalist discourse has effectively eclipsed the rape and issues of women's safety.[51] I suggest that the problem of an overarching Okinawan voice that both subsumes feminist/women's agendas and interprets the rape of the schoolgirl metaphorically as the defilement of an image of a pure and chaste Okinawa is its link with an inherently patriarchal political outlook.

The language in which Okinawa is a sacrificed or prostituted daughter is inappropriate for use by feminists. It indicates a tacit acceptance of the nationalist trope of the family state. The chastity of the victim as daughter becomes the locus of concern and the condition for regarding the rape as sacrifice. While this language is not immediately in conflict with feminists' language of the systematic violation of women's civil rights through violence, it does not criticize a sexual double standard in which raped girls are "ruined," although it presents that loss in the name of the greater good. The girl's defilement and victimization are presented as a sacrifice on the altar of nationalism; they are interpreted as a patriotic act, a "sacrifice" by Okinawans for the good of the larger, national whole.

It seems incongruous that feminists should espouse this patriarchal model, yet perhaps Okinawan feminists feel that toeing the nationalist line is simply a practical strategy for criticizing the structure from within. In other words, it may be that they hope that by adopting this language, Okinawan feminists are, in effect, standing the state on its head, criticizing it by using the very language (of patriarchal nationalism) by which it is legitimized. Feminism as subversion is the most positive reading possible of what seems, on balance, a problematic adoption of nationalist, patriarchal tropes.

Women working in Okinawa's base-related and (now) resort tourism-related sex and entertainment industry have long borne the brunt of their socially stigmatizing and physically debilitating, dangerous work, including abuse by their patrons. Protest leaders, who define an idea of collective cultural self through reference to a pristine, pre-colonial past, draw upon images of purity and chastity, such as the Himeyuri and the raped schoolgirl; yet the real prostituted daughters of Okinawa are excluded. Indeed, in many ways, bar and brothel women are lingering and unwanted images of pre-war era Okinawa as the low ethnic "other."[57]

Despite their many and long-standing sacrifices, these women are coded as less deserving of public concern by many groups because they are not "pure." The lack of sensitivity to the fact that there is little work available to uneducated women other than bar and sex work melds with the focus on the 12-year-old raped girl as the primary symbol of sacrifice and victimhood (just as the Himeyuri served in this capacity for wartime and postwar Okinawa until 1995). Yet the raped girl differs fundamentally from other women in Okinawa: precisely because she is a girl, her chastity places her within the protection of the patriarchal family. Women working in the sex trade have always been relegated to the lowest rungs of the social order, although in the first decades after the war, the survival of many Okinawan families relied on the incomes of these same women—sisters, mothers, and other female relatives. Now that most Okinawans have managed to put behind them the hardscrabble years, the women who still bear the burden of such sacrifices—now mostly older Okinawan women or Filipinas working in Okinawa—have been forgotten, stigmatized by, and therefore relegated to, work in bar and brothel districts.

Ironically, the very women who have experienced the life of the prostituted daughter are excluded from public recognition as that particular symbol of Okinawan victimhood. That is, Okinawan women working in the sex trade, around bases and in the tourist industry, are ineligible for inclusion within the protective embrace of the collective family, despite having sacrificed their own reputations as "decent women" in the service of families. Feminists have often been guilty of misrepresenting these women and claiming to speak for them. Still, whatever criticisms we may have of feminist appropriations of other

women's voices, in Okinawa they are at least willing to take seriously the situation of these forgotten women and include them in their agendas.

Conclusion

... Okinawans generally agree that the 1995 rape shows the need to re-examine policies allowing U.S. bases on Okinawa. It has been used justifiably as leverage against Tokyo for the removal of U.S. bases and the return of Okinawan lands. Feminist groups object to the focus on an agenda of economic development of Okinawan lands (most probably by Japanese corporate capital, as has been the case with resort development in Okinawa since the late 1960s), which they believe leads to the marginalization and perhaps eventual exclusion of what they consider to be the heart of the matter: protecting and improving women's lives. For example, to what degree would small businesses owned and run by women be protected? Much of the development that has already occurred in Okinawa is by large, well-known Japanese corporations that may not be interested in the needs of small business owners, women such as Keiko and Kaa-chan who run a snack shop and bar in Kin, or the woman who operates the Churasa Soap Factory in Onna.

Indeed, the issue of how women will figure in the service economy of tourism is not addressed. While women have been expected to support men in their political protests for Okinawan rights, the result has not necessarily been the fulfillment of women's agendas. Rather, women are expected to defer their goals to the aims of Okinawan identity politics (read "economic development," in this case).

From the perspective of a local government attempting to improve overall economic conditions, there is a practical logic to moving from servicing the U.S. military to servicing Japanese and Asian tourists. The infrastructure is in place: shops catering to outsiders, recreational/entertainment outlets, and a history of leasing land to foreigners. Because women in these industries will simply cater to a different clientele, the problem of women seems to disappear.[53]

Okinawan feminists and other women with whom I have spoken fear that, in this way, women will continue to be the base of a new tourist economy pyramid, mostly earning minimum wages and enjoying few if any employee benefits. As Enloe suggests, an economically and socially marginalized existence will continue for these women within the sexual economy of tourism. The problem will remain invisible as long as officials insist on deferring issues of women's human rights to the cause of Okinawan nationalism. Many local businesses have been transformed by tourism, but the lot of most unskilled female laborers, especially those in the sex trade, has not changed. Assembly-

woman Takazato is concerned that women's lives may not improve in the development scenario painted by prefectural authorities;[54] this plan simply replicates a service economy that is patriarchal in its ideological origins, particularly in the ways that work roles have been designated as either male or female.[55]

By raising these issues, one of my goals has been to remind those of us who so readily appropriate the rape for our various purposes of the person at its core: the 12-year-old Okinawan girl whose body was brutally beaten and whose life was forever altered by that violation one night in 1995. Indeed, I began to write about this rape in order to understand and work through how to write about this tragedy as a feminist scholar—that is, without losing sight of the girl herself. This is why it is necessary to revisit the rape. For it was initially from compassion for the victim that most of us became "involved" in our various ways with this rape. While the compassion may not have disappeared, most of us have shifted our focus to the so-called larger political issues. A feminist politics calls on us to maintain and reaffirm, as much as possible, the connection to the subjects of our study. In the end, we must remember that the victim is a schoolgirl, a child in an Okinawan family in Kin deprived of her youth and innocence. Whatever else we have had to say about the connection between her and Okinawa belongs to the political world of adults, a world into which she was violently and prematurely thrust.

Notes

1 Parts of this chapter were previously published in *Critical Asian Studies* 33, No.2 (2001): 243–266 (www.bcasnet.org); the editors of this anthology thank the journal for granting permission to reuse it. The author thanks Tom Fenton, Gerald Figal, Takashi Fujitani, Yoko Genka, David Howell,William Kinzley, James Roberson, and especially Laura Hein for comments and suggestions. An earlier version of this article was presented at the Washington and Southeast Japan Seminar, George Washington University, January 29, 2000. This article is based on my dissertation research on Okinawan women's wartime memories, wartime and postwar experiences, and the development of their political subjectivity.

2 Personal communication with *Okinawa Times* senior correspondent Tomohiro Yara (April 29, 2008).

3 Kenji Tierney, personal communication, February 13, 2008; "News Navigator: Record of Postwar Fatalities and Sex Crimes Caused by U.S. Military in Okinawa," *Mainichi Shinbun* (February 13, 2008); and Norimitsu Onishi, "Allegation of Rape by A US Marine Riles Fukuda," *The New York Times* (February 14, 2008).

4 Blaine Harden, "U.S. Soldier's Murder Case Reignites Anger in Japan," *The Washington Post* (May 3, 2008).

5 Daryl Lindsey, "Submarine Accident Sparks Debate over Navy Policy," *Salon.com* (February 17, 2001).

6 John Gregory Dunne, "The American Raj: Pearl Harbor as Metaphor," *New Yorker* (May 7, 2001); Steven Meyers, "Captain of Trawler Testifies on Collision with Submarine," *The New York Times* (March 15, 2001).

7 "U.S. Ambassador Urges Japan to Boost Military Spending amid Splurge by Asian Neighbors," *Mainichi Shinbun* (May 21, 2008).

8 Linda Angst, *In a Dark Time: Memory, Community, and Gendered Nationalisms in Postwar Okinawa* (Cambridge: Harvard University Press, forthcoming).

9 Paul von Zeilbauer, "Soldier to Plead Guilty in Iraq Rape and Killings," *The New York Times* (November 11, 2006).

10 Masamichi Inoue, *Okinawa and the U.S. Military: Identity Making in the Age of Globalization* (New York: Columbia University Press, 2007).

11 "Alleged Rape Angers Japan," *The Los Angeles Times* (February 22, 2008).

12 See Chalmers Johnson, *Blowback: The Costs and Consequences of American Empire* (New York: Henry Holt, 2000); and Chalmers Johnson, ed., *Okinawa: Cold War Island* (San Diego: Japan Policy Research Institute, 1999).

13 Personal communication, Tomohiro Yara (April 29, 2008).

14 Personal communication with Ritsumeikan Peace Museum Staff Member, (June 21, 2004).

15 This organization, often located at the main gates of U.S. bases, provides recreational programs for service personnel abroad.

16 The clause that stipulated that U.S. soldiers be tried by military courts of law was amended as a result of this trial. Accused offenders may now be tried in local courts of law.

17 Andrew Pollack, "Okinawa Governor Takes on Both Japan and U.S.," *The New York Times* (October 4, 1995).

18 "In Okinawa, Protest Against U.S. Military Following Rape Case," *The New York Times* (October 22, 1995).

19 "Okinawans Angry at Decision on Land,"*The Daily Yomiuri* (November 22, 1995).

20 Chibana Shoichi is the activist who burned the Japanese flag in protest of the visit of the crown prince to the 1987 national sports meet held that year in his village, which had been the site of one of the first "forced mass suicides" during the Battle of Okinawa; Okinawans

generally hold Japanese soldiers and Japanese wartime propaganda responsible for these civilian atrocities.

21 Ryochi Nishida, "US Bases' Uneasy Overseas Relationship: Okinawa Rape Puts Entire Military on Trial," *The Daily Yomiuri* (November 11, 1995); Cheryl WuDunn, "Yomitan Journal: A Pacifist Landlord Makes War on U.S. Bases," *The New York Times* (November 12, 1995).

22 "Rape Trial in Okinawa Opens for 3 G.I.'s," *The New York Times* (December 4, 1995); Nicholas Kristof, "Welcome Mat Is Wearing Thin for G.I.'s in Asia," *The New York Times* (December 3, 1995).

23 Andrew Pollack, "In Okinawa, U.S. Base Remains a Big Issue," *The New York Times* (March 9, 1996).

24 Judith Butler and Joan Scott, eds., *Feminists Theorize the Political* (New York: Routledge, 1992).

25 Cynthia Enloe, *Bananas, Beaches, and Bases: Making Feminist Sense of International Politics* (Berkeley: University of California Press, 1989).

26 Admittedly, "solving" the problem of sovereignty that is, ridding the island prefecture of U.S. bases—may seem on the surface to present the conditions women demand, namely, a safer living and work environment for Okinawans, especially Okinawan women, freed from tens of thousands of mostly young, foreign, male troops. However, given the unlikelihood of the United States and Japan agreeing to the removal of U.S. bases any time soon, except in rare concessions (such as MCAS facility), the deferral of a feminist agenda is likely to be a long-term, and therefore serious, problem in local identity politics. A recent example is the minimal coverage of the international women's summit (entitled "Redefining Security"), sponsored by the San Francisco-based East Asia-U.S. Women's Network Against Violence, held in Okinawa in June 2000, one month before the G8 summit in July (personal communication, including conference materials, from women's summit organizers, May 2000).

27 "Ota Eyes Budget for Plebiscite on Future of Okinawa Bases," *Japan Times* (May 21, 1996).

28 Carol Delaney, "Father State, Motherland, and the Birth of Modern Turkey," in *Naturalizing Power: Essays in Feminist Cultural Analysis*, edited by Sylvia Yanagisako and Carol Delaney (New York: Routledge, 1995), 190, 191.

29 Ernesto Laclau and Chantal Mouffe, *Hegemony and Socialist Strategy: Towards a Radical Democratic Politics* (London: Verso, 1985), 11.

30 Linda Angst, "Gendered Nationalism: The Himeyuri Story and Okinawan Identity in Postwar Japan," in *PoLAR: Political and Legal Anthropology Review*, special edition, 20, No.1 (May 1997): 100–113.

31 See Mike Molasky's discussion of the imagery of raped Japanese prostitutes as "an allegory of national crisis and shared victimhood" in *The American Occupation of Japan and Okinawa: Literature and Memory* (New York: Routledge, 1999). Molasky provides a provocative analysis of the ways in which the Himeyuri image enjoys popular appeal in the mainland, in part through its sexualization. On the other hand, Lisa Yoneyama argues that maternal purity is evoked in nationalist discourse on the atomic bombing of Hiroshima. See Lisa Yoneyama, *Hiroshima Traces: Time, Space, and the Dialectics of Memory* (Berkeley: University of California Press, 1999).

32 Takazato Suzuyo, "I Refuse," in "Fort Okinawa," special issue, *Bulletin of the Atomic Scientists*, July/August 1996.

33 This fact has implications for Japanese democracy as well: The most controversial aspect of the Himeyuri story is whether the girls sacrificed themselves willingly or were coerced into dying, an ambiguity that speaks directly to contemporary Japanese democracy. If Okinawa was abandoned by the nation, are Japan's leaders really acting in the best interests of all the citi-

zens? As one of Japan's prefectures, doesn't the very condition of Okinawa, essentially a territory given over to an outside sovereign power, raise the question of political fairness as well as effectiveness and legitimacy?

34 Sharon Marcus, "Fighting Bodies, Fighting Words: A Theory and Politics of Rape Prevention," in *Feminists Theorize the Political*, 387.

35 Ibid., 388.

36 Ibid., 391.

37 Ibid.

38 Ibid.

39 Gwen Kirk, Rachel Cornwell, and Margot Okazawa-Rey, "Women and the U.S. Military in East Asia," in *Foreign Policy in Focus*, Interhemispheric Resource Center and Institute for Policy Studies, 4, No. 9 (1999): 2.

40 See Ernesto Laclau and Chantal Mouffe, *Hegemony and Socialist Strategy*.

41 Lydia Liu, "The Female Body and National Discourse: *The Field of Life and Death* Revisited," in *Scattered Hegemonies: Postmodernity and Transnational Feminist Practices*, edited by Inderpal Grewal and Caren Kaplan (Minneapolis: University of Minnesota Press, 1994), 40.

42 See Kazuko Watanabe, "Militarism, Colonialism, and the Trafficking of Women: 'Comfort Women' Forced into Sexual Labor for Japanese Soldiers" in *Bulletin of Concerned Asian Scholars* 26, No. 4 (1994): 3–16; and Laura Hein, "Cursing and Celebrating the Victims: 'Military Comfort Women'," paper delivered at Washington and Southeast Japan Seminar, Georgetown University, Washington, D.C., January 1998.

43 See Cynthia Enloe, *Bananas, Beaches, and Bases*.

44 See Carol Delaney, "Father State, Motherland, and the Birth of Modern Turkey."

45 Lydia Liu, "The Female Body and National Discourse," 41.

46 See Sara Ruddick's discussion of an "antimilitarist feminism in which feminist and antimilitarist commitments are interwoven from the start." In this scenario, any man or woman becomes simultaneously feminist and antimilitarist by linking war-making with masculine domination. My argument here questions the authenticity of—or at least the degree of commitment to—such claims by male and other non-feminist leaders of Okinawa's anti-base movement. Sara Ruddick, "Notes toward a Feminist Peace Politics," in *Gendering War Talk*, edited by Miriam Cooke and Angela Woollacott (Princeton: Princeton University Press, 1993), 109–127.

47 Cynthia Enloe notes that this is a common problem, *Bananas, Beaches, and Bases*, 19–41.

48 Several sources estimate that in 1969, when there were 80,000 U.S. personnel in Okinawa at the height of the Vietnam War, U.S. spending on the island amounted to $260 million per year or 40 percent of Okinawa's GNP. The per capita income of Okinawans was $580 per year. James Billard, "Okinawa: The Island without a Country," in *National Geographic Magazine* 136, No. 3 (1969): 423–88. See also Kyan Shinichi, ed., *Okinawa no Rodo Keizai* (Okinawa's labor economics) (Naha: Okinawa Labor Economics Office, 1989).

49 Looking only at prostitution in Okinawa in 1969, three years before reversion and during the height of the Vietnam War, Takazato Suzuyo reports that "7,360 Okinawan women were known to be involved in prostitution. Calculating Okinawa's population at 500,000, we can see that one out of every seventy Okinawan women was involved in prostitution in that period. Furthermore, calculating the age when women might become involved ... as between 13–16 to 60, the ratio of women in this age group who may have been involved in prostitution increases to 1 in 40." This was reported in an article published shortly before the schoolgirl's rape: Takazato Suzuyo, "Testimony: An Okinawa Swallowed Up by the Bases," in the "Voices from Japan" edition of *Women's Asia* 1, August 1995.

50 Lydia Liu, "The Female Body and National Discourse," 41.

51 Ibid., 43.

52 Linda Angst, "Gendered Nationalism," and "'In a Dark Time': Community, Memory, and the Making of Ethnic Selves in Okinawan Women's Narratives" (Ph.D. diss., Yale University, January 2001).

53 Suzuki Noriyuki and Tamashiro Satoko, "Okinawa no Fuiripinjin: Teijūsha to shite, mata gaikokujin rōdōsha to shite" (Okinawa's Filipinos: As permanent residents and as foreign laborers), in *Ryūdai Hōgaku* (University of Ryūkyūs, School of Law Publishing) 58 (1997): 1–23.

54 Takazato Suzuyo, "Testimony," 21–22.

55 See also Lenore Manderson and Margaret Jolly, ed., *Sites of Desire, Economies of Pleasure: Sexualities in Asia and the Pacific* (Chicago: University of Chicago Press, 1997).

CHAPTER 8

Media Constructions of Ethnicized Masculinity in South Africa

Pamela Scully

On 6 December 2005, Jacob Zuma, 63, the recently dismissed Deputy President of South Africa, was charged with raping a 31-year-old woman whom he had known since she was a child. The alleged rape occurred on 2 November 2005. The Zuma rape trial was a brutal affair for the alleged victim—supporters of Zuma identified her by name in posters they displayed outside the courthouse and shouted "burn the bitch"; the judge allowed the defense to discuss her sexual history at length, and Zuma argued that he had to have sex with her because Zulu custom required it.

The trial generated intense media coverage. The reporting tended to gel around particular issues: Zuma's arguments about Zulu masculinity, HIV/AIDS education, and politics. The international media also reported on the intimidation of the alleged victim and the various protests outside the court, and the implications for women in the future.[1] Many commentators analyzed the trial at least in part as a contest over the direction of the governing African National Congress (ANC). Some accepted that the government trumped up a case to torpedo Zuma's political career. Even skeptics still saw the struggle for the truth about the events of 2 November 2005 as a struggle over interpretation. In this view, Zuma's camp represented a populist traditional view of both politics and women's rights, and that of South African President Thabo Mbeki the move to modernity and the liberal state. Steven Robins points out that in fact the patriarchal traditionalist and the modernizing state were perfectly compatible. Zuma certainly used ethnic symbols and appeals to what he called "traditional" Zulu values in order to deny the woman's rape claims. Zuma also used the legal system, the Internet, and clever public relations campaigns to reach the South African public.[2]

The rape trial, which lasted from 6 March to 8 May 2006, brought together many different elements of the new democratic South Africa, which

came into being with the ending of apartheid in 1994. On 10 May 1994, almost exactly twelve years before the day that the verdict in the Zuma trial was handed down, Nelson Mandela became president. The terrible legacies of apartheid, in which the government directed funds for education, housing and health care almost solely at whites, ensured that the new ANC government would have a difficult time bringing social and economic justice to South Africa. By 1999 when Mbeki succeeded Mandela as President of South Africa after a national election, the ravages of HIV/AIDS only compounded the challenges.

In the next five years, stalwart supporters of the ANC became increasingly frustrated with Mbeki's leadership. They questioned his refusal to speak out in favor of antiretroviral distribution to HIV/AIDS sufferers, his continuing support of Robert Mugabe's dictatorship in nearby Zimbabwe that was sending millions of refugees into South Africa, and Mbeki's embrace of a liberalizing economic agenda that seemed to favor only a small minority of South Africans rather than the large numbers of poor. In this context, people within the ANC began to look to Jacob Zuma to reorient the party to address popular concerns.

Until 2005, Zuma was Deputy President and former member of the ANC's National Executive Committee. He has called himself a socialist, and in contrast to Mbeki has a populist touch. He has close ties to the South African Communist Party and has played an important role in KwaZulu Natal province in keeping support for the ANC alive. Zuma seemed likely to be the next president of South Africa until he became embroiled in a corruption charge and was dismissed from the Deputy Presidency. Nonetheless, at the time of the rape trial, he maintained widespread support within the ANC, and the media documented what they saw as a growing rift within the party between supporters of Mbeki and those of Zuma.

The trial was a powerful moment in South African history, occurring as South Africa celebrated the tenth anniversary of the new democratic constitution. The prosecution of the case against the former Deputy President was itself an indication of the tremendous legal and constitutional strides in regard to women's rights in post-apartheid South Africa. The constitution is lauded as a pioneering document in addressing the rights of all people. Section 9 of the Bill of Rights explicitly states that "The state may not unfairly discriminate directly or indirectly against anyone on one or more grounds, including race, gender, sex, pregnancy, marital status, ethnic or social origin, colour, sexual orientation, age, disability, religion, conscience, belief, culture, language and birth."[3] The constitution thus explicitly protects women's and gay rights. Yet

South Africa continues to grapple with the challenges of making such legal rights mean something in day-to-day life.

The trial touched on the insecure status of women in post-apartheid South Africa, the significance of HIV/AIDS, and the rising political tensions within the ANC. In their coverage of the Zuma trial, different media touched on all these issues. Of the media sources consulted, the BBC News online provided the most detailed coverage of the trial. AllAfrica.com, an internet database for news carried in African papers, carried frequent reports from the South African newspapers *The Sunday Times* and *Business Day*. *The Mail and Guardian*, one of South Africa's flagship papers, covered highlights of the trial, published letters from readers about the case, and continued to ponder the issues raised by the case in the months after the verdict. *The New York Times* discussed the high points of the initial charge, some of Zuma's statements on HIV/AIDS, and the verdict.

The media analysis of the failure of women's rights to take hold in South Africa remains salient, while their analysis of the fate of Zuma now seems quaintly naïve. Political and media commentators argued that the accusation of rape had ruined Zuma's political career, which was already faltering because of charges that he had been involved in an illegal arms deal. Jacob Zuma proved them wrong. His supporters created a website—Friends of Jacob Zuma—that posted messages of support and documents relating to the trial and to his life as a politician.[4] Zuma and his lawyer triumphed in using ethnicity and culture as explanatory frames to account for Zuma's actions. This appeal to culture combined with a widespread view that women manipulate men into sex and then cry foul, resonated so widely in South Africa and with the male judge, that he found Zuma not guilty on 6 May 2006. In the course of 2006 and into 2007, Zuma garnered even more support from within the ANC. On 18 December 2007, the ANC elected Zuma head of their party. Political observers and most South Africans expect that Zuma will become president of South Africa after the elections in 2009.

The Trial

Discussion of the trial and of Zuma's behavior became a national pastime in South Africa. The judge's six-hour verdict was covered live on television and radio—testament to the interest in the case. The public noise surrounding the trial was so loud that the judge commented on it in his final judgment. Judge Willem Van der Merwe said "it is not acceptable that a court be bombarded with political, personal or group agendas and comments."[5]

In late 2005, an HIV positive AIDS activist in her early thirties, who self-identified as a lesbian, alleged that Zuma had raped her in his Johannesburg

home on 2 November 2005. The victim's name was not allowed to be publicly stated, and supporters named her Khwezi, or star. She had known Jacob Zuma since childhood; since her father had died in 1985, Zuma had become a father-figure to her. She alleged that he came to the guest room where she slept, woke her up and offered her a massage. When she refused, he raped her.

The complainant testified that she had not cried out during the incident as she was in shock. In the course of the trial it emerged that she had been raped a number of times as a child. The court allowed the defense to include the sexual history of the complainant. This meant that Khwezi was then questioned in court about the number of men who had penetrated her in her lifetime, a rough copy of a book she was writing was submitted by the defense, and she was made to discuss her experience of being raped three times as a child and young person. Experts argued that such experiences of rape would have made her even more reluctant to cry out. Khwezi argued that Zuma had felt bad about the incident as he subsequently offered to compensate her, including offering her his hand in marriage. Zweli Mkhize, a Zuma ally and finance minister in the KwaZulu-Natal provincial government, apparently contacted Khwezi's mother, some forty text messages were exchanged between them, to intervene on Zuma's behalf.[6]

Zuma offered a very different reading. In an interview in *The Sowetan*, one of Johannesburg's leading newspapers, Zuma stated that "I am not a rapist. I don't struggle to have liaisons with women."[7] Zuma, who has a polygamous marriage, admitted that he had had sex with Khwezi. However, he claimed that the act had been consensual and that he had given her a massage with baby oil beforehand. He couched his defense in clear ethnic garb. He asserted that Khwezi had come to his house wearing a skirt, which was unusual for her. He also said that while in his house she had not sat properly: "under normal circumstances, if a woman is dressed in a skirt she will sit properly with her legs together. But she would cross her legs and would not mind if the skirt was raised very much." The ex-Deputy President also alleged that the fact that the complainant had shown her thighs meant that she wanted sex and that he had to give it to her as he could not leave her in a state of arousal. "As I was growing up as a young boy, I was told if you get to that stage with a woman and you don't do anything it is said she will become infuriated with you, that she may even lay false charges of rape against you."[8]

In what remains one of his most controversial statements, Zuma said he took a shower after having sex with Khwezi, apparently in part because he thought this would prevent him catching HIV/AIDS. This caused an outcry among activists who saw the statement as undoing much of the effort they had put into informing the public of safe-sex procedures. Zuma testified that he

was willing to marry Khwezi and that there had been negotiations with her aunts: "… if we reached an agreement with that, I would have had my cows ready."[9] Here he referenced *lobola*, the gift of cows to a woman's family to compensate for the loss of her labor when she moved to her husband's residence.

The defense strategy successfully couched its explanation within a cultural frame. Sally Engle Merry has shown how human rights discourses, particularly when it comes to dealing with violence against women, are often trumped by appeals to cultural specificity.[10] Even feminist activists, let alone men untutored in gender sensitivity, tend to back off from asserting the need for women's rights if it is seen to be in conflict with values that are purported to be "traditional" or customary.[11] The desire of Westerners, and in the case of South Africa post-apartheid legal scholars, to respect cultural autonomy and a desire not to reproduce imperialist attitudes creates a space for powerful men to claim rights over women. Indeed, Zuma and his lawyer Kemp modeled a defense that invoked popular perceptions of Zulu culture as a particularly masculine and dominant ethnicity in South Africa. They also justified his sexual encounter with Khwezi as a sign that he was fulfilling his obligations as a Zulu male.

Outside the court, Zuma proved to be masterful at working the crowd. He sang a popular song from the ANC struggle against apartheid: "Lethu Mshini Wami" (Bring Me My Machine Gun), thus linking his fight to escape conviction with his leadership in the ANC. In court, Zuma spoke in isiZulu to emphasize his identity as a Zulu man. He used Zulu idioms in his crossexamination, referring to the judge as "*nkosi*" or king. As Robins argues, Zuma used a representation of a particular "'traditional' masculinity and conservative sexual politics" to unite supporters as diverse as the ANC Youth League, older Zulu women, rural and urban constituents.[12]

At the heart of the trial lay different interpretations or ostensible interpretations of the same act, all debated within a legal frame that put the alleged victim on trial.[13] Khwezi's supporters argued that what happened was a rape. Zuma's champions held that she was manipulative and dishonest and further complicit in a larger plot within the leadership of the ANC to deny Zuma his rightful ascent to the presidency of the party and the country.

Rape Law and Rape Culture

Despite the guarantees of women's rights in the democratic South African constitution of 1996, much transformation still needs to happen in the arena of women's sexual rights. Even in 2008, South African rape law still only defines rape as penetration of a woman or girl. Men cannot legally be found to

be victims of rape. At the time of the trial, the law in existence was the Sexual Offences Act dating to 1957, an apartheid-era law. The sexual history of the woman could still be brought in as evidence, and this strategy helped win Zuma his acquittal.[14] On 6 May 2006 the judge found Zuma not guilty. The judge reached this verdict in part because he credited defense witnesses who alleged that Khwezi had previously made false claims of rape.[15]

Despite the verdict, the fact that a woman was able to take a leading politician to court set a precedent in South Africa, where rape is both commonplace and very under reported. Very little academic study exists of rape in South Africa outside of the burgeoning literature in public health. While rape has been on the statute books for centuries, for most of South African history rape has not been prosecuted very seriously unless a white woman was raped by a black man.[16] While the new South African constitution remains one of the most affirming in the world in its support of women's and gay rights, both groups have found it a struggle to see those rights translated into everyday life.

Feminists talk of a South African "rape culture" in which men feel entitled to have sex with women at will. Rape statistics in South Africa remain among the highest in the world; one group estimates that a woman is raped every twenty-six seconds although only one in nine rapes is reported.[17] One in three women will be raped in her lifetime.[18] The South African Law Reform Commission reported in 2006 that over one million rapes are committed each year in South Africa.[19] Commentators note disturbing trends in rape statistics with more and more children and infants being subjected to rape—some 21,000 child rapes, for example, were reported in 2000. The following year, *The Sowetan*, the leading Johannesburg paper with a wide black readership, lamented that "South Africa's infants are under siege."[20] A child has a greater chance of being raped than being taught to read—a 2002 study found that the largest group of perpetrators is school teachers.[21]

In South Africa, as in so many other places, men rape in order to force women in general to enact subservience by punishing those women seen as acting too independently, wearing "provocative clothes," or simply showing insufficient interest in men. As Helen Moffett has noted, sexual violence continues to be "an ordeal visited on women in order to keep them and their peers compliant with social 'norms' determined by hegemonic, powerful, yet threatened patriarchal structures."[22]

By laying a charge against Zuma, a leading male leader in the ANC struggle, and recently the Deputy President of South Africa, Khwezi enacted independence on the public stage, but an independence that insisted that the rights of women did not end at the door of the so-called private sphere. The Zuma trial challenged the separation of public rights of men and women from

the private authority many men continue to expect to retain in post-apartheid South Africa. Different groups saw Khwezi as having insulted a male elder by bringing the charge of rape in the first place, as being a lesbian and thus already outside of the bounds of respectability, and as someone who had brought the ANC into disrepute. The sexual encounter between Khwezi and Zuma happened in the context of this rape culture and in the context of the new constitution and its respect for women's constitutional rights as full citizens of the republic.

The rape trial turned into a new stage on which to discipline a woman. Both the judge's handling of the case and the actions of Zuma supporters set the parameters of regulation. The disciplining of women involved in the trial happened both outside and inside the court, and the South African media concentrated on all these events. The alleged rape took place on 2 November 2005. A month later, the court charged Zuma with rape. The trial finally started on 6 March 2006. In the intervening months, Zuma supporters went on the offensive: The Friends of Jacob Zuma website received hundreds of postings from supporters. A song by the female group *Insingane Zoma* that called for charges to be dropped had sold some 50,000 copies by 16 February 2006, this despite an attempt by the South African Broadcasting Corporation to exclude the song from its playlist—not a popular move since it smacked of censorship by the Mbeki government.[23]

The trial itself was an ordeal for Khwezi. As one analyst of the rape trial noted, until 1998, women's testimony in rape cases was considered prima facie "unreliable." The courts applied the "cautionary rule" in approaching the evidence of women in rape cases, along with similar skepticism regarding testimony of children and accomplices among others.[24] In this respect, the post-apartheid era witnessed some real progress in the prosecution of rape cases, including the passing of the Sexual Offences Act shortly after the conclusion of the Zuma trial.[25] The editorial referred to above, however, can also be read as a reminder to the judge to be cognizant of the legal changes. The editorial ends by stating, "It is now up to the judge to apply his mind and discretion in each case, based on the strength of the evidence and the witnesses before him."[26]

In fact, the trial demonstrated the difficulty women continue to have bringing rape charges and of being treated well both in and out of court. Newspapers remarked on the fact that while Zuma arrived in court in a motorcade as a celebrity, Khwezi had to arrive at 7 A.M., before the crowds could see her and was then rushed into the courthouse with a scarf over her face. On the day that Khwezi entered the courtroom to testify to what had happened to her, Zuma supporters were already mobilizing outside the court. The *Mail and*

Guardian reported that a poster asked, "How much did they pay you, *nond-indwa* (bitch)?"[27] On 7 March, supporters held pictures of the woman with her name emblazoned across them. Male supporters paraded outside the court-room wearing "100% Zulu Boy" tee shirts. The ANC Youth League organized various rallies outside the court that created a climate of hostility to the alleged victim.

The Youth League argued that the woman was seeking "cheap popularity by abusing public sympathy"[28] and that the trial was linked to a political plot to bring down Zuma. Feminist groups spoke out about the prevalence of rape in South Africa, and it was the One-in-Nine movement, referring to the low rate of reported rape, that organized expressions of support for Khwezi. On 27 March, the campaign was made to remove posters that asked the question "Jacob Zuma Sexual Predator!!" A female Anglican cleric also stood outside the court in her clerical robes in support of the victim.[29]

If rape had occurred, it was clear that many South Africans—including, it seems, the court—considered that the experience had brought shame on Khwezi rather than the man who was accused of raping her. While the hearings were supposed to be held in camera to protect the identity of the victim, the court was often full of spectators, and her name was soon well known. The media were generally very responsible about maintaining the privacy of the complainant, but online blogs and sites published her name. The BBC noted as early as 15 February that the court handled the rape case badly in terms of keeping the woman's identity a secret.[30] Soon, Khwezi was subject to direct intimidation: By the time the verdict was announced, she had been forced into hiding because of threats to her person. People attacked the alleged victim's home on two occasions.[31] Shortly after the trial ended she went into exile. The Netherlands granted her asylum in July 2007.[32]

Women's Rights and the Challenge of Liberty

The vocal and sometimes violently expressed hostility to Khwezi demonstrates the challenge in bringing together women's sexual rights and the right to freedom with the nationalist discourse of the era of anti-colonial struggles and the terrain of post-colonial nation building.[33] In the course of the anti-apartheid struggle, the ANC, like other liberation movements such as ZANU-PF in Zimbabwe, concentrated on uniting supporters behind an ideology of nationalism that left little space for discussing sexism within the ranks of the organization itself. The movement focused on the need to end apartheid. This new era, it was argued, would then usher in the conditions for liberation and equality for all.

The foundational document of the struggle, "The Freedom Charter," drawn up in 1955, displays the ambivalence of the time and the movement. It imagines a masculine citizenry as it states "we, the people of South Africa, black and white together equals, countrymen and brothers adopt this Freedom Charter ..." but it also called for "every man and woman to have the vote." This ambiguity about the status of women left them out of citizenship, but understood that they would enjoy legal rights in the future. The document demonstrates the ongoing unease and theoretical poverty of the national project in understanding women as full citizens of the struggle itself, and thus entitled to shape the post-colonial moment, not just to be granted equality by men. While women were certainly active in the struggle both as combatants and as community leaders, like their male comrades they most explicitly combated racism, not necessarily the sexism which permeated South African life in general.[34]

As Shireen Hassim has argued, the incorporation of women's rights in the transition to post-colonial rule in South Africa has been unusual in comparison to many other national struggles that resulted in women's marginalization. In South Africa, women's participation was heightened and "extended into the realm of representative government."[35] While the new post-apartheid South Africa certainly has proven a far better place for women in constitutional terms, ongoing violence against women, and a general unease with implications of what women's full liberty means for men's status and rights, continues to help fuel the enormous sexual violence against women and attempts to maintain male control. It is thus not surprising that we saw evidence of these fears and anger played out in the trial. As Steven Robins has noted "media commentators and gender activists claimed that the trial was a lens onto the rise of an authoritarian and sexist culture of patriarchy, misogyny, and sexual violence."[36] In so doing the media helped reproduce a popular dichotomy often made in human rights activism between the liberalizing and gender-sensitive tendencies of human rights discourse, and the patriarchal backwardness of traditional "ethnic cultures."[37] As media coverage made clear, however, the fault lines of misogyny were fuzzy.

The trial exposed the great limitations of the legal discourse of rights with regard to women's freedom to live the lives of their choice.[38] Rights discourse historically has tended to limit the notion of rights to large constitutional matters and bracket the household and personal lives from the reach of gender transformation. This is also the case in South Africa. The South African constitution is innovative in identifying gender orientation and gender as categories that exist in the world of rights. But it remains a classic liberal text insofar as emphasizing rights within the public sphere. As feminist scholars have long

pointed out, transformation for women depends upon a rejection of the separation of public and private spheres, and a recognition that, for women, some of the most urgent transformations must occur in the space of the intimate, precisely around sexual freedom and domestic equality: indeed the very spaces and concepts that remain so threatening to so many men.[39] Scholars both inside and outside South Africa continue to wrestle with the challenges of making a rights-based approach work in arenas outside of parliamentary-type structures, and particularly in the realms of the household and rural arenas where male elders often successfully claim male privilege through an appeal to "tradition."[40]

Feminist interpretations of the constitution, of rights-based discourse, and of society in general are becoming more prevalent in South African academia. However, few women's history or women's studies courses are taught at the major universities, and politicians and influential classes continue to sideline women's issues in the public sphere beyond the realm of formal rights. As a result, South African culture remains untutored in thinking through the multiple meanings of women's independence, and many men continue to see women's sexual independence and a truly egalitarian world inside the household as inconceivable forms of women's rights.

The Media and Sexual Violence

Newspapers framed their discussion of sexual politics primarily through an analysis of Zuma's strategies, rather than through the standpoint of the alleged victim. This had implications for the amount of space devoted to women's issues, despite the general impression one receives that the media empathized with Khwezi.[41] The media focused most on Zuma's political fortunes and the justification he gave for his behavior as being in accordance with Zulu values. Not as much attention was given to analyzing the experience of Khwezi in the course of the trial.

Media discussion of the victim's experience tended to revolve around the pressure being put on her by the crowds outside the courthouse. Newspapers covered the actions of the Zuma camp that were deeply hostile to Khwezi, and that displayed a deep-seated anger toward the sexual autonomy of women. To some extent one could argue that the media helped fuel this hostility by reporting on it; on the other hand, journalists expressed some discomfort and criticism of the activities taking place outside the court. Journalists paid less attention to the victimization the accuser experienced through the very proceedings of the court. The media generally accepted the court's role as a space of justice that required little comment, although one could argue that the nature of the proceedings also were highly damaging to both Khwezi and to

women in general, especially women who wanted to bring rape charges in future. Newspapers did, however, print commentary by feminist and other activist groups who cautioned that the trial would be a setback for women's rights.[42]

With regard to Khwezi's experience of the trial and the effect on women's rights, South African journalists veered between respect for the alleged victim, and finding some details of her life so salacious as to make great copy. They invoked attention to gender as a form of titillation rather than analysis. The media respected Khwezi by not publishing her name and showing some outrage with Zuma's tactics. News 24 published some details of her statements and those of the defense relating to her sexual history and her private life. One online news source seems to have found it titillating to juxtapose her identity as a lesbian with her past sexual history with men: "Lesbian Khwezi names 5 men," the headline screamed.[43] The Sunday Times discussed the implications of the fact that the prosecutor was a woman. She was one of only two women working at such a high level in the entire country. Charin de Beer was considered to be "meticulous and unyielding in her prosecutorial duties." But even an article that implicitly praised de Beer was titled "Zuma's Foe, the Tough Cookie" casting a coy sexual tone to the coverage.[44]

Some of the greatest criticism of Zuma came from the public who wrote letters to the editors. Zuma and his defense team invoked cries of outrage for justifying rape of a woman he had known as a family member since her childhood. As one letter to the editor said, "Malume is brother to one's sister. The relationship between ... niece and nephew is closer than fatherly—it is maternalistic.... Zuma, given our respect for the dead, betrayed his closest of friends.... Her father must be turning in his grave."[45] A reader lamented that Zuma was so comfortable having liaisons: "He is a married man and should be exemplary, especially when we are confronted by the colossal predicament of HIV/AIDS."[46] Another stated, "His behaviour was utterly misogynistic; it was not in the name of cultural mores he acted, but in defiance of them."[47]

The media generally turned to feminist groups to offer critiques. There was a great divergence of opinion from women on the nature of the trial and its meaning for South Africa. The Commission on Gender Equality criticized the rallies outside the court organized by the ANC Youth League for creating such a climate of hostility to the complainant. The ANC Women's League, while fairly restrained in publicly discussing the trial, did voice concern about Zuma's behavior saying, "We are saddened by the fact that this incident implicates a leader that people have put confidence and trust in...."[48] The New York Times interviewed Nomboniso Gasa, a feminist ANC member, who argued

that people found Zuma's actions "repulsive. He has broken every socio-cultural rule."[49]

On the other hand, women who saw their primary identity coming from their roles as female elders and mothers, found the spectacle of an unmarried woman criticizing an important senior man for sexual abuse an unacceptable breach of etiquette. Newspapers paid attention to this constituency in their coverage of the crowd of supporters outside the courthouse. Zuma appears to have found particular support for this argument from older Zulu women in his home constituency in KwaZulu Natal. In November 2005, following Zuma's dismissal from the Deputy Presidency of South Africa, women bared their breasts to the new, and female, Deputy President Mblambo Nqucuka, in a sign of extreme disrespect.[50] At the time of the trial it was in fact older women, many brought in from Zuma's political stronghold of KwaZulu, who burned the photographs of the complainant while saying "burn the bitch."

The trial and coverage exposed deep fault lines in South Africa at the juncture of ethnic mobilization and women's rights. Zuma's defense proved so adeptly how mobilization around ethnic solidarity could silence criticisms of women's rights, and how defense of bodily integrity and the right to say no could be an affront to a man's sense of himself. The trial also exposed generational tensions among women. It was the older women who had suffered under apartheid and who had no doubt put up with so much who seemed to have felt less empathetic to the complainant. Instead of seeing a victim, they saw a woman who was willing to jeopardize all of the years the older women had invested in supporting the men of the anti-apartheid struggle.[51]

The Media, Zuma and HIV/AIDS

If the reporting on women's issues in the trial was attenuated, the media were almost unanimous in their focus on and discussion of Zuma's statements about HIV/AIDS. In his final judgment even the judge noted Zuma's irresponsibility in having unprotected sex and especially with a woman who was known to be HIV positive. Papers reported widely on the fact that Zuma did not wear a condom. Zuma appears not to have taken the issue very seriously, arguing that both he and Khwezi had "made the decision to continue without wearing a condom."

The outcry about Zuma's action arose out of a general frustration with the government's handling of the AIDS crisis in South Africa. For a number of years, President Mbeki refused to allow the distribution of antiretroviral drugs to patients, holding that no clear connection had been established between HIV and AIDS. The Treatment Action Campaign, led by Zackie Achmat, finally forced the government to roll out treatment after a concerted grassroots

struggle that used many of the tactics honed during the anti-apartheid move-
ment.[52] Many activists saw Zuma's refusal to behave responsibly as a step
backward. Before his dismissal from the Deputy Presidency of the country,
Zuma, after all, had been head of the National AIDS Council! *All Africa* re-
ported that activist groups believed that Zuma's statement "was a huge setback
for prevention campaigns." Anso Thom reported on the Southern African
HIV Clinicians Society's attempt to clarify the correct ways of dealing with
HIV and ended with their statement that called "on public figures to show
responsibility when making statements on HIV prevention, especially when
these are in conflict with current scientific and government messages."[53]

BuaNews out of Pretoria reported on the government's attempts to defuse
the crisis around Zuma's irresponsible behavior. In contrast to other newspa-
pers that vilified Zuma's engaging in unprotected sex, *BuaNews* reported that
Health Minister, Manto Tshabalala-Msimang, criticized the media for not be-
ing clear about the government's message as to how to prevent HIV/AIDS.
She argued that if the media had been as good at promoting clear messages to
prevent the disease as they had been about covering the trial, much could have
been done. The minister herself has been embroiled in much controversy over
her long-time refusal to promote the use of antiretroviral drugs.[54]

"Not Guilty"

During the trial, commentators generally concluded that whatever the out-
come, Zuma's presidential ambitions had been thwarted by the rape accusa-
tion. Shortly after news of the rape accusation became public, *The New York
Times* stated that the rape accusation had caused "political damage."[55] On 9
April, with the trial well under way, Johannesburg's *Sunday Times* argued that
Zuma was "fighting to save his political career."[56] But what the trial proved was
that pressure could be brought to bear on the courts, and that in the end,
Zuma had a very strong and large constituency. By 6 March, when the trial
finally began under Justice van der Merwe, a white judge, three black judges
had stepped down under charges by the defense that they could not be impar-
tial against Zuma, or because the political pressure associated with the case was
too hard to bear.[57]

The verdict was greeted with shock by the media. *The Post* of Lusaka,
Zambia, argued that Zuma's acquittal was "absurd." Dr. Neo Simutanyi's edi-
torial still held that the trial had done "irreparable" damage to Zuma's reputa-
tion. He stated that the trial was not about rape but rather about power, and
the ambition of a politician and his supporters to ensure that he is the next
president of South Africa.[58] *The New York Times* devoted an editorial to the
verdict, lamenting that "The 'She Asked for It' Defense Wins." The *Times*

wondered, "Where do we begin?" to explain the depth of sexism expressed by Zuma, which the newspaper argued was emblematic of wider attitudes in South Africa.[59] *The New York Times*, however, also had to acknowledge that their prediction of Zuma's political demise had been incorrect. By 10 May, shortly after the verdict on 6 May, *The New York Times* had to eat its words. Talking of the year having been a "series of shocks" for Jacob Zuma, the paper now said that it was "critics turn to be shocked." The newspaper now referred to Zuma as a "gifted politician" who had read his constituency and knew well how to play to it.[60]

Indeed the Zuma defense ploy that cast Khwezi as an irrational woman who actually desired Zuma but was not able to admit it tapped into widespread ideas about sexuality that justified men's access to women across cultural frames. The success of that framing, and the challenges faced by feminists who sought to reshape public attitudes towards rape and women's sexuality, is seen by the fact that even before the trial ended, the government was making plans to send Khwezi into exile. On 7 May, Dominic Mahlangu and others reported that a "'high level' security assessment undertaken by officials from the police, the intelligence services and the witness protection program" had concluded that Khwezi needed to be sent abroad for her own safety. They concluded that she was not safe anywhere in South Africa and that she faced threats to her life.[61]

Conclusion: Legacies of the Zuma Trial

The threats of violence and the general threat of extra-legal measures that had been raised in the trial continue. The tension between Mbeki and Zuma has reached almost epic proportions. In Zuma's trial for corruption in July 2006 (the case is still pending) threats of violence continued. *The Sunday Times* covered the case, again paying much attention to the scenes outside the courtroom where Zuma supporters carried a coffin with Mbeki's image on it. Supporters continue to believe that the rape trial was part of a conspiracy to deny him the presidency.[62]

Zuma's rape trial and the way the witness was treated exposed the deep misogyny in South African culture, which continues to the present day. In November 2007, the ANC Women's League voted for Zuma in the election for president of the ANC, despite the statements he had made during the trial.[63] The 100% Zulu Boy tee shirts only gained in popularity after the trial, being used at rallies in support of Zuma.[64] The trial did perhaps draw the media's attention even more to the issue of rape in contemporary South Africa. *The Sowetan* newspaper does a particularly good job of documenting the violence visited on women. In 2008, two years after the trial ended, the country

was gripped by reports of the gang rape and murder of a young woman be-
cause she was a lesbian.[65] In February 2008, a woman at a taxi rank in Johan-
nesburg was beaten up by a crowd for wearing a miniskirt and thus supposedly
provoking violence and rape.[66]

The incident provoked women to organize a protest march, but women
continue to live in a culture of rape, of what Susan Brison has termed rape's
"post-memory" where women grow up with stories of rape and live with a
sense of its inevitability.[67] South Africa remains a battleground for the mean-
ing of true democracy and calls for a new interpretation of women's rights that
insists on freedom.

On the first anniversary of the trial, a feminist lamented the repercussions
of the verdict and of the deep misogyny that was exposed during the trial. She
speaks of the "state of siege" that women live under in South Africa.[68]

> I am deeply saddened still that a woman who spoke her violation and her pain has
> been exiled from her country...I am still sad that the woman we know publicly as
> Khwezi is still exiled for such a necessary act of courage....
> So, it is Khwezi, wherever she is, who is in my thoughts today and tomorrow. I
> hope she is well, and... I look forward to a country that she can return to and feel safe
> in, a country where we no longer need to live in siege....

In the course of 2008, as the book goes to press, Zuma's rise to power contin-
ued unabated. In September, the corruption charges were dropped on a tech-
nicality with the judge suggesting that the Mbeki government's investigations
had been politically motivated; Thabo Mbeki was forced to step down as
President of South Africa, and Zuma looked set to become the next president
of the country after elections in 2009. But politics remain volatile. We still
have not seen the final outcome of the Zuma story. Perhaps one day Khwezi
will be able to return home.

Notes

1 *The Lancet*, for example, documented various aspects of the trial and concluded with some of the progress made by government toward addressing women's rights: focuses on Thuthuzela Centres, one stop counseling and legal centers for victims of sexual violence. Clare Knapp, "Rape on Trial in South Africa," *The Lancet* 357 (March 4, 2006): 719.

2 Steven Robins, "Sexual Rights and Sexual Cultures: Reflection on 'The Zuma Affair' and the 'New Masculinities' in the New South Africa," *Horizontes Antropologicos*, Porto Alegre 12, No. 26 (July–December 2006): 149–183. For a different version, see his "Sexual Politics and the Zuma Rape Trial," *Journal of Southern African Studies* 34, No. 2 (2008): 411–427. On Zuma and masculinity also see Kopano Ratele, "Ruling Masculinity and Sexuality," *Feminist Africa* 6 (September 2006): 48–64.

3 The South African Constitution in its entirety is available at http://www.info.gov.za/documents/constitution/1996/96cons2.htm. For a discussion of the implications of this constitution for women's rights see Gay Seidman, "Gendered Citizenship: South Africa's Democratic Transition and the Construction of a Gendered State," *Gender and Society* 13, No. 3 (1999): 287–307.

4 As of June 16, 2008, there were 12,210 messages of support on the website.

5 Quoted in Steven Robins, "Sexual Rights," 155.

6 Amy Musgrave and Jenni Evans, "Zuma's story 'laughable, fanciful'," *Mail and Guardian Online* (April 15, 2006); Ernest Mabuza, "Zuma Trial Witnesses Let off the Hook," *Business Day* (Johannesburg) (April 26, 2006).

7 Quoted in "Zuma lawyers seek rape trial end," *BBC News Online* (March 27, 2006).

8 Di Neo Simutanyi, *The Post*, Lusaka, allafrica.com/stories/200605150932.html; Ernest Mabuza, "News," *Business Day* (April 5, 2006); Moipone Malefane, Wisani wa ka Ngobeni and Brendan Boyle, "ANC Leaders Take on Zuma," *Sunday Times* (June 4, 2006); "Zuma Trial Helpful in Fight Against Aids," *JournAIDS*. http://www.journaids.org/blog/2006/04/07/zuma-rape-trial-helpful-in-fight-against-hivaids/

9 "SA's Zuma showered to avoid HIV," *BBC News Online* (April 5, 2006).

10 Sally Engle Merry, *Human Rights and Gender Violence: Translating Transnational Law into Local Justice* (Chicago: University of Chicago Press, 2006).

11 See Pamela Scully, "Afterword: Finding Gendered Justice in the Age of Human Rights" in *Domestic Violence and the Law in Africa*, edited by Richard Roberts, Emily Burrill, Elizabeth Thornberry (Columbus: Ohio University Press, forthcoming).

12 Steven Robins, "Sexual Rights," 165.

13 Sidra Minhas' chapter in this volume documents a similar strategy being enacted in Pakistan.

14 Point made by Ayesha Kajee, in Moyiga Nduru, "Zuma Acquitted—but 'The Struggle Continues'," *Inter Press Service* (Johannesburg) (May 8, 2008). The new Sexual Offences Act, passed later in 2006, now prevents the sexual history of the alleged victim from being introduced in court. Allafrica.com/stories/printable/200605090027.html

15 Johannesburg's *Business Day* queried why the prosecution failed to call key witnesses to the stand. These included Zweli Mkhize, Zuma's lawyer Mike Hulley and intelligence minister Ronnie Kasrils, who the victim apparently called for advice. See Ernest Mabuza, "Zuma Trial Witnesses."

16 See Pamela Scully, "Rape, Race and Colonial Cultures: The Sexual Politics of Identity in the Nineteenth-century Cape Colony, South Africa," *American Historical Review* 100, No. 2 (April 1995): 335–359; also Pamela Scully, *Liberating the Family?* (Portsmouth: Heinemann, 1997), ch. 6. On contemporary rape culture see Helen Moffett, "'These women, they force us to rape

them': Rape as Narrative of Social Control in Post Apartheid South Africa," *Journal of Southern African Studies* 32, No. 1 (2006): 129–144; and Elaine Salo, "Gangs and Sexuality on the Cape Flats," *African Gender Institute Newsletter* 7 (December 2000): http://web.uct.ac.za/org/agi/pubs/newsletters/vol7/elaine.htm. Rachel Jewkes has been associated with many important studies of rape in South Africa. See Naeemah Abrahams, Rachel Jewkes, and Ria Laubsher, "'I do not believe in democracy in the home': Men's Relationships with and Abuse of Women" (Cape Town, Medical Research Council of South Africa, 1999), cited in Helen Moffett, "'These women'." Also see Rachel Jewkes. Jonathan Levin, Nolwazi Mbananga and Debbie Bradshaw, "Rape of Girls in South Africa," *The Lancet* 359, No. 9303, 319–320, among some one hundred articles, including a focus on HIV/AIDs and sexual violence. For an exploration of the ethical issues that constrain research on this topic see Diana Russell, for example, "Between a Rock and a Hard Place: The Politics of Wwhite Feminists Conducting Research on Black Women in South Africa," *Feminism and Psychology* 6, No. 2 (May 1996): 176–180.

17 "Rape on Trial in South Africa," *The Lancet* 357 (March 4, 2006): 719.

18 Helen Moffett, "'These women'," 129.

19 Steven Robins, "Sexual Rights," 158.

20 Reported in "South Africa facing child rape crisis," *CNN.com* (November 26, 2001). See also Helen Moffett, "'These women'," 134.

21 Rachel Jewkes, et al., "Rape of Girls in South Africa."

22 Helen Moffett, "'These women'," 138.

23 "Soaring sales for pro-Zuma song," *BBC News Online* (February 16, 2008).

24 Judy Green, "Opinion," *Business Day* (April 21, 2006).

25 Indeed, the apparent flourishing of rape in post-apartheid South Africa might well partly be a result of the attention the ANC government gives to documenting rape as opposed to the apartheid government. Erin Tunney is completing a Ph.D. in Women's Studies at Emory University that analyzes gender-based violence in post-conflict South Africa and Northern Ireland.

26 Judy Green, "Opinion."

27 Jenni Evans and Riaan Wolmarans, "Timeline of the Zuma Trial," *Mail and Guardian Online* (March 21, 2006).

28 Clare Knapp, "Rape on Trial in South Africa," *World Report*, 719.

29 On feminist support for Khwezi, see Vasu Reddy and Cheryl Potgieter, "'Real men stand up for the truth': Discursive Meanings in the Jacob Zuma Rape Trial," *Southern African Linguistics and Applied Language Studies* 24, No. 4 (2006): 511–521.

30 "Zuma case reveals SA rape problem," *BBC News Online* (February 15, 2006).

31 Simutanyi, *The Post*, Lusaka, allafrica.com/stories/200605150932.html

32 See Mavis Makuni, "Accuser Put 'on Trial' in Zuma Case," *Financial Gazette* (Harare) (May 10, 2006), Allafrica.com/stories/200605110115.html; "Report: Zuma rape accuser gets asylum in Netherlands," *Mail and Guardian Online* (July 3, 2007).

33 See the special issue of *Signs: Journal of Women and Culture in Society* 32, No. 4 (Summer 2007) on War and Terror I: Raced-Gendered Logics and Effects in Conflict Zones, especially Aaronette M. White, "All the Men Are Fighting for Freedom, All the Women Are Mourning Their Men, but Some of Us Carried Guns: A Raced-Gendered Analysis of Fanon's Psychological Perspectives on War," 857–884; and Meg Samuelson, "The Disfigured Body of the Female Guerrilla: (De)Militarization, Sexual Violence, and Redomestication in Zoë Wicomb's *David's Story*," 833–856.

34 For an early and eloquent discussion of patriarchy in South Africa see Belinda Bozzoli, "Marxism, Feminism and South African Studies," *Journal of Southern African Studies* 9, No. 2 (1983): 139–171. On women and national struggles, with a focus on South Africa, see Anne McClintock, "Family Feuds: Gender, Nationalism and the Family" *Feminist Review* 44 (Summer 1993): 61–80.

35 Shireen Hassim, "'A Conspiracy of Women': The Women's Movement in South Africa's Transition to Democracy," *Social Research* 69, No. 3 (Fall 1999): 693–732.

36 Steven Robins, "Sexual Rights," 157.

37 For an examination of the uses of culture and gender in United Nations human rights discourse, see Sally Engle Merry, *Human Rights and Gender Violence*. For an analysis of the disciplinary tendencies of human rights discourse see Harri Englund, *Prisoners of Freedom: Human Rights and the African Poor* (Berkeley: University of California Press, 2006).

38 For an extended discussion of the need to discuss liberty as well as equality, see Linda Zerilli, *Feminism and The Abyss of Freedom* (Chicago: University of Chicago Press, 2005).

39 See, for example, Carole Pateman, *The Disorder of Women: Democracy, Feminism, and Political Theory* (Stanford: Stanford University Press, 1989); Martha Nussbaum, *Women and Human Development: The Capabilities Approach* (Cambridge: Cambridge University Press, 2000); Celina Romany, "State Responsibility Goes Private: A Feminist Critique of the Public/Private Distinction in International Human Rights Law," in *Human Rights of Women: National and International Perspectives*, edited by Rebecca Cook (Philadelphia: University of Pennsylvania Press, 1994); Donna Sullivan, "The Private/Public Distinction in International Human Rights Law" in *Women's Rights, Human Rights: International Feminist Perspectives*, edited by Julie Peters and Andrea Wolper (New York: Routledge, 1995).

40 Of course these elders are often using cell phones and driving cars as they make the case of unchanging traditional values.

41 See headlines such as "Zuma's story 'laughable, fanciful'"; "23 Days that shook our world"; and "Zuma case reveals SA rape problem."

42 See Judy Green, "Opinion."

43 News24.com, http://www.news24.com/News24/South_Africa/Zuma/0,,2-7-1040_1895253,00.html. On rape trials see Anastasia Maw, Gail Womersely and Michelle O'Sullivan, "The psycho-social impact of rape and its implications for expert evidence in rape trials," in *Should We Consent: The Politics of Rape Reform in South Africa*, edited by Lillian Artz and Dee Smythe (Cape Town: Juta Publications, forthcoming).

44 Charles Molele, "Zuma's Foe, the Tough Cookie," *Sunday Times* (Johannesburg) (April 9, 2006).

45 Ngqu, in "Letters," *Mail and Guardian Online* (May 19–May 26, 2006).

46 Ntwampe Morata, in "Letters," *Mail and Guardian Online* (March 17–March 23, 2006).

47 Trivern H. Ramjettan, "Letters," *Mail and Guardian Online* (May 19–May 26, 2006).

48 "Gender Takes Back Seat in Succession Battle," *AllAfrica.com* (December 6, 2007): Allafrica.com/stories/20071206945.html.

49 Michael Wines, "A Highly Charged Rape Trial Tests South Africa's Ideals," *The New York Times* (April 10, 2006).

50 "Letters," *All Africa.com* (November 25, 2005).

51 For a powerful examination of the fissures around gender in the anti-apartheid struggle, see the novel by Zoe Wicomb, *David's Story* (New York: The Feminist Press, 2002).

52 See Steven Robins, "'Long live Zackie': AIDS Activism, Science and Citizenship after Apartheid," *Journal of Southern African Studies* 30, No. 3 (April 2007): 651–672.

53 Dr Neo Simutanyi, *The Post*; Anso Thom, "Health-e (Cape Town)," (April 10, 2006): al-lafrica.com/stories/200604100890.html

54 Tshabalala-Msimang herself continues to be a highly controversial minister given her alliance with doctors who refuse the connections between HIV and AIDS, and her refusal to promote ARVs. Report from *BueNews*, Themba Gadebe: allafrica.com/stories/printable/200605120173.html

55 "In Fall from Grace...," *The New York Times* (December 7, 2005).

56 Charles Molele, "Zuma's Foe, the Tough Cookie."

57 "Zuma 'love child' confounds trial," *BBC News* online (February 15, 2006).

58 Dr Neo Simutanyi, *The Post*.

59 "The 'She Asked for It' Defense Wins," *The New York Times* (May 10, 2006).

60 Michael Wines, "A Highly Charged Rape Trial..."

61 "Exile for Zuma's Accuser," *Sunday Times* (May 7, 2006): allafrica.com/stories.200605081138.html

62 "Zuma Rides the Crest of a Wave," *Sunday Times* (September 24, 2006): allafrica.com/stories/200609250926.html

63 Wendy Jasson Da Costa, "ANC Women Choose One of Their Own," *The Cape Argus* (November 27, 2007): allafrica.com/stories/printable/200711270123.html

64 Deon de Lange, "ANC Bans T-Shirts," *The Cape Argus* (December 12, 2007).

65 Dan Fuhpe, "Lesbian Rape Accused...," *The Sowetan* (June 4, 2008).

66 "Outrage over Attack on Miniskirt-wearing Woman," *Mail and Guardian Online*, (February 19, 2008).

67 Susan Brinson, *Aftermath: Violence and the Remaking of the Self* (Princeton: Princeton University Press, 2002), 97.

68 Pumlagqola, "A Year Since the Zuma Rape Case Judgment," *Loudrastress*: http://pumlagqola.wordpress.com/2007/05/07/a-year-since-the-zuma-rape-case-judgement/. For a meditation inspired by the trial see Mmatshilo Motsei, *The Kanga and the Kangaroo Court: Reflections on the Rape Trial of Jacob Zuma* (Jacana Media, 2007).

Transformative/Alternative Practices

Gendered Narratives of Child Sexual Abuse in Fiction Film

Karen Boyle

"If only I'd been raped as a child, then I could know authenticity."

In Todd Solondz's 1998 film *Happiness*, Helen Jordan (Lara Flynn Boyle) reflects in an interior monologue that if only she had been raped as a child *then* she would know authenticity. Helen is a commercially and critically successful poet whose subject is child sexual abuse. Her (fictional) work is a testament to the representability of child sexual abuse and, as her anxiety over her lack of personal experience ironically suggests, to the pervasive nature of child sexual abuse testimony in the public sphere.

Yet the *filmic* representation of child sexual abuse is precisely what *Happiness* withholds. The child sexual abuse narrative, which centers around Helen's brother-in-law Bill Maplewood (Dylan Baker), is structured by absences: the abuse takes place off screen; the abused boys are marginal characters; and Bill disappears from the diegetic world without comment following his confession. *Happiness* thus points to one of the fundamental contradictions that this article seeks to explore: for all the media "noise" about child sexual abuse (which the fictional Helen profits from and of which feminist critics, including Louise Armstrong and Jenny Kitzinger, have written provocative critiques), it remains largely disembodied in narrative fiction film.[1] Further, while feminist critics have built up a substantial body of work analyzing and theorizing gendered violence in narrative fiction film, representations of child sexual abuse have yet to receive the same critical attention, something this article seeks to remedy.[2]

Helen's comments have further significance for my analysis in their bringing to the foreground experience and authenticity. For Helen's story to be accepted as authentic (even within *Happiness'* fictional world), she assumes it has to have been lived, and, further, that had she lived that experience she would

be able to recount it "authentically." Satirical as they may be, these comments find resonance in popular and academic arenas. For example, writer J.T. Leroy's one-time persona as an androgynous but biologically male hustler and abuse-survivor lent texts such as *The Heart Is Deceitful Above All Things* an urgency and believability.[3] The subsequent revelation that the person behind the persona was a 40-year-old woman was read by some as a deception, undermining the "truth" of the (fictional) text. In relation to child sexual abuse, therefore, it would seem that "authenticity" is simplistically equated with first-hand traumatic experience. Complementary to this is the insistence that true stories of child sexual abuse are true in every aspect or not at all. Had Helen been "raped at 12" (as the title of one of her poems states) then she would have remembered, and remembered every detail: the fictional narrative here mirrors the structure and assumptions of fact-based narratives of child sexual abuse.[4]

Yet, as *Happiness* also suggests, there is a gendered dimension to public remembering and an appropriate mode for its expression. Helen's (in)experience is a reflection of the popular concern with the falsifiable nature of traumatic memory that came to dominate media narratives of child sexual abuse from the late 1980s onward. As Armstrong argues, the media became fixated on the threat posed by "hysterical" and untruthful women who, in complex ways, could be argued to profit from their victimized deceptions.[5] In contrast, the "true" victims in *Happiness*—the boys abused by Bill—remain utterly silent, their experience interpreted by the adults who surround them. The act of telling is thus both feminized and distrusted, and, in this respect, *Happiness* again echoes the (popular, critical, political, legal, therapeutic) treatment of child sexual abuse testimony in nonfictional forms. On the one hand, the experience and memory of child sexual abuse are understood to be so traumatic that it leaves the victim/survivor speechless. The victim/survivor's willingness to speak publicly thus casts doubt on their authenticity—if they had *really* suffered, then why would they want to relive that experience? This resonates with responses to sexual abuse more generally where "real" rape is still frequently constructed as the "worst thing that could possibly happen," rendering the victim's very survival suspect and potentially shameful.[6] On the other hand, the victim/survivor's testimony is rigorously publicly probed and policed as though, to be believed at all, they must be able to provide intricate and accurate detail. The reverse logic appears to operate here: If they had *really* suffered then how could they ever forget it?—meaning that any slips in memory cast doubt on the authenticity of the entire experience.[7] At stake, then, in both fictional and nonfictional forms, is the believability of the victim/survivor and the relationship among memory, truth, and telling.[8] Against this backdrop, Helen's deception is successful, arguably because she has chosen poetry as her

medium: it has a niche readership, is quite obviously "crafted," and demands active interpretation on the part of its readers. Helen's poems are not held to the same standards of evidence as representations in more realist or illusionist modes, including the film in which her own story is embedded.

These questions around memory, truth, telling, and the means of telling are central to Janet Walker's *Trauma Cinema*, one of the few texts to explore filmic representations of child sexual abuse. After a brief account of Walker's argument in the next section, I will go on to consider how three films that are focused on the sexual abuse of boys—*The Prince of Tides* (dir. Barbra Streisand, 1991), *Sleepers* (dir. Barry Levinson, 1996) and *Mysterious Skin* (dir. Gregg Araki, 2004)—deal with memory and disclosure. All three films were released after the advent of the "memory wars" had re-framed public discourse on child sexual abuse to emphasize the question of the reliability and verifiability of memory. Their fictional worlds reflect this real-world development, all focusing on adult survivors' memories. I will argue that the narrative structure and preoccupations of these films offer points of connection with Walker's work, particularly her analysis of "trauma documentaries." In all three of my fictional examples, the (re)telling of the story of child sexual abuse is marked by evasions and contradictions, pointing to the vagaries of traumatic memory. However, as my analysis of *The Prince of Tides* and *Sleepers* will suggest, this is not necessarily progressive in and of itself. Rather, by considering the various ways in which telling, showing, and concealing child sexual abuse are linked to conceptualizations of gender and sexuality, I will argue that the political—*feminist* potential that Walker finds in the "trauma documentaries" is not a generically specific one but, rather, depends on a willingness to reject (formally and thematically) masculine authority.

The Traumatic Paradox

At the beginning of *Trauma Cinema*, Walker establishes the inherent contradiction of traumatic memory:

> memories for traumatic events are known for being *more* veridical than memories for everyday events when it comes to the "gist" of memory. But it is also true that real catastrophes can disturb memory processing. Whereas popular and legal venues tend to take an "it happened or it didn't" approach that rejects reports of traumatic experiences containing mistakes or amnesiac elements, contemporary psychological theories show that such memory features are a common consequence of traumatic experience itself. Forgetting and mistakes in memory may actually stand, therefore, as a testament to the genuine nature of the event a person is trying to recall. This is the inherent contradiction of traumatic memory—what I have termed the "traumatic paradox": traumatic events can and do produce the very amnesias and mistakes in memory that are generally considered to undermine the legitimacy of a retrospective report about a remembered incident.[9]

As Walker notes, the tendency in popular venues (including the media) has been to ignore the traumatic paradox and insist that memory is either wholly accurate or wholly inaccurate. From the late 1980s onward, the media story about child sexual abuse became focused on proving or disproving the accuracy of individual accounts, utilizing the form of personal testimony that had been so important to early feminist "speak outs" but rejecting their use of testimony as a building block to political analysis. As Armstrong so pithily puts it, for the media "the personal is—the personal."[10]

Walker further notes that the either/or proposition that so dominates fact-based accounts—"sexual abuse happened and recollections of it are true, or it did not happen and purported recollections should be culled out and attributed to 'false memory syndrome'"[11]—fits well the narrative demands of illusionist cinema, a form that "facilitates the identification of spectators with characters and purports to show the world as it is."[12] For much of cinematic history, of course, "the world as it is" was a world in which incest as a form of abuse simply did not exist. Even when source material was explicit in its detailing of incestuous relationships, Walker argues that Classical Hollywood excised any mention of incest as an issue of memory or experience.

Skipping forward, Walker then considers television movies and documentaries which, since the 1970s, have been far more explicit in their treatment of incest. Made-for-TV movies, she suggests, were initially unequivocal in privileging victims/survivors' memories, although—mirroring the development of the public discourse on child sexual abuse more generally —the narratives typically revolved around securing evidence to convince doubters within the filmic world. While the political and personal importance of such visibility cannot be understated, Walker reads the simplicity of the stories as something of a hostage to fortune, noting that in their portrayal of evidence—often accompanied by a visualization of the past through the use of flashbacks—these dramas are "more realistic than real life," providing the spectator with unequivocal evidence realistically unavailable.[13] However, although they include apparently tangible portrayals of recalled abuse, these portrayals are marked by absence and incoherence as editorial fragmentation—such as the use of disorientating camera angles or alterations in light and film stock—conveys the emotional truth of a memory that is otherwise ethically unrepresentable in a realist mode. The narrative emphasis on the victim/ survivor in these television fictions may itself be read as a legacy of Freud's reframing of incest in relation to fantasy. That is, the story of child sexual abuse is the story of the child/adult survivor, *their* believability and *their* survival. Indeed, it is notable that representations of child sexual abuse frequently obliterate the abuser altogether so that—with a few recent exceptions, such as *The Woodsman* (dir. Nicole Kassell,

2004) and *Hard Candy* (dir. David Slade, 2005)—his motivations remain largely unscrutinized. In this respect, films about child sexual abuse have much in common with representations (factual and fictional) of other forms of sexual violence[14] and, indeed, with the focus on victims/survivors' culpability in rape trials.[15]

Walker then turns her attention to the "trauma documentary" which, she argues, most fully and explicitly realizes the "traumatic paradox." In these documentaries—including *Some Nudity Required* (dir. Johanna Demetrakas and Odette Springer, 1998), *Just, Melvin: Just Evil* (dir. James Ronald Whitney, 2000) and *Capturing the Friedmans* (dir. Andrew Jarecki, 2003)—the vagaries of memory are exposed as those involved remember, forget, contradict themselves and each other, and misremember details. As such, these films create a way of understanding that incest could have happened and may yet be understood through the intersections of a variety of accounts that may be factually inaccurate but experientially true. The absence of an individualized, coherent narrative of verifiable facts does not imply the absence of trauma but rather replicates the traumatic paradox, liberating the public debate about incest from the either/or proposition that has so stymied theoretical, therapeutic, legal, and representational advances in recent decades. The radical potential of this in practical terms lies in the acknowledgment that there is a process of *interpretation* involved in memory (even for the rememberer), that the interpretations available will partly depend on context and that the subjectivity of this process is not, in itself, a negation of the reality of abuse or the culpability of the abuser. In cinematic terms, the potential lies in the demands these films make on their spectators by refusing to provide coherent and comfortable points of identification or entirely verifiable evidence—a position that more closely resembles that occupied by the real-world witness to traumatic remembering.

Does contemporary fiction film have similar potential? Certainly intrafamilial abuse is no longer completely excised: recent films tackle the issue explicitly, dealing with both female and male victims and familial and nonfamilial abuse. Further, although *memories* of child sexual abuse are the focus of this article, it is worth noting that not all contemporary child sexual abuse films consign the abuse to memory. However, even if located in the film's present, the child sexual abuse is typically an adult's story as the abuse creates a disequilibrium mirroring a crisis in the life of the adult protagonist that the film works to resolve. As such, the *interpretation* of the experience remains a central issue and, even when we are offered "objective" evidence of that experience, questions around the truth status of testimony and other evidence recur within the diegesis. Thus, although contemporary fiction films may be more explicit in their treatment of child sexual abuse than the Classical Hol-

lywood texts examined by Walker, the problems with representing child sexual abuse identified in her work remain. The analysis presented in the remainder of this article suggests that, while there are complexities in these representations that undoubtedly create space for exploring the "traumatic paradox," the radical potential of such explorations may be limited by anxieties over gender and sexuality.

"I need you to be her memory."

The Prince of Tides is a film about memory but it is a gendered memory and the narration of its recovery, despite difficulties and omissions which hint at the traumatic paradox, works to reinstate hetero-patriarchal authority.

The film opens with a slowly moving shot of the marshes of the Carolina Sea Islands infused with the orange glow of a low sun and accompanied by a gentle, melodic score. The expansive landscape shots give way to young children playing freely and affectionately, navigating land and sea and escaping parental vision. However, the soundtrack creates tension as the parents' hectoring voices leak into the diegetic past and the narrator, the adult Tom Wingo (Nick Nolte), tells of his father's violence and his mother's fallibility. The adult Tom is removed from this environment by another catastrophic event—his twin sister Savannah's (Melinda Dillon) attempted suicide—and travels to New York at the request of Savannah's psychiatrist, Dr. Susan Lowenstein (Barbra Streisand). Tom's task, Lowenstein tells him, is to be Savannah's memory and fill in the missing details that his sister is unable to provide.

Tom's sessions with Lowenstein are the focus of the first two-thirds of the film, climaxing with his revelation of the family secret—Tom, Savannah, and their mother Lila (Kate Nelligan) were raped by three escaped convicts. Tom's disclosure brings about a shift in narrative focus from the recovery of the past to the romance of the present: there are no more flashbacks or therapy sessions; Savannah gains a diegetic voice and leaves the hospital; and Tom is free to enter into a relationship with Lowenstein and eventually to resume his familial roles. This is also the moment at which, as Tom-the-narrator later states, he learns to love his mother and father. The briefly glimpsed and otherwise anonymous rapists take on the role of monstrous others and the parents—including the bullish father whose verbal and emotional abuse of his wife and children we have witnessed in flashback—can be restored to "all their flawed, outrageous humanity."

Tom not only takes on responsibility for his sister's recovery, he also intervenes in Lowenstein's unraveling marriage and her troubled relationship with her teenage son. As such, Tom reasserts the importance of patriarchal author-

ity to the management of gender roles: his attraction to Lowenstein re-feminizes her while his football coaching of her son allows the effeminate boy to gain physical and mental confidence and strength. These interventions also re-establish Tom's masculinity, restoring his physicality as an athlete and lover. Once his authority is thus thematically established, Tom can be reinstated within his own family.

Yet, one of the interesting contradictions of the film is the way in which its formal construction cedes Tom such authority from the outset. Notably, although Tom's remembering takes place in a therapeutic environment, the film is at pains to establish that Tom himself is not the patient. Tom's author-ity is underlined through the comparison with his sister who is diegetically mute until Tom's disclosure "cures" her (notably Savannah's sessions with Lowenstein have no part in the film). And The Prince of Tides is not unique in this: in Festen (dir. Thomas Vinterberg, 1998) and La Bestia nel cuore (dir. Crit-ina Comencini, 2005)—both of which also focus on the abuse of siblings—it is similarly left to the adult brother to act as his sister's memory, while in The War Zone (dir. Tim Roth, 1998), the brother's camera documents what his sister refuses to disclose. Outside the family, adult women in Nuts (dir. Martin Ritt, 1987) and Magnolia (dir. Paul Thomas Anderson, 1999) also rely on men to tell the story of their abuse suggesting, perhaps, a more general distrust of female survivors' speech. Women—like children—are rarely given the opportu-nity to speak of their own experience and interpret its significance. In this re-spect, fiction film is broadly in line with other media forms.[16]

Unlike Savannah, Tom is the narrator of his own story, and he is able to tell the story "straight" rather than through the allusion and metaphor that characterizes Savannah's written work. Although Tom's voice-over credits Lowenstein as the facilitator of his speech ("The man who never talked now was doing nothing else, her questions making me as dizzy as her perfume") we rarely witness these dizzying questions, and his sexual attraction to her—indicated not only in voice-over but in point-of-view shots which linger on her body—emphasizes Lowenstein's physicality rather than her questioning voice. The position of powerlessness occupied by the raped male child is therefore recuperated by the adult, so that the act of disclosure is not a moment of vul-nerability but of heterosexual healing and agency.

Although the film is ultimately unambiguous in its acceptance of the ve-racity of Tom's memory—such that his disclosure brings the "therapy" to an abrupt end and provides Savannah with immediate resolution—there are in-consistencies, gaps, and contradictions in the telling that point to the vagaries of traumatic memory and the difficulties of its representation. This is particu-larly striking in the disclosure itself, where there is a clear tension between what is said in Lowenstein's office and what is shown in the fractured

flashback anchored by Tom's narration. This tension is manifest firstly in the sharp differentiation in the editing, performance, and sound in the two spaces. In Lowenstein's office, the two central characters are shown in lingering and static close-ups and medium-shots as Tom falteringly tells his story. In contrast, the visual rendering of his memory is fractured and chaotic, the rapists' intrusion into the family home rendered in a series of brief flashbacks that confuse the spatial relationships of characters and the diegetic point-of-view system. This reflects Tom's refusal to remember specific details, yet the repeated audio-visual intrusion of the memory into the therapy session simultaneously highlights his inability to forget. It is significant that this is unique to Tom's experience: while Savannah *cannot* remember, Tom *chooses* not to. When Tom tells Lowenstein that his mother and sister were raped, his language is unambiguous ("One of them raped Savannah. One of them raped my mother.") in marked contrast to his eventual self-disclosure when rapid movement between the spoken and visualized reconstruction keep us at a distance by never allowing us to see or hear everything at once. The word "rape" is never used to describe Tom's experience, and the fast editing and hand-held camera work in the flashbacks establish chaos rather than material fact. Although we are left with no doubt that Tom was raped, the rape of the boy child is, in Tom's words, "unimaginable, literally." The truth, then, is an emotional and individual truth contained within the therapeutic context and diegetically authenticated not by veridical detail but by Lowenstein's tearful response. This is one of the few scenes where we do actually hear Lowenstein's questions and witness their impact on Tom; nonetheless the camera continues to move with Tom, presenting Lowenstein from his slightly elevated point-of-view. Arguably, Lowenstein's emotional response also undercuts her professional role as she finally cradles Tom in her arms and whispers words of comfort. Thus, not only does the scene evade male rape but it closes with a moment of intimacy between the two leads that is central to the progression of their romance and Tom's eventual resumption of his patriarchal roles.

This brief discussion of *The Prince of Tides* suggests certain parallels with Walker's analysis of "trauma documentaries" in that the telling of the survivor's story in a realist mode results in necessary gaps and fissures that arguably point to the vagaries of traumatic memory. However, this analysis also suggests that these tensions are smoothed over by the authority invested in the male victim/survivor/narrator at the same time as the female victim/survivor is diegetically silenced. In the next section, I will further this argument through a consideration of another mainstream film, this time centered around the abuse of a group of boys.

"I'm the only one who can speak for them, and for the children we were."

Sleepers also focuses on the intrusion of past experience of child sexual abuse in the adult life of its male protagonist, but here the survivor-narrator, Shakes (Jason Patric), is one of four male friends abused as children in a juvenile detention facility. Despite this film's acknowledgment of a collective male trauma, its formal reinstatement of the authority of its survivor-narrator is similar to *The Prince of Tides*.

Sleepers begins with the voice-over of the adult Shakes:

> This is a true story about friendship that runs deeper than blood. This is my story, and that of the only three friends in my life who truly mattered. Two of them were killers who never made it past the age of 29. The other is a non-practicing attorney living with the pain of his past, too afraid to let it go, never confronting its horror. I'm the only one that could speak for them and the children we were.

Shakes' voice-over, accompanied by a slow-motion shot of the boys dancing exuberantly, introduces us to the central characters as children. Immediately, the film sets up a tension in its representation of the past: though the scene appears to be a happy one, the voice of the future and the manipulation of the image impose a foreboding tone. The effect of this is to position Shakes both within the story ("this is *my* story") and authoritatively outside of it, reflecting on a shared but as yet non-specific past from a future that the film will never visualize and his friends never see. The act of telling, which, as I have suggested is often feminized and distrusted in other contexts, is here presented as a responsibility all the more weighty for the devastating impact of silence on the lives of the other boys. Shakes' (and Tom's) ability to speak *for* others means that his story is never presented as a uniquely *individual* tale but, rather, can be argued to offer a more *generalized* truth. This distinguishes Shakes' story from media representations of sexual violence against women (both factual and fictional) where, as I have argued elsewhere, the emphasis on the individual obscures connections between women and, therefore, denies the possibility of a structural analysis of men's violence against women.[17] Further, as the film does not state its (disputed) relationship to real-life events up front but, rather, reveals these details in a postscript, the viewer is encouraged to accept the authority of the narrator and the truth of the story he tells (albeit within an apparently fictional world) at the outset. While the "either/or" proposition may, as Walker argues, structure television movies, uncertainty is not the structuring principle here although, as we will see, the abuse remains unrepresentable.

After the credits a caption offers a precise fixing of the time and place (Hell's Kitchen, Summer 1966) when the boys—introduced with an aerial shot,

sunbathing on a roof above Hell's Kitchen—felt themselves to be "absolute rulers" of this "cement kingdom." The boys are subjects within an urban land-scape that—although blighted by violence—offers them relative freedom and clearly defined models of acceptable homosocial, but strictly heterosexual, masculinity. The question implicitly posed is how did these boys become the damaged men of Shakes' opening narration?

It is nearly forty minutes into the film before an answer is offered. The boys have been sent to a juvenile prison, the Wilkinson Home for Boys, fol-lowing a prank that went dangerously wrong. One of the guards, Sean Nokes (Kevin Bacon), has taken a disturbing interest in them, first humiliating Shakes (Joe Perrino) and then extending this humiliation to his friends, forc-ing them to eat off the canteen floor following a fracas with another inmate. The first rapes follow immediately from this. From an exterior shot of the dimly lit prison building at night, the camera slowly descends below ground as a non-diegetic, ominous, and discordant score foreshadows the horror to come. Shifting from a vertical to horizontal movement, the camera continues along the long, narrow, windowless basement corridor. Even before Nokes comes into view, his amplified and relatively high-pitched voice echoes, filling the space. The sense of claustrophobia is heightened by the lack of natural light, the fluorescent wall-lights producing an eerie, greenish glow. This brief sequence sets the scene for the rapes to follow, a scene that is physically and visually set apart from the bright, light, "cement kingdom" of Hell's Kitchen.

As the scene unfolds, there is a tension between establishing an emotional closeness to the boys and, as in *The Prince of Tides*, remaining oblique about the actual sexual abuse. In a sequence lasting just over a minute—from the moment Nokes shuts the boys in a wire-fenced dungeon until the camera re-treats from it—a sequence of twenty close-ups formally establish the boys' con-fusion and fear. Many shots reveal little (an ear, a bare light bulb with metal chain, the lapels of the guards' uniforms) and the movement of camera and characters confuses any clear sense of spatial relationships. Instead we have a dizzying series of fragments further obscured by the wire fencing standing be-tween us and the characters, blocking our view and casting ominous shadows. As the camera retreats down the dark corridor filling the screen with black-ness, the adult Shakes resumes his narration:

> There are no clear pictures of the sexual abuse we endured. I buried it as deep as it can possibly go. What I remember most clearly from that chilly October night is that it was my 14th birthday. And the end of my childhood.

Like Shakes—and Tom before him—we are offered no clear pictures. This in-creases our reliance on Shakes' voice-over shoring up his narrative authority

even at the moment of his childhood victimization. Later, Shakes is given an even more authoritative role, describing, in voice-over, other scenes of abuse at which he was not present:

> There were other cries too [...] the sounds of pained anguish. Those cries can change the course of a life. They are cries that once heard can never be erased from memory and this one night those cries belonged to my friend John, when Ralph Ferguson paid him a visit.

As he describes his inability to forget his aural witnessing, there is a cut from the young Shakes lying in his cell to a low-level shot of Ralph Ferguson (Terry Kinney) leaving John's (Geoffrey Wigdor) cell, John's cries only faintly audible beneath John Williams' score. It is not only that the film offers no clear pictures then, but at the moments of Shakes' narration where memory is most forcefully linked to hearing, we are offered no clear diegetic sound. As with *The Prince of Tides* the film thus depends upon our identification with, and belief in, the male narrator.

Perhaps the most striking example of this is when the adult Shakes first speaks diegetically about their experiences at Wilkinson's. In Fall 1981, the adult John (Ron Eldard) and Tommy (Billy Crudup), now career criminals, kill Nokes after a random meeting in a neighborhood bar. Michael (Brad Pitt), now a public prosecutor, fights for the case, determined to put Wilkinson's on trial. Playing his part in Michael's plan, Shakes takes their childhood friend Carol (Minnie Driver) with him to visit the neighborhood priest (Robert De Niro) in order to enlist his support in court by telling him of the realities of their lives at Wilkinson's. Once Shakes begins his diegetic story, however, it is not his words we are asked to believe in but the emotional impact of their delivery as Shakes' listeners are the visual focus of the scene. At the same time, Shakes' diegetic voice is interrupted almost immediately by his voice-over in which he emphasizes his rationale for disclosure ("If Father Bobby was going to be involved he deserved to know what he was getting himself into") rather than the story itself. The diegetic disclosure is restricted to fragments thereafter, competing with a swelling non-diegetic score until it is finally drowned out completely and the camera comes to rest in a lingering close-up on Father Bobby underscoring the emphasis on emotion and witness rather than evidence and experience. This is particularly interesting if we think of *Sleepers* as a courtroom drama, for the central conceit behind the trial is to hold the Wilkinson's guards accountable without ever disclosing that John and Tommy were repeatedly raped. The ostensible reason for this is that such disclosure would provide motive and hence jeopardize their acquittal for Nokes' murder. However, it is interesting that it is only in the absence of any explicit recounting of the victims/survivors' experiences that the perpetrators can be held ac-

countable. As such, *Sleepers* arguably thematizes the wider cultural and legal distrust of actual victim/survivor testimony: if John and Tommy were to speak at all, then it would be their credibility that was at issue. But *Sleepers* also replicates this distrust in the disclosure scene as Shakes' authority is dependent on us *not* hearing his words directly.

Carol's presence in this scene is important as she functions throughout as a reminder of the boys' heterosexuality—as Lowenstein does for Tom. Her introduction explicitly points up this function (she serves as "look out" while the boys spy on the women's dressing rooms at the Icescapades) and her sexual and emotional relationships with the male characters are the subject of recurring diegetic commentary. Later, Carol's presence at the men's emotional reunion acts as an explicit alibi, ensuring that the nature of their connection is understood within a heterosexual frame (the homosociality of their encounter jokingly dispelled by her line "What is this, a gay bar?"). As the men reminisce about happier times, the camera continually cuts back to Carol's reaction and it is clear that she is the lynchpin in maintaining the relationships among men whose lives have gone in very different directions. By the end of the film, Carol—and not the experience of rape—has become the common link among them. Her presence is also pivotal in establishing the difference between the abused and the abusers. The abusers are diegetically restricted to the almost exclusively homosocial worlds of the prison, the police force, and the neighborhood bar. Although it is established in court that Ferguson has subsequently married, he remains an effeminate, shifty character, his voice echoing as he speaks into the microphone, his face in perpetual half-shadow. Therefore, although the film struggles to represent the *sexual* of sexual abuse, it implicitly casts the sexual abusers as sexually deviant, allowing heterosexual masculinity to escape scrutiny.

As with *The Prince of Tides*, then, this discussion of *Sleepers* suggests that the layered representation of the memory of child sexual abuse and its intrusion in the lives of adult survivors suggests something of the vagaries of traumatic memory. Framed within a context of justice rather than therapy, and focusing on the abuse of boys by known others rather than anonymous rapists, *Sleepers* nonetheless invests similar narrative authority in the male abuse survivor. In both films there is a tension between the child sexual abuse narrative in the film's past (a narrative of uncertainty and victimization), and the formal and thematic recuperation of masculine authority in the film's present. As the act of telling is both feminized and distrusted in the culture more generally, both films are only able to achieve this recuperation by obscuring narratively pivotal moments of disclosure. In other words, the very authority of the male survivors depends on us *not* witnessing either the childhood abuse or their adult

disclosure directly, but accepting that these acts *do* take place. In contrast, in my final analysis I want to suggest that *Mysterious Skin* offers a representation that both admits something of the vagaries of traumatic memory *and*, by attempting to show that abuse from the very different perspectives of two abused boys, offers more fluid possibilities for making sense of child sexual abuse based not on masculine authority but collective remembering.

"Lost. Gone without a trace."

Mysterious Skin focuses on Brian Lackey (George Webster/Brady Corbet) and Neil McCormick (Chase Ellison/Joseph Gordon-Levitt) who have very different ways of understanding their Little League coach's (Bill Sage) sexual abuse of them as 8 year olds. The film spans just over ten years from the summer of 1981 (the time of the initial abuse) to its conclusion in 1991. Brian and Neil's stories are intercut throughout, the childhood scenes introduced by the teenagers' voice-overs. It is Brian's voice we hear first, describing how, the summer he was 8-years-old, five hours disappeared from his life, "Lost. Gone without a trace." Brian's journey is to try to piece together what happened in those missing hours that—far from leaving no trace—have left an indelible mark. Brian is initially convinced that he was abducted by aliens but a memory of another boy leads him to Neil and, in the film's final scenes, the two are reunited to make sense of what happened to them more than ten years earlier. That this "making sense" is part of a longer process is clear in Neil's very different journey to the film's conclusion.

By intercutting Brian's and Neil's stories, the film complicates the status of both boys' memories, highlighting the extent to which fantasy and veridical detail combine in the process of making sense of their childhood trauma. Most obviously, the intercutting of Brian's speculations about alien-abduction with Neil's account of seduction points to the *function* of both: as stories that embellish fact with fantasy as a means of accessing the affective truths of experiences for which the children have no words. That these stories are woven into the boys' later experiences highlights both the enduring power of the memories *and* their relatively fluid character as their meanings change for the boys in light of subsequent experiences, knowledge, and relationships. In other words, the film is preoccupied with both the power and permeability of traumatic memory.

This concern with memory is announced at the outset. In a mesmerizingly beautiful credit sequence, pastel-colored breakfast cereal slowly comes into focus against a stark white background, the camera descending with the falling cereal until the upturned face of a young boy comes into view. The boy is smiling, his lips slightly parted and eyes closed as the cereal dusts his face with

sugar. His apparent pleasure sits uneasily with the tone and pace of the sequence: the initially blurry image, stark background, and slow-motion movement suggesting something of its "unreality" while the meditative, almost elegiac, music combined with the abrupt ending of the sequence inject a tone of sadness and loss. When this scene is retrospectively contextualized eleven minutes later—a playful food-fight serving as the prelude to Coach's abuse of Neil—these tensions are even more apparent. The stark white background that initially removed the moment from time and place is replaced with the Coach's kitchen, remembered in intricate detail by Neil. The elegiac music is replaced with a more up-tempo score that cuts out before the rape that is eerily silent in comparison. The ambivalence of the earlier scene is also retained in the child's performance, which registers unease and uncertainty and the voice-over of the teenage Neil, which professes the child's pleasure in an unemotive, virtually monotone register. In this layered (re)construction of the cereal scene we are, therefore, made aware of the imaginative function of memory.

Moreover, *Mysterious Skin*, uniquely of the films discussed, acknowledges formally and thematically that it is the *sexual* nature of the abuse that complicates both the child Neil's experience and the adult Neil's memory. Unlike Brian's story, Neil's account of events does not begin immediately after those five hours but, rather, some weeks later when he "came for the first time" watching his mother (Elizabeth Shue) with her boyfriend, Alfred (David Lee Smith). While Neil's teen voice-over insists that he could not take his eyes off Alfred, on screen Alfred's face becomes interchangeable with the Coach of his fantasy. As Neil closes his eyes as he climaxes (recalling the credit sequence), it is Coach's face that fills the screen, the child's memories and/or fantasies embedded within the adult narration. This device is used again later when, as a 15-year-old, Neil turns his first trick and visualizes the sugar-dusted smiling boy from the credits. Embedded within the adult Neil's version of himself as a 15-year-old is this decontextualized fragment of himself as a child from the perspective of his remembered self. Each return to this image thus offers a different interpretation encouraging an interrogation of its function at specific moments. Most tellingly, it highlights the tension between Coach's presentation of his actions (as affection bestowed on the privileged) and the child's discomfort, and suggests Neil's various attempts to imaginatively resolve these tensions. There is a further complication in the play between desire and identification in Neil's relationship with the Coach, notable not only in the moment of the 8-year-old's climax (when it is the memory/fantasy of Coach's climax that triggers his own), but also in Neil's subsequent adoption of Coach's role in his own sexual abuse of a Brian look-alike on Halloween 1983.

The Halloween setting of this disturbing scene underscores the role-play involved in Neil's abusive imitation.

Although Neil's deadpan narration admits nothing of trauma, the traumatic traces of abuse can be detected in the formal and thematic connections between the different moments in Neil's story. For instance, the tricks Neil performs as a 15- and 18-year-old recall his childhood abuse in a number of ways: his first john is a sales rep with a car full of snack foods reminiscent of Coach's well-stocked cupboards; the sex-for-money scenes have no non-diegetic music, their relative silence recalling the rape and frustrating any erotic investment; and Neil's youth is emphasized in poses that make him appear physically small in comparison with the bulk of the men who buy his body. Most significantly, Neil rarely appears in the same frame as the men who have sex with him. In the scenes with Coach there is a practical reason for this (protecting the child actor), however the replication of this framing in the later scenes suggests that dislocation and lack of mutuality characterize the commercial transactions, too. Moreover, in the child sexual abuse scene, Araki does not maintain eye-line matches between shots, instead having his actors perform to camera. This results in an extremely uncomfortable and contradictory experience as we are positioned *within* the scene, yet aware of the constructed nature of what we are watching/ experiencing. The direct address is also utilized during Neil's final trick when his john/rapist proffers drugs directly to camera, again disrupting spatial continuity to place the spectator uncomfortably within this explicitly violent scene, encouraging a re-reading of the earlier scene.

Such connections occur not only *within* Neil's story but also *between* Neil and Brian's accounts. These two apparently very different accounts compete, complement, and interrupt one another throughout, visually layered (particularly toward the end of the film) by the use of lap-dissolves and punctuated by frequent cuts to black screen. One of the most striking visual links between the two stories is the use of an upside-down head-and-shoulders shot, first used in the 8-year-old Brian's story where it is embedded within the child's nightmare, an unconscious replaying of an event he will not consciously remember as an adult until the film's conclusion. During his first trick, Neil is also shown in an upside-down shot as he lies on the motel room bed while the john performs oral sex. This visual link thus complicates both narrators' accounts. Brian may think he was abducted by aliens, but Neil's fellating john suggests what is actually going on outside the frame. Neil may express pleasure, but the link with Brian's traumatic past casts doubt on this reading. The shots also have a disorientating effect for the spectator, establishing a proximity to the characters' emotional states by making us aware of the film's artifice: in

placing us outside of the action, these shots allow us to identify more closely with the characters' alienation and dissociation.

That alienation is commented on diegetically through the characters' relationship to popular culture. In one particularly striking scene, the teen Neil and his friend Wendy (Michelle Trachtenberg) are filmed against the backdrop of an abandoned drive-in, a setting that simultaneously draws attention to the characters' performances and to the void within which they enact these roles. Indeed, Wendy explicitly notes that theirs are not the drive-in stories of 1987. This scene is immediately followed by Brian's spellbound spectatorship of *World of Mystery*, a television show showcasing stories of alien abduction that provides him with a way of understanding those missing hours in 1981. Thus, for both characters, the possibilities for making sense of their experience are at least in part shaped by a popular culture that made virtually no mention of child sexual abuse. Brian and Neil's memories of Coach, while very different, are also filtered through popular culture: for Brian he takes the ominous shape of an alien invader, while Neil's point of reference is his mother's *Playgirl* magazines. The child sexual abuser is simply not culturally recognizable in 1981, and so the boys seek alternative figures with which to compare and understand the man who raped them (though "rape" is not in their vocabulary). Similarly, although the teenage Neil can refer to his "queer" desires both diegetically and in voice-over, the child Neil lacks any reference point for these desires other than that provided by Coach or his heterosexual mother, whose lovers and pin-ups become the stuff of Neil's queer re-readings. Put simply, in 1981 "queer" is a term of abuse and "child sexual abuse" does not exist. No wonder, then, that Neil and Brian are engaged in a creative process of (re)interpreting a past that, at the time, denied their lived realities.

The boys are also diegetically involved in the production of images. Coach builds up to rape by photographing and audio-recording Neil's childish transgressions of bodily decorum (burping, swearing, pulling faces). The technology—Polaroid photography, sound recording devices—fragments Neil's experience and provides an uncertain record. Placed in an almost obsessive sequence in Coach's photo album, the photographs have a sinister quality reinforced by the child's expressed discomfort (he thinks he looks "stupid"). Yet, the photographs and recordings are also experienced as gifts, a record of his importance and desirability that, as an adult, Neil chooses to keep in a bedside drawer. However, subject to (re)interpretation by his friend Eric (Jeff Licon), these artifacts are again rendered strange and worrying. Context is all.[18]

These details point to the unreliability of history, the work of fantasy, the influence of popular culture and the unreliability of memory, but the intertwining of the boys' stories also provides many points of veridical detail; the

spectator is left in no doubt that the experience the boys share is one of sexual abuse. When the central characters finally meet as adults, their collective (re)telling of the story enhances both of their understandings while acknowledging the truth in each account. So, for instance, on returning to Coach's house (which Coach himself has long since left), the blue light dominating Brian's dreams finds an immediate real-world referent in the porch light while the physical layout of the house matches Neil's accounts. The adult "symptoms" that have been part of the narrative puzzle (Brian's nosebleeds, his fit when he submerges his arm in the mutilated cow) are traced to their origins (his first blackout in Coach's house, the children fisting Coach). But this is not a one-way process, as it is in telling the story to Brian that Neil is finally able to acknowledge that his idol abused him and other boys, and that soliciting Neil's "consent" with flattery and reward was part of the abuse.

Yet there is a sense that even this account remains incomplete: its telling is fragmented by flashbacks typically accompanied by a non-diegetic score that abruptly interrupts the diegetic narration; Brian's questions prompt Neil to add detail he had originally missed; and, most importantly, Brian's recovery of those missing hours does not bring closure. In his final voice-over Neil states, "I wanted to tell Brian that it was over now, everything would be ok. But that was a lie. Plus, I couldn't speak anyway." The non-diegetic Sigur Ros track used in this sequence was chosen, according to Araki's DVD commentary, because it sounds "almost like a child's piano." It serves here not only as an elegy for innocence betrayed but its repetitive qualities and the fact that, uniquely in the film, it is "out of time" (a 2002 track in a 1991 scene) reinforce Neil's words: this story is not over, not confined to a singular moment in time or fixed interpretation. The closing shot suggests that the telling of the story is, itself, subject to the distortions of memory, the retreating crane shot non-naturalistically isolating the boys on the couch against a black background in a reversal of the film's opening. As the boys disappear into decontextualized blackness, Neil's final voice-over is enigmatic, offering none of the "what happened next" that characterizes the conclusion of both *The Prince of Tides* and *Sleepers* and leaving the boys—and their memories—outside of time and place.

Conclusion

This chapter has suggested that the potential to capture the vagaries of the traumatic memory that Walker observes in trauma documentaries is not genre specific. All three films discussed here demonstrate thematically something of the difficulty of remembering and disclosing child sexual abuse, specifically for male victims/survivors. However, in both *The Prince of Tides* and *Sleepers* this thematic concern is counter-balanced by a recuperation of masculine authority

most clearly demonstrated in a refusal to allow for direct representation of the narrator's victimization in either words or images. In contrast, *Mysterious Skin* is not concerned with revisiting the traumatic past in order to (re)establish a fixed, authoritative identity for its male leads. Rather, Araki's film positions its survivors as continually involved in a process of (re)interpreting their traumatic past in relation to the specific conditions of their intellectual and emotional development. As such, it invests its protagonists with believability not because they are authoritative narrators of their own stories but, rather, because they are involved in an on-going process of "making sense" that does not end with the final credits. *Mysterious Skin* is the only one of the three films discussed here to show how the experience of child sexual abuse is (re)constructed *during childhood*. As such, the process of making sense begins at the moment of abuse and is not—as in the other two films—restricted to a moment in adult life when the survivor is finally able to interpret their previously unintelligible childhood self, fixing the identity of that child ("abuse victim") only to transcend it. Notably, in both *The Prince of Tides* and *Sleepers* that adult (re)interpretation is further fixed by the discursive and generic framing of the disclosure as, respectively, a moment of therapeutic healing and of justice. In other words, in both these films, it is the diegetic adult witnessing that finally accords meaning to the child's experience.

It is no doubt significant that it is in the context of New Queer Cinema that the complexity of the traumatic memory of child sexual abuse is most vividly represented in fictional form. As Michael DeAngelis establishes, the relations of remembering and forgetting a past with which the queer historical subject has a typically fraught relationship have been central to this cinematic movement and the broader cultural and political project of which it is a part.[19] Michele Aaron similarly argues that defying the sanctity of the past is a defining feature of New Queer Cinema, an approach that fits well with Walker's understanding of "trauma cinema" as that which destabilizes the fixity of character and spectatorial positioning.[20] To be clear, I am not arguing that this is a *uniquely* queer approach to understanding the past or, specifically, childhood. However, there is a clear parallel between the destabilizing of identity and the linearity of its historical construction that has been a central theme in much queer theorizing, and *Mysterious Skin's* imaginative (re)construction of the past.

Moreover, in both *The Prince of Tides* and *Sleepers* the specifically *sexual* nature of the abuse—although never in doubt—remains unrepresentable. This perhaps speaks to the broader cultural investment in an ideal of childhood "innocence," which is at once asexual and resolutely heterosexual, but it also prevents us from understanding how that abuse may be experienced and understood by children in relation to their developing *sexual* identity. Against

this backdrop, any linking of children and sexuality arguably appears "queer," particularly if it takes place in a context that acknowledges that the child's experience of what is sexual may be profoundly contradictory, confusing, and fluid. However, in terms of social and cultural understandings of, and responses to, child sexual *abuse*, this context is profoundly important. It arguably frees the victim/survivor from judgments about their authenticity and intelligibility based on their ability to embody adult ideals of childhood—which, in part, hinge on their inability to speak of the abuse—and allows very different stories to emerge that are open to the complexity yet intelligibility of children's own responses to trauma, to sex, and to their sense of themselves. Although victims/survivors and their advocates may be understandably wary of narratives that place in the foreground both the fantastical *and* the literal, following Walker I would argue that it is only by acknowledging such complexity that "true" accounts of the experience, memory, and meanings of child sexual abuse can emerge.

Notes

1 Louise Armstrong, *Rocking the Cradle of Sexual Politics: What Happened When Women Said Incest* (Reading, MA: Addison-Wesley, 1994); Jenny Kitzinger, *Framing Abuse: Media Influence and Public Understanding of Sexual Violence against Children* (London: Pluto, 2004).

2 For an overview, see Karen Boyle, *Media and Violence: Gendering the Debates* (London: Sage, 2005).

3 J.T. Leroy, *The Heart Is Deceitful Above All Things* (London: Bloomsbury, 2001).

4 Janet Walker, *Trauma Cinema: Documenting Incest and the Holocaust* (Berkeley: University of California Press, 2005).

5 Louise Armstrong, *Rocking the Cradle*.

6 Susan Estrich, *Real Rape* (Cambridge: Harvard University Press, 1987).

7 See Jane Kilby, "Redeeming Memories: The Politics of Trauma and History," *Feminist Theory* 3, No. 2 (2002): 201–210; S. C. Taylor, *Court Licensed Abuse: Patriarchal Love and the Legal Response to Intrafamilial Sexual Abuse of Children* (New York: Peter Lang, 2004); and Janet Walker, *Trauma Cinema*.

8 Régine Jean-Charles' chapter in this volume addresses similar issues pertaining to the politics of testimony, witnessing and representational practice but in the context of the Rwandan genocide.

9 Janet Walker, *Trauma Cinema*, 4.

10 Louise Armstrong, *Rocking the Cradle*, 38.

11 Janet Walker, *Trauma Cinema*, xviii.

12 Janet Walker, *Trauma Cinema*, 19.

13 Janet Walker, *Trauma Cinema*, 59.

14 Karen Boyle, *Media and Violence*.

15 Sue Lees, *Carnal Knowledge: Rape on Trial*, revised ed. (London: Women's Press, 2002); S. C. Taylor, *Court Licensed Abuse*.

16 Louise Armstrong, *Rocking the Cradle*.

17 Karen Boyle, *Media and Violence*.

18 For a more general discussion of this point, see Anne Higonnet, *Pictures of Innocence: The History and Crisis of Ideal Childhood* (London: Thames & Hudson, 1998).

19 Michael DeAngelis, "The Characteristics of New Queer Filmmaking: Case Study—Todd Haynes," in *New Queer Cinema: A Critical Reader*, edited by Michele Aaron (Edinburgh: Edinburgh University Press, 2004), 41–52.

20 Michele Aaron, "New Queer Cinema: An Introduction," in *New Queer Cinema*, 3–14.

CHAPTER 10

Exposing Domestic Violence in Country Music Videos

Julie Haynes

The intense media coverage surrounding the murders of young pregnant women Laci Peterson and Lori Hacking in the early 2000s highlights the continuing prevalence of violence against women in the United States. The convictions of the women's husbands also spotlight the pervasiveness of intimate partner violence or domestic violence in the United States. According to the U.S. Centers for Disease Control and Prevention, violence against women represents a "substantial health problem" in the country.[1] The most common form of violence committed against women is domestic violence, and while this crime affects either males or females, women are far more likely to be its victims.[2] Reports vary on the number of female victims, but statistics range from approximately 1.3 to 3 million women physically assaulted by a domestic partner each year in the United States.[3] A 2003 Bureau of Justice report on intimate partner violence noted that 1,247 women were killed in the United States by intimate partners in the year 2000, an average of three women murdered each day.[4]

Despite the significant number of women abused or killed by their partners, public outrage regarding domestic violence is a relatively recent phenomenon. Although critiques of violence against women have existed historically, cultural attitudes supporting the subordinate role of women and the privacy of the domestic sphere have muffled these criticisms. Violence against women became an explicit political issue during the 1970s in the United States, spearheaded by the modern women's movement. In her memoir of the movement, Susan Brownmiller explains how previous generations were restricted in their critiques:

> The rules of polite feminine propriety, the universal bans on the use of forthright, realistic language in public forums, had kept the violence issues dormant, consigned

to allusions spoken in hushed voices, relegated to the private, the personal, the shamefully unmentionable, until a freer climate permitted such things to be articulated aloud. Women in the seventies, after giving voice to such formerly unmentionable issues of physical autonomy as sexual satisfaction, birth control, abortion, and sexual preference, were finally ready to speak about rape and battery too.[5]

Those speaking out included Erin Pizzey, who helped open the first battered women's shelter in the United Kingdom and publicized the problem in her book, *Scream Quietly or the Neighbors Will Hear*.[6] In the United States, Del Martin's book *Battered Wives* exposed the prevalence and complexities of domestic violence.[7]

By the late 1970s and 1980s, discourse on the problems of domestic violence had entered into mainstream popular culture in the United States. In particular, media attention focused on several legal cases in which women were acquitted for murdering their abusive husbands. The most famous of these cases was the story of Francine Hughes, who murdered her husband by setting his bed on fire. Hughes' story was adapted into a made-for-television movie starring Farrah Fawcett in 1984 and was viewed by 75 million people on the night of its initial airing, making it one of the highest rated TV movies of all time.[8] According to Elayne Rapping, *The Burning Bed* "became a media event and also entered the public sphere of significant ideological discourse in ways that other cultural artifacts consumed in other, less public contexts would not."[9]

Other media depictions and public discussions of domestic violence would follow. In the 1990s, the issue received considerable media attention due to the high-profile murder trial of O. J. Simpson. Television court analysts, for example, speculated whether Nicole Brown Simpson's murder was the culmination of her husband's history of violence in the relationship.

The issue of domestic violence also became a frequent theme in the 1990s in a seemingly unlikely place: country music and country music videos. Despite the genre's conservative reputation, one of its hallmarks during this decade was its attention to women's issues, a phenomenon some have referred to as the "new women's movement in country music."[10] Country music promoters, performers, and the popular press frequently addressed the significant contributions of women within the industry, their advancements, and the "pro-woman" orientation and messages of certain country music artists, female and male. In this "Women of Country" discourse, leading artists such as Reba McEntire, Garth Brooks, Shania Twain, Martina McBride, Faith Hill, and the Dixie Chicks often explored the problems of domestic violence in their songs and music videos.

In this chapter, I analyze the rhetorical strategies that artists and video directors employ to address domestic violence within the country music video format. My analysis focuses on three of the most popular and acclaimed videos addressing this topic: Garth Brooks' "The Thunder Rolls"(1991), Martina McBride's "Independence Day" (1994), and Collin Raye's "I Think About You" (1996). The videos incorporate three major visual strategies that confront prevailing stereotypes regarding domestic abuse, especially questioning the tendency to frame such abuse as an individual problem. First, the three texts work within the music video format to visually present the violence in question. The visual register calls attention to the realities of the issue in ways that other, strictly discursive (such as speeches or lyrics) approaches cannot. A second strategy the videos employ is to show a diverse group of both domestic assault victims and abusers. These depictions challenge the assumption that there is a "typical" person who is an abuser or is abused. Third, the videos appropriate patriarchal icons to critique both violent perpetrators and a culture of violence. The deployment of iconic images such as those of the cowboy or the police officer highlight socially acceptable forms of violence and connect them to domestic abuse, thus implicating the culture in perpetuating the problem of domestic violence. Indeed, a significant feature of these texts is that, unlike most artifacts in mainstream popular culture that engage feminist issues, these videos extend their critique beyond a focus on the individual to society as a whole.[11] They invite viewers to take a stand against this form of gendered violence.

Gender and Gendered Violence in Music Video

Scholars from a variety of fields and theoretical perspectives have attempted to "make sense" of the music video.[12] Cultural critics highlight the post-modern features of rock music videos and music television.[13] Historical studies have situated the music video within the filmic and televisual traditions, demonstrating its connections to such media events as musicals, variety shows, and commercials.[14] Rhetorical scholars outline music video categories and strategies,[15] and a number of music video scholars have theorized the form's visual/aural relationship.[16] Country music videos have received far less academic attention than their rock video counterparts. As with videos in other musical genres such as hip-hop, country music videos gained popularity in the mid-1980s (several years after MTV debuted in 1981) and were shown on other cable networks, such as The Nashville Network (TNN) and Country Music Television (CMT).[17] While work on rock music videos contributes in important ways to an understanding of country videos, Mark Fenster docu-

ments the different industrial and aesthetic development of the latter.[18] He explains:

> [T]he development of a country video aesthetic includes the successful establishment of a classical narrative style that suits the genre's lyrical content. Unlike the more disjointed, fragmented narratives of pop/rock videos, which owe more to experimental films and advertising, most country video narratives are more directly descended from the classical Hollywood style.[19]

A recurring area of interest in music video scholarship is the construction of gender in music videos.[20] Lisa A. Lewis has explored counter-hegemonic portrayals of women in rock videos. Citing the rising number of female musicians on MTV, she contends that many videos by women specifically address female adolescents.[21] These videos often subvert dominant gender codes often by appropriating masculine forms of address. For instance, Lewis analyzes several videos that appropriate the male space of "the street." In these videos, female artists transform a potentially violent place for women into an arena for dancing and celebration, and in doing so, (re)claim the street as a space for women.[22] Robin Roberts also examines positive depictions of women found in music videos from a variety of genres. She spotlights videos in pop, country, and rap that articulate a feminist message, exploring "issues that are of central importance to feminists: gender and performance, race and gender, postmodernism and feminism, humor and feminism, sexuality and feminism."[23]

Other studies have examined the sexist nature of music videos, exploring both the limited roles offered for women by the media form[24] and music videos' misogynist content.[25] Some scholars argue that women are frequently objectified and "used exclusively as decorative objects" in many rock videos.[26] Often "[f]emales are portrayed as submissive, passive, yet sensual and physically attractive."[27] Notwithstanding these criticisms "sexism still abounds, and the depiction of these gender roles in rock videos continues to be fairly traditional."[28] In the 1990s, MTV music videos featured women much less frequently than men and presented them in limited, stereotypical roles that emphasized their physical appearance.[29] Country music videos replicate these images. According to Julie Andsager and Kimberly Roe, music videos made by male artists still overwhelmingly depict women in "condescending or very traditional portrayals," while those by female artists frequently portray women in non-traditional and positive ways.[30] This body of scholarship suggests that music videos' images continue the "symbolic annihilation of women."[31]

Country Music Scholarship

Country music scholars have explored recurring lyrical themes including those based on the topics of alcohol,[32] infidelity,[33] political orientation,[34] and religion.[35] A number of works map out the relationship between country music and Southern identity[36] or working-class identity as it relates to country music work songs.[37]

Analyses of gender and country music have focused primarily on lyrical themes that prescribe or transgress gender norms. For instance, Karen Saucier Lundy argues that, "The images reflected in country music lyrics serve to reinforce stereotypes, primarily those of traditional gender role expression. Women's roles are limited to lover, wife, and mother, and rarely as co-worker and professional career person."[38] These songs "reinforce the image of men as controlling and women as submissive and supportive even in the face of discontented suffering."[39]

Other scholars argue that despite the genre's reputation for conservative gender norms (typified in Tammy Wynette's "Stand By Your Man"), country music has always contained resistant discourses regarding women's roles. Some scholars suggest that since the nineteenth century, but especially since the 1950s, country music has been attentive to women's issues.[40] Mary Bufwack concurs that even "at a time when there was no women's movement, a strong feminist sensibility was emerging among female country performers."[41] She believes the genre "contains elements which nurture female opposition to male domination and exploitation."[42]

Gendered Violence in Country Music Scholarship

Numerous studies have explored the theme of violence against women, a theme that can be traced back to country's roots in Appalachian folk ballads and bluegrass music. The "murder ballad," for example, exposes this type of violence; women are killed for infidelity or unrequited love. Mary Bufwack and Robert Oermann note, "In song as in life, women are far more often the victims of violence than its perpetrators. The archetypal folk ballad in this country is the murder of a hapless, pregnant girl by a boyfriend who is unwilling to marry her."[43] Some scholars argue that a significant number of these murder ballads are misogynist, justifying abuse toward women.[44] They contain female sexuality that is "neutralized or domesticated by death."[45]

While numerous ballads condone violence against women, others function to expose such violence by documenting the tragedy of women murdered by their lovers. According to Bufwack and Oermann, these songs are part of an oral tradition and serve as warnings for nineteenth-century women. These

"women's warning songs" caution women against the dangers of men, as in "The Cuckoo" ("On Top of Old Smokey"):

> Courting's a pleasure and parting's a grief
> But a false-hearted lover is worse than a thief
> A thief will but rob you, and take all you've saved
> But a false-hearted lover will lead you to your grave
> The grave will consume you and turn you to dust
> And where is the young man that a woman can trust?[46]

Songs in the country music tradition both romanticize and normalize violence against women as well as expose and critique it.

Critiques of Domestic Violence

As noted, a sub-genre of Appalachian folk ballads warns women about the dangers of violence inflicted by significant others. One collection of songs speaks of a mythological heroine (often named "Polly") who is murdered or nearly murdered by her lover ("Willie" or "Billy"). While some lyrics condone Polly's murder for her promiscuity and unwed pregnancy, others warn that Willie is villainous, and still others have Polly outwitting him. Additional ballads recount real-life murders, such as the 1808 murder of Naomi ("Omie") Wise by her boyfriend Jonathan Lewis in North Carolina, or the decapitation of Pearl Bryan by her lover in 1897.[47] In these songs, it is clearly the male who is the villain. For example, in "Omie Wise," the evil of her lover is evident:

> The wretch then did choke her, as we understand;
> And threw her in the river below the milldam;
> Be it murder or treason, O! what a great crime,
> To drown poor little Omie and leave her behind.[48]

Ballads such as these not only work as moral tales against pre-marital sex, they also expose the possibilities and realities of domestic violence.

Discourse regarding violence against women continued to be a part of the country music culture as it developed into an industry. The industry's first recording artists, the Carter Family, recorded "Young Freda Bolt" in 1938, another murder ballad of a woman killed by her suitor. As in so many of these stories, Freda's boyfriend promises to marry her, but instead lures her to the mountains of Virginia where he leaves "his sweetheart/In agony to die." Songs of this genre also regained popularity during the 1960s and 1970s due, in part, to the folk music revival of that period. Dolly Parton, for example, recorded a version of the abuse ballad "Little Blossoms" in 1963.[49]

Throughout the 1970s and 1980s, the problems of domestic violence re-mained a recurrent, although often implicit, theme. Often this was echoed in the life stories of country music's female performers. In written and film biographies, the public was exposed to the abuse experienced by such country notables as Loretta Lynn, Patsy Cline, and Tammy Wynette. Both the 1980 film adaptation of Loretta Lynn's autobiography, *Coal Miner's Daughter*, and the 1985 film of Patsy Cline's life and death, *Sweet Dreams*, document episodes of domestic violence. Despite the films' sometimes-ambivalent positions toward this violence, viewers still bear witness to the abuse as they watch Sissy Spacek as Loretta Lynn and Jessica Lange as Patsy Cline being slapped, punched, verbally abused, and/or sexually assaulted on screen. Lynn is explicit in her critique of this violence in the written version of her autobiography: "I still feel there's better ways to handle a woman than whipping her into line. And I make that point clear in my songs, in case you hadn't noticed."[50] Tammy Wynette also recounts bouts of domestic violence in her 1979 autobiography, *Stand by Your Man*, including a description of her often-violent relationship with George Jones, who once while inebriated chased Wynette around their home with a shotgun.[51] These memoirs and representations helped set the stage for more explicit discussions of domestic violence in the late 1980s and 1990s.

In 1987, Reba McEntire recorded "The Stairs," a song that recounts how an abused wife must explain her bruises by saying that she has fallen down the stairs again. The song compares the severity of the wife's beatings by relating her injuries to those of falling down a flight of stairs.[52] In the 1990s, other high-profile country artists began addressing the issue of violence against women in their songs. Faith Hill's "A Man's Home Is His Castle" (1994), Martina McBride's "Broken Wing" (1997), Shania Twain's "Black Eyes, Blue Tears" (1997), and the Dixie Chicks' "Goodbye Earl" (1999) all explore some aspect of intimate partner violence.

Domestic Violence in Country Music Videos

Another popular outlet for exploring the theme of domestic violence during the 1990s was the country music video. Music videos provide a unique opportunity for artists to add a visual dimension to their lyrics and to further develop the lyrics' narrative. This aspect of video is particularly evident in the country music genre, where lyrics and videos often follow clear narratives.[53] As my analysis reveals, *seeing* depictions of domestic violence can function as a powerful critique of the social problem in ways that other, less visual forms of rhetoric (such as lyrics alone) cannot. Additionally, artists may introduce the issue of domestic abuse in a music video when a song does not deal directly

with the subject. The lyrics of Garth Brooks' "The Thunder Rolls" (1991), for example, represent a typical country music "cheating" song, describing a wife's worry over her husband's late return in bad weather until she realizes he has been unfaithful. The music video, however, depicts the husband as both an adulterer and an abuser.

Garth Brooks' "The Thunder Rolls" was the first country music video to introduce the issue of domestic violence. The song itself generated little controversy; however, TNN and CMT banned the music video. Despite the networks' concerns, the video won the Country Music Association's "Music Video of the Year" award for 1991.[54] "The Thunder Rolls" arguably paved the way for other representations of domestic violence in country music videos, such as Martina McBride's "Independence Day" (1994). McBride's video also received extensive media coverage and was named "Video of the Year" for 1994 by the Country Music Association, the first time a female artist won the award.[55] Collin Raye's "I Think About You" (1996) builds upon the critique of domestic violence found in Brooks' and McBride's videos and exposes a culture of violence in our society that contributes to battery. This video garnered the 1996 "Music Video of the Year" award from the Academy of Country Music.[56] In the sections that follow, I draw upon examples from these videos to demonstrate how country music videos address domestic violence.

Bearing Witness: Visual Images of Battery

Music videos that depict images of violence against women have been criticized as misogynist, usually with good reason.[57] However, such imagery can also function to illuminate the realities and brutality of such violence, and thus offer a critique of it. By watching these videos, viewers are forced to "bear witness" to the violence. This strategy is particularly useful for exposing domestic abuse, a crime that is considered private and frequently has no witnesses. In the case of "The Thunder Rolls," the visual depiction of violence departs from the song's lyrics, further drawing attention to the issue.

"The Thunder Rolls" was written by Pat Alger and Garth Brooks and debuted on *Billboard's* country music charts on May 18, 1991, holding the number one position for two weeks.[58] The lyrics describe a wife waiting for her husband to come home one late, stormy night. She worries that something has happened to him but realizes when he arrives home (from the smell of perfume) that he has been cheating on her. According to Brooks, he and Alger had written a third verse that ended with the protagonist killing her unfaithful husband, so that "tonight will be the last time she'll wonder where he's been." Although he did not record this version, Brooks did include the rendition during concert performances to rousing audience responses. He decided to

include this interpretation (although not the additional lyrics) in the creation of the video for "The Thunder Rolls." In the video, the wife does kill her cheating husband, who not only is depicted as unfaithful, but as a wife and child abuser as well.[59]

"The Thunder Rolls" video juxtaposes images of Garth Brooks performing with a visual depiction of the song's lyrics, with Brooks playing a villainous husband (donning a wig, beard, and glasses). The video shows the husband in a seedy motel room with a mistress, while his wife sits at home waiting in a luxurious living room. Evidence of abuse is clear when viewers see bruises on the wife's face, and when Brooks arrives home, physical fighting ensues. A little girl peers down from a balcony, witnessing the violence, and later becomes its potential target as her father looms toward her. In response, the wife shoots him. In the video's finale, police arrive to the couple's home, while Brooks, the performer, looks toward the camera in regret.

The first time viewers are made aware of the domestic violence theme is when the waiting wife turns toward the camera, her face showing evidence of battery with a black eye and other bruises. Until this point in the video, the lyrics of "The Thunder Rolls" and the visual story line are consistent: a man cheats on his wife while she waits at home for his return. However, the wife's abuse abruptly departs from the lyrical narrative. By introducing the issue of domestic violence in such an unexpected way, the video provides an element of surprise that gives the issue dramatic impact. The bruising covers a significant portion of the left side of her face, suggesting that it is the result of a beating (versus an accident or a one-time punch). When the husband returns home, the physical abuse is evident when he grabs her arm as the two argue. The wife struggles and he backhands her so that she falls back against a sofa. What makes these images even more disturbing in the video is the presence of the little girl who witnesses this violence. As with *The Burning Bed*, the fact that the wife presumably kills her abuser is controversial but illuminates the difficulties in remedying cycles of abuse, particularly when children are involved. Finally, Brooks' regretful look toward the camera addresses the audience directly. Significantly, this gaze extends the video from a text that merely depicts domestic violence to one that functions as an invitation to take a stand against such forms of abuse.

Unlike "The Thunder Rolls," the video for "Independence Day" builds upon lyrics that explicitly critique domestic abuse. The title immediately calls to mind the U.S. national holiday and its associated celebratory symbols—fireworks, flags, and picnics—not the horrors of domestic violence. Yet the song's lyrics focus on one woman's memories of her mother's abuse at the hands of her father. In the song, the woman recounts the summer when she

was eight years old and how her mother ultimately ended the abusive relationship. The notion of "independence," then, is recast from a national, historical concept to a personal victory over oppression. The lyrics also criticize neighbors and friends who knew of the abuse but did not intervene.[60]

The "Independence Day" video was directed by Deaton Flanigen and is shot entirely in black and white, cinematography that implies the singer is remembering her childhood. Opening images of a mother and daughter at play are disrupted, as the lyrics explain that the mother "tried to pretend he wasn't drinkin' again/But daddy left the proof on her cheek." Viewers see the daughter standing in a doorway of the family's working-class home. Her mother sits at the kitchen table, staring nervously off in the distance, while in the background, the shadowy figure of her father storms past. When the woman turns to hug her daughter, a black eye (the iconic image of wife battery) is clearly visible on the mother's face.

As the video proceeds, shots of McBride singing are interspersed with images of a small town parade and scenes of the family's domestic plight. In one scene, the mother sits on the living room floor holding a lit match and then lets it fall through her fingers. In other scenes, the little girl runs to the parade to escape the turmoil at home and when she returns, police and firefighters are at the house, which is ablaze. McBride sings that the mother "lit up the sky that fourth of July," indicating she has set the house on fire. Writing of "Independence Day," Robin Roberts notes how the connection between domestic abuse and the victim setting a fire calls to mind the 1984 television movie, *The Burning Bed*.[61] As a result of this association, the implication of the lyrics is that the wife has killed her husband in the blaze. Because viewers see the mother sitting on the floor and dropping the match, presumably in her lap, the implication is that she commits suicide, with or without killing her husband in the process.

As in "The Thunder Rolls," domestic violence is first indicated in the video by showing the mother's bruises. Despite the fact that the video is shot in black and white, the black eye appears severe and grotesque. In one scene, the camera shifts from a close-up of the woman's bruised face to the daughter's as she hugs her mother in order to comfort her. These images, like those in "The Thunder Rolls," invite the viewer to feel sadness and regret and to see domestic violence as a tragic circumstance for both the victims and their children.

Graphic visual images of battery also take place in the video, as the husband abuses the mother in several scenes. What is interesting in "Independence Day," however, is that these scenes are juxtaposed with images of clowns at a parade. Two clowns delight the crowd with their slapstick antics. Young

and old alike laugh as the clowns slap, hit, and punch each other. Only the daughter looks on horrified. The parallel between the clowns' games and the father's abuse becomes obvious as the video switches from scenes of the clowns with those of the mother being beaten. In one scene the father grabs the mother out of a chair and holds her by her arms as he shakes her. In another he throws her to the ground, and while sitting on top of her, holds her head immobile in his hands. These scenes go beyond more common visual images of abuse, such as slapping, and ask viewers to witness disturbing violent acts. Moreover, the video takes a culturally acceptable form of violence and, by recontextualizing it, demonstrates how violence often is trivialized in U.S. society. This reframing of socially sanctioned violence, then, shifts the blame for domestic abuse from an individual batterer to a culture that not only permits, but quite often applauds, violence and violent imagery. This depiction confronts the stereotype that battery is perpetrated by disturbed individuals and instead implicates the culture as a whole in engendering violent attitudes toward women.

Collin Raye's 1996 song and video, "I Think About You," also indict Western culture for promoting violence against women by showing visual images of violence. The title sounds like a typical country song of heterosexual romance. However, the lyrics are sung from the perspective of a father singing to his eight-year-old daughter. Throughout the song, Raye describes seeing the mistreatment and exploitation of women in society, from the objectification of women in advertisements to street harassment, and remarks that all of these women "used to be somebody's little girl." In the video for "I Think About You," Raye plays a police officer who responds to a series of calls that somehow involve abuses toward women. These scenes are interspersed with Raye off-duty with his teenage daughter, as the two go about daily activities. The happy scenes of Raye and his daughter make the images of violence against women appear even more grim.

The video begins in a cinematic style that is reminiscent of the reality television series, COPS. The camera follows Raye, dressed as a police officer, with quick, jerked motions and a blue, slightly grainy lens that simulates night vision. Because of the immediacy that the camera angles foster, viewers are transformed from passive observers of the violent situation and instead are positioned as witnesses to the scene. The jump cuts and frenetic pace of the camera work add to a feeling of confusion and disorientation. The fact that such cinematography also mimics reality television further suggests that such circumstances are likely to be found in "real" life.

On one call, Raye's character and his partner assist an elderly woman. The woman sits in an alley in the pouring rain. Her lack of shelter, tattered clothes,

and disheveled appearance all indicate that she is homeless. The woman appears disoriented as Raye wraps her in a wool blanket and walks with her to his car, presumably to take her to a shelter. While the scene does not display overt signs of physical abuse, the video and lyrics argue that our culture's neglect of such women is tantamount to violence. This point is made clear as the video shifts from a close-up of the elderly woman in the patrol car to the face of a battered woman in her thirties. The battered woman's face reveals evidence of a recent beating, including a prominent black eye and a cut, swollen lip. Raye solemnly escorts the woman and her two small girls to a shelter where a smiling nun offers them refuge. Meanwhile, the lyrics build upon the visual connection between the homeless woman and the young mother: "When I see a woman on the news/ Who didn't asked to be abandoned or abused/ It doesn't matter who she is/ I think about you." In the context of the video, the elderly woman (the abandoned) and the mother (the abused) both represent victims of a society that ignores its problems, especially those involving violence against women. Again, the text, both lyrically and visually, goes beyond more typical representations of such violence and indicts the culture as a whole for its many manifestations.

Depictions of Abusers and the Abused

In addition to showing violent images that expose the realities of domestic violence, country music videos also challenge a prevailing myth concerning those who are domestic abusers and those who are victims and survivors of such abuse. According to scholars of domestic violence, a common stereotype of abuse victims is that they are from poor or lower socioeconomic backgrounds.[62] Del Martin notes, "Some believe outright that [domestic violence] is a direct result of poverty and low social status. Prevailing stereotypes of ghetto life often incorporate images of women being beaten and thrown around as a matter of course."[63] The assumption is that poor or working-class males are more prone to abuse family members in order to assert power they are otherwise missing in their public lives. In reality, however, women of all social classes can be victims of domestic violence. Researchers suggest that the perception of more abuse among working-class women may be linked to underreporting among those of the middle and upper class. Lenore Walker argues that middle- and upper-class women fail to report abuse because they "fear social embarrassment and harming their husbands' careers. Many also believe the respect in which their husbands are held in the community will cast doubt upon the credibility of their battering stories."[64] Martin further explains:

Lower-class families have fewer resources and less privacy, and are more apt to contact public social-control agencies, such as the police, which compile domestic-disturbance statistics. Middle-class families have greater access to private support services, such as marriage counselors and psychiatrists, who do not as a rule compile statistics. In the case of serious injury, lower-class victims are sent to emergency rooms in public hospitals; middle- or upper-class wives can afford to contact private doctors or hospitals. These differences make lower-class family violence more visible as police or emergency-room statistics, and therefore more available to researchers.[65]

The videos in this analysis challenge this myth by depicting abusers and victims from various backgrounds. Particularly when taken as a whole, these videos show how domestic violence affects individuals from a variety of social strata.

In "The Thunder Rolls," both the husband and the wife are depicted as wealthy; the husband wears a business suit and carries a leather briefcase, suggesting he is a businessman. When he leaves his mistress, he drives away in a luxury sedan. The wife is shown in a large, elegant living room surrounded by expensive furnishings, gilded picture frames, and a marble fireplace. Additionally, the wife wears a silk robe as she waits for her husband, a costume choice that conflicts with the lyrical description of the wife wearing a "faded, flannel gown." Such images of affluence, coupled with the depictions of violence, work to instruct viewers that domestic violence can occur anywhere and among any social class.

On the surface, the portrayals of the husband and wife in "Independence Day" seem to be consistent with stereotypes of working-class abusers and victims. The lyrics describe the family as living in a small, rural town, and the house is shown as modest and in need of repair. Both husband and wife wear jeans, and the husband wears a plaid flannel shirt and rugged work boots, arguably symbols of working-class masculinity. The lyrics further stereotypes of abuse as they recount how the father has been drinking. This cultural myth suggests that abusers are usually good-natured, non-violent individuals and that it is only when they drink that they become violent. Despite conforming to these stereotypes, "Independence Day" asserts that domestic violence does occur in working-class homes and when alcohol is involved. However, the video does not imply that domestic violence is isolated to these individuals or to this social class. On the contrary, the juxtaposition of the clowns' humorous violence and the violent images of abuse in the video emphasizes that the problem of domestic violence is not the actions of aberrant individuals, but a culture of violence that permits such violent acts to occur.

"I Think About You" depicts the most varied images of violent perpetrators and abuse victims. In particular, the video suggests that women of all ages can be victims of violence. Victims portrayed in the video represent a broad

range of ages, from young girls to young, middle-aged, and elderly women. Camera shots often jump from one woman to another emphasizing the diversity of victims. The types of violence these women face also differ. For example, one scene shows a victim of domestic abuse, while other scenes illuminate the threats of violence women face. In one scene, two male restaurant patrons harass a middle-aged waitress. She rebuffs their advances and seems irritated by their comments and suggestive gestures, telling them angrily to "Watch it" as she tries to serve their food. Sitting in a booth behind the men, Raye and his partner interrupt the encounter, and Raye is forced to flash his badge at the men's menacing postures. In the background the lyrics explain how women confront harassment in everyday public places. For example, the protagonist describes how men look at a woman as a sexual object when she walks down the street. The song continues that all women must constantly be on guard against violence by being aware of their surroundings and avoiding contact with strangers. Although this section of the video does not depict actual violence against women, it exposes the undercurrent of violence in society that threatens all women. In doing so, "I Think About You," like "Independence Day" argues that problems such as domestic abuse are not the result of rogue individuals, but of a society that fosters a hostile climate against women.

Those who are violent or who threaten violence in "I Think About You" represent a cross-section of society as well. The first perpetrator seen in the video appears to be in his 50s and fits the stereotype of a criminal. His hair is unkempt and his clothes are disheveled. He resists arrest and his eyes are wide in an expression that suggests rage or intoxication. In contrast, the men who harass the waitress appear to be "average," middle-class men. They are dressed plainly, appear well groomed, and occupy an "everyday," safe location of a public restaurant. Neither the men's visual appearance nor their location appears threatening. Visually, then, the video argues that there is no one "type" of person who is violent.

Appropriating Patriarchal Icons

Another visual strategy country music videos use to expose domestic violence is the appropriation of icons normally associated with masculinity or patriarchy. Often these images are also a part of country music culture. Icons such as the cowboy, community parades, and the police officer are used to draw attention to the problems of domestic violence. By using familiar, traditional images in unfamiliar ways, the videos illuminate the problem of domestic violence and position viewers to take a stand against this violence.

The image of the cowboy is a stock American icon and an enduring sym-
bol of country music culture. The cowboy represents a classic American hero,
an emblem of masculinity made popular through the American western film
genre and typified by actors such as John Wayne.[66] The image is also rooted in
country music history. Historian Bill Malone explains:

> The emergence of the western image in country music was probably inevitable;
> throughout the twentieth century the cowboy has been the object of unparalleled
> romantic adulation and interest. Given the pejorative connotations that clung to
> farming and rural life, the adoption of cowboy clothing and western themes was a
> logical step for a country singer.[67]

Like many male country artists, Garth Brooks has appropriated the image
of the cowboy since the beginning of his career. He traditionally wears jeans, a
western-style shirt, and a cowboy hat. In "The Thunder Rolls" video, Brooks'
cowboy image is used to distinguish the "real" Garth Brooks from the charac-
ter in the video that Brooks also plays. Because this character is a villain, the
distinction between the two Garth Brooks also sets up a "good guy" (the
cowboy) versus "bad guy" (the abuser) dichotomy in the video. The images of
the villain cheating and abusing his wife are frequently seen in conjunction
with Brooks in performance. On several occasions, Brooks the performer
directly addresses viewers as he sings with an expression of moral disgust at the
actions of the character. For example, several times Brooks looks into the
camera in a close-up shot and shakes his head in disapproval as he sings. The
cowboy, then, is recast from a symbol of stoic masculinity to a representative
of those who would speak out against domestic violence. "The Thunder Rolls"
concludes that there are "bad guys"—those who abuse women—and "good
guys"—those who criticize such abuse. In establishing himself as a good guy,
Brooks invites viewers to join him in a critique of domestic violence.

In "Independence Day," the icons of the American flag and the parade are
used to point out the injustices and brutalities of domestic violence. The lyrics
of "Independence Day" rely heavily on patriotic references, the most obvious
being the title of the song, whose lyrics also borrow lines from "The Star
Spangled Banner" and describe the mother's actions as a "revolution." The
image of the American flag is featured repeatedly throughout the music video
to reinforce this connection and patriotic tone. For example, the parade is
lined with crowds who enthusiastically wave miniature flags, and a several-
stories high flag is draped prominently behind McBride as she sings. Through
this symbolism, the video arguably asks viewers to connect America's fight for
freedom with the mother's personal freedom from abuse. Thus, according to
"Independence Day," if viewers believe in values associated with the United

States, such as freedom and liberty, then they must also believe that domestic abuse is a form of oppression that should be acted against. Using patriotic imagery to confront domestic violence in this way seems especially appropriate with a country music audience, given the genre's long tradition of music with a patriotic message.[68]

The parade also symbolizes small town life, and the black-and-white imagery and mid-century aesthetic of the video suggest the innocence of a simpler time. "Independence Day," however, confronts the myth of this innocence and exposes the dark side of small town life. In the lyrics, McBride refers to the townspeople's gossip, explaining that everyone knew of her mother's abuse but did nothing to intervene. The song thus holds the community accountable for knowing about the violence—indeed, even gossiping about it—but failing to take any action to stop it. Such an indictment arguably represents a call to action for listeners/viewers. The audience is charged with speaking out or acting against domestic violence.

"I Think About You" appropriates the patriarchal icon of the police officer in its critique of violence against women. The image of the police officer is a particularly interesting symbol to appropriate in this context. Historically, the role of the police in domestic disputes has been controversial. According to some critics, the police are at best ineffectual and, at worst, perpetuate the problem, seeing domestic violence as a private affair.[69] Others argue that a lack of resources and victim cooperation keep police from effectively responding to the crime.[70] By using a police officer as the protagonist, and showing him tackling violence against women, the video argues that some in law enforcement are actively attempting to address the problem. Raye's role as a police officer also takes a traditionally patriarchal symbol of masculine authority and uses it to speak on behalf of women's issues. Masculinity, hegemonically constructed as violent, is transformed into acting against violence and on behalf of women.[71] As in "The Thunder Rolls," the video suggests that there are "good guys"—those who confront violence against women—and "bad guys"—those who commit acts of violence against women. "I Think About You" extends this observation by creating an awareness of society's complicity in this problem and demonstrating how seemingly non-violent attitudes and behaviors contribute to a culture that is ultimately unfriendly to and potentially dangerous for its female citizens. By appropriating popular symbols, these videos critique the dominant culture, again positioning the problem of domestic violence as a cultural rather than as a personal issue.

Conclusion

This chapter has explored the various visual strategies used by country music videos to expose the issue of domestic violence. By graphically displaying acts of violence and evidence of abuse, depicting a variety of domestic assault victims and perpetrators, and appropriating patriarchal icons, these videos not only draw attention to the issue of domestic abuse, but also help to deconstruct prevailing myths about this form of violence. Additionally, the videos depart from other popular culture depictions of violence that show sympathy for the victims but portray them as isolated, individual problems. In "The Thunder Rolls," "Independence Day," and "I Think About You," the issue of domestic violence is constructed as a societal problem, with cultural causes and with the potential for social solutions. Indeed, viewers are invited to see themselves as part of a potential solution to domestic battery.

Like many texts in mainstream media, however, the videos have limitations as a form of feminist rhetoric. For example, while class issues are addressed, issues of race and sexual orientation as they relate to domestic violence are not interrogated. And while the use of the patriarchal symbols of the cowboy and the police officer might highlight how constructions of masculinity might be used in the service of women's issues, these symbols might also convey a type of paternalism, subtly reinforcing the notion that women can be saved from their problems by masculine forms of authority. Yet despite their limitations, these music videos represent a significant cultural discourse regarding domestic violence. The texts not only address the issue of domestic abuse, but also expose the complexities of the issue in a highly visual manner. Indeed, the rhetorical form of the country music video has the potential to reach a broad range of individuals, many of whom might not be exposed to political feminist rhetoric. As such, using this genre has the potential to raise cultural awareness about this particular form of gendered violence.

Notes

1 Centers for Disease Control and Prevention, "Costs of Intimate Partner Violence Against Women in the U.S.," (August 5, 2004): http://www.cdc.gov/ncipc/pub-res/ipv_cost/02_introduction.htm.

2 See, for example, Patricia Tjaden and Nancy Thoennes, *Full Report of the Prevalence, Incidence, and Consequences of Violence Against Women: Findings from the National Violence Against Women Survey*, (National Institute of Justice, Department of Justice, November 2003). See also Bureau of Justice Statistics Crime Data Brief, *Intimate Partner Violence, 1993–2001* (February 2003).

3 The National Institute of Justice reports that approximately 1.3 million women are victims of intimate partner violence per year in the United States. See Patricia Tjaden and Nancy Thoennes,*Full Report*. A Commonwealth Fund survey reports three million women as domestic violence victims annually in the United States. See The Commonwealth Fund, *Health Concerns Across a Woman's Lifespan: 1998 Survey of Women's Health* (New York, May 1999).

4 Bureau of Justice Statistics Crime Data Brief, *Intimate Partner Violence, 1993–2001* (February 2003).

5 Susan Brownmiller, *In Our Time: Memoir of a Revolution* (New York: The Dial Press, 1999), 194. For further elaboration of Brownmiller's work and its reception, see chapter 12 in this volume.

6 Erin Pizzey, *Scream Quietly or the Neighbors Will Hear* (London: Penguin, 1974).

7 Del Martin, *Battered Wives* (San Francisco: Glide Publications, 1976).

8 See Elayne Rapping, *The Movie of the Week: Private Stories, Public Events* (Minneapolis: University of Minnesota Press, 1992) and Leonard Maltin, *Leonard Maltin's Movie and Video Guide: 1998* (New York: Plume, 1997), 184.

9 Elayne Rapping, *Movie of the Week*, xxviii.

10 Beverly Keel, "Between Riot Grrrl and Quiet Girl: The New Women's Movement in Country Music," in *A Boy Named Sue: Gender and Country Music*, edited by Kristine M. McCusker and Diane Pecknold (Jackson: University Press of Mississippi, 2004), 155–177.

11 See, for example, Bonnie J. Dow, *Prime-Time Feminism: Television, Media Culture, and the Women's Movement Since 1970* (Philadelphia: University of Pennsylvania Press, 1996); Bonnie J. Dow, "*Ally McBeal*, Lifestyle Feminism, and the Politics of Personal Happiness," *Communication Review* 5 (2002): 259–264.

12 Joe Gow, "Making Sense of Music Video: Research During the Inaugural Decade," *Journal of American Culture* 15 (Fall 1992): 35–43.

13 See, for example, E. Ann Kaplan, *Rocking Around the Clock: Music Television, Postmodernism, and Consumer Culture* (London: Methuen, 1987); John Fiske, "MTV: Post-Structural Post-Modern," *Journal of Communication Inquiry*10 (Winter 1986): 74–79.

14 See, for example, Gary Burns, "Film and Popular Music," in *Film and the Arts in Symbiosis: A Resource Guide*, edited by Gary R. Edgerton (New York: Greenwood Press, 1988), 217–242; Gary Burns and Robert Thompson, "Music, Television, and Video: Historical and Aesthetic Considerations," *Popular Music and Society* 11 (1987): 11–25.

15 Joe Gow, "Music Video as Communication: Popular Formulas and Emerging Genres," *Journal of Popular Culture*26 (1992): 41–70; and Joe Gow, "Music Video as Persuasive Form: The Case of the Pseudo-Reflexive Strategy," *Communication Quarterly*41 (1993): 318–327.

16 See, for example, Joe Gow, "Mood and Meaning in Music Video: The Dynamics of AudioVisual Synergy," *Southern Communication Journal* 59 (Spring 1994): 225–261; Robert Walser, *Running with the Devil: Power, Gender, and Madness in Heavy Metal Music* (Hanover,

NH: Wesleyan University Press, 1993); R. Serge Denisoff, *Inside MTV* (New Brunswick, NJ: Transaction Books, 1988); Marsha Kinder, "Music Video and the Spectator: Television, Ideology, and Dream," in *Television: The Critical View*, edited by Horace Newcomb (New York: Oxford University Press, 1987).

17 In the case of rap or hip-hop music videos, Tricia Rose notes that the cable network BET (Black Entertainment Television) began showing rap videos in response to MTV's refusal to regularly air black artists' videos. With MTV's debut of "Yo! MTV Raps" in 1989, the channel began regularly featuring rap artists. See Tricia Rose, *Black Noise: Rap Music and Black Culture in Contemporary America* (Middletown, CT: Wesleyan University Press, 1994), 8–11.

18 Mark Fenster, "Genre and Form: The Development of the Country Music Video," in *Sound and Vision: The Music Video Reader*, edited by Andrew Goodwin, Simon Frith, and Lawrence Grossberg (New York: Routledge, 1993),109–128.

19 Mark Fenster, "Genre and Form," 115.

20 See, "The Women Behind the Movement," *Broadcasting* 15 (July 1985): 42; Joe Gow, "Reconsidering Gender Roles on MTV: Depictions in the Most Popular Music Videos of the Early 1990s," paper presented at the Speech Communication Association Convention, San Antonio, 1995.

21 Lisa A. Lewis, *Gender Politics and MTV: Voicing the Difference* (Philadelphia: Temple University Press, 1990).

22 Lisa Lewis, *Gender Politics and MTV*; Lisa A. Lewis, "Being Discovered: The Emergence of Female Address on MTV," in *Sound and Vision*, 129–151.

23 Robin Roberts, *Ladies First! Women in Music Videos* (Jackson: University of Mississippi Press, 1996),184.

24 See, Joe Gow, "Reconsidering."

25 See, for example, Richard C. Vincent, "Clio's Consciousness Raised? Portrayal of Women in Rock Videos, Reexamined," *Journalism Quarterly* 66 (1989): 155–160; Richard C. Vincent, Dennis K. Davis, and Lilly Ann Boruszkowski, "Sexism on MTV: The Portrayal of Women in Rock Videos," *Journalism Quarterly* 64 (1987): 750–755, 941; Sut Jhally, *Dreamworlds 3: Desire, Sex, and Power in Music Video* (Media Education Foundation, 2007).

26 Richard Vincent, et al., "Sexism on MTV," 754; Joe Gow, "Reconsidering."

27 Richard Vincent, et al., "Sexism on MTV," 941.

28 Richard Vincent, "Clio's Consciousness Raised?"160.

29 Joe Gow, "Reconsidering."

30 Julie L. Andsager and Kimberly Roe, "Country Music Video in Country's Year of the Woman," *Journal of Communication* 49 (Winter 1999): 69–82.

31 Gaye Tuchman, "The Symbolic Annihilation of Women by the Mass Media," in *Hearth and Home: Images of Women in the Mass Media*, edited by Gaye Tuchman, Arlene Kaplan Daniels, and James Walker Benet (New York: Oxford University Press, 1978), 3–38.

32 See, for example, Charles Jaret and Jacqueline Boles, "Sounds of Seduction: Sex and Alcohol in Country Music Lyrics," in *America's Musical Pulse: Popular Music in Twentieth Century Society*, edited by Kenneth Bindas (Westport, CT: Greenwood Press, 1992), 257–267; Charles Jaret and Lyn Thaxton, "Bubbles in My Beer Revisited: The Image of Liquor in Country Music," *Popular Music and Society* 7 (1980): 214–222; H. Paul Chalfant and Robert E. Beckley, "Beguiling and Betrayal: The Image of Alcohol Use in Country Music," *Journal of Studies on Alcohol* 38 (1977): 1428–1433; Judith Stone, "Lookin' for Science in All the Wrong Places," *Discover* (March 1989): 96–99.

33 See, for example, Jimmie N. Rogers, *The Country Music Message: All About Lovin' and Livin'* (Englewood Cliffs, NJ: Prentice-Hall, 1983); and Jimmie N. Rogers, *The Country Music Message: Revisited* (Fayetteville: University of Arkansas Press, 1989)

34 See, for example, Jens Lund, "Fundamentalism, Racism, and Political Reaction in Country Music," in *The Sounds of Social Change*, edited by R. Serge Denisoff and Richard A. Peterson (Chicago: Rand McNally, 1972), 79-91; Paul DiMaggio, Richard A. Peterson, and Jack Esco, "Country Music: Ballad of the Silent Majority," in *The Sounds of Social Change*, 38-55.

35 See, for example, Jens Lund, "Fundamentalism, Racism," 79-83.

36 See, for example, Bill C. Malone, *Southern Music/American Music* (Lexington: University Press of Kentucky, 1979); Bill C. Malone, *Singing Cowboys and Musical Mountaineers: Southern Culture and the Roots of Country Music* (Athens: University of Georgia Press, 1993); Melton A. McLaurin, "Songs of the South: The Changing Image of the South in Country Music," in *You Wrote My Life: Lyrical Themes in Country Music*, edited by Melton McLaurin and Richard Peterson (Philadelphia: Gordon and Breach, 1992),15-34; James C. Cobb, "From Rocky Top to Detroit City: Country Music and the Economic Transformation of the South," in *You Wrote My Life*, 63-80; James C. Cobb, "From Muskogee to Luckenbach: Country Music and the 'Southernization' of America," *Journal of Popular Culture* 16 (1982-1983): 81-91; Stephen A. Smith, "Sounds of the South: The Rhetorical Saga of Country Music Lyrics," *Southern States Speech Communication Journal* 45 (1980): 390-396.

37 Charles R. Conrad, "Work Songs, Hegemony, and Illusions of Self," *Critical Studies in Mass Communication* 5 (1988): 179-201. For a general overview of country music see Bill C. Malone, *Country Music U.S.A.*, rev. ed. (Austin: University of Texas Press, 1985).

38 Karen Saucier Lundy, "Women and Country Music," in *America's Musical Pulse*, 213-219. See also, Karen A. Saucier, "Healers and Heartbreakers: Images of Women and Men in Country Music," *Journal of Popular Culture* 20 (1986): 147-166.

39 Karen Lundy, "Women and Country Music," 215.

40 Beverly Keel, "Between Riot Grrrl and Quiet Girl."

41 Mary Bufwack, "The Feminist Sensibility in Post-War Country Music," *The Southern Quarterly* 22 (Spring 1984): 143.

42 Mary Bufwack, "Feminist Sensibility," 143. Mary Bufwack and Robert K. Oermann's, *Finding Her Voice: The Saga of Women in Country* (New York; Crown Publishers, 1993) represents a biographical history of women's involvement in country music, in which the authors discuss how female artists have challenged discrimination in the industry and have incorporated women's issues in their songs. For an exploration of issues of sexual identity and masculinities in country music see Michael Bertrand, "I Don't Think Hank Done It That Way: Elvis, Country Music and the Reconstruction of Southern Masculinity," in *A Boy Named Sue*, 59-85; Curtis W. Ellison, *Country Music Culture: From Hard Times to Heaven* (Jackson: University Press of Mississippi, 1995); Diane Pecknold, "'I Wanna Play House': Configurations of Masculinity in the Nashville Sound Era," in *A Boy Named Sue*, 86-106; and Teresa Ortega, "'My Name Is Sue! How Do You Do?': Johnny Cash as Lesbian Icon," *South Atlantic Quarterly* 94 (Winter 1995): 259-272.

43 Mary A. Bufwack and Robert K. Oermann, *Finding Her Voice*, 20.

44 Teresa Goddu, "Bloody Daggers and Lonesome Graveyards: The Gothic and Country Music," *The South Atlantic Quarterly* 94 (Winter 1995): 57-80. See also, Kenneth D. Tunnell, "Blood Marks the Spot Where Poor Ellen Was Found: Violent Crime in Bluegrass Music," *Popular Music and Society* 153 (Fall 1991).

45 Teresa Goddu, "Bloody Daggers," 69.

46 Mary Bufwack and Robert Oermann, *Finding Her Voice*, 9.

47 Mary Bufwack and Robert Oermann, *Finding Her Voice*, 20–21.

48 In *The Digital Tradition*, DT #627, http://shorty.mudcat.org/!!-song99.cfm?stuff=fall99+D+ 9371931.

49 Dolly Parton, "Little Blossoms" (traditional, arranged by D. Kleiber) on *Hits Made Famous by Country Queens*, Somerset Recordings, January 1, 1963.

50 Loretta Lynn with George Vecsey, *Loretta Lynn: Coal Miner's Daughter* (New York: Warner Books, 1976), 31. Lynn is referring to songs such as "Don't Come Home A-Drinkin' (with Lovin' On Your Mind)" (1966), which criticizes a husband who comes home inebriated and demands sex from his wife.

51 Tammy Wynette with Joan Dew, *Stand by Your Man* (New York: Simon and Schuster, 1979).

52 Reba McEntire, "The Stairs" (Pamela Brown, David Roberts) on *The Last One to Know*, MCA Nashville, January 1, 1987.

53 See Mark Fenster, "Genre and Form."

54 See, www.cmaawards.com. It would be difficult to over-emphasize Garth Brooks' popularity or his influence on country music in the 1990s. By the year 2000, Brooks had sold over 100 million albums—the most of any solo artist in U.S. history. He officially retired in 2001. See, Melinda Newman, "Garth Brooks' Last Album? He Feels His Capitol 'Scarecrow' Set is His Final Bow," *Billboard* (November 3, 2001): 5, 105–106.

55 Edward Morris, *Edward Morris' Complete Guide to Country Music Videos* (Nashville: Storm Coast Press, 1997), 109.

56 Edward Morris, *Edward Morris' Complete Guide*, 138.

57 See, for example, Joe Gow, "Reconsidering"; Sut Jhally, *Dreamworlds 3*.

58 Joel Whitburn, *Joel Whitburn's Top Country Singles, 1944–1997* (Menomonee Falls, Wisconsin: Record Research, Inc., 1998), 56.

59 The video was produced by High Five Productions and directed by Bud Schaetzle. For Garth Brooks' own explanation of the creation of "The Thunder Rolls" video, see his interview included in the video compilation, *Garth Brooks* (Hollywood, CA: Liberty Home Video, 1991). The cable networks CMT and TNN banned the video, citing its "violent content." See Edward Morris, *Edward Morris' Complete Guide*, 46.

60 "Independence Day" was written by Gretchen Peters.

61 Robin Roberts, *Ladies First!*, 129.

62 See, for example, Del Martin, *Battered Wives* or Lenore E. Walker, *The Battered Woman* (New York: Harper Perennial, 1979).

63 Del Martin, *Battered Wives*, 54.

64 Lenore Walker, *The Battered Woman*, 22.

65 Del Martin, *Battered Wives*, 54.

66 For discussions of the cowboy myth, see, for example, Robert B. Ray, *A Certain Tendency of the Hollywood Cinema, 1930–1980* (Princeton: Princeton University Press, 1985).

67 Bill C. Malone, *Country Music U.S.A.*, 137.

68 Country music's inclusion of patriotic themes is exemplified by Lee Greenwood's "God Bless the USA," which became a type of soundtrack for the U.S. involvement in the Gulf War.

69 See, for example, Lenore Walker, *The Battered Woman*.

70 See, for example, Richard L. Davis, *Domestic Violence: Facts and Fallacies* (Westport, Connecticut: Praeger, 1998).

71 See, for example, Jackson Katz, "Advertising and the Construction of Violent White Masculinity," in *Gender, Race, and Class in Media: A Text-Reader*, 2d ed., edited by Gail Dines and Jean M. Humez (Thousand Oaks, CA: Sage, 2003), 349–358.

CHAPTER 11

Mediated Violence and Women's Activism in Serbia

Danica Minic

After mass protests in October 2000 forced Slobodan Milosevic to acknowledge his defeat in the September elections, a coalition of eighteen parties formed the first properly democratic, post-socialist Serbian government. Parts of the Serbian public were inspired by these political changes and hoped that there would be some accountability for a range of issues: war crimes committed by Serbian military and paramilitary forces during the ex-Yugoslav wars, the previous regime's murders of opposition politicians and journalists, and the illegally acquired fortunes of the tycoons close to Milosevic. The central political problem facing the first post-Milosevic government,[1] therefore, concerned the following questions: discontinuity with the previous authoritarian regime, responsibility for the crimes of those connected to the regime, and the overall reconstruction and transformation of economic and political institutions. This large coalition, however, was hampered by political rifts and active resistance to its reforms, and its momentum was severely damaged by the assassination of the Prime Minister Zoran Djindjic, the figurehead of the political changes, in March 2003. The Djindjic assassination trial took place between December 2003 and May 2007 and ended in twelve convictions for members of a local organized crime group and former members of Milosevic's State Security Services.[2]

During the period of the first post-Milosevic government, the issues of media responsibility for hate speech and women's rights have arisen as part of the struggles for political change from authoritarian to democratic and civil rights discourses. According to a number of analysts, parts of the Serbian media have significantly contributed to the incitement of ethnic hatred and the legitimization of belligerent politics.[3] In their public requests that the

journalists should take responsibility for inciting ethnic hatred, the critics of
hate speech stressed the following points: hate speech has been one of the
main generators of the wars in the 1990s[4] and, because of "the destruction of
criteria and values"[5] during this decade, it has become normalized not only in
the media, but in institutions of power such as political parties, the Serbian
Orthodox Church, the Serbian Academy of Science and Arts, and the then
Yugoslav Army.[6] After the war, to which certain media houses and workers
substantially contributed, no one has been charged with hate speech.
Nevertheless, such criticisms of hate speech have at least prompted new
legislation. In April 2003, the new Law on Public Communication was
introduced, forbidding both publishing and broadcasting hate speech, and
permitting registered organizations dealing with human rights to appear as the
appellant party in a lawsuit related to hate speech.[7]

Women's rights have been a part of this broader struggle for discontinuity
in at least three ways. First, the new government has shown willingness to
make the issue of women's rights part of its political agenda, using it also as a
sign of its pro-democratic orientation. To what extent this was implemented or
was simply a means of advertising remains to be researched. However, if
bringing gender-related issues into the foreground of politics has been no
more than "advertising" an anti-authoritarian and pro-democratic agenda, this
nevertheless has symbolic and political importance as one more way of
signalling the change of regime.[8] Second, women's greater visibility and power
during this period was related to the positioning of women's nongovernmental
organizations (NGOs) and the women in NGOs with respect to Milosevic's
regime throughout the previous decade. Women increasingly participated in
the NGO scene, which developed parallel institutions opposed to those of the
regime, and after the political change many of them simply continued the
same work but moved to state institutions. Third, women's NGOs saw this
new political climate as an opportunity to make their claims more vocal and
more public, and attempted to cooperate in their activities with state
institutions and female politicians in Parliament.

In this chapter I analyze those debates about hate speech in the Serbian
media that occurred during 2002–2003 and in which the issues of
responsibility for hate speech and women's rights were brought together.
Previous discussions on the issue of hate speech in the Serbian media have
mainly been with respect to ethnic hate speech[9] and occasionally to verbal
violence against political opponents. The debates presented in this chapter
focus on hate speech against women, a topic that has largely been ignored by
that segment of the public otherwise critical of hate speech. These debates
were provoked by the women NGOs' protests against various cases of sexism

in the media that occurred in the period under discussion. This chapter will focus on two[10] extensive debates: press coverage of a female politician, and a TV short. In examining these debates, my central analytical objectives are as follows. In the first section, I shall show that the analyzed cases not only fall under the category of hate speech, but that such speech is actually violent conduct that prevents women from participating as equals in public life through their pornographic sexualization. In the second section, the topic is considered within the political context of Serbia to analyze the specific ideological and political investments given to the issue of hate speech against women by the different participants in the debates. At the same time, these two objectives will be related to the two major themes within these debates: discrimination and violence against women, and the "authorial" attribution of hate speech against women within different constructs of Serbian national identity and tradition.

The first case concerns the debate about sexist treatment of a female politician in the media in December 2002. After it became clear that, as a result of the unsuccessful presidential elections, Natasa Micic, then President of the Serbian Parliament, would temporarily become the (first female) President of Serbia, the next issues of the "serious" political daily (*Politika*)[11] and weekly (*NIN*)[12] appeared with a paparazzi photo of her on their covers. The photo showed Micic emerging from a car as her skirt flipped up, showing her legs. Other newspapers reprinted the photo, as general public speech on Micic escalated, with a focus on things such as her legs, hairstyle and clothes, rather than her political activities or performances. Female politicians and women's groups protested and were supported by a segment of the public. These photographs, and the reactions to them, opened a discussion on hate speech against women: in this case, against women politicians or women in public professions in general.

The second case arose out of the new Law on Public Communication. In November 2003 a lawsuit was filed against a TV show for promoting discrimination on the grounds of sex. Fifty-five women's NGOs, supported by a number of other NGOs and individuals, protested against a TV short entitled *It Cannot Hurt*, broadcast on TV Pink, and sued its author and the editor-in-chief. Throughout October 2003, in mini-monologues broadcast several times a day, women were classified according to their sexualized body parts using extremely derogatory language.[13] For the purposes of this lawsuit, members of different organizations formed an *ad hoc* coalition under the name "Initiative against Misogyny in the Media" (IPMM),[14] with a campaign slogan of: "It hurts everybody, because insults incite violence." In their statements, IPMM pointed out three goals: the removal of such content from TV Pink, make the media

and society more *decent* in general, and affirm the newly adopted law that offers the possibility of resistance against verbal violence. Their lawsuit, labeled as historical, being the first lawsuit against hate speech, and their statements have provoked numerous reactions and counter-arguments, and have generated more extensive debate on mediated violence against women than has existed in previous cases.

One striking feature of these debates is the sheer number of different names and definitions women's groups have used to try to define the problem; for example, sexism,[15] misogyny,[16] verbal violence, verbal terror, sexual harassment, indecent, vulgar, primitive speech, fascism, etc. Norman Fairclough identifies this phenomenon as overwording: an excess of different names applied to a particular situation and argues that this is often interpretable as a sign that a certain issue is a matter of ideological contestation, as no consensus can be found regarding how it should be defined.[17] I would argue that these two instances of women's protests should then be viewed as a pioneering work of coming-to-terms with a problem of hate speech against women and struggling over its definition. In order to negotiate and respect this array of words that women's NGOs themselves have used, I have chosen as a point of departure an umbrella phrase: "mediated violence against women."

Initially I will move beyond this elusive phrase and over-wording, and show that the kinds of offensive speech that women's NGOs have protested against can be defined as pornographic hate speech, which not only communicates (sexual) hatred but is violent conduct that is embedded in patterns of institutionalized discrimination against women. Pornographic hate speech here does not narrowly refer to pornography—although elements of these two media cases could also be classified generically as such—but to the practice of silencing women and hindering their participation in public life through a kind of pornographic sexualization that dissociates women's sexuality from human potentials of speech and agency.[18]

Subsequently, I will approach my topic from the perspective of the broader Serbian political context and point out different political and ideological investments in hate speech against women and the political relevance of the struggle against it. My main argument in this part concerns the ways in which the issue of sexism in the media has been understood and used for political and ideological purposes by the main participants in the debates. On the one hand, I argue that the issue of hate speech against women and the relationships among culture, politics and violence have been defined by all the participants, including women's NGOs, through a series of antagonistic relationships such as European/non-European, local/global,

urban/rural, high culture/low culture. In my view, this undermines feminist criticism of hate speech against women by trapping it within the discursive field of nationalism that is based precisely in such antagonisms. On the other hand, I show that the protests of women's NGOs were a part of the broader struggle to make public figures take responsibility for hate speech, and further argue that these protests were a good strategic site for women's NGOs to make their claims more visible and public.

Finally, the following analysis contributes to feminist scholarship on hate crimes from the perspective of the Serbian context in a way that goes beyond a mere rehearsal of the points raised by the early anti-pornography movement in the second wave of U.S. feminist research. Similarities between the debates in the two contexts abound: discussions of sexism with respect to free speech and misreading or co-opting feminist protests against pornography as demands for public decency and obscenity charges are just two of the more prominent points. More importantly, feminist understandings of the relations between pornographic notions of women's sexuality and violence and discrimination against women have been central in both cases. However, the major difference between the two stems from their different focus in terms of media material: pornography as a particular genre, in the U.S. case, and pornographic sexualization of women as widely spread throughout the mainstream media and public discourses on women in the Serbian instance. While early U.S. anti-pornography feminists mainly focused on the relations between pornography and violence against women in the sex industry and rape, Serbian feminists protested against the use of pornographic representations in the media and public in general, as a means of promoting and enacting discrimination against women.

The differences between the two also arise from the different positioning of the feminist critique. In the United States, feminism is perceived as a homegrown critique; the Serbian debates are greatly informed by the particular ways in which feminist critiques of sexism are articulated and perceived within the antagonistic discourses on "local tradition" versus "Western hegemony." This entanglement partly mirrors the ways in which sexism is intertwined with nationalist discourses, which also has led Serbian feminists to universalize their protests against sexism by relating pornographic hate speech to ethnic hate speech as a major tool of forging war in Yugoslavia. While Western attempts to develop common arguments against pornography and racist speech provide relevant points of reference and analytical tools here, they can be applied only with careful consideration of the specificity of the present Serbian context as it is shaped by the wars, U.N. sanctions and the dictatorship of the 1990s, a major institutional crisis due to the transitional

period, contested state borders and corruption, and different but interrelated chauvinist identity politics.

Given the similarities and differences between the debates in the two contexts, my chapter both builds on specific arguments on hate speech developed by Anglo-American anti-pornography feminists and critical race scholars and approaches them in new ways. First, my aim is to utilize these arguments within a broader framework of politics of recognition and, in particular, Nancy Fraser's understanding of misrecognition as status subordination. This combination of arguments and approaches allows me to explore the ways in which pornographic notions of women's sexuality are embedded in institutionalized patterns of discrimination against women and the curtailment of their civil rights. Second, by analyzing the particular Serbian debates on the topic predominantly explored within the U.S. context, this text not only contributes to broader feminist scholarship on pornography as hate speech by placing the information on "one more country" into a set feminist framework but explores how the feminist critique of pornography changes and is informed by its specific geopolitical positioning in the Serbian context which is at the same time both "Western" and "non-Western."

Hate Speech, Discrimination, and Violence against Women

Debates about pornography and hate speech in general have, to a great extent, revolved around the issue of hate speech pragmatics, theorizing the injurious force of offensive words and images, and arguing often that, instead of speech, we should see them as violent, discriminatory conduct. Anti-pornography feminists and critical race scholars have argued that racist speech or pornography not only communicates racial or sexual hatred but also enacts discrimination on the grounds of race and/or sex and, therefore, demands legal regulation.[19] Here, I will address the issue of hate speech as violent conduct with respect to the offensive representations of women in the Serbian media and examine how *words about* women come to be used as *words against* women.[20] Drawing on the scholarship on hate speech, feminist literature on pornography and Nancy Fraser's[21] understanding of politics of recognition, I demonstrate a link between hate speech against women in the media and hate speech used to discredit, humiliate, and hurt actual women in actual (public) situations. Pornographic hate speech in the media draws on, sustains, and legitimates cultural values that communicate sexual inequality. However, what are only words or images in the media become violent conduct when the same hate speech is used against actual women, as in the case when female MPs are addressed in sexual terms in the course of their work in Parliament by their male colleagues.

There are two arguments developed by anti-pornography feminists and critical race scholars that are relevant for my analysis. The first points out that hate speech is conduct that can seriously undermine the performance of the addressee at work, school, etc., and can significantly prevent certain social groups from exercising their civil rights and liberties. A representative example of such practices has been the use of pornography at traditionally male-dominated jobs, where it has often been directed against the minority of women as a means of enacting gender inequality at a workplace "where they do not belong."[22] Arguments that see pornography as a common means of pressure on women to remain marginal in traditionally male professions, and the public sphere in general, are of particular importance for my analysis, which in part focuses on the ways in which sexualization of women is used to discredit them in public professions.

The second argument covers the concept of silencing and is developed within a new scholarship on censorship.[23] In this new understanding, censorship came to be characterized as either explicit—external, usually state-exercised—censorship, or implicit censorship, which has been identified by feminist and hate speech scholars as silencing, and came to be a new argument in support of the legal regulation of hate speech. In implicit censorship, silencing is largely privatized: citizens do it to each other. Silencing is mainly understood as an effect of hate speech and pornography in that derogatory words or representations perform a de-authorization of the speech of the addressee, undermining his or her capacity to respond on equal terms. Catharine MacKinnon invokes the cases of testimonies of sexual harassment as paradigmatic examples of such de-authorization. According to her, women's speech that should be evidence of harm is sexualized by a pornographic logic that discredits them as accomplices to the violence they have endured. Pornographic assumptions of women's consent to sexual abuse continuously subvert evidence of violence and turn it into another pornographic encounter, once again taking "no" for "yes."[24]

In the case of the media response to Natasa Micic becoming president of Serbia, the sexualization operates in both of these ways: silencing women's speech and thus preventing her, as a woman, from exercising her civil rights and liberties. In this respect, one of Micic's comments about the effects of the paparazzi photographs is significant:

> I have participated in a donors' conference for supplying equipment for a surgery block of a hospital in Uzice, for which the Government of Serbia has assigned fifteen million dinars. The event was of great importance for the region of Uzice, but everything has been reduced to the photo, and not to the speech that I gave on this occasion.[25]

In this case, pornographic logic was deployed in making politics incommensurable with women's sexuality, discrediting Micic's credibility as a professional and literally silencing her speech. Micic's physical appearance, her good looks, and femininity, were made the number one topic whenever she was mentioned by the media, other politicians, and public figures. Such use of sexualization to discredit a female politician is a standard example of the way pornographic logic operates, which dissociates women's sexuality from the human potentials of speech and agency is embedded in institutionalized patterns of discrimination.

There are two levels at which this sexualization of female politicians operates. The first is that of pragmatics, an almost banal case of the handiness of female sexualization in political struggles where the opponent happens to be a woman.[26] The second level is the repositories of cultural cognitions on which this pragmatics draws. If pornographic logic that dissociates female sexuality from speech and agency was not to a large extent part of the cultural values of a society, then its pragmatic uses would not be so effective. The evidence lies in the fact that a great part of the Serbian public did not appear to have major difficulties in recognizing the "awkwardnesses" of having a female president. A comment by Vladan Radosavljevic, director of Media Centre, exemplifies the commonsense sexist attitude toward women in politics:

> I was not thinking at all if Mrs. Micic is a woman or not, I have said that I cannot imagine her as a serious President and that it will be certainly comic when TV shows us her and generals, sitting on the meeting of the Supreme Defense Council.[27]

It is important to note here that the discrediting of Micic as a professional through sexualization is in no way exceptional. As a Member of Parliament (MP), Teodora Vlahovic pointed out in one interview,[28] offensive comments against women in Parliament are common and are calculated to discredit them and make them feel uncomfortable in situations when they give a speech. Micic, referred to such comments too, saying that apart from continuous discussion of her looks, she has often been told what she should do instead of "sitting there in the office."[29] According to Vlahovic, such offensive comments in the course of Parliamentary sessions are often made because of the general manner in which MPs do not address other MPs, but rather the TV audience. Because Parliament sessions are broadcast, the offensive manner of communication has become common as a means of free political advertising.

In addition to offensive comments against women politicians, women

journalists have been discredited in similar ways. Only a couple of months before the photos of Micic, a journalist, Natasa Odalovic, was offended by another journalist (and advisor to then President Kostunica), Aleksandar Tijanic, who called her "a call-girl of Serbian journalism" in the course of their taped conversation.[30] This case resulted in a "Petition against hate speech" by the Women's Political Network, consisting of women MPs, which protested against the "language of hatred, violence and discrimination [...] that cannot be tolerated from anyone and especially not from senior state officials."[31] Months later, provoked by the public discourse on Micic, Odalovic wrote an article about verbal violence against women and has given perhaps the most articulate public critique of it:[32]

> ... the way it is spoken and written in Serbia, what can publicly be done to any woman politician, journalist, or activist of different organizations, and how that is observed with a dose of perverse maliciousness, who keeps silent about it and how, to what extent and to whom this problem is completely marginal, this is that scandalous visa that Serbian society has given to violators to turn the verbal terror, the violence of cynicism and depreciation of women who work in public professions to physical abuse.[33]

She relates this argument to actual examples[34] of the discrediting of women in public professions through their sexualization and derogatory stereotypes and points out how such public speech on Micic was accompanied by statements on her incapacity to perform assigned duties. Further, she concludes that there has been an ongoing trend in Serbia of "pornoization and discriminatory sexualization of every woman who dares to engage in a public profession without renouncing the specificity of her sex."[35]

That her argument is viable is evident also from the way in which various parts of the media have treated and labeled the women who sued TV Pink for promoting discrimination. These women have at times been called the same derogatory names used in the TV show that they sued for hate speech,[36] and have been faced with the commonplace assertion that they are protesting because they have recognized themselves in the descriptions, such as "hanging-tits," "rotten-ass," etc.[37] They were also labelled by epithets and stereotypes usually reserved for feminists, expressions that in most cases are concerned with women's sexuality. Thus, in the comments of public figures that some of the media eagerly reported, they were often referred to as "some desperate women," "with complexes,"[38] "with some strong dissatisfaction,"[39] "incapable of normal life," "non-women," "sexually frustrated," "members of escort services," "transsexual creeps," "piggy-ass models," "worn-out writers of literature from gynecological departments," "societies for screaming and faked orgasms," "hopelessly more open down below than up in their heads,"

"cohorts of vaginas in a destructive attack on anything that acknowledges logic and reason," etc.[40] Similar to the case of women in public professions, the sexualization of women's protest has been used to discredit and dismiss it. The same hate speech that was first "only art" has been used as a means of discrediting their speech by a pornographic reversal of their protest on the assumption that it is their lack of such speech—that is, their unfulfilled sexual wish—that makes them pursue this public action.

Accordingly, there is a relation between pornographic hate speech in the media and discriminatory sexualization as violent conduct against women in public professions and debates because, in both cases, derogatory sexualization has the effects of silencing and distorting women's speech. I propose to see the relation between hate speech in the media and its enactment against actual women within Fraser's model of misrecognition as status subordination. Arguing this point, Fraser observes that what is at stake here is not a free-floating cultural harm (e.g., hate speech), but institutionalized patterns of cultural values that prevent members of certain social groups from taking part as equals in social life. According to her:

> To be misrecognized, accordingly, is not simply to be thought ill of, looked down upon or devalued in others' attitudes, beliefs or representations. It is rather to be denied the status of a full partner in social interaction, as a consequence of institutionalized patterns of cultural value that constitute one as comparatively unworthy of respect or esteem.[41]

Consequently, misrecognition as status subordination is not exercised solely through culture as a site of injustice and derogatory representations of certain social groups, but through institutionalized relations grounded in such cultural values. "On the status model, then, misrecognition constitutes a form of institutionalized subordination, and thus a serious violation of justice."[42] Pornographic hate speech is thus a form of violence through which institutionalized discrimination against women is enacted.

Drawing on Fraser's understanding of misrecognition, I see the practices of hate speech against women in Serbia in accordance with this model and argue that derogatory speech about women in the field of culture is embedded in institutionalized patterns, which, subsequently, further subordinate women as a social group. Moreover, this model adequately defines the relation between different sites of hate speech that women's NGOs have protested against—TV shows on the one hand, and hate speech against women in public professions or debates on the other. In both sites, the derogatory words and representations are the same. Only, in the first case, they are derogatory *words about* women in the field of culture, and in the second one, they are the same derogatory *words directed at* actual women[43] when attempting to participate

equally in social life, and can be seen as violent conduct. Starting from the argument that these *words* are violence against women and a means of institutionalized discrimination, in the next section I look into the specifics of the discourses on the relations between culture and politics in the Serbian context as endorsed by women's NGOs and their opponents in these debates.

Attributing Hate Speech to "Our People"

Contestations over speech on the grounds of charges of inciting hatred always open up the question of attribution. Who is the author of the speech? Who is to blame? To whom should responsibility be attributed? Interestingly enough, commonsense arguments that have been used in debates over hate speech against women in Serbia could be interpreted as different paraphrases of Judith Butler's main argument in relation to this question.[44] According to her, a hate speech act has the force to injure because it refers to conventions that are related to a certain history of subordination and an authoritarian set of practices. Therefore, there is no author of hate speech and an individual can be responsible only for its repetition and distribution.

In Butler's theoretical framework, hate speech is part of an on-going process of subjectivation through which individuals are interpellated as subjects and given a social and discursive existence. In order to theorize the force of hate speech to interpellate subjects—performing rituals of social subordination (of women, gays, racial minorities, etc.)—Butler points to Austin's concept of a "total speech situation." She argues that a hate speech act is "not a momentary happening but a certain nexus of temporal horizons,"[45] an act that has its historicity, that echoes prior and future invocations of a certain convention and creates a relation to a certain linguistic community (of racists, for example). She says, "···that action echoes prior actions and accumulates the force of authority through the repetition or citation of a prior and authoritative set of practices."[46] In interpellation by hate speech, the power of discourse to enact what it names "is secured through convention."[47]

Starting from Butler's analysis of the force of hate speech to injure, I would like to pose the following questions regarding the debates about hate speech against women in Serbia: What is the "total speech situation" in question? Of what is this speech a repetition? Which subjects are hailed in the course of these debates? These questions are highly apt because the displacement of authorship and responsibility for hate speech has been one of the major issues in the Serbian debates about hate speech against women. In this section I mainly focus on the 2003 lawsuit against TV Pink, as it has raised the most polemic of this kind. Milan Gutovic, the author of TV Pink's

short *It Cannot Hurt*, and Zeljko Mitrovic, TV Pink's editor-in-chief, were sued by fifty-five women's NGOs for promoting discrimination against women in that program. In their explanations for the lawsuit, women's NGOs highlighted those excerpts from the program in which Gutovic classified women according to their sexualized body parts and their "sexual appeal" to men. For instance, Gutovic divided women into those that "put out" and those that "don't put out," offered advice to men on how to choose between young and old women, and concluded that "a slit is a slit: always up for it." [48] In the public responses to the lawsuit, the offensive speech in question was attributed either to "our people" and "our tradition" or related to the recent past of the repressive and nationalist politics of the Serbian regime in the 1990s.

My analysis of this case has two objectives. First, I point out the ways in which TV Pink's hate speech against women was recognized by part of the critical public as a re-enactment of the criminal power of Milosevic's regime. Because of this, the lawsuit gained special importance as a potential landmark case that would symbolize discontinuity with the hate speech practices of the previous decade. Second, I show the ways in which the argument made by TV Pink and the women's NGOs are immersed in antagonisms drawing on either nationalist populism, as did TV Pink, or, in the case of women's NGOs, on discourses that often assume the forms of reverse cultural essentialism similar to what Maria Todorova identifies as Balkanism. [49] Taking religion and race as crucial categories of difference in the opposition between European and non-European, Todorova considers that Balkanist discourse does not construct the Balkans as incomplete "other," but as incomplete "self" (of Europe). Situated within this antagonism, debates about hate speech against women once again end up in such oppositions between "us" and "them," "Serbs" and "the Balkans," and "Europe" and "the West."

The most elaborate example of attributing hate speech to "our tradition" is the argumentation produced by TV Pink and the actor Gutovic, as "the author" of the show *It Cannot Hurt*. According to him and the public relations service of TV Pink, the text of this show, that is, his previously quoted sexist remarks, is grounded in "erotic folk literature," "old, people's language," "well-known ethnologic literature," etc. The following extract from an interview with Gutovic is a representative sample of this argumentation:

So, you yourself are creating the text you are reading out in the show *It Cannot Hurt?*

Gutovic: That is already well-known ethnological material, I am repeating this for the fifteenth time ... Hundreds of people, who have worked in ethnology, [50] have been collecting [material about] the nature of our regions ... They have studied how people

> have been joking, swearing ... It is the whole study, it exists in the Academy of Science ... I haven't written that. Significant persons from the field of ethnology have written it. They have been explaining the nature of our man.[51]

By referring to "tradition" and "our people" as origins of contested (hate) speech, TV Pink's argumentation constructs and appropriates the meanings of "tradition" and "our people," as well as the possible subject positions as members of, or outcasts from, such a community. Because the speech in question is elsewhere referred to by Gutovic as the way most men comment on women, and references to tradition implicitly exclude any other tradition but "Serbian," the authorization is more or less obvious. This authorization in the first place constructs "masculinity" as a legitimate practice of slurs against women and, second, reinforces this patriarchal power position by its implicit articulation within populist discourses of Serbian nationalism as a legitimate practice of slurs against other ethnicities, which, considering the recent past of ethnic wars, still strongly resonates.

To explain how this dispute about reading tradition came to be relevant within the debate over hate speech against women, I refer to a number of analysts who have argued that the 1990s in Serbia were characterized by the processes of re-traditionalization and re-patriarchalization, which were grounded in a chauvinist way of recycling tradition. Folklore and tradition thus came to be used as legitimizing grounds for both nationalism and the revival of patriarchy, insofar as chauvinist propaganda was very often put in folkloric forms and presented as *vox populi*.[52] Bringing this argument to bear on the debate triggered by the lawsuit against TV Pink, Marina Blagojevic points out that such recycling of tradition occurred in accordance with the new antagonistic pattern of relations to the "other," inaugurated in the nineties in Serbia, which was grounded in relations to ethnic others but has been transposed to gender relations too.[53] It is in this way, then, that exploitation of the references to tradition has become associated with the authorization to make slurs against other ethnicities or women.[54]

Blagojevic's claim of a connection between ethnic and gender antagonisms is relevant in the context of these debates, considering the fact that reference to the relation between hate speech against other ethnicities and women has been a common point between many participants. The following extract from an interview with Mira Kovacevic, an IPMM member, is a representative comment:

> The aim is to stop hate speech in the media, against any group, including women. Before, it was hate speech against other people in our country, so we could listen to diverse expressions about Croats, Bosnians and other national groups. Now, since that is not anymore 'in' vocabulary, many observers from aside are watching,

following, somehow women have been the most harmless terrain to hit.[55]

What is important to note here is that the speech Gutovic and TV Pink are defending clearly invokes fresh memories for part of the critical public of their predecessors' hate speech, which incited ethnic hatred and significantly contributed to the wars in ex-Yugoslavia. It also appears as a symbol of the violence and crimes of the previous regime, and a reminder of the fact that responsibility has not been taken for most of these crimes. This lawsuit was therefore seen as potentially historic because, for the first time, responsibility for hate speech would be assumed[56] and because it was meant to raise standards of communication in the direction of excluding hate speech against any social group.[57]

The reference to part of the media and their contribution to the war is a second important attribution of hate speech against women in this debate. This reference is complex in that it comprises not only civil rights discourses on hate speech but also involvement with a kind of identity politics. This is so because the question of media responsibility, as an accomplice in the repression and war politics of Milosevic's regime, highlights not only the use of hate speech in so-called informative programs, the paradigm of which was the state TV news, but also what has often been defined as the popular culture of the regime and its main promoter, TV Pink. The most concise example of the dual character of the question of media responsibility is a phrase from a women's NGOs press conference about the lawsuit, saying that it is time to stop "cultural genocide" in TV Pink.[58]

The debate about TV Pink's popular culture and its connection to Milosevic's regime is an important one in the Serbian cultural and political context, and it underlies to a great extent this particular debate about the lawsuit. I would even argue that TV Pink's popular culture, and the critical discourses about it, constitute an Austinian "total speech situation" in terms of the debate about the NGOs' lawsuit. Therefore, I find it important to outline some of its main features in order to explain how the critique of sexist hate speech by women's NGOs engages not only in a struggle for civil rights, but also in a kind of cultural essentialism that is the exact reverse of TV Pink's, that is, by attributing hate speech against women to the backwardness of "our people."

The main product of TV Pink's "culture of power in Serbia"[59] was turbofolk, a highly eclectic music genre, and its stars. With its references to populist folk traditions and the visual aesthetics of MTV clips, turbofolk was a glamorous and romanticized representation of a new criminal elite and, in terms of its gender politics, it combined commercialization of women's bodies and repatriarchalization of women as "Serbian mothers".[60] Therefore, when

the phrase "cultural genocide of TV Pink" was used at IPMM's press conference about the lawsuit against TV Pink, the underlying statement was that the current hate speech against women in TV Pink is a re-enactment of the patriarchal and war culture of *turbofolk*. Although in principle I agree with this underlying statement, I would argue that the critique of TV Pink and *turbofolk* that informs this statement has certain very problematic aspects, which to some extent also shape the general articulation of protests against hate speech in Serbia. The problems in assessing TV Pink and popular culture's contributions to the chauvinism of Milosevic's regime start with their interpretations in terms of culturally-essentialist dichotomies, such as rural/urban, local/global, national/international, European/non-European, high/low culture, etc., which was precisely the case with a diverse array of its critics: anti-nationalist, so-called urban and feminist critics.[61]

Such discourses on *turbofolk* are to a great extent an underlying paradigm for an understanding by women's NGOs of the relations between "culture" (e.g., hate speech) and chauvinist violence and discrimination against women. Although they do not repeat all of the dichotomies established by different discourses on *turbofolk*, they do perpetuate some of them (e.g., urban/rural, European/Balkan, national/international). Therefore, women's protests against hate speech can be seen also as an exercise of identity politics that is based on essentialist notions of "us" and "them," only the ascribed values are the opposite of those mobilized in TV Pink's defense of hate speech. This practice can also be traced in the attribution of hate speech against women to the "primitive mentality" of the "average Balkan man" as opposed to (Western) "civilization," when explaining the problem of sexism in the Serbian media.

Thus, a title from the public discussion on sexism in advertising reads: *Mister, that is no way to go to Europe*.[62] Such culturally essentialist presuppositions are, to a great extent, grounded in a Balkanist discourse that, as Maria Todorova[63] has shown, for most of the people living in the Balkans consists of ambivalent feelings about Balkan identities. These feelings and attitudes are related in both negative and affirmative ways to the Balkans, but always in comparison to (Western) Europe. Therefore, the other side of this antagonistic discourse involves the positive and negative references to examples of European countries with respect to the vexed issue of sexism in the media. Affirmative references focus on the actions taken by the public toward withdrawing a certain offensive billboard, implicitly showing the model of a respectable public. The negative ones are exemplified by the following interpretation of the protest by the women's NGOs against offensive billboards by Lazar Boskovic, the art director of one of the criticized

campaigns: "And if they are doing this today only to attract the attention of their donors and fill in the budgets of their organizations, we understand them completely."[64] Here, the issue of hate speech against women is positioned as the part of the imperialist politics that the international community adopts toward Serbia, and women's NGOs are seen as collaborators.

In light of the critique of such culturally essentialist antagonisms, I would argue that attributions by women's NGOs of hate speech against women to "local primitives" undermines their struggles for women's rights because it partly positions them in the field of nationalist "identity politics," which feeds on such antagonisms between Serbia or the Balkans and Europe or the "New World Order" to legitimize its chauvinist authorization for slurs and violence. Such identity politics invokes commonplace assumptions about the intertwining of discourses on gender and nation, both in nationalist and feminist projects: patriarchal tradition is often seen as central to the national identity in nationalist projects, but at the same time women's emancipation is frequently tied to the progress of the nation in feminist projects. In TV Pink's case, sexism is associated with tradition as a symbolic core of national identity, while for the women's NGOs, women's status is used as a litmus test for the "backwardness" or "progress" of a nation. Therefore, while I would strongly agree with the critical interpretation of TV Pink's hate speech as an invocation of a *culture of power* in Serbia and its *turbofolk* mix of sexism and promotion of (war) criminals, I would also call for a greater critical awareness on the part of women's NGOs of the ways in which their culturally-essentialist assumptions are entangled in nationalist identity politics, or are even its mirror image. What is needed is to create a space where anti-nationalist feminism would be possible without reproducing power relations embedded in stereotypes about civilized Western, European, urban, high culture as opposed to the uncivilized culture of the East, the Balkans, the rural and the "local primitives."

Conclusion and an Update

I have chosen as the initial point of my chapter an umbrella term, "mediated violence against women," in order to negotiate, and respect, the overwording involved in the protests by women's NGOs that triggered debate about the definition of offensive speech. However, following my analysis, I would argue that it is legitimate to replace this elusive term with a more identifiable and appropriate term such as hate speech against women. The legitimacy of this replacement is grounded in my arguments about the ways in which hate speech, in the cases that I have discussed, performs a silencing of women's speech through derogatory sexualization. The discussed cases have in common

a pornographic logic of sexual degradation or hatred of women that is either underlined by rape myths according to which women's "no" actually means "yes," or a dehumanization that dissociates women's sexuality from human potentials of speech and agency. I have argued that hate speech against women in the media not only communicates sexual hatred but draws on, sustains, and legitimates cultural values underpinning violence and institutionalized patterns of discrimination against women that prevent them from participating in social life on equal terms.

In addition to showing the ways in which derogatory sexualization of women is used as a cultural value to undermine and prevent participation of women in public life, I have also analyzed the ideological investments in the issue of hate speech against women within the Serbian political context. On the one hand, these particular debates are framed by the broader ideological and political struggle over the question of the Serbian media's responsibility for hate speech and its role in the nationalist and war politics of Milosevic's regime. In this context, a part of the public that supported the lawsuit by IPMM against TV Pink has insisted on the historic significance of this lawsuit exactly because the question of media responsibility, in legal terms, has been put aside since the political change. On the other hand, both sides in these debates have supported their stances with ideological claims that have, in different ways, related the problematic speech to essentialist notions of "our people."

While TV Pink's strategy has sought to legitimize hate speech against women by populist and chauvinist appropriation of Serbian tradition, reading it as slurs and attempting to ground a linguistic community of "our people" on this basis, women's NGOs have engendered inadvertently a different kind of cultural essentialism. Grounded either in Balkanist discourse or other kinds of discourses that are governed by dichotomies between European/non-European, local/global, urban/rural, high culture/low culture, they have perpetuated the antagonisms intrinsic to the discourse of nationalism that brings to the foreground an opposition to the "West" and so-called New World Order. By addressing the problem of hate speech against women as characteristic of "local (rural, ill educated, Balkan, etc.) primitives," in contrast to European civilization, they have undermined their struggle against hate speech by making it partly a reverse form of a nationalist discourse.

Finally, given that hate speech is obviously a legitimate practice for part of the public that, in some of cases, has substantial political and media power, it is plausible to say that legal regulation of hate speech could be the only powerful means that women's NGOs can refer to in order to delegitimize it. It can even be claimed that the new law allowing for lawsuits against hate speech

has created an institutionally legitimate basis for women's NGOs to pursue women's rights, perhaps more efficiently than in their occasional cultural activism. The campaigns against hate speech have proved to be a good strategic site for addressing different forms of gender inequality, precisely because of their visibility and publicity. Considering the extent to which women's NGOs in Serbia are ghettoized despite their great numbers, I would argue that this kind of activism has been one of the rare examples of their coming *on scene*. These cases have shown how the debates on sexist hate speech can be a powerful discursive site for pursuing a politics of recognition in terms of women's equal participation in social life.

A certain positive change is noticeable in some of the recent general criticisms[65] of hate speech, and this is partly due to women's protests against sexism in the media. Whereas hate speech used to be discussed almost exclusively in terms of ethnic hate speech, in recent general critical assessments of the media, sexism is now more often incorporated as a related issue. Also, there seems to be more cooperation between women's, and other NGOs, and journalists. As some recent projects suggest, women's and other NGOs seem to engage more and more in organizing educational programs for journalists oriented toward a more gender-sensitive and responsible journalism.[66] The two trends that have followed the protests I have discussed—NGOs organizing training for journalists, and independent journalistic associations acknowledging sexism in the media as a problem—seem to be the two bottom-up strategies for improving representations of women in the media.

Although the strategies and effects of these new projects are yet to be researched, the journalism that should result from training and ethical codes must be supported by a certain amount of top-down commitment to gender-sensitive media in order for it to be recognized, and enacted, as a plausible value. The crucial issue in this respect is institutional and political restoration of accountability, in terms of both a functioning legal system and mechanisms of media self-regulation. The epilogue of the lawsuit against TV Pink is illustrative of the problems faced in terms of the legal system: only two initial court hearings have taken place and others have been cancelled, owing either to TV Pink's representatives not appearing or to cancellations by the court itself.[67] With respect to the media, a part of the process of reconstruction should have been the lustration of journalists responsible for inciting hatred that led to the wars, something that has never taken place.[68] Instead, some of those who have been recognized by women's or other NGOs as the primary hate speakers have recently been appointed to powerful positions in the media.[69] Accordingly, I would emphasize that in an environment of social and

institutional collapse, media representations of women can be a meaningful project only as a part of an overall attempt to reconstruct society and its institutions. Otherwise, any attempt at change becomes absurd, like those hopeful appeals made to specific laws in a situation of complete juridical dysfunction.

Notes

This text is a shorter and revised version of my MA thesis, *Mediated Violence and Women's Activism in Serbia: A Site of Discursive Violence*, Department of Gender Studies, Central European University, Budapest, 2004. I wish to thank the following people for their help, insights and suggestions: Erzsebet Barat, Hallet Brazelton, James Brydon, Jasmina Lukic, and Snjezana Milivojevic. Also, my thanks go to Bojana Veselinovic and Dragica Vukadinovic at AWIN, who helped my work at their media archive.

1 This is the period between the October 2000 overthrow of the Milosevic regime and the establishment of the second post-Milosevic government in March 2004. The prime minister of this first government was Zoran Djindjic, a politician at the forefront of the reform process, during whose government Milosevic was extradited to the Hague Tribunal.

2 After the parliamentary elections in December 2004 and the subsequent prolonged coalition talks between parties, the second post-Milosevic government was formed in March 2004, with Vojislav Kostunica as Prime Minister and with the support of Milosevic's Socialist Party. Analysis of the differences between the governments of Zoran Djindjic and Vojislav Kostunica lies beyond the scope of this chapter. However, because I define the period of the first government through its attempts at discontinuity with Milosevic's regime, it should be observed that the second government (with a few exceptions) was deeply reluctant to engage with the issues of responsibility for the criminal legacy of the Serbian regime in the 1990s.

3 See Ivan Colovic, *Politika Simbola* (Beograd: Biblioteka XX vek, 2000); Ivan Colovic, *Bordel ratnika* (Beograd: Biblioteka XX vek, 1994); Nebojsa Popov, ed., *The Road to War in Serbia: Trauma and Catharsis* (Budapest: CEU Press, 2000); Svetlana Slapsak et al., eds., *The War Started on Maksimir* (Belgrade: Media Center, 1997).

4 Marina Blagojevic, "Ubica za potencijalne konzumente," *Danas* (December 1, 2003), 6.

5 Ljubisa Rajic, quoted in Gordana Jocic, "Umetnost ili vulgarnost—mizoginija na TV Pink," *Nezavisna svetlost*, Internet Weekly No. 427 (November 28–December 6, 2003): http://www.svetlost.co.yu/arhiva/2003/427/427-3.htm

6 See Beverly Allen, *Rape Warfare: The Hidden Genocide in Bosnia-Herzegovina and Croatia* (Minneapolis: University of Minnesota Press, 1996).

7 The 2003 Law on Public Communication addresses the issue of hate speech in Articles 38–40. According to Article 38, "It is forbidden to publish ideas, information or opinions that incite discrimination, hatred or violence against persons or groups of persons because of their belonging or non-belonging to a race, religion, nation, ethnicity, gender or because of their sexual orientation, irrespective of whether their publication constitutes a criminal offence." The next article stipulates that a person who is a target of such speech can sue an author or editor responsible for such publication and demand that this content be removed and that the accused parties publish the verdict at their expense. Furthermore, such a lawsuit can also be filed by registered organizations protecting "freedoms and rights of people and citizens," as well as by organizations defending rights of groups mentioned in the previous article. Lastly, Article 40 defines exemptions from this law. Publication of hate speech will not be seen as an offence to this law if it is part of a scientific or journalistic text which is published without an intention to incite discrimination, hatred or violence, and with an intention to draw attention critically to phenomena that can incite such behavior. See "Zakon o javnom informisanju," *Sluzbeni Glasnik* 43, No. 3 (2003): http://www.parlament.sr.gov.yu/content/lat/akta/akta_detalji.asp?Id=84&t=Z#.

8 This gender-related politics ranged from the case of one minister's resignation because he had been accused of sexual harassment by female colleagues to having women occupy the positions of chair and vice chair in the Parliament.

9 For example, the most recent case (2006) that provoked much uproar on the part of the public concerned an occurrence in Parliament when Ivana Dulic Markovic, the Minister of Agriculture, was verbally attacked by a parliamentary colleague who uttered slurs about her Croatian origins.

10 The case that preceded these two concerned a regional billboard campaign for automobile tires in November 2001 displaying a naked woman, a ballet dancer, her legs spread, doing the splits, accompanied by the slogan: "Adjustable to every surface." The members of thirty-one women's groups issued a joint protest against the sexism in this campaign and there were similar protests from women in Croatia and Bosnia and Herzegovina. This case spurred women's NGOs' activism against sexism in the media and raised public interest in this issue. I have analyzed this case at greater length in my thesis.

11 *Politika* (December, 10, 2002): 1.

12 *NIN* (December 12, 2002): front cover.

13 These statements, and the specific words that women's NGOs have singled out from this program when explaining the reasons for their lawsuit in public, were the following: Women can be divided into young and "oldies." Both are "fuckies" and "screwies," but these old ones are "hanging-tits" and "rotten-ass" and these young ones are "piggy-ass" and "shaky-tits." But in "oldies" "the machine" always stays young, "operates," "works." Some look like "new," and are "in good condition" and "great for soldiers who do not have other women around to copulate with them."

 Also, women can be divided according to weight and capacity. Weight relates to "tits" and capacity to the general structure. Although bigger "tits" are better, smaller ones are also acceptable, because "tits are not so important, they are like appetizers." There is another classification of women—into "wanties" and "cling-legs," although those that cling in principle want. "Oldies" have a "natural wanthood," especially "second-hand" ones. One should only be careful of *bataljuge*; when "they catch you, they turn you into nothing," because "wanthood" in women can sometimes be too much. Cited in: Jocic, "Umetnost ili vulgarnost—mizoginija na TV Pink"

14 See "Inicijativa protiv mizoginije u medijima": http://www.awin.org.yu/linkovi2.htm.

15 In these debates, sexism has been, perhaps, the most easily used term, but the least defined. It has been used mainly in relation to pornographic representations that are derogatory of women, with respect to sex/gender stereotypes and, sometimes, as a parallel to racism.

16 Misogyny has been introduced in these debates by Marina Blagojevic, whose theoretical work on the concept has informed these women's NGOs' protests. According to her, the induction of ethnic antagonisms that led to the ex-Yugoslavia wars in the 1990s set out the pattern for relations to the Other, and it is this pattern of antagonistic relations to the Other that generates new and more violent forms of misogyny. See: Marina Blagojevic, ed., *Mapiranje mizoginije: diskursi i prakse* (Beograd: AZIN, 2000).

17 Norman Fairclough, *Language and Power* (New York: Longman, 1989).

18 Patricia Holland makes a similar point in her discussion of the relation between the British tabloid press and the democratic participation of women. She argues that the politics of sexual fantasy communicated by the page-three girls presents sexual difference in a way that reinforces sexual inequality and therefore poses limits to the democratic discursive space by continuing to link women with the trivial and subverting women's democratic participation. See "The Politics of the Smile: 'Soft News' and the Sexualization of the Popular Press," in *News, Gender and Power*, edited by Cynthia Carter, Gill Branston and Stuart Allan (New York: Routledge, 1998), 17–33.

19 See Catherine Itzin, ed., *Pornography* (Oxford: Oxford University Press, 1992); Catharine MacKinnon, *Only Words* (Cambridge: Harvard University Press, 1993); Mari Matsuda et al., eds., *Words That Wound* (Boulder, CO: Westview Press, 1993); Laura J. Lederer and Richard Delgado, eds., *The Price We Pay: The Case Against Racist Speech, Hate Propaganda and Pornography* (New York: Hill and Wang, 1995); Lynne Segal and Mary MacIntosh, eds., *Sex Exposed—Sexuality and Pornography Debate* (London: Virago Press, 1992); Drucilla Cornell, ed., *Feminism & Pornography* (Oxford: Oxford University Press, 2000).

20 See Teun van Dijk, "Racism and Argumentation: 'Race Riot' Rhetoric in Tabloid Editorials": http://www.discourse-in-society.org/teun.html

21 Nancy Fraser, "Politics of Recognition," *New Left Review*, (May–June 2000): http://www.newleftreview.net/PDFarticles/NLR23707.pdf; and her *Justice Interruptus: Critical Reflections of the "Postsocialist" Condition* (New York: Routledge, 1997).

22 Barbara Trees, "Like a Smack in the Face: Pornography in Trades," in *Reconstructing Gender: A Multicultural Anthology*, edited by Estelle Disch (Mountain View: Mayfield), 379–381.

23 See Robert C. Post, ed., *Censorship and Silencing: Practices of Cultural Regulation* (Los Angeles: The Getty Research Institute, 1998).

24 Catharine MacKinnon, *Only Words*; Rae Langton, "Subordination, Silence, and Pornography's Authority," in *Censorship and Silencing*, 261–284.

25 Natasa Micic, "Zenski danak," interview by Marijana Milosavljevic, *NIN* (December 19, 2002): 22.

26 Micic is a member of Civil Alliance of Serbia, the party that was consistently anti-nationalist and opposed to war. Discrediting her is, therefore, in some of these cases, not only a display of sexism but also characteristic of political positions opposed to discontinuity with the legacy of the Milosevic regime.

27 "Reformisti protiv seksista," *NIN* (December 19, 2002): 23.

28 Teodora Vlahovic, "U skupstini ima mizoginije," Interview by Nadezda Radovic, *Danas*, *Weekend Supplement* (November 9–10, 2002): 6.

29 "Pobedila macizam," *Blic* (January 19, 2003): 3

30 B. Toncic, "Nekontrolisani sukobi i "bube" za medije," *Danas* (July 16, 2002): 5.

31 Ibid.

32 Natasa Odalovic, "Jajnici i muckovi," *Danas* (December 13, 2002): 7.

33 Ibid.

34 Apart from the Micic case, she mentions as another example the phrase addressed to the Minister of Energy Kori Udovicki, during a protest gathering: "Turn on the light, so I can see your pussy."

35 Ibid.

36 Sandra Dimitrijevic, "Zene protiv Laneta," *Politika* (November 22, 2003): 9.

37 Milan Gutovic, "Kad odem, ne vracam se na ovaj svet," interview by Silvana Stankovic, *Novosti* (November 23, 2003): 32.

38 "Duhovni genocid ne moze da skodi," *Internacional* (November 21, 2003): 7.

39 "Mizoginija u ruzicastom," *Ekspres* (November 21, 2003): 5.

40 Aleksandar Tijanic, "Ne krivite mi ga," *NIN* (January 8, 2004): 21; Bogdan Tirnanic, "Zena je zena," *NIN* (January 28, 2004).

41 Nancy Fraser, "Politics of Recognition."

42 Ibid.

43 See Teun van Dijk, "Racism and Argumentation."

44 Judith Butler, *Excitable Speech: A Politics of the Performative* (London: Routledge, 1997).

45 Ibid., 13.

46 Ibid., 51.

47 Ibid., 24.

48 "Kampanja protiv mizoginije," *OneWorld Southeast Europe* (November 20, 2003): http://ssla.oneworldsee.org/article/view/73277/1/3476

49 Maria Todorova draws a distinction between Orientalism, as Edward Said characterized it, and Balkanism. She defines Orientalism as a discourse based on opposition while Balkanism is based on ambiguity. She singles out the metaphors that were mostly used in relation to the Balkans: the bridge or crossroad between cultures, races, religions, often signifying hybridity. She argues that Orientalism deals with differences between types while Balkanism deals with the differences within one type. See *Imagining the Balkans* (New York: Oxford University Press, 1997).

50 Ethnologists from Belgrade University have protested such a definition and reading of tradition. For instance, Ildiko Erdelji points out that none of the words that Gutovic used in his show exist in the ethnologic literature. Instead, this case has provided new ethnographic data on the patterns of "people's" thought "in whose creation the members of the so called 'tabloid elite' have had the most prominent role." See her "Po obrascu tabloid elite," *Danas* (December 15, 2003).

51 Milan Gutovic, "Kad odem, ne vracam se na ovaj svet," interview by Silvana Stankovic, *Novosti* (November 23, 2003): 32.

52 See Ivan Colovic, *Politika Simbola*; Ivan Colovic, *Bordel ratnika*; Neboisa Popov, ed., *The Road to War in Serbia*; Svetlana Slapsak et al., eds., *The War Started on Maksimir*.

53 Marina Blagojevic, "Udica za potencijalne konzumente."

54 Such intertwining of nationalism and sexism begs the question of female subjects in relation to nationalism, given their dual position as both inside and outside of the nation proper, and the ways in which women relate to sexist speech as a part of nationalist political discourse. While the issue of the reception of nationalist and sexist hate speech is beyond the scope of this paper, I would however like to point out this issue as an important area for further research regarding sexist hate speech practices in Serbia. For the fabricated nature of tradition, see Eric Hobsbawm and Terrence Ranger, ed., *The Invention of Tradition* (Cambridge: Cambridge University Press, 1992) and for the intertwining of gender and nationalism see Nira Yuval Davis, *Gender and Nation* (London: Sage, 1997).

55 Mira Kovacevic, "Svima skodi jer vredjanjem pocinje nasilje," interview by Zoran B. Nikolic, *Blic News* (December 24, 2003): 36.

56 Milica Jovanovic, "Pustolov protiv zena," *Danas* (November 24, 2003): http://www.danas.co.yu/20031124/dijalog1.html

57 Marina Blagojevic, "Udica za potencijalne konzumente"; Mira Kovacevic, "Svima skodi, jer vredjanjem pocinje nasilje."

58 Sladjana Milosevic, a rock singer who has supported the lawsuit, said this at the press conference organized by IPMM.

59 See Eric Gordy, *The Culture of Power in Serbia: Nationalism and Destruction of Alternatives* (University Park: Pennsylvania State University Press, 1999).

60 TV Pink does not broadcast news, but it aired the ceremony of a marriage between the biggest *turbofolk* star, Ceca, and the Serbian war criminal Arkan as the "marriage of a decade," presenting them as the ideal Serbian couple.

61 See Branislav Dimitrijevic, "Globalni turbo-folk," *NIN* (July, 20, 2002), 38; Branislav Dimitrijevic, "Ove je savremena umetnost: turbo-folk kao radikalni performans," *Prelom* 2/3 (2002): 94–101.

62 "Gospodine, ne ide se tako u Evropu," *Politika* (May 15, 2002).

63 See Maria Todorova, *Imagining the Balkans*.

64 Aleksandar Apostolovski, "Manipulise se i muskim telom," *Politika* (November 9, 2001).

65 Media Watch Serbia, *A Return of Hate Speech, Anti-Semitism and Misogyny, Report on the Status of Ethics in Serbian Print Media*, March 2005: http://www.mediacenter.org.yu/code/navigate.asp?Id=669

66 See Projekti/Zene i Mediji, http://www.babe.hr/; *Publikacije/Prirucnik mediji: Ka Evropi: Marginalizovane grupe i odgovorno novinarstvo*, http://www.labris.org.yu/index.php?option=com_frontpage&Itemid=; *Seminar za novinare "Odgovornost medija i nasilje nad ženama,"* Beograd, 6_7. novembar 2004; http://www.awin.org.yu/srp/dataS/arhivavesti.htm; *Seminari: Obuka za lokalne nevladine organizacije i medijske kuće*, http://www.astra.org.yu/

67 Personal interview with Milica Minic, IPMM activist, December, 2005. A very common problem of court proceedings in Serbia is the sheer length of the trials, which in some cases leads to the expiration of lawsuits. Many trials are very long not only because of the slowness of the courts, but because the sued parties avoid appearing at the proceedings. This is possible because they abuse the law according to which a party who does not appear at the trial should be forced to be present only after the third time they were absent. Consequently, dragging trials is a common strategy of avoiding responsibility.

68 Lustration is a term that became widely used in the context of post-socialist transitional justice. It means the prevention of those with high-ranking positions in the totalitarian regimes from holding important posts in the new system. See Magarditsch Hatschikjan, Dusan Reljic and Nenad Sebek, eds., *Disclosing Hidden History: Lustration in the Western Balkans* (Thessaloniki and Belgrade: Center for Democracy and Reconciliation in Southeast Europe, Thessaloniki, and Center for Peace and Democracy Development, Belgrade, and CICERO, Belgrade, 2005).

69 Most telling is the fact that the new director of the Serbian state TV is Aleksandar Tijanic, the journalist who called his female colleague "the call-girl of Serbian journalism." Given that a list of his public misogynist attacks on women who happen to be his political opponents is a long one, and that his general journalistic oeuvre is perceived by a number of journalists, activists and public figures as a symbol of hate speech, his current position (at which he was placed by the second post-Milosevic government) is indicative of the general lack of interest of the authorities in dealing with the problem of hate speech.

Beneath the Layers of Violence

Representations of Rape and the Rwandan Genocide

Régine Michelle Jean-Charles

Francophone literary critic Françoise Lionnet has written an article on violence that notes, "... women writers are often especially aware of their task as producers of images that both participate in the dominant representations of their culture and simultaneously undermine and subvert those images by offering a re-vision of familiar scripts."[1] I use Lionnet's work as a point of departure because she charts a theory, as she calls it "a geography of pain," that locates subjectivity within the portrayal of violence, and often, through the use of violence—which is the case of the female characters she examines, each of whom commit acts of violence. By looking at projects that are written with "meticulous attention to realistic detail, and the paradoxical desire to communicate, *in the most honest way possible*, the radically subjective, and generally incommunicable, experience of pain," Lionnet explores tensions between the reality of violence and its representation.[2] While Lionnet is certainly not the first to identify the challenges that emerge when one represents violence, I begin with her work because she focuses on the question of subjectivity in relation to the portrayal of violence.[3]

Lionnet's endeavor is especially provocative when we consider what I will refer to here as layered instances of violence, that is, different manifestations of violence that occur simultaneously. Gendered violence is often layered in this way, as attested to in the frequent rapes of women in the context of war. This chapter focuses on the how artistic representation excavates the layers of violence within the 1994 Rwandan genocide, that is, the incommunicable pain that transpired over the course of one hundred days of carnage during which thousands of Tutsis and moderate Hutus and Twa were slaughtered.

Rwanda is also an important example of layered violence because of the multi-varied "locations" of Rwandese women, Third World African women, who suffer from several forms of oppression in terms of how they are cast in society.[4] For these women, the simultaneity of oppressions imbricates the experience of genocide.

Because of the deafening silence that eclipsed the original catastrophe of genocide in Rwanda, it seems peculiar to speak of a dominant image. We can however discern several familiar representations, which traverse the mind through sight and sound, and that have since surfaced in the media. These are the grating hack of the machete, the bleached desiccated skulls arranged in a multitude of perfect rows, the truculent mobs proclaiming Hutu Power, and the ubiquitous rape of women. It is this last figure, or representation—the raped woman—that I focus on to consider how those who depict the Rwandan genocide participate in and subvert a dominant representation from a culture that is not their own. I will examine the presence of rape narratives in Véronique Tadjo's *The Shadow of Imana: Travels in the Heart of Rwanda*,[5] and Raoul Peck's film *Sometimes in April*. I argue that their representations of sexual violence complicate and enhance female subjectivity, that is, within these texts raped bodies go from being a familiar image of genocide to possessing specific and unique functions in which lie a nascent subjectivity for the survivor/victim. For each of these scenes of rape I am not only interested in considering how the filmmaker and the writer render the excruciating image, but also in how these representations pay careful attention to the voices and to the experiences of gendered violence within the larger system of portraying genocide. I hope to show how non-Rwandese can participate in the effort to communicate images of genocide, in the same way that Lionnet describes as "the most honest way possible," by eschewing reductive images that re-victimize women. Finally, because I am especially interested in rape as a gendered form of violence whose ultimate goal is to deprive women of power, I suggest how the reconstruction of rape narratives and representations can contextualize the Rwandan genocide without relativizing or denying the particularities of gendered violence. The examples analyzed here account for the atrocity of rape alone as well as when it is used as a genocidal strategy.

Before situating my work in terms of the important scholarship on the representation of rape in literature and in film, I want to turn briefly to Elaine Scarry's *The Body in Pain* in which the incommunicability of pain was most famously dissected. *The Body in Pain* presents a genealogy of pain by considering a vast number of texts in a rigorously interdisciplinary fashion. Although Scarry does pay ample attention to the issues of war and torture, very rarely does she assess the role of gendered violence within these frameworks. Not-

withstanding the paucity of gendered analysis, her focus on the body has un-
deniable implications for gendered violence. In particular, when we accept
that rape was used as a form of torture, certain points in Scarry's work pertain
to this study of rape in the Rwandan genocide.[6] Scarry's articulation of pain as
"that which cannot be denied and that which cannot be confirmed" is crucial
to an understanding of rape because of the dilemma faced by rape survivors in
a society that pathologically disbelieves their experiences of pain.[7] Further-
more, when we consider, as Scarry points out, that "the person in pain is so
bereft of speech," we are reminded of the culture of silence that surrounds
sexual violence and represses survivors; this silence is given another dimension
when added to the silence in response to the Rwandan genocide.[8]

The rich scholarship on literary and cinematic representations of rape in-
forms this chapter.[9] Within this field, rape has been scrutinized for its cultural
construction: critics and theorists interrogate the description and function of
scenes of rape, extrapolating from them the implicit cultural significances and
developing insights about how sexual violence operates within various catego-
ries. U.S. writer and activist Susan Brownmiller ushered in the movement to
write rape into the area of criticism with the publication of *Against Our Will:
Men, Women, and Rape.*[10] This founding text of feminist criticism inspired criti-
cal dialogue about rape through a sustained and detailed examination of the
presence of sexual violence in U.S. culture by exploring it as a crime, as a men-
tality, and as a global phenomenon for the first time. Brownmiller cites exam-
ples from as early as sixteenth-century France to the Boston strangler in the
United States, opening the doors for an international history of rape.[11]
Brownmiller's text has been recognized as a pioneering and influential femi-
nist work on rape, although it has been criticized, in particular by African
American feminist activist Angela Davis, for her neglect of the interplay of
race and gender in addressing the issue of rape.[12] Nonetheless, it is important
to note *Against Our Will* as the starting point for literature looking at rape
from a critical angle.

Since the 1970s critical discourse on rape has taken the form of studies in
the realms of literature, popular culture, television, and cinema, each time
grounding the cultural with historical and sociological material, often through
the lens of feminist analysis. If Brownmiller was largely responsible for initiat-
ing discussions about rape in a cultural context, then Lynn Higgins and
Brenda Silver were the first to probe the relationship between rape and repre-
sentation. Their notable collection, *Rape and Representation*, assembles texts
that approach images of rape through different optics. They explain that,

... one crucial step taken by feminist literary critics ... has been to trace the ways in
which women (artists or characters) 'represent' themselves ... This entails discerning

where or how they break through discourses that have circumscribed their perceptions of the causes and the nature of sexual violation ... But the act of rereading rape involves more than listening to silences; it requires restoring rape to the literal, to the body: restoring, that is, the violence—the physical sexual violation.[13]

They not only call for a restoration of the material violence within the imaginary landscape in order to avoid eclipsing the violent experience of rape, but they also demand that we re-think and re-examine the project of representation. The literal portrait of violation is essential to such a framework, but it is not without its difficulties. When depicting rape, there are numerous points to consider—How is rape described in the text? Which rhetorical strategies are employed to tell the stories of survivors? How do they react to their violations and what are the long- and short-term effects of the assaults? Within each of these broad categories there are more specific questions to be asked—Does the author portray the rape in detail? Is it explicit or implicit? Is the survivor's story told in the first or third person? How is the memory of the rape approached? How does the author furnish a view of trauma? What becomes of the violated body? These are but a few of the questions that theorists of rape have addressed implicitly and explicitly.

For example, Ann J. Cahill suggests that the role of the body, at least through depiction that does not undermine or altogether obliterate subjectivity, is often neglected in creative renderings of rape. In *Rethinking Rape* she implores that we, "... understand rape as an act charged with political and bodily meanings, as a threat to the possibility of the bodily integrity of women, and therefore a threat to her status as a person."[14] Feminist analysis is a commonly useful lens for understanding the complexities that underlie "real" rape versus "reading," "writing," and "representing" rape.[15] In *Watching Rape: Film and Television in Postfeminist Culture*, Sarah Projansky addresses the commonality of rape narratives and situates them within transforming ideologies, to explore a "space" in which discourses of feminism, post-feminism, and rape intersect and influence each other.[16] Tanya Horeck, the author of *Public Rape: Representing Violation in Fiction and Film*, also proposes that every cultural portrait of rape problematizes representation, observing an endemic misrepresentation, but she intentionally seeks to move away from characterizing representations of rape as positive or negative.[17] As these texts explicate through different strands of theoretical inquiry, the example of rape underlines the failure of the cultural to accurately convey an act that is at once corporeal, emotional, physical, and intensely traumatic. Ellen Rooney names this challenge in stark terms by cautioning that "reading sexual violence remains hazardous."[18] Likewise, in her study *Intimate Violence: Reading Rape and Torture in Twentieth Century Fiction*, Laura Tanner emphasizes that there is something "at stake" in the process

of reading rape.[19] Explaining what these stakes are, how and if one can surmount them, and suggesting what they may indicate for society, culture, and politics has been an underlying theme of the growing cultural criticism about rape.

The aforementioned texts, while different in their approaches and underpinning theories, invariably indicate that rape poses challenges for representation. The specifics of the problem of representation in relation to rape take on multiple forms that include perspective positioning, narrative detail, discursive description, and the mechanics of language. Those who represent sexual violence in literature or in film risk objectifying their subject, because scenes of rape can be read voyeuristically in the space between seduction and violence. There is also the possibility that the story of rape will re-victimize the subject, as she becomes identified only in terms of the violence inflicted upon her. Or, it is possible for scenes of rape to normalize the horrific reality by making use of violation for creative purposes only, refusing the union of aesthetics and politics. How do artists attempt to resolve these problems? That is, when we take into account all of these critiques, is it possible to achieve a "positive" portrayal of rape? Tanya Horeck argues that we should divest from "positive" and "negative" representations because representation is inherently problematic. While I agree with Horeck that there is some danger in the pursuit of this positive/negative binary of representation, I think that when we turn our attention to rape survivors and their function within rape narratives, it is useful to think in these terms. I will argue that, in the depiction of rape in the context of Rwanda, the protection and the restoration of subjectivity constitute positive representations. My view is similar to the one espoused by Rajeswari Sunder Rajan in her essay "Life After Rape: Narrative, Rape and Feminism." According to Rajan it is indeed possible—and useful—to think of positive representations. Examples are to be found in "feminist texts of rape [that] counter narrative determinism" and ultimately, Rajan explains, "such negotiations are achieved by and result in alternative structures of narrative."[20] This use of narrative determinism contends that, in the representation of rape, narrative as a structure often obscures any will, and ultimately any subjectivity we might add, possessed by the survivor. For the purposes of our study the most important of these strategies is "representing a woman who becomes subject through rape rather than merely one subjected to its violation."[21] Along with this strategy, I would also designate a "positive portrayal" as one that manages to expose the material violence of rape, draw attention to the experience of the raped body, create possibilities for subjectivity despite rape, and contextualize the widespread realities of rape.

The two texts that serve as the basis for this analysis, Ivorian writer Véro-
nique Tadjo's *In the Shadow of Imana: Journeys into the Heart of Rwanda*, and the
film *Sometimes in April* by Haitian director Raoul Peck, can be understood as
creative interventions by artists who are not Rwandese of origin, but who posi-
tion themselves as image-makers who bear responsibility for how they repre-
sent traumatic events. I have chosen these two pieces because they also
constitute an effort on behalf of those outside of Rwanda to represent the
genocide. As such they speak to the significance of testimony and witnessing
present within traumatic discourse, unlike what Shoshana Felman argues
when she writes that, "testimony cannot simply be relayed, repeated, or re-
ported by another without losing its function as a testimony."[22] But, I want to
suggest that the Rwandan genocide, because of the original denial of its occur-
rence and the lack of international response, necessitates a different relation-
ship wherein others who have not personally experienced the genocide are
called to also account for its horror by listening to and relaying the trauma of
others. When we also consider the Arusha International Criminal Tribunals,
and the Gacaca courts in Rwanda, the necessity for testimonies to be shared in
multiple venues, media, sites, and formats comes into view as an element of
healing.

This is why Rwandese such as Yolande Mukagasana, one of the first geno-
cide survivors to publish her written testimony, have not only taken up the
task of writing their own testimonies but also of helping others to tell their
own stories by compiling the testimonies of survivors, victims, and perpetra-
tors of the genocide. Mukagasana initiated such a collective effort, *Les blessures
du silence: témoignages du génocide au Rwanda*, only after writing her own testi-
monial narrative in *La mort ne veut pas de moi* and *N'aie pas peur de savoir Rwan-
da: une rescapée tutsi raconte*.[23] Reproducing narratives of those who witnessed
and survived the genocide privileges the subjectivity of those who actually ex-
perienced the events. Here the witnessing and the testimony are doubled by
the realization that these are stories to pass on and by the active participation
in the effort to pass them on. Tadjo and Peck each explicitly express a pre-
existing urge to engage representations of the genocide. Both were approached
to participate in projects that would translate the trauma of the genocide into
art. Similarly, both have identified their projects as moments of transforma-
tion in their creative trajectories. As such their texts call forth the dialectics of
transnational engagement, the problematics of representing genocide, and the
tensions of grappling with traumatic remembrance. Their efforts also engage
the responsibility and the role of the artist/intellectual in the face of sweeping
violations of human rights. Moreover, both of the texts adopt a self-critical

approach appropriate to their positionalities as image-makers of a genocide of which they were not victims.

Rape as a Genocidal Strategy and Strategies of Genocidal Rape Representation

To write about representing rape within the genocide, let us begin with the historical facts: rape was an essential component of the Hutu strategy.[24] By raping women they could accomplish several goals simultaneously: 1) inflict pain on women considered as the enemy; 2) force women into shame; 3) symbolically emasculate Tutsi men by forcing them to watch the "taking of their women"; and 4) further ensure the future obliteration of the Tutsi ethnicity by impregnating women with Hutu genes. *Shattered Lives: Sexual Violence During the Rwandan Genocide*, a report by Human Rights Watch, details the atrocities against women:

> During the 1994 genocide, Rwandan women were subjected to sexual violence on a massive scale, perpetrated by members of the infamous Hutu militia groups known as the *Interahamwe*, by other civilians, and by soldiers of the Rwandan Armed Forces ... including the Presidential Guard ... Although the exact number of women raped will never be known, testimonies from survivors confirm that rape was extremely widespread and that thousands of women were individually raped, gang-raped, raped with objects such as sharpened sticks or gun barrels, held in sexual slavery ... or sexually mutilated. These crimes were frequently part of a pattern in which Tutsi women were raped after they had witnessed the torture and killings of their relatives and the destruction and looting of their homes. According to witnesses, many women were killed immediately after being raped ... Rapes were sometimes followed by sexual mutilation, including mutilation of the vagina and pelvic area with machetes, knives, sticks, boiling water, and in one case, acid.[25]

The accounts in the report are excerpted directly from the personal testimonics of survivors who have increasingly come forward with their traumatic testimonies during the past eleven years. Through their courageous acts of telling, these women bear witness to the horror that invaded and branded them physically and emotionally. Given the prevalence of rape during the genocide—it is estimated that 250,000 to 500,000 rapes were committed—it is not alarming that rape as an act of war has emerged as one of the dominant representations of the Rwandan genocide.

Ivoirienne Véronique Tadjo wrote *The Shadow of Imana: Travels into the Heart of Rwanda* as her contribution to the collective project, "*Écrire par devoir de mémoire*"/ "Our Duty to Remember." The genesis of "Our Duty to Remember" can be traced back to Fest'Africa, an annual gathering organized by African Arts and Media Association.[26] "Our Duty to Remember" was born in 1997 out of frustration over how the international community responded to the genocide and was motivated by discontent over the dearth of commentary

on and analysis of the genocide especially by African writers from all over the continent.[27] In order to break the silence that gnawed at their collective conscience, the participants of "Our Duty to Remember" became proactive: they would travel to Rwanda, visit sites of genocide, interview survivors—both victims and perpetrators—and write about their experiences. Under the leadership of Fest'Africa director Nocky Djedanoum, the collective, made up of ten writers, set out to spend a nine-month period in Rwanda in an effort to use their creativity as a tool for commentary and analysis.[28]

Tadjo's *The Shadow of Imana* chronicles journeys that she made into Rwanda with the "Our Duty to Remember" collective. In her text Tadjo adopts what I call an aesthetic of multiplicity as more than a literary technique, but as a mode of writing specifically used to grapple with the representation of genocide. With the phrase "an aesthetic of multiplicity," I mean to indicate a new form of inscription that attempts to translate violence and trauma through multifaceted techniques, among which we find journalistic account, fictional prose, personal testimony, and poetry coalescing into a single formation. This technique, I suggest, is a strategy that mirrors the occurrence of rape; because it occurred so frequently, it invariably took on different forms. My goal here is to show how Tadjo's aesthetic of multiplicity foregrounds the fact that there is no monolithic story of rape, in fact that different narratives exist.

When Tadjo embarks on the first thorough description of someone affected by the genocide, it is of a female subject, *la femme ligotée*—the bound-up woman. As the first expository act of representing genocide in the entire text, *la femme ligotée* uncovers layers of violence. The woman she describes was raped and had her throat slit by the murderers:

> Nyamata Church. Site of genocide ... A Woman bound hand and foot. Mukandori. Aged twenty-five. Exhumed in 1997. Home: the town of Nyamata. Married. Any children? Her wrists are bound, and tied to her ankles. Her legs are spread wide apart. Her body is lying on its side. She looks like an enormous fossilised fetus. She has been laid on a dirty blanket, in front of *carefully lined skulls* and bones scattered on a mat. *She has been raped.* A pickaxe has been forced into her vagina. She died from *a machete blow to the nape of her neck.* You can see the groove left by the impact. She still has a blanket over her shoulders but the material is now encrusted into the skin. She is there as an example, exhumed from the ditch where she has fallen with other bodies. On show so that no one can forget ... A mummified victim of genocide. Remnants of hair are attached to her skin.[29]

In this graphic description we can note the initial clinical rapportage of the scene—the naming of the location followed by the subject to be described assigns to it an archival nature. Beginning with basic methods for categorization, home, marital status, et cetera, it reads like a scene displaying the collection of

evidence, an endeavor to deliver the victim's condition in an objective and almost sterile nature. But the rawness of the details makes it impossible to choose indifference. In the original French, the use of the *passé composé* reminds us of the completion of the action, accentuating death; although the details make it seem more current, along with the fact that the body remains exposed, in another act of violation. This results in a discursive tension at the level of representation. As we draw additional conclusions beyond the material context, we can note the effects of the textual clinicization—the attempt to create distance is undercut by the reality. No technique can distance the horrors of genocide, so the use of a more distant tone becomes a reminder of the consistent power that subsumes the reality of genocide. Tadjo utilizes three of the familiar representations named in the introduction of this chapter—"carefully lined skulls," "a machete blow," and "she has been raped." But the employment of these images does not undermine the focus of this passage that pivots around the identity of the victim and the gendered aspect of the incident.

As a close reading of the text reveals, there are additional corporeal elements of memory, that is to say the literal embodiment of memory, wherein the female body becomes a *site of memory*. Here we can return to Cahill's *Rethinking Rape*, which encourages an understanding of rape that reinforces bodily experience, but that does not deny a space in which individual specificities can flourish. She writes, "rape needs to be thought of as ... something that is taken up and experienced differently by different women but also holds some common aspects ... as an experience that begins with the body but does not end there."[30] Marked by the trauma of rape now in addition to the unequivocally traumatic experience of genocide, these women can never escape the memories. As a site onto which the memory of genocide is inscribed, *la femme ligotée's* body becomes a site of traumatic memory. This realm of memory is somewhat different from Pierre Nora's conception of *lieu de mémoire*, but I would argue that Nora's formulation is fitting in this case because the body of *la femme ligotée* is a literal point where history and memory converge, a place "où se cristallise et se réfugie la mémoire."[31] We can further conceive of the raped body as a *lieu de mémoire* because of how it bears upon collective memory—according to the passage, it is this potency of the memory that even allows it to be transferred onto other bodies. Immediately after seeing the body Tadjo notes:

> [t]he horror of the sullied earth and of time laying down layers of dust in its passage. The bones of the skeleton corpses are disintegrating before our very eyes. The stench infects our nostrils and settles inside our lungs, contaminates our flesh, infiltrates our brains. Even later on, this smell will linger in our bodies and our minds.[32]

This transference (from the victims' bones, to the earth, to those who are present viewing the sites) reinforces the power of the remembered rape as a site of memory. The language of contagion brings to life the pungent odor being conveyed, but also travels beyond scent and the visceral into the intellectual, emotional, and spiritual effects of genocide. Inclusion of the mind and the spirit designates the manifold spheres of influence that genocide traverses. Everything is contaminated by the smell; the odor becomes a metaphor for the pollution pervading the mind, bodies, and spirits of not only in Rwanda but also throughout the world. It is an unrelenting infection that even years afterward would remain in the hearts and bodies of those who inhale it. The resulting disease is a perverse sickness where genocide is forgotten, the victims' voices are silenced, and the world can turn its gaze away, never denouncing violence in a refusal of recognition. The mechanisms of contagion and contamination highlight the duration of the genocide, further establishing it as a type of trauma. In the expository act of writing rape as infectious memory, Tadjo points to how the violation of a dead woman can have effects that outlast the genocide. As she becomes a site of memory that imprints those around her, la femme ligotée is endowed with an identity and a self that establishes her subjectivity.

Tadjo locates the retelling of genocide within individual voices, and within their interstices—that is, the gaps in which the stories are not shared explicitly but instead their effects are enumerated. Narratives, in their subjectivity, are useful vessels of counter-memory and are crucial because, without the voices of those that experienced the genocide, their memories would be destroyed. While the narratives of survivors are an integral part of Tadjo's project, in another scene where rape is made explicit, she goes beyond voice by focusing closely on the emotional aftermath of sexual violence. Thus she shows the forms of trauma that accompany layers of violence—beneath post traumatic stress syndrome there is rape trauma syndrome. This story is that of Anastasie, whose flesh imprisons her as the memory of her rape steadily asserts and reasserts itself. From the minute she wakes up the rape assaults her mind, "Anastasie would wake suddenly as dawn was breaking and be invaded by the memory of her rape."[33] The portrait of Anastasie suffering from rape trauma syndrome continues:

> She was trapped in the prison of her flesh. Her tongue felt furry, and prevented her from uttering the slightest word. Her desires had been worn away like rocks lashed by a stormy sea. She no longer recognised the inside of her body, felt a stranger to this heavy mass which was crushing her spirit. She felt exhausted even before glimpsing the beginning of the day.[34]

As with rape survivors in various contexts, for Anastasie the rape constitutes an "ineradicable memory," which is how Catherine Clinton describes the mark of sexual assault.[35] The memories of her rape prevent Anastasie from wanting to do anything or to go anywhere. She is even unable to recognize her own body, feeling like a stranger, even alien to it. This lassitude is the result of the unremitting trauma of her rape, of which we learn as soon as the chapter opens. Rather than describe the rape first, Tadjo again takes the site upon which the rape occurs, the woman's body, and describes the effects. By doing so she places emphasis on disembodiment, disempowerment, and distance, showing us how the body has been severed and fragmented. The distancing of the body is performed through its description as a prison and a heavy mass and by its comparison to a group of rocks. Tadjo uses visual imagery to articulate the tumultuous emotions. Now the distance between the body, marked as a traumatic memory of genocide, and the survivor's self governs her existence. Anastasie longs to "disappear into oblivion, sail along gently, let herself be carried away by the underground stream."[36]

The use of water provides another multilayered metaphor. In the first half of the paragraph, water is an image used to conjure violence. It is a reminder of the violent rushing and overflowing nature of the rape and as Anastasie describes her eroding desire "worn away like rocks lashed by a stormy sea," we witness the violent motion of the water slapping the rocks.[37] A few sentences later, water becomes her refuge as she longs to navigate "*les flots souterrains*"– "the underground stream." The two images do not contradict one another, instead they signal the intricately woven nature of sexual violence and the torrents of emotions that ensue in its wake. These images depicting the troubling realities of rape as they expose the woman's body after violation, and describing how one survivor feels emotionally and physically, disclose the persistent memory of rape. What is particularly remarkable about this example is the ambiguity surrounding when Anastasie was actually raped; it could have been during the genocide or during another time of violence. Overall this haze over temporality serves as a reminder that rape is not only a crime of war; this gesture that is a significant acknowledgment of the war waged on woman's bodies outside of the context of genocide, and one that accedes to their multiple locations.[38]

The narratives of rape in Tadjo's text, as I have attempted to sketch out here, focus our attention on the distinctions inherently present in the experience of rape. Our realization of the victim/survivor's subjectivity pivots around discursive (as in the union of body and memory), narrative (as in the choice of rapportage), and textual modes (as in the use of the water image) that underscore the specificity of rape for those who are subject to it in the context of the

Rwandan genocide. Ultimately, Tadjo's aesthetic of multiplicity in *The Shadow of Imana* manages to reveal an embodied female subject beneath layers of violence.

As in the text by Véronique Tadjo, the representation of genocidal rape in *Sometimes in April* marshals existing narratives of sexual violence and renders them according to empowered and embodied female subjectivities. In his portrayal of the Rwandan genocide, Haitian filmmaker Raoul Peck worked assiduously to incorporate the experience of survivors by seeking out their voices and participation in *Sometimes in April*. Peck's efforts remind us that the "outsider" as creator is potentially problematic. He reveals during an interview for *The Making of Sometimes in April* that, "it was always important that step by step I had the trust of the people over there and they felt I was telling their story."[39] The story that Peck tells is an attempt to "explain the ... political background around genocide," and as he divulges further, he was not "interested in doing a sort of Black *Schindler's List*."[40] Peck's commitment is made manifest throughout the film as well as in its marketing—the world premiere was in a Kigali stadium for a Rwandese audience. If the affirmative response by this population is any indication, the film will contribute significantly to providing a nuanced understanding of the complexities surrounding the genocide.

Sometimes in April is a film about the Rwandan genocide as it unfolded and what followed it. It relates the story of two Hutu brothers, one struggling to rebuild his life after losing everything during the genocide, and the other held for trial at the Arusha Tribunal.

> Yes, it's April again. Every year April the rainy season starts. And every year, every day a haunting emptiness descends over our hearts ... every year in April I remember how quickly life ends ... and every year I remember how lucky I should feel to be alive. Every year in April I remember ...[41]

This somber chorus of reflections begins the fictional story of *Sometimes in April* protagonist Augustin Muganza, a former Hutu soldier turned schoolteacher whose family was killed during the genocide. Because he refused to join the ranks of the slaughtering Hutus, Augustin and his family had to hide and flee from the genocide. He entrusts care of his Tutsi wife and their children to his brother, Honoré, a radio journalist well loved by the Interahamwe for supporting their politics of hate. *Sometimes in April* begins ten years after the genocide and shows how these two brothers must heal from the traumatic wounds of memory, visible through flashbacks and overlapping time frames. The film proffers a grim look at the genocide that does not evade the details of how the massacres occurred. Unlike its Oscar-nominated cousin *Hotel Rwanda*, the Peck film goes to great lengths to demonstrate the complexity of genocide

without crowning a heroic figure and without diminishing the horrific details of the slaughter that lasted one hundred days but whose origins are embedded deep within history. While there are certain images common to both films— the white painted/black-letter branded U.N. trucks, the intermarriage of a Hutu protagonist and a Tutsi woman, the actual Hotel Mille Collines, and the radios blaring their hate propaganda—the films are totally different in their approach to remembering the genocide. Peck captures three moments that enlighten our understanding of the genocide. First, through a lengthy introduction he offers a written history of the events leading up to the genocide, beginning with Belgian colonialism. Then throughout the film he alternates between the present, ten years after the genocide during the International Criminal Court Tribunal, and ten years previously during the days of the mass killings. Like Véronique Tadjo and her Fest'Africa colleagues, the participants in the making of *Sometimes in April* felt an overwhelming need to participate in the project as a way to speak out against the lack of media and international responses to the genocide. The actor who plays Augustin, Idris Elba, explains this desire in a magazine article:

> [i]n [his native] England the news was Africans killing Africans ... again. Little did I know a million people had been slaughtered in three months. I had to do this film for the sake of *those people* so their story could be told in full reality, not through some CNN or BBC reporter's edit ...[42]

Again, I would like to look at two scenes in the film that portray the rape of women—Valentine's testimony at the Tribunal and the fate of Jeanne, Augustin's wife. I aim to show that these scenes point to the integral role of women in the unfolding history of the Rwandan genocide. The first is the testimony of Valentine, a secret witness for the Tribunal in Arusha. When she first appears Valentine speaks to Augustin through the walls of his hotel room. Although she has never met him, Valentine asks Augustin to come hear her testify the following day. Her vulnerable request is a cry for humanization. By inviting someone she chooses to be present at her testimony, Valentine selects her own witness and empowers herself. What follows is her testimony:

> The first one, he took my baby off my back and put it on the floor. He penetrated me. He came to me and he had me a second time. Later, I don't remember exactly where, the interahamwes held us in another room and they raped all the girls. A young man threw himself on me ... After that he did humiliating things to me, he did not even remember that I was a mother ... When the second man was finished, the third one came and he forced me to lay down again. He raped me ... At that moment I just wanted to die ... Then the fourth one came and he took me ... At that moment I thought, God in heaven who are these men? ... The next day the interahamwes came and they made us go back to that house but they had to drag me there like a dead person, I was dead.[43]

The scene of Valentine's testimony of her rape at the cultural community center is based on a true story of the trial of Jean-Paul Akayesu, whose conviction marked the second time someone was charged and convicted of rape as an act of genocide in an International Tribunal.[44] The inclusion of the Akayesu trial told only from the perspective of a raped survivor is significant in redressing the impact of these monumental political strides on a single individual. As such we are given an intimate look into what the international human rights success meant at the personal and individual level. In Valentine's monotonous tone the listener discerns pain, courage, and perseverance. Her lingering feelings of trauma cause her to seek out Augustin for support. She asks him to attend the testimony so that her words can be heard by someone other than the officials and the judges at the trial, someone inevitably close to her but removed from her experience as a survivor. By framing the rape from a female perspective Peck continues where Tadjo left off when she described Anastasie's feelings. The portrayal of Valentine is both historically accurate—some of her words were taken directly from the testimonies of survivors in the previously cited United Nations report—and it assigns voice and authority to the rape survivor for, as a witness for the Tribunal, her testimony is crucial to the eventual and pivotal sentencing of Akayesu. By allowing Valentine to tell her story, a story that is based on a specific reality, Peck demonstrates how rape survivors constitute an indispensable element of the reconciliation process.

The mother of two sons, Valentine is also the double of Augustin's dead wife, Jeanne, who we learn two scenes later suffered a similar fate. After her rape Jeanne pulls a grenade that leads to the demise of her perpetrators, as well as to her own death. When she asks them, "Do you think I am afraid to die?" she voices the cry of women such as Valentine who after multiple rapes "just wanted to die."[45] Her suicide and her murder of her rapists is an act of bravery because by sending the women away before killing the assailants, she protects them to the greatest extent possible within the circumstances. Jeanne's selfless act of vengeance also bears symbolic significance through which we can imagine all of the women who were crippled into inaction after being raped. Peck never shows us the actual rape on screen. Instead we see the women immediately after "a horrific night." There are obvious signs of what took place in the room: the women's ripped clothes, crippled demeanor, and position cowering in the corner. The sight of the men zipping up their pants, buckling their belts, and all but congratulating one another with slaps on their backs leaves us with no doubt that multiple rapes have just taken place.

The examples from *The Shadow of Imana* and *Sometimes in April* highlight four distinct methods for representing "positive" subjectivity for rape survivors of the Rwandan genocide: the reflection on a dead woman who was a victim of

sexual assault, the memories of a woman uncertain about when she was raped, the testimony of a survivor of gang rape, and the woman who retaliates against her perpetrators. In addition, I propose that there is an underlying progression in the view of subjectivity for the four narratives of rape I have drawn out in this paper. First, in *la femme ligotée*/the bound woman, we see the raped body exposed that functions as metonymy for genocide. The triple violation of the body—that the woman was first raped, then had the pickaxe thrust into her vagina, and then had her body left outside the grave to be exposed as an example—is a frightful warning of how genocide can always repeat itself.[46] This is also similar to what writer and member of "Our Duty to Remember" Boubacar Boris Diop coined the double genocide—the genocide that occurred and the subsequent silence surrounding it.[47] The example of Anastasie is an elaborate exploration of the effects of rape on the survivor's psyche, an expository act that renders the reality of rape trauma syndrome and focuses on the body. In the case of Valentine, we have a woman voicing her own story, despite its harrowing nature, for a political end whose larger goal is reconciliation. Finally, in Jeanne we see a raped woman who goes from being a hapless victim of sexual assault to an empowered agent of her final destiny and that of her perpetrators. This progression of narratives can be seen as a chain of subjectivities that with each step goes further in pursuit of creating women who are subjects, and not just the "spoils of war"; women whose experiences of gendered violence are not forgotten, discarded, or lost in the goal to write about the Rwandan genocide. The progression attests to the growing possibility that genocide can be rendered in complex terms that excavate its multiple layers of violence.

Rape is ineffable in its ability to be reproduced. The act of violation snatches power from the victim, and each memory of the rape is an excruciatingly painful process. In representing rape, artists must find a way to capture the immutable pain that is suffered by survivors/victims. This pain is irrevocably incommunicable on a number of levels, as is the trauma of genocide. Yolande Mukagasana, one of the first survivors of the Rwandan genocide to publish her written testimony, has remained passionately committed to encouraging all people to educate themselves about the events that transpired during 1994, as well as what led up to it and what has followed it. In *Les blessures du silence/ The Wounds of Silence*, she explains that a reductive image of genocide is just as detrimental as a forgetting of the past:

> Ne retenir du génocide rwandais que les images des corps déchiquetés par des machettes pour aussitôt s'apitoyer sur des camps de refugiés atteints de cholera, comme si celui-ci avait aussi choisi ses victimes, c'est transformer d'un coup de baguette magique des personnes concernés par ce génocide—bourreaux, complices, survivants, innocents—en simple victime d'un drame humanitaire. C'est surtout refuser d'analyser le

mécanisme et le fonctionnement de ce génocide, c'est accepter qu'il puisse se repro-
duire au Rwanda ou ailleurs.[48]
To retain from the Rwandan genocide but the images of bodies torn to pieces and
machetes in order to immediately have pity on the refugee camps suffering from chol-
era, as though the former had also chosen its victims, it is to transform, with the wave
of a magic wand, the people affected by the genocide—the killers, accomplices, survi-
vors, innocent—into mere victims of a humanitarian drama. In particular, to do this is
to refuse to analyze the mechanism and the function of this genocide, it is to accept
that it can reproduce itself in Rwanda or elsewhere.[49]

Mukagasana warns that reductive images engender re-victimization because
they forgo analysis. Seemingly responsive to Mukagasana's supplication, Tadjo
and Peck represent the mechanism of rape as one element of genocide that is
complexly multilayered. As we saw in the scholarship on rape and representa-
tion at the beginning of this chapter, there are numerous challenges that sur-
face as one renders rape. When we then consider a layered experience of
violence as we did here with representations of rape within genocide, the chal-
lenges persist and intensify. By delivering portrayals of rape that are neither
reductive nor limiting in their renditions, Tadjo and Peck have deftly negoti-
ated the challenges Mukagasana expresses. They achieve this, as I have tried to
demonstrate, in a number of ways: by turning their attention to the elabora-
tion of subjectivity, by displaying episodes of rape with different outcomes for
the victim/survivor, by employing different narrative modes to tell the stories
of rape, and by indicating the significance of gendered violence within other
violent contexts. By showing what lies beneath layers of violence, their compel-
ling representations indicate an unflagging commitment to privileging the
voices of those survivors who suffered gendered violence during the genocide.
 More than a decade after the Rwandan genocide, the twenty-first century
has finally brought forth multiple cinematic and literary representations of the
genocide.[50] Especially because of the acute media recognition of *Hotel Rwanda*,
these representations have garnered attention from larger audiences for whom
the actual genocide went on practically imperceptibly. In many ways the popu-
larity of these texts signifies international guilt and anxiety about how the
genocide was ignored when it first occurred. A larger project can be perceived
in many of these efforts: to educate people about what happened so that, as
Mukagasana implored, it will not be acceptable for genocide to be "repro-
duced elsewhere." Yet, currently another genocide rages on in the Sudan. To
discuss the implications of *The Shadow of Imana* and *Sometimes of April*—both
texts that offer textured understanding to the layers of violence endemic to
genocide—is to hope that the necessity of these types of projects for remember-
ing genocide will not continue in perpetuity. In the context of rape, the inter-
national trials that followed the genocide represented a historic moment as
one of the first times that perpetrators of rape were tried for crimes against

humanity.[51] The recognition of rape as a crime against humanity is one of the groundbreaking, though overdue, achievements of the Arusha Tribunals.

When we consider these issues cumulatively—rape representation and genocide—in the context of cultural criticism, we are still left with the problem of representation. The problematics of trauma and memory ensure that representation will remain at issue when literature of film seeks to portray the genocide. Likewise, the global existence of a "rape culture," denying the experience and the significance of rape narratives, ensures that representations of rape will map contested spaces.[52] Perhaps the most important accomplishment of texts like *The Shadow of Imana* and *Sometimes in April* is that they suggest that alternative representations are possible. These possibilities are embodied by representations that do not re-victimize the victims and survivors of genocidal rape, do not trivialize the experience of those who suffered during the genocide, do not erroneously suggest that rape only occurs in times of war, and do not dilute the traumatic experience of thousands and their dead.

Notes

1 Françoise Lionnet, "Geographies of Pain: Captive Bodies and Violent Acts in the Fictions of Myriam Warner-Vieyra, Gayl Jones, and Bessie Head," *Callaloo*16, No. 1 (1993): 132-52.

2 Ibid., 137 (emphasis mine).

3 Elaine Scarry pursues the topic in her study *The Body in Pain: The Making and Unmaking of the World*, a veritable exegesis on the incommunicability of pain. Although, as Rajeswari Sunder Rajan has argued, "Scarry created out of pain the very condition of the female subject ... 'the radical subjectivity of pain' as Scarry calls it, referring to its essential privacy and incommunicability can also serve as the basis of subjectivity in the sense of ... the constitution of the identity of the self/subject." See Rajeswari Sunder Rajan, *Real and Imagined Women: Gender, Culture and Postcolonialism* (London: Routledge, 1993), 20.

4 I borrow this term from Chandra Talpade Mohanty, who like many global feminist theorists, has focused on the simultaneity of oppressions such as race, gender, class, nationality, sexuality, culture and other "locations" that informs my vision of feminist politics. In the case of Rwanda we must consider race, gender, nationality, culture, and ethnicity. See Chandra Talpade Mohanty, "'Under Western Eyes' Revisited: Feminist Solidarity through Anti-Capitalist Struggles," *Signs* 28, No. 2 (2003): 499-535.

5 Throughout this chapter I will be referring to the text in its English translation rather than in the original French *L'Ombre d'Imana: Voyages jusqu'au bout du Rwanda* (Arles: Acte Sud, 2001).

6 Beverly Allen defines genocidal rape as "a military policy of rape for the purpose of genocide ..."; Allen goes on to note that rape is "often part of torture preceding death" and that it "furthers the genocidal plan of ethnic cleansing." See her *Rape Warfare: The Hidden Genocide in Bosnia-Herzegovina and Croatia* (Minneapolis: University of Minnesota Press, 1996), vii.

7 Elaine Scarry, *The Body in Pain*, 4.

8 Ibid., 6.

9 There is an extensive body of literature on rape discourse in the U.S. context, some of these works include: Diana Russell, *The Politics of Rape: The Victim's Perspective* (New York: Stein and Day, 1974); Noreen Connell, *Rape the First Sourcebook for Women* (New York: New American Library, 1974); Susan Brownmiller, *Against Our Will: Men, Women, and Rape* (London: Penguin, 1975); Susan Estrich, *Real Rape* (Cambridge: Harvard University Press, 1987); Liz Kelly, *Surviving Sexual Violence* (Cambridge, UK: Polity Press, 1988); Robin Warshaw, *I Never Called It Rape: The Ms. Report on Recognizing, Fighting, and Surviving Date and Acquaintance Rape* (New York: Harper & Row, 1988); Elizabeth Grauerholz and Mary Kowaleski, eds., *Sexual Coercion: A Sourcebook on its Nature, Causes and Prevention* (Lexington, Mass.: Lexington Books, 1991); Lynn A. Higgins and Brenda R. Silver, eds., *Rape and Representation* (New York: Columbia University Press, 1991); Laura E. Tanner, *Intimate Violence: Reading Rape and Torture in Twentieth Century Fiction* (Bloomington: Indiana University Press, 1994); Lisa Cuklanz, *Rape on Trial: How the Mass Media Construct Legal Reform and Social Change* (Philadelphia: University of Pennsylvania Press, 1996); Ann J. Cahill, *Rethinking Rape* (London: Cornell University Press, 2001); Sabine Sielke, *Reading Rape: The Rhetoric of Sexual Violence in American Literature and Culture, 1790–1990* (Princeton: Princeton University Press, 2002); and Tanya Horeck, *Public Rape: Representing Violation in Fiction and Film* (London: Routledge, 2004).

10 Susan Brownmiller, *Against Our Will*.

11 Ibid.

12 Lisa Cuklanz offers a nuanced reading of these founding texts in her *Rape on Prime Time: Television, Masculinity, and Sexual Violence* (Philadelphia: University of Pennsylvania Press, 1996).

13 Lynn A. Higgins and Brenda R. Silver, eds., *Rape and Representation*, 3–4.

14 Ann Cahill, *Rethinking Rape*, 10.

15 Wendy Hesford and Wendy Kozol have edited a collection that explores the "crisis of the 'real'" in regards to various forms of violence in *Haunting Violations: Feminist Criticism and the Crisis of the "Real"* (Urbana: University of Illinois Press, 2001).

16 Sarah Projansky, *Watching Rape: Film and Television in Postfeminist Culture* (New York: New York University Press, 2001), 89.

17 "In examining how rape is always a problem of representation, just as the problem of representation is constantly revealed through the issue of rape, my aim is to disturb a positive-images approach to the question of violence. Discussions of literary and filmic representations of rape have been particularly prone to pivot on the question of whether a depiction of sexual violence is 'good' or 'bad'." Tanya Horeck, *Public Rape*, 7.

18 Ellen Rooney, "Criticism and the Subject of Sexual Violence," *MLN* 98, No. 5 (December 1983): 1269–1278, 1270.

19 Laura Tanner, *Intimate Violence*, 3.

20 Rajeswari Sunder Rajan, *Real and Imagined Women*, 76–77.

21 Rajan also names the following reasons: "... by structuring post-rape narrative that traces her strategies of survival instead of a rape-centered narrative that privileges chastity and leads inexorably to 'trials' to establish it; by locating the raped women in structures of oppression rather than heterosexual 'romantic' relationships; by literalizing instead of mystifying the representation of rape; and, finally, by counting the cost of rape for its victims in terms more complex than the extinction of female selfhood in death or silence." Rajeswari Sunder Rajan, *Real and Imagined Women*, 77.

22 Shoshana Felman, "Education and Crisis, or the Vicissitudes of Teaching," in *Trauma: Explorations in Memory*, edited by Cathy Caruth (Baltimore: Johns Hopkins University Press, 1995), 15.

23 Yolande Mukagasana, *Les Blessures du Silence: Temoignages du Genocide au Rwanda* (Medecins sans Frontières, 2001); Yolande Mukagasana, *La Mort ne Veut pas de Moi* (Paris: Fixot, 1997); and Yolande Mukagasana, *N'aie pas Peur de Savoir* (Paris: R. Laffont, 1999).

24 It should be noted that Tutsi women were not the only women raped during the genocide; part of the Interahamwe strategy was to also eliminate, torture, kill, and rape moderate Hutu men and women.

25 Human Rights Watch/Africa, Women's Rights Project (Human Rights Watch), and Fédération internationale des droits de l'homme, *Shattered Lives: Sexual Violence during the Rwandan Genocide and Its Aftermath* (New York: Human Rights Watch, 1996).

26 This organization is more commonly known by its French name *l'Association Arts et Médias d'Afrique.*

27 Participating writer Boubacar Boris Diop explains that the project was spearheaded by Fest'Africa director, Nocky Djedanoum, "Le directeur du festival, Nocky Djedanoum, a pensé que ce serait bien d'envoyer au Rwanda des auteurs africains puisque, quand il y a eu le génocide, tout le monde en a un peu parlé mais pas les auteurs africains. C'est Nocky qui a donc eu cette très belle idée..." "Le Rwanda m'a appris a appeler les monstres par leur nom" Entretien avec Boubacar Boris Diop," *Africultures* 30 (September 2000) "Rwanda 2000: mémoires d'avenir" (Paris: L'Harmattan, 2000), 15.

28 The following is a list of the ten writers, their country of origin, and the names of the texts they wrote as a part of the project: Boubacar Boris Diop, Sénégal. *Murambi, le livre des ossements* (Stock, 2000); Monique Ilboudo. Burkina Faso. *Mukratete* (Le Figuier et Fest'Africa editions 2000); Koulsy Lamko, Tchad. *La phalène des collines* (Kuljaama, Kigali 2000); Tierno

Monenembo, Guinée. *L'aîné des orphelins* (Seuil, 2000); Meja Mwangi, Kenya. *Great Sadness* (forthcoming); Vénuste Kayimahé, Rwanda. *France-Rwanda, les coulisses du genocide*; Véronique Tadjo, Côte d'Ivoire. *L'ombre d'Imana: Voyages jusqu'au bout du Rwanda* (Actes sud, 2001); Jean-Marie Vianney Rurangwa, Rwanda. *Le genocide des Tutsi expliqué à un étranger* (Le Figuier Fest'Africa Editions, 2000); Abdourahman Ali waberi, Djibouti. *Terminus: Textes Pour le Rwanda* (Le Serpent à Plumes, 2000); Nocky Djedanoum, Tchad. *Nyamirambo!* (Le Figuier Fest'Africa Editions, 2000).

29 Véronique Tadjo, *The Shadow of Imana: Travels in the Heart of Rwanda*, trans. Veronica Wakerley (Johannesburg: Heinemann, 2002), 11.

30 Ann Cahill, *Rethinking Rape*, 5.

31 Pierre Nora, *Les Lieux de Mémoire I* (Paris: Gallimard, 1984), xvii. Also cited in *History and Memory in African American Culture*, edited by Geneviève Fabre and Robert O'Meally (New York: Oxford University Press, 1994), 7.

32 Véronique Tadjo, *The Shadow of Imana*.

33 Ibid., 63.

34 Ibid.

35 Catherine Clinton, "'With a Whip in His Hand': Rape, Memory, and African-American Women," in *History and Memory in African American Culture*, edited by Geneviève Fabre and Robert O'Meally (New York: Oxford University Press, 1994), 205-218.

36 Véronique Tadjo, *The Shadow of Imana*, 63.

37 Ibid.

38 I find it useful here to cite Catharine MacKinnon when she writes, "the trouble has been that men do in war what they do in peace, only more so, when it comes to women the complacency that surrounds peace time extends to war time...."; Catharine MacKinnon, "Rape, Genocide, and Women's Human Rights," in *Violence Against Women: Philosophical Perspectives*, edited by Stanley French, Wanda Teays and Laura Purdy (Ithaca. Cornell University Press, 1998), 43-56, 53.

39 *The Making of Sometimes in April*. United States, HBO Films.

40 Ibid.

41 Dir., Raoul Peck, *Sometimes in April*. United States, HBO Films (2005).

42 "Interview with Idris Elba," *Honey Magazine*, March 2005

43 Dir., Raoul Peck, *Sometimes in April*. United States, HBO Films (2005).

44 The first time that rape was recognized as a crime of genocide was in 1993 during the International Criminal Tribunals for the Former Yugoslavia (ICTY). See Beverly Allen, *Rape Warfare* for more information about rape during this ethnic cleansing.

45 Dir., Raoul Peck, *Sometimes in April*. United States, HBO Films (2005).

46 Nowhere is this repetition more evident than in the current situation in Darfur, Sudan.

47 Boubacar Boris Diop made these comments at the annual African Literatures Association meeting in 2005. To Diop's observation we could add a third element that took place in between—the initial international refusal and failure to name the events in Rwanda as genocide.

48 Yolande Mukagasana, *Les blessures du silence* (Arles: Actes sud, 2001), 11.

49 Translation mine.

50 There have been a number of films over the past few years especially: *100 Days* (Drama, 2002); *Sometimes in April* (Drama, 2004); *Hotel Rwanda* (Drama, 2004); *Shooting Dogs* (Drama, 2005); *A Sunday at the Pool in Kigali* (Drama, 2005).

51 Because the International Criminal Tribunals for the former Yugoslavia punished rape as a form of ethnic cleansing, the Rwandan genocide represented the first time individual acts of rape were prosecuted as acts of genocide.

52 According to the authors of *Transforming a Rape Culture*, "A [rape culture] is a complex of beliefs that encourages male aggression and supports violence against women." See Emilie Buchwald, Pamela Fletcher and Martha Roth, eds., "Preface," in *Transforming a Rape Culture* (Minneapolis: Milkweed Editions, 1993), 1-4.

CONTRIBUTORS

M. Cristina Alcalde is Assistant Professor of Gender and Women's Studies and Anthropology at the University of Kentucky. She holds a Ph.D. in Anthropology and an M.A. in Latin American Studies from Indiana University. Her work focuses on gender, class, race, resistance, and domestic violence in Peru, and more recently also among Latinos in the U.S. Some of her publications include articles in the *Journal of Latin American and Caribbean Anthropology*; *Meridians: Feminism, Race, Transnationalism*; *Latin American Perspectives*; and the co-edited volume (with Joseph Zavala) *Visión del Perú de académicos peruanos en Estados Unidos* [Visions of Peru of Peruvian Academics in the United States].

Linda Isako Angst is Assistant Professor of Sociology/Anthropology and Gender Studies at Lewis and Clark College, where she also contributes to the programs in East Asian Studies and Ethnic Studies. Her research has focused on questions of nostalgia and collective memory, ethnicity, colonialism/postcolonialism, gender, and national identity formation in Japan. Forthcoming from Harvard University Press, her monograph, *In A Dark Time: Memory, Community, and Gendered Nationalism in Postwar Okinawa*, addresses questions of Okinawan women's political subjectivity, particularly as understood through their narratives about wartime experiences, memories, and postwar occupation by the U.S. military.

Karen Boyle is a Lecturer in Film & Television Studies at the University of Glasgow, Scotland. She is the author of *Media & Violence: Gendering the Debates* (Sage, 2005) and has published a range of articles on gender, violence, pornography and the media.

Lisa Cuklanz is Associate Professor and Chair of the Department of Communication at Boston College. She is author of *Rape on Trial: How the Mass media Construct Legal Reform and Social Change* (University of Pennsylvania Press, 1996) and *Rape on Prime Time: Television, Masculinity, and Sexual Violence* (University of Pennsylvania Press, 2000) as well as numerous articles published in journals including *Women's Studies in Communication*, *Critical Studies in Media Communication*, and *Communication Quarterly*.

Jia Gao lectures in the Asia Institute at The University of Melbourne, Australia. His research interests include sociological studies of post-1978 Chinese society, with particular focus on public opinion and socio-political dynamics in post-Mao China. He has published widely on Chinese migration and Chinese media in such journals as *International Migration Review* and *Asian and Pacific Migration Journal*, contributed a book chapter to *Media and the Chinese Diaspora: Community, Communications and*

Commerce (edited by Wanning Sun, Routledge, 2006), and has recently co-authored three research papers with Dr Peter C. Pugsley.

Julie Haynes is an Associate Professor of Communication Studies at Rowan University. She received her Ph.D. in Speech Communication from Penn State University and her Master's from Texas A&M University. Her research interests include feminist resistance rhetorics, rhetorical dimensions of media and popular culture, and rhetoric of regional identity.

Régine Michelle Jean-Charles is an Assistant Professor of African and African Diaspora Studies and Romance Languages and Literatures at Boston College. She received her B.A. from the University of Pennsylvania, as well as an A.M. and Ph.D. from Harvard University. Professor Jean-Charles was a postdoctoral fellow at the University of Virginia's Carter G. Woodson Institute for African-American and African Studies. Her current manuscript "Gendering Violence: Francophone Women Writers, Representations of Violence, and the Violence of Representation" uses a feminist theoretical optic to explore the discourses of violence in postcolonial francophone literature and culture.

Dr Elaine Jeffreys is Senior Lecturer in China Studies at the University of Technology, Sydney, and a member of the UTS China Research Centre. She is the editor of *Sex and Sexuality in China* (Routledge 2006) and author of *China, Sex and Prostitution* (RoutledgeCurzon 2004). Recent publications include: 'Advanced producers or moral polluters? China's bureaucrat-entrepreneurs and sexual corruption', in *The New Rich in China: Future Rulers, Present Lives*, edited by David S. G. Goodman (Routledge 2008); and 'Querying queer theory: debating male-male prostitution in the Chinese Media', *Critical Asian Studies* 39, 1 (2007): 151–75.

Gordene Mackenzie, long time gender activist, is the author of *Transgender Nation*, and director of *In Memory of Rita*. She is director of Women's Studies at Merrimack College where she teaches courses on Gender, Media, Film, Global Women's Issues, and Southwest Studies in the US. She produces and co-hosts GenderTalk radio.

Mary Marcel (PhD, UC Berkeley) is the author of *Freud's Traumatic Memory: Reclaiming the Seduction Theory and Revisiting Oedipus*. Her research focuses on feminist psychology, rhetoric, media coverage of social movements, business ethics and communication. She has published in *The Cambridge Quarterly* and *The Encyclopedia of Rhetoric*, and teaches at Bentley College.

Danica Minic is a graduate of the University of Belgrade, Department of Comparative Literature and Theory of Literature. She earned an MA in Gender Studies, Central European University, Budapest, 2004 and was Chevening Scholar at Oxford University, 2005/2006. She is currently a PhD student at CEU, researching gender and media diversity in Serbian and Croatian television.

Sidra Fatima Minhas is visiting faculty at Government College University, Lahore and a Research Associate with the Canada-Pakistan Basic Education Project. She graduated from the Institute of Education in 2005 with an MA in Education, Gender and International Development. Her research interests include gender and education with special interest in Pakistan.

Sujata Moorti is Professor and Chair of the program in Women's and Gender Studies at Middlebury College. She is author of The Color of Rape (SUNY Press, 2002), as well as numerous articles on gender and representation published in journals including Critical Studies in Media Communication; Media, Culture and Society, and International Journal of Cultural Studies. She is also the co-editor of Global Bollywood (University of Minnesota Press, 2008).

Peter C. Pugsley lectures in media at The University of Adelaide, Australia. Published articles and reviews on the contemporary media in Asia have appeared in the Asian Journal of Communication, International Communication Gazette, Westminster Papers in Communication and Culture, The China Journal and Media International Australia.

Pamela Scully is Associate Professor of Women's Studies and African Studies at Emory University, USA. Her work has focused on gender, law and sexual violence in historical perspective. Her publications include "Rape, Race and Colonial Culture: The Sexual Politics of Identity in the Nineteenth-Century Cape Colony, South Africa," American Historical Review 300 (April 1995); Liberating the Family! Gender and British Slave Emancipation in the Rural Western Cape, South Africa, 1823-1853 (Heinemann, 1997); Gender and Slave Emancipation in the Atlantic World, co-edited with Diana Paton (Princeton, 2005) and Sara Baartman and the Hottentot Venus: A Ghost Story and a Biography, co-authored with Clifton Crais (Princeton, Fall 2008). Her research is now focusing on history, gender and human rights in Africa.

INDEX

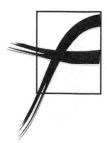

Intersections in Communications and Culture

Global Approaches and Transdisciplinary Perspectives

General Editors: Cameron McCarthy & Angharad N. Valdivia

An Institute of Communications Research, University of Illinois Commemorative Series

This series aims to publish a range of new critical scholarship that seeks to engage and transcend the disciplinary isolationism and genre confinement that now characterizes so much of contemporary research in communication studies and related fields. The editors are particularly interested in manuscripts that address the broad intersections, movement, and hybrid trajectories that currently define the encounters between human groups in modern institutions and societies and the way these dynamic intersections are coded and represented in contemporary popular cultural forms and in the organization of knowledge. Works that emphasize methodological nuance, texture and dialogue across traditions and disciplines (communications, feminist studies, area and ethnic studies, arts, humanities, sciences, education, philosophy, etc.) and that engage the dynamics of variation, diversity and discontinuity in the local and international settings are strongly encouraged.

LIST OF TOPICS

- Multidisciplinary Media Studies
- Cultural Studies
- Gender, Race, & Class
- Postcolonialism
- Globalization
- Diaspora Studies
- Border Studies
- Popular Culture
- Art & Representation
- Body Politics
- Governing Practices

- Histories of the Present
- Health (Policy) Studies
- Space and Identity
- (Im)migration
- Global Ethnographies
- Public Intellectuals
- World Music
- Virtual Identity Studies
- Queer Theory
- Critical Multiculturalism

Manuscripts should be sent to:

Cameron McCarthy OR Angharad N. Valdivia
Institute of Communications Research
University of Illinois at Urbana-Champaign
222B Armory Bldg., 555 E. Armory Avenue
Champaign, IL 61820

To order other books in this series, please contact our Customer Service Department:
(800) 770-LANG (within the U.S.)
(212) 647-7706 (outside the U.S.)
(212) 647-7707 FAX

Or browse online by series:
www.peterlang.com